Modest_Witness@Second_Millennium

.FemaleMan©_Meets_OncoMouse™

Modest_Witness@

Donna J.

With paintings by Lynn M. Randolph

econd_Millennium

.FemaleMan©_Meets_OncoMouse™

Feminism and Technoscience

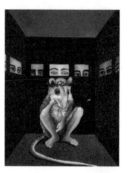

H a r a w a y

Routledge

New York • London

Published in 1997 by
Routledge
29 West 35th Street
New York, NY 10001

Published in Great Britain by
Routledge
11 New Fetter Lane
London EC4P 4EE

Library of Congress Cataloging-in-Publication Data available from the Library of Congress.

Front Cover: Lynn Randolph, The Annunciation of the Second Coming, oil on canvas, 58" x 64", 1996.

Lynn Randolph's angel, painted according to Renaissance conventions except for her transparent wings, announces not the birth of Christ, but the warning that life on earth is changing irrevocably. On the right hand of the painting, a cosmic galaxy made of a giant DNA molecule echoes the angel's message. Striding through the stylized fifteenth-century Italian colonnade along the pathway of a computer circuit board, the classical and statuesque electronic goddess carries in her troubling body both a threat and a promise. She is a matrix, one who is pregnant with the contradictions, emergencies, delusions, and hopes of colliding sociotechnical worlds.

For Rusten, Field Notes, and HogWorks

Acknowledgments

A book is a visible sign of the contributions of an extended web of colleagues; friends (human and animal); students; antagonists; and workers of all sorts in libraries, publishing houses, laboratories, corporations, funding institutions, and classrooms. It is not possible to acknowledge all the gifts of ideas, time, liveliness, disagreements, references, shared passions, bits of language, visual images, political commitment, food, money, jobs, travel, and much else that I have received from the networks of people who made this book possible. But I want to try to name a few of the people and institutions and hope that their names can stand for all others to whom I feel connected in this project.

First, the paintings by Lynn M. Randolph in this book are part of an ongoing traffic between us in images, ideas, and hopes. Her art has been an extraordinary intellectual and physical gift.

I remain in awe of my colleagues, students, and co-workers at the University of California at Santa Cruz, my academic home since 1980. I owe special thanks to Sheila Peuse, Billie Harris, Alexandra Armstrong, Sylvia Holmes, and Kathy Durcan. Co-teaching with Dana Takagi and Anna Tsing was a special privilege. My department is made up of scholars and friends who have changed my life and mind repeatedly. Thanks to Victor Burgin, Jim Clifford, Angela Davis, Teresa deLauretis, Barbara Epstein, Gary Lease, and Hayden White.

Graduate students shape my thinking profoundly; their influence extends long after they leave UCSC. Despite my efforts carefully and conspicuously to cite oral, unpublished, and published works by students, more than once I have found myself credited for an idea or argument that germinated with a graduate student in a seminar or discussion in my office. Intellectual work flourishes in webs; writing is always a conversation, hidden or not; and ideas should not be owned. My title word FemaleMan© points to a joke, a fact, and a debt. Although I am conscious of many more present and past students inhabiting these pages, I can name here only those I worked with closely who have finished their Ph.D.s since my last book was published in 1991: Elizabeth Bird, Megan Boler, Nancy Campbell, Laura Chernaik, Giovanna Di Chiro, Julia

Creet, Vince Diaz, Joseph Dumit, Ron Eglash, Eric Engles, Julia Erhart, Ramona Fernandez, Sharon Ghamari-Tabrizi, Thyrza Goodeve, Chris Gray, John Hartigan, Mary John, Laura Hyun-Yi Kang, Lorraine Kenny, Valerie Kuletz, Melissa Matthes, Yoshiko Miyake, Chéla Sandoval, Victoria Smith, Alluquere Stone, Marita Sturken, Noël Sturgeon, Jennifer Terry, and Sarah Williams. Joanne Barker, Julian Bleecker, Claudia Castañeda, Marcy Darnovsky, Ilene Feinman, Barbara Ige, Yvonne Keller, and Anjie Rosga are poised to finish as I write this acknowledgment. Cori Hayden and Brendan Brisker generously let me use unpublished papers. I am also grateful to doctoral students outside UCSC on whose dissertation committees I have served since 1991: Monica Casper, Alex Chasin, Charis Cussins, and Deborah Davis.

Many colleagues in the wider world, in and out of the academy, contributed to this book by engaging me in extended conversations, reading my papers at various stages of completion, inviting me to speak, translating my writing, and sharing their own work-in-progress. Thanks especially to Pnina Abiram, Carol Adams, Kristin Asdal, Karen Barad, Kum-Kum Bhavnani, Lynda Birke, Liana Borghi, Rosi Braidotti, Brita Brenna, Richard Burian, Judith Butler, Susan Caudill, Adele Clarke, Giulia Colaizzi, Martha Crouch, Linda Donelson, William Cronon, Gary Downey, Paul Edwards, Shelly Errington, Anne Fausto-Sterling, Elizabeth Fee, Andrew Feenberg, Margaret Fitzsimmons, Michael Flower, Sarah Franklin, Joan Fujimura, Peter Galison, Lucia Gattone, Scott Gilbert, David Goodman, Elisabeth Gulbrandsen, Sandra Harding, Susan Harding, Valerie Hartouni, Nancy Hartsock, David Harvey, N. Katherine Hayles, Frigga Haug, Deborah Heath, Stephan Helmreich, Margo Hendricks, David Hess, Caroline Jones, Lily Kay, Evelyn Fox Keller, Katie King, Ynestra King, Bruno Latour, Diana Long, Helen Longino, John Law, Lynn Margulis, Emily Martin, Carolyn Martin-Shaw, Carolyn Merchant, Gregg Mitmann, Helene Moglen, Ingunn Moser, Gary Olson, Aihwa Ong, Elizabeth Potter, Baukje Prinz, Paul Rabinow, Rayna Rapp, Hilary Rose, Mark Rose, Joseph Rouse, Elvira Scheich, David Schneider, Richard Sclove, Joan Scott, Fernando Jose García Selgas, Steve Shapin, Anneke Smelik, Anne Spirn, Brian Cantwell Smith, Neil Smith, Karin Spaink, S. Leigh Star, Marilyn Strathern, Lucy Suchman, Dana Takagi, Peter Taylor, Sharon Traweek, Anna Tsing, David Walls, Bonnie Wheeler, Langdon Winner, Susan Wright, Alison Wylie, Robert Young.

Several extended workshops were especially important to me in writing this book. I am indebted to the members of the winter, 1991, residential seminar on "Ethical Implications of Biotechnology," at the University of California Humanities Research Institute at Irvine and to the UCHRI for support. In 1994, I participated in the wonderful UCHRI residential workshop on

"Reinventing Nature," organized by William Cronon. In the fall of 1994 I was a member of a week-long seminar on cyborg anthropology at the School of Advanced Research in Santa Fe, New Mexico. The way the people in that seminar sustained principled and caring conversations, which were full of disagreements as well as shared ways of seeing things, stands as the model for me of what academic life can be like. Thanks also the Center for Technology and Culture of the University of Oslo, the San Francisco Bay Area Technology and Culture Group, and the UCSC Center for Cultural Studies and the Science Studies Discussion Group. I am grateful for UCSC Academic Senate Research Grants.

Rusten Hogness is my friend; life companion; editor; interlocutor; fellow science lover and critic; and co-guardian of dogs, cats, memories, and land. Terry and Adolph Fasana have given more to this book than they know.

Thanks to Bill Germano for being the best editor and publisher I can imagine.

• • •

The following chapters are reprinted by permission:

Modest_Witness@Second_Millennium (Chapter 1)
[revised from "Modest Witness: Feminist Diffractions in Science Studies," in Peter Galison and David Stump, eds., *The Disunity of Sciences: Boundaries, Contexts, and Power* (Stanford University Press, forthcoming)]

FemaleMan©MeetsOncoMouse™. Mice into Wormholes: A Technoscience Fugue in Two Parts (Chapter 2)
[revised from essay in Gary Downey, Sharon Traweek, and Joseph Dumit, eds., *Cyborgs and Citadels: Interventions in the Anthropology of Technohumanism* (School of American Research; Seattle: University of Washington Press, forthcoming)]

Fetus: The Virtual Speculum in the New World Order (Chapter 5)
[revised from *Feminist Review*, special issue edited by Ann Phoenix and Avtar Brah, forthcoming; and essay in Adele Clarke and Virginia Olesen, eds., *Revisioning Women, Health and Healing: Feminist, Cultural and Technoscience Studies Perspectives*, forthcoming]

Race: Universal Donors in a Vampire Culture. It's All in the Family: Biological Kinship Categories in the Twentieth-Century United States (Chapter 6)
[revised from William Cronon, ed., *Uncommon Ground* (New York: Norton, 1995), pp. 321–66, 531–36]

Contents

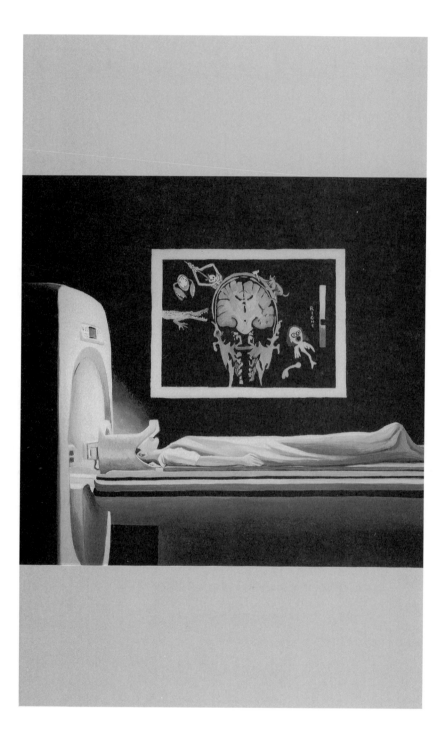

ONE

SYNTACTICS

THE GRAMMAR OF FEMINISM AND TECHNOSCIENCE

Immeasurable Results, Lynn Randolph, oil on masonite, 9-1/2" x 10", 1994

Immeasurable Results is patterned after an advertisement for Hitachi's Magnetic Resonance Imaging (MRI) medical device. The diagnostic film framed above the recumbent body of the draped woman records the assemblage of objects and dreams that fill family albums, clinical records, national imaginaries, and personal journals in technoscientific cultures at the end of the Second Christian Millennium. The material-semiotic event, for which the Hitachi machine is tool and trope, is an articulation of high-technology capital, diverse skills, interdisciplinary negotiations, bodily organic structures, marketing strategies, personal and public symbolic codes, medical doctrines, transnational economies, scientific industry's labor systems, and patient-consumer hopes and fears. The woman with her head in the imaging apparatus is the

artist, Lynn M. Randolph. This is a self-portrait of interior psychic and diagnostic spaces and of exterior human and mechanical bodily postures. The painting shows a measuring device; its computer-mediated scanning image; and, on the same film with calibration cues in the righthand margin, the projected dreams and nightmares that remain immeasurable within the machine's information calculus. Immeasurable Results is a screen projection of conscious and unconscious layers proper to a biomedical world. Joining Randolph's metaphorical realism and cyborg surrealism, Immeasurable Results is the recursive screen-within-a-screen record of a material-semiotic apparatus of bodily production and reproduction in the regime of technobiopower. Immeasurable Results records a slice of what feminists call the "lived experience" of that apparatus.

A fantasy mermaid with an open fish mouth; a parallel floating penis and testes of the same piscine shape as the doll's; a pocketwatch without clock hands, armed instead with crab claws, whose nightmare timekeeping is outside mechanical chronology; a red demon hammering at the skull, echoing the pounding heard by the woman inside the MRI machine, punctuating the staccato bits of information emitted from the brain-machine interface; a day-of-the-dead Mexican skeleton poised with a spear to announce the impending death lurking in the traitorous flesh; an alligator-predator; and, in the center of this ring of surrealist beings, the technical, medical frontal section, cut without knives, through the brain, sinus cavities, and throat: These images are produced by the semiosis of the machine, body, and psyche in hybrid communication. All of these images—certainly including the bloodless optical slice of the woman's head and neck—are intensely personal. Technoscientific subjects and objects are gestating in the matrices of the MRI scan. The moment of reading and scanning, of being read and being scanned, is the moment of vulnerability through which new articulations are made. In Joseph Dumit's provocative terms, the brain-imaging device are part of an apparatus of "objective self fashioning" (Dumit 1995; 56-86).

The specificity of the painting cannot be missed—its particular race-and gender-marked patient, her individual dreams and possible pathologies, the identifiable corporation selling computerized medical imaging devices, the web of beliefs and practices pertaining to health and disease, the economic configurations tying flesh and diagnostic film together. These signs make sense in the fiercely physical, semiotic world of technoscience, which is the real and imaginary field for Modest_Witness@Second_Millennium. We read these signs by the syntactical rules of technoscience. We are inside its material grammar; we both embody and contest its rules. But we are also in a world of immeasurable results, a world that exceeds its representations and blasts syntax. This excessive world defies both denunciation and celebration while exacting care and accountability. We are in the family saga, where FemaleMan© meets her sibling species called OncoMouse™ in the nodes of the Net. That encounter is my self-portrait in the durable traditions of Western self-fashioning. That is where my book begins.

SYNTACTICS

The Grammar of Feminism and Technoscience

> "The ability to access information is power," Nili said with her slight accent in her husky voice. . . . "The ability to read and write belonged to the Church except for heretics and Jews. We are people of the book. We have always considered getting knowledge part of being human."
>
> —Marge Piercy, *He, She and It*

Literacies

Nili bat Marah Golinken is the technologically enhanced, genetically engineered, matrilineal Jewish warrior woman in the postnuclear holocaust world of Marge Piercy's *He, She and It*. The novel explores the many kinds of boundaries at stake when a seventeenth-century golem in Prague's ghetto and a twenty-first-century cyborg in a Jewish freetown in North America are blasphemously brought into being to defend their endangered communities. Introducing herself at the home of the old woman, Malkah, who helped her colleague Avram to program the cyborg, Nili says of herself:

> "I can tolerate levels of bombardment that would kill you. We live in the hills — inside them, that is. We are a joint community of the descendants of Israeli and Palestinian women who survived. We each keep our religion, observe each other's holidays and fast days. We have no men. We clone and engineer genes. After birth we undergo additional alteration. We have created ourselves to endure, to survive, to hold our land. Soon we will begin rebuilding Yerushalaim. . . . We live in extreme isolation. We have a highly developed technology for our needs, but we don't tie into the Net. I'm a spy and a scout. . . . I am sent like the dove or maybe the raven

1

from Noah's ark to find out if the world is ready for us, and also if there's anything out here we might want." (Piercy 991:205–06)

Nili comes into the story in partnership with her lover, Riva, daughter of Malkah and an anarchist data pirate who has turned into a serious revolutionary against the transnational corporate order that webs the globe. Nili and Riva are committed to the principle that information must not be a commodity. In the vulnerabilities and potencies of their altered bodies, these technologically savvy women understand the bond of literacy and wealth that structures the chances of life and death in their world. Nili, Riva, Malkah, and the cyborg live without innocence in the regime of technobiopower, where literacy is about the joining of informatics, biologics, and economics—about the kinship of the chip, gene, seed, bomb, lineage, ecosystem, and database.

Nili remembers that in the European past, the Catholic Church controlled literacy, except for the potent exceptions of heretics, infidels, and Jews, who can claim the status of peoples of the book with an originary authority that strikes at the heart of the Church's monopoly.[1] Tunneling under the wreckage of a violent history with the other Israeli and Palestinian survivors, Nili belongs to these oppositional traditions of reading and writing, with their generative accounts of what can count as human, as knowledge, as history, as insider and outsider. Dove, raven, and reconstructed assassin, Nili fights for rebuilding Yerushalaim outside the appropriations of Christian salvation history—and outside the patriarchal assumptions of all of the official peoples of the book, in both their religious and technoscientific incarnations. Her interrupted origin stories provide a platform for surfing the sacred-secular technoscientific web that infuses *Modest_Witness@Second_Millennium*:"We have always considered getting knowledge part of being human."

My book takes shape through cascading accounts of humans, nonhumans, technoscience, nation, feminism, democracy, property, race, history, and kinship. Beginning in the mythic times called the Scientific Revolution, my titular modest witness indulges in narratives about the imaginary configurations called the New World Order, Inc., and the Second Christian Millennium. I learned early that the imaginary and the real figure each other in concrete fact, and so I take the actual and the figural seriously as constitutive of lived material-semiotic worlds. Taught to read and write inside the stories of Christian salvation history and technoscientific progress, I am neither heretic, infidel, nor Jew, but I am a marked woman informed by those literacies as well as by those given to me by birth and education. Shaped as an insider and an outsider to the hegemonic powers and discourses of my European and North American legacies, I remember that anti-Semitism and misogyny intensified in the Renaissance and

Scientific Revolution of early modern Europe, that racism and colonialism flourished in the traveling habits of the cosmopolitan Enlightenment, and that the intensified misery of billions of men and women seems organically rooted in the freedoms of transnational capitalism and technoscience. But I also remember the dreams and achievements of contingent freedoms, situated knowledges, and relief of suffering that are inextricable from this contaminated triple historical heritage. I remain a child of the Scientific Revolution, the Enlightenment, and technoscience. My modest witness cannot ever be simply oppositional. Rather, s/he is suspicious, implicated, knowing, ignorant, worried, and hopeful. Inside the net of stories, agencies, and instruments that constitute technoscience, s/he is committed to learning how to avoid both the narratives and the realities of the Net that threaten her world at the end of the Second Christian Millennium. S/he is seeking to learn and practice the mixed literacies and differential consciousness that are more faithful to the way the world, including the world of technoscience, actually works.[2]

And so this book is sited as a node that leads to the Internet, which is synecdochic for the wealth of connections that constitute a specific, finite, material-semiotic universe called technoscience.

Modest_Witness@Second_Millennium.FemaleMan©*_Meets_OncoMouse*™ is an e-mail address. Let us see how its nodes and operators map out the tropes and topics of this book.

Keystrokes

My title contains three syntactical marks: @, ©, ™. Each little modifier signs us into history in particular ways. The @, ©, and ™ are minimalist origin narratives in themselves. Part of a writing technology (King 1991; Derrida 1976; Latour and Woolgar 1979), the marks also map an argument; they indicate its proper grammar. Like the special signing apparatus for operations in symbolic logic, the marks in my title are operators within a particular sociotechnical discourse. This discourse takes shape from the material, social, and literary technologies that bind us together as entities within the region of historical hyperspace called technoscience.

Hyper means "over" or "beyond," in the sense of "overshooting" or "extravagance." Thus, technoscience indicates a time-space modality that is extravagant, that overshoots passages through naked or unmarked history. Technoscience extravagantly exceeds the distinction between science and technology as well as those between nature and society, subjects and objects, and the natural and the artifactual that structured the imaginary time called modernity. I use technoscience to signify a mutation in historical narrative, similar to the

mutations that mark the difference between the sense of time in European medieval chronicles and the secular, cumulative salvation histories of modernity. Like all the other chimerical, condensed word forms that are cobbled together without-benefit-of-hyphen in the hyperspace of the New World Order, Inc., the word technoscience communicates the promiscuously fused and transgenic quality of its domains by a kind of visual onomatopoeia. Once upon a time, in another, closely related, ethnospecific narrative field called Western philosophy, such entities were thought to be subjects and objects, and they were reputed to be the finest and most stable actors and actants in the Greatest Story Ever Told—the one about modernity and man. In the imploded time-space anomalies of late-twentieth-century transnational capitalism and technoscience, subjects and objects, as well as the natural and the artificial, are transported through science-fictional wormholes to emerge as something quite other. Even drenched with all the hype about revolution and technoscience that pervades contemporary discussion, the ferocity of the transformations lived in daily life throughout the world are undeniable.

The "@" and "." are the title's chief signifiers of the Net. An ordinary e-mail address specifies where the addressee is in a highly capitalized, transnationally sustained, machine language-mediated communications network that gives byte to the euphemisms of the "global village." Dependent upon a densely distributed array of local and regional nodes, e-mail is one of a powerful set of recent technologies that materially produce what is so blithely called "global culture." E-mail is one of the passage points—both distributed and obligatory—through which identities ebb and flow in the Net of technoscience. Despite all the hype, technoscience is not the Greatest Story Ever Told, but it is playing powerfully to large, widely distributed audiences.

Partly because the Internet was originally developed for defense research and communication, including communication among academic scientists, and then extended to more civilian users primarily in universities, the system is only now becoming densely commodified (Krol 1992:11–30). The Net still has many of the practices and ethics of a public commons, but one that is being rapidly enclosed. The civilian freedoms of the Net are indebted to a tax-supported commons tied initially to Cold War priorities and then to goals of national economic competitiveness and requiring a broad technoscientific research and communication apparatus. The Internet was midwifed in the 1970s as a U.S. Defense Department network called ARPAnet, which was an experimental network designed to support military research.[3] The noncentralized structure of the communication

system was related to the need for it to survive nuclear destruction of component parts.

As other U.S. (and Scandinavian) organizations built their own networks, they used the ARPAnet's communications protocols. Connecting all these systems was, therefore, an attractive goal. In the late 1980s the National Science Foundation (NSF) established five supercomputer centers that made the capabilities of the world's fastest computers available for general scholarly research. Using ARPAnet technology, the tax-supported NSF created a web of regional networks connected with each other through a supercomputer center. "The NSF promoted universal educational access by funding campus connection only if the campus had a plan to spread access around. So everyone attending a four-year college could become an Internet user" (1992:13). The NSFnet came to form the backbone of the Internet, and the impact throughout the social fabric has been tremendous. Then, following policy set by the president and congress in 1992, the NSF fully privatized its system in 1995. The large users remain unworried and expect the continuing growth of volume and advances in technology to lower their costs in the long run. In addition the new net system will support high-speed, wide-bandwidth uses such as videoconferencing and other visual processing applications that the old NSFnet could not handle. Overall, immediate costs to users are expected to go up 10 percent to 100 percent, depending on distance from an access point. The losers are likely to be small colleges, institutions in more remote areas, and public libraries (Lawler 1995). Those parts of the public commons that cannot contribute to capital accumulation for private corporations, such as MCI, Bellcore, and Sprint, which reap the benefits of decades of tax-supported infrastructure, will naturally wither away in the free market. The rebirth of the nation seems to demand it.[4]

Furthermore, the Internet has been international for many years, but originally only U.S. allies and overseas military bases were connected. By the mid-1990s most countries in the world had attempted to connect as part of their national educational, commercial, and technology goals. More than 20 million users in over 60 countries were tied into the Internet by 1995. Inequality of access and the dominance of the Internet's, and so the United States', communications protocol standards—thereby isolating nets using other standards—have become serious international issues. As Marilyn Strathern put the matter in another context, "A world made to Euro-American specifications will already be connected up in determined ways" (1992:17).

Not even mentioning the World Wide Web, Mosaic, NetScape, and a host of other tools sustaining the information order at the end of the millennium, I am giving a very partial and abbreviated account of the Internet, much less of com-

puter-mediated communications systems in general. But even this micro-soft version shows that the relations in the Internet—among military needs, academic research, commercial development, democracy, access to knowledge, standardization, globalization, and wealth—embody many of the themes of technoscience in the last quarter of the twentieth century. Unlike the situation for Nili's community, which chose not to be part of the Net, there is no better place for my modest witness to lurk to be a spy and scout—and, to be sure, a user. Located in material-semiotic fact in the nodes of one of the world's most powerful technoscientific research institutions, the University of California, my modest witness is necessarily reminded of her terms of access as s/he logs on to collect her e-mail on a machine beside a Doonesbury cartoon. Trudeau draws a

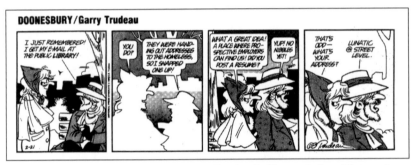

Figure 1.1 Doonesbury. © 1995 Garry Trudeau. Reprinted with permission of Universal Press Syndicate. All rights reserved.

street person going to collect his e-mail at the public library, where addresses had been handed out free to the homeless. Looking for potential employers' responses to his job résumé, he posts an address that puts the hype about the universal democracy built into the technoscientific information system into perspective: lunatic@street_level.

Trudeau helps unlock the confusion of the "irrational" New World Order feared both by New Age people and by right-wing armed militias in the United States—who are convinced, in chilling anti-Semitic patterns, that the bankers and gray men are taking over the world—with the "rational" New World Order of the post-Cold War, transnational free-market system imagined by presidents, congresses, planners, and parliaments and advanced by the political-economic strategies of flexible accumulation and by free-trade instruments such as the North American Free Trade Agreement (NAFTA) and General Agreement on Tariffs and Trade (GATT). Informed by lunatic@street_level, as well as by Anna Tsing (1993b), the subtle ethnographer and theorist of the complex, shifting, and nonsystemic geometries of margins and centers in the contemporary

world, I try to write on the razor edge between *paranoia* that the New World Order effected by the bonding of transnational capital and technoscience actually defines the world and the *denial* that large, distributed, articulated practices of domination are in fact luxuriating in just that bonding. Our task is learning to navigate both the imagined Net and the actual net with the bracing literacies of Nili's "heretics, infidels, and Jews" and their many sisters and brothers who have learned the skills of differential consciousness. Reading and writing on the razor edge between paranoia and denial, I venture to consider the syntax of intellectual property in my title's Internet address.

The © and ™ in my title mark the syntax of natural / social / technical relationships congealed into property. Built into the Constitution and early legislative acts of the United States, these marks, as much as the "@" in my address, are about the origins and fates of nations as well as of personal and corporate individuals. Each dealing with the implosion of bodies, texts, and property, the Internet and the Market conjointly supply the principal metaphors and instruments for contesting communication, commerce, freedom, and foundations in the New World Order, Inc.

Like the stigmata of gender and race, which signify asymmetrical, regularly reproduced processes that give some human beings rights in other human beings that they do not have in themselves (Rubin 1975), the copyright, patent, and trademark are specific, asymmetrical, congealed processes—which must be constantly revivified in law and commerce as well as in science—that give some agencies and actors statuses in sociotechnical production not allowed to other agencies and actors. By sociotechnical production I mean the knowledge-power processes that inscribe and materialize the world in some forms rather than others. Only some of the necessary "writers" have the semiotic status of "authors" for any "text." That little point has animated transnational industries of literary and philosophical deconstruction. Similarly, only some actors and actants that are necessarily allied in a patented innovation have the status of owner and inventor, authorized to brand a contingent but eminently real entity with their trademark.

I am intensely interested in the power of such "syntactical" marks as the © and ™. I am extremely curious about what kinds of bodies, what forms of frozen as well as motile sociotechnical alliances, also called social relationships, these little ornaments can adorn, at whose cost, and to whose benefit. In particular, I am interested in the kinds of artifactual chimeras, like the FemaleMan and OncoMouse in my title, that bear such distinctive brands so naturally. I am absorbed by the supplement, excess, and commentary implied in these little marks; I ask what kinds of entities can be marked up in these ways.[5] I am riveted

by "brand names" as "genders"; that is, as generic marks that are directional signals on maps of power and knowledge. I am curious about how members of technoscientific cultures are, literally, invested in their proprietary kin, both psychically and commercially.

Property is the kind of relationality that poses as the-thing-in-itself, the commodity, the thing outside relationship, the thing that can be exhaustively measured, mapped, owned, appropriated, disposed. Something of an unreconstructed and dogged Marxist, I remain very interested in how social relationships get congealed into and taken for decontextualized things. But unlike Marx, and allied with a few prominent and deliberately crazy scholars in science studies, with armies of very powerful and paradigmatically sane scientists and engineers, and with a motley band of off-the-wall ecofeminists and science-fiction enthusiasts, I insist that social relationships include nonhumans as well as humans as *socially* (or, what is the same thing for this odd congeries, sociotechnically) active partners. All that is unhuman is not un-kind, outside kinship, outside the orders of signification, excluded from trading in signs and wonders.

Figures

Signs and wonders brings us to the next contaminated practice suffusing my book and built into the title *Modest_Witness@Second_Millennium.FemaleMan**_Meets_OncoMouse*TM: that is, figuration. In my book, entities such as the modest witness of the Scientific Revolution, the FemaleMan of commodified transnational feminism, and OncoMouseTM of the biotechnical war on cancer are all figures in secular technoscientific salvation stories full of promise. The promises are cheek-by-jowl with ultimate threats as well. Apocalypse, in the sense of the final destruction of man's home world, and comedy, in the sense both of the humorous and of the ultimate harmonious resolution of all conflict through progress, are bedfellows in the soap opera of technoscience. Figuration

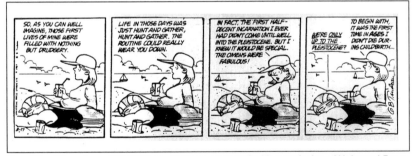

Figure 1.2 **Doonesbury. © 1987 Garry Trudeau. reprinted with permission of Universal Press Syndicate. All rights reserved.**

in technoscientific texts and artifacts is often simultaneously apocalyptic and comedic. As we will examine in detail later, figuration in technoscience seems to operate according to the corporate slogan for the patented transgenic rodent, OncoMouse™, "available only from DuPont, where better things for better living come to life."

Teleconferencing with lunatic@street_level, I explore technoscientific figuration with the help of another Doonesbury cartoon. Here, my modest witness is a New Age woman recounting her past lives. In her various incarnations, she recapitulates hominid evolutionary history as that developmental account is narrated within paleoanthropology. The typical fusing of New Age belief and orthodox scientific model is part of what makes the cartoon funny. Garry Trudeau's cartoon character, named Boopsie, figures—that is, embodies—"the "universal" story of "woman." Part of the joke is the whimsical reversal of the humanist narrative to give the story of woman instead of man. In this cartoon, "Man," that is, Boopsie's bored partner, is the one who listens (sort of). Biology is the vehicle of universality; we are in the domain of technobiopower, with its subject formations, beliefs, and practices. The early ages of drudgery— "Hunt and gather, hunt and gather, the routine could really wear you down"— give way in the saga of hominid progress to the Pleistocene: "The omens were fabulous." The punchline captures perfectly the identifications and hopes built into technoscientific accounts of progress; without losing their physical reality, the sufferings of the earlier period are transcended in the sociotechnical advances of universal history. "To begin with, it was the first time in ages I didn't die in childbirth." Technology, including the technology of the body itself, is the real subject of universal history. Trudeau knows that the story of technical progress is at the heart of Enlightenment humanism. He also has just the right twist on how the humor works when the subject of technical progress is woman and her body instead of man and his tools. Like the cartoonist Gary Larson, Trudeau comprehends how his audiences inhabit and are inhabited by the stories and explanations of technoscience. Trudeau understands the identities forged, the subject positions opened up, and the substitutions and surrogacies sketched in practices of figuration. He understands how Woman the Gatherer is a figure for the late-twentieth-century, white, middle-class woman on the beach with her football-helmet-clad companion, the descendent of Man the Hunter.

Figuration is a complex practice with deep roots in the semiotics of Western Christian realism. I am especially interested in a specific sense of time built into Christian figuration. I think this kind of time is characteristic of the promises and threats of technoscience in the United States, with its ebullient,

secular, disavowed, Christian national stories and practices. Despite the extraordinary multicultural, multiethnic, multireligious populations in the United States, with quite various traditions of signifying time and community, U.S. scientific culture is replete with figures and stories that can only be called Christian. Figural realism infuses Christian discourse in all of that religious tradition's contested and polyvocal variety, and this kind of figuration shapes much of the technoscientific sense of history and progress. That is why I locate my modest witness in the less than universal—to put it mildly—time zone of the end of the Second (Christian) Millennium. In the United States, at least, technoscience is a millenniarian discourse about beginnings and ends, first and last things, suffering and progress, figure and fulfillment. And the OncoMouse™ on the back cover of *Modest_Witness@Second_Millennium* doesn't have a crown of thorns on her head for no reason.

As Erich Auerbach explained in his great study of mimetic practice in Western literature, "Figural interpretation establishes a connection between two events or persons in such a way that the first signifies not only itself but also the second, while the second involves or fulfills the first.... They are both contained in the flowing stream which is historical life" (1953:64). The heart of figural realism is the Christian practice of reading the story of Christ into Jewish scripture. Although in Christian figuration both figure and fulfillment are materially real, history is fully contained in the eternal plan of Divine Providence, which alone can supply the key to historical meaning. Containing and fulfilling the whole, (Christian) salvation history *is* history. Auerbach insists that this kind of temporality is utterly alien to the conceptions of classical antiquity, both Jewish and Greek.

Auerbach examines Dante's development of figural realism in *The Divine Comedy*. Dante's innovation was to draw the end of man with such extraordinary vividness and variety "that the listener is all too occupied by the figure in the fulfillment.... The fullness of life which Dante incorporates into that interpretation is so rich and so strong that its manifestations force their way into the listener's soul independently of any interpretation. The image of man eclipses the image of God" (1953:176). The sense of history as a totality remains in this humanist order, and the overwhelming power of the images that promise fulfillment (or damnation) on earth infuses secular histories of progress and apocalypse. Secular salvation history depends on the power of images and the temporality of ultimate threats and promises to contain the heteroglossia and flux of events. This is the sense of time and of representation that I think informs technoscience in the United States. The discourses of genetics and information sciences are especially replete with instances of barely secularized Christian figural realism at work.

The legacy of figural realism is what puts my title's modest witness in the sacred secular time zones of the end of the Second Millennium and the New World Order. Second Millennium is the time machine that has to be reprogrammed by Nili's heretics, infidels, and Jews, who, it is crucial to remember, "have always considered getting knowledge part of being human." Challenging the material-semiotic practices of technoscience is in the interests of a deeper, broader, and more open scientific literacy, which this book will call situated knowledges.

Figuration has many meanings besides, or intersecting with, those proper to the legacy of Christian realism.[6] Aristotelian "figures of discourse" are about the spatial arrangements in rhetoric. A figure is geometrical and rhetorical; topics and tropes are both spatial concepts. The "figure" is the French term for the face, a meaning kept in English in the notion of the lineaments of a story. "To figure" means to count or calculate and also to be in a story, to have a role. A figure is also a drawing. Figures pertain to graphic representation and visual forms in general, a matter of no small importance in visually saturated technoscientific culture. Figures do not have to be representational and mimetic, but they do have to be tropic; that is, they cannot be literal and self-identical. Figures must involve at least some kind of displacement that can trouble identifications and certainties.

Figurations are performative images that can be inhabited. Verbal or visual, figurations can be condensed maps of contestable worlds. All language, including mathematics, is figurative, that is, made of tropes, constituted by bumps that make us swerve from literal-mindedness. I emphasize figuration to make explicit and inescapable the tropic quality of all material-semiotic processes, especially in technoscience. For example, think of a small set of objects into which lives and worlds are built—chip, gene, seed, fetus, database, bomb, race, brain, ecosystem. This mantralike list is made up of imploded atoms or dense nodes that explode into entire worlds of practice. The chip, seed, or gene is simultaneously literal and figurative. we inhabit and are inhabited by such figures that map universes of knowledge, practice and power. To read such maps with mixed and differential literacies and without the totality, appropriations, apocalyptic disasters, comedic resolutions, and salvation histories of secularized Christian realism is the task of the mutated modest witness.

Time and Space

Figures always bring with them some temporal modality that organizes interpretive practice. I understand Foucault's (1978) concept of biopower to refer to the practices of administration, therapeutics, and surveillance of bodies that discursively constitute, increase, and manage the forces of living organisms. He gives shape to his theoretical concept through delineating the

nineteenth-century figures of the masturbating child, reproducing Malthusian couple, hysterical woman, and homosexual pervert. The temporality of these biopolitical figures is developmental.[7] They are all involved in dramas of health, degeneration, and the organic efficiencies and pathologies of production and reproduction. Developmental time is a legitimate descendant of the temporality of salvation history proper to the figures of Christian realism and technoscientific humanism.

Similarly, my cyborg figures inhabit a mutated time-space regime that I call technobiopower. Intersecting with—and sometimes displacing—the development, fulfillment, and containment proper to figural realism, the temporal modality pertaining to cyborgs is condensation, fusion, and implosion. This is more the temporality of the science-fictional wormhole, that spatial anomaly that casts travelers into unexpected regions of space, than of the birth passages of the biopolitical body. The implosion of the technical, organic, political, economic, oneiric, and textual that is evident in the material-semiotic practices and entities in late-twentieth-century technoscience informs my practice of figuration. Cyborg figures—such as the end-of-the-millennium seed, chip, gene, database, bomb, fetus, race, brain, and ecosystem—are the offspring of implosions of subjects and objects and of the natural and artificial. Perhaps cyborgs inhabit less the domains of "life," with its developmental and organic temporalities, than of "life itself,"[8] with its temporalities embedded in communications enhancement and system redesign. Life itself is life enterprised up, where, in the dyspeptic version of the technoscientific soap opera, the species becomes the brand name and the figure becomes the price. Ironically, the millennarian fulfillment of development is the excessive condensation of implosion.

Temporalities intertwine with particular spatial modalities, and cyborg spatialization seems to be less about "the universal" than "the global." The globalization of the world, of "planet Earth," is a semiotic-material production of some forms of life rather than others. Technoscience is the story of such globalization; it is the travelogue of distributed, heterogeneous, linked, sociotechnical circulations that craft the world as a net called the global. The cyborg life forms that inhabit the recently congealed planet Earth—the "whole earth" of eco-activists and green commodity catalogs—gestated in a historically specific technoscientific womb. Consider, for example, only four horns of this multilobed reproductive wormhole:

1 The apparatuses of twentieth-century military conflicts, embedded in repeated world wars; decades of cold war; nuclear weapons and their institutional matrix in strategic planning, endless scenario production,

and simulations in think tanks such as RAND; the immune system-like networking strategies for postcolonial global control inscribed in low-intensity-conflict doctrines; and post-Cold War, simultaneous-multiple-war-fighting strategies depending on rapid massive deployment, concentrated control of information and communications, and high-intensity, subnuclear precision weapons (Helsel 1993; Gray 1991; Edwards 1995)

2 The apparatuses of hypercapitalist market traffic and flexible accumulation strategies, all relying on stunning speeds and powers of manipulation of scale, especially miniaturization, which characterize the paradigmatic "high-technology" transnational corporations (Harvey 1989;Virilio 1983; Martin 1992)

3 The apparatuses of production of that technoscientific planetary habitat space called the ecosystem, with its constitutive birth pangs in resource management practices in such institutions as national fisheries in the 1920s and 1930s; in post-World War II theoretical fascination with all things cybernetic; in the Atomic Energy Commission-mediated research projects in the 1950s for tracing radioisotopes through food chains in the Pacific ocean; in 1970s global modeling practices indebted to the Club of Rome and to international projects such as the United Nations Educational, Scientific, and Cultural Organization's (UNESCO) Man and the Biosphere program; and in the early salvos of widespread "green war" as a dominant New World Order security concern, with its diplomatic forms played out in 1992 at the Earth Summit in Rio de Janeiro (Escobar 1994; Taylor and Buttel 1992)[9]

4 The apparatuses of production of globalized, extraterrestrial, everyday consciousness in the planetary pandemic of multisite, multimedia, multispecies, multicultural, cyborgian entertainment events such as *Star Trek, Blade Runner, Terminator, Alien,* and their proliferating sequelae in the daily information stream, embedded in transnational, U.S.-dominated, broad-spectrum media conglomerates, such as those forged by the mergers of Time-Warner with CNN and of the Disney universe with Capital Cities, owner of CBS (Gabilondo 1991; Sofia 1992).[10]

The offspring of these technoscientific wombs are cyborgs—imploded germinal entities, densely packed condensations of worlds, shocked into being from the force of the implosion of the natural and the artificial, nature and culture, subject and object, machine and organic body, money and lives, narrative and reality. Cyborgs are the stem cells in the marrow of the technoscientific body; they differentiate into the subjects and objects at stake in the contested zones of technoscientific culture. Cyborg figures must be read, too, with the mixed, unfinished literacies Nili is ready to teach.

So, what kinds of kin are allied in the proprietary forms of life in these days near the end of the Second Christian Millennium? How do we, who inhabit such stories, make psychic and commercial investments in forms of life, where the lines among human, machine, and organic nature are highly permeable and eminently revisable? How useful is my abiding suspicion that "biology"—the historically specific, congealed embodiments in the world as well as the technoscientific discourse positing such bodies—is an accumulation strategy? The point is less disreputable if I write that "biotechnology"—both the discourse and the body constituted as a biotechnics—is an accumulation strategy. But much of what is accumulated is more strange than capital, more kind than alien, more alluring than gold. It is time to move from grammar to content, from syntactics to semantics, from logic to body.

Contents

Modest_Witness@Second_Millennium is organized around the anatomy of meanings. The book's sections correspond to the parts of the human science of semiotics. Part I, Syntactics: The Grammar of Feminism and Technoscience, corresponds to *syntactics*, or the formal structure of signification. Part II, Semantics: Modest_Witness@Second_Millennium.FemaleMan©_Meets_OncoMouse™ matches *semantics*, or the contents and figures of a communication. Part III, Pragmatics: Technoscience in Hypertext, recalls *pragmatics*, or the physiology of meaning-making. Inventing a fourth category of semantics and troping on the conventional parts of the subject, I end my book with *Diffractions*, Lynn Randolph's painting of a split figure moving through a screen into a world where interference patterns can make a difference in how meanings are made and lived. Each chapter can be read as a separate essay, but in sequence, the chapters are a kind of Pilgrim's Progress through the story fields, material-semiotic apparatuses, and political stakes where biologics and informatics cohabit and reproduce. Guiding the reader through the grammar of the title, Part I explains its e-mail address, the mixed and differential literacies necessary to evade millennarian closures, and the contaminated practice of figuration that pervades the

book. Interfacing and mixing narrative fiction, biological argument, historical analysis, political inquiry, mathematical jokes, religious reworkings, literary readings, and visual imagery, the book is itself generically heterogeneous. Its mixed genres and its interdigitating verbal and visual organs ask for a generous literacy from the reader. In its most basic sense, this book is my exercise regime and self-help manual for how not to be literal minded, while engaging promiscuously in serious moral and political inquiry about feminism, antiracism, democracy, knowledge, and justice in certain important domains of contemporary science and technology. I also want those who inhabit *Modest_Witness@Second_Millennium* to have a good time. Comedy is both object of attention and method.

Contesting the meanings of words, instruments, and figures, Part II brings the reader into the time zone of the Scientific Revolution through the figure of the modest witness, who bears testimony to matters of fact constituted by means of material, literary, and social technologies crafted in the experimental way of life. Drawing on approaches developed in feminist science studies to communities of practice, boundary objects, situated knowledges, agential realism, and strong objectivity, the chapter aims to mutate the modest witness into a more usable vehicle for entering the wormholes of contemporary millennarian technoscience. The second chapter of the Semantics section interrogates the kinship of the FemaleMan$^{©}$ and OncoMouseTM. These late-twentieth-century figures inhabit the story fields and sociotechnical practices of feminism and biotechnology. Beginning with a comparison of transuranic elements and transgenic organisms and lingering in the biotechnological laboratory, the chapter examines a broad range of popular and official texts, careers, economic developments, global webs, research practices, visual materials, and efforts to construct a more democratic science. The purpose is to enliven our practical imagination of who the actors are and what is at stake in some of the material-semiotic domains of modern biology. By the end of Semantics, the family has been assembled and the action can expand.

Part III, a *pragmatics*, tinkers with mechanisms for unwinding sticky threads and making new articulations in the dense knots and hypertextual webs of technoscience. The topics are the Human Genome Project and its mapping practices; the transnational and transgeneric bond between reproductive technology and reproductive freedom projects; the changing discourses of human unity and difference in biological approaches to race across the twentieth century; and the kinship of diverse cyborg figures that populate ecology, medical technology, cinema, and evolutionary biology. Technoscientific visual culture;

inhospitable versions of fetishism; jokes, songs, and solemn pronouncements; the close weave of art, money, and science; and proliferating vampire figures all find their place in this Pragmatics section.

My invented category of semantics, *diffractions*, takes advantage of the optical metaphors and instruments that are so common in Western philosophy and science. Reflexivity has been much recommended as a critical practice, but my suspicion is that reflexivity, like reflection, only displaces the same elsewhere, setting up the worries about copy and original and the search for the authentic and really real. Reflexivity is a bad trope for escaping the false choice between realism and relativism in thinking about strong objectivity and situated knowledges in technoscientific knowledge. What we need is to make a difference in material-semiotic apparatuses, to diffract the rays of technoscience so that we get more promising interference patterns on the recording films of our lives and bodies. Diffraction is an optical metaphor for the effort to make a difference in the world. Lynn Randolph's suggestive painting on the last page concludes *Modest_Witness@Second_Millennium. FemaleMan©_Meets_OncoMouse^{TM}* with an interference pattern, not with a reflection of the same displaced elsewhere. Randolph gave me a powerful figure for troping the end of my culture's parochial millennium, in both its feminist and its technoscientific versions. That is, Randolph's woman is a device for considering how to make the end swerve. What more could a people given to teleology ask for at the last?

Throughout *Modest_Witness@Second_Millennium*, the paintings of Lynn Randolph introduce and frame themes and arguments. Randolph's and my own metaphoric realism and cyborg surrealism are in punctuated conversation. Our verbal and visual figures were sometimes developed in direct response to each other's work. I have placed one of her paintings, paired with my commentary, at the beginning of each part and of two individual chapters. I am indebted to Randolph for conversations and letters in which she helped me see her art, which then infiltrated the tissue of my sentences. Similarly, some of her paintings were done in response to earlier versions of chapters. The book contains ten of Randolph's troubling and hopeful paintings, each exploring the material and psychic territory of technoscience. I am grateful to her with all my heart. Her willingness to let me weave her work into mine is a rare gift. It is through the eyes of her mouse-human hybrid in *The Laboratory, or the Passion of OncoMouse* that I watch Robert Boyle's experiments with the air-pump in seventeenth-century London, from which the modest witnesses of this book began their travels toward the end of the millennium.

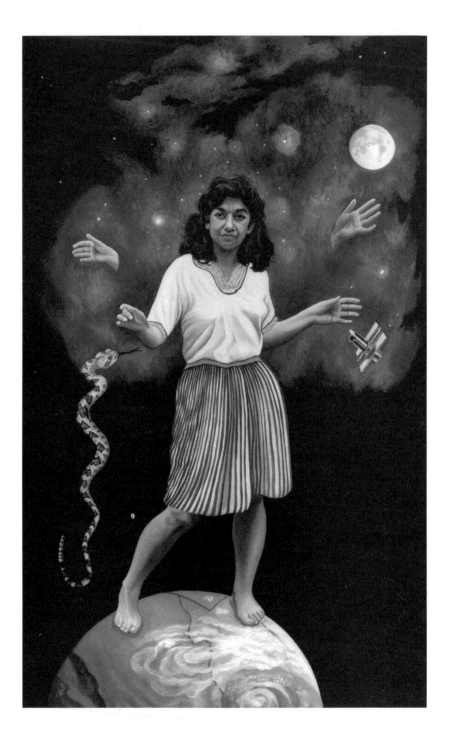

T W O

SEMANTICS

MODEST_WITNESS@SECOND_MILLENNIUM. FEMALEMAN©_MEETS_ONCOMOUSE™

La Mestiza Cosmica, Lynn Randolph, oil on canvas, 30" x 24", 1992

A painting from the Randolph series called "The Ilusas [deluded women]: Representations of Women Who Are Out of Bounds," the 1992 oil called La Mestiza Cosmica is a Virgin of Guadéloupe. As Randolph tells us, that important figure is "related to the Virgin of the Apocalypse who crushes the serpent and is in possession of the heavens, the place from which she protects her chosen people. She is still revered in Mexico today as she is a symbol of rebellion against the rich, upper and middle class. She unites races and mediates between humans and the divine, the natural and the technological. In my painting a Mestiza stands with one foot in Texas and one foot in Mexico. She is taming a diamond-back rattlesnake with one hand and manipulating the Hubbell telescope with another. I paint particular people, usually my friends and family. First I see them in my head, then I photograph them as they appear in my vision, and I use the photographs as material resources for the painting" (1993:6).

The meanings Randolph gives her Virgin of Guadéloupe resonate with the tones I want to be heard throughout this section on figures and meanings, tropes and tools, in technoscience. La Mestiza Cosmica is the kind of modest witness that is coming into existence at the end of the Second Christian Millennium, when what can count as freedom, justice, knowledge, and skill are again very much at stake in the mutated experimental way of life inherited from the mythic times called the Scientific Revolution. Randolph's mestiza straddles the borders that are being redrawn in both the free-trade agreements of the New World Order, Inc., and the fierce anti-immigrant politics of the rich nations against the poor and nonwhite. Technoscience is fundamental to the dense flows across these borders of capital, people, know-how, machines, genes, and much more. La Mestiza Cosmica is historically specific, located in a particular time, place, and body; she is therefore a figure for the kind of global consciousness my mutated modest witness should cultivate. The rattlesnake suggests the mode of consciousness, called the Coatlique state, theorized by Gloria Anzaldúa in Borderlands / La Frontera. Not unlike Anzaldúa, who maintains a necessarily eclectic altar on her computer, Randolph's mestiza joins the snake and the Hubbell telescope to demonstrate the kind of vision that both physical and virtual witnesses must cultivate in the New World Order. This woman is a scientist and a wise person who is situated on the planet earth and in space, figures of the technoscientifically mediated globalization that is transforming chances for life and death for all of the earth's inhabitants. Randolph risks the imagery of the New Age and the charge of appropriation across races and cultures to locate her figure so that the parts of her body are in potent physical and symbolic zones. Like her contemporary model on the Texas-Mexico border, La Mestiza Cosmica is indigenous to these millennial borderlands. She is a retooled modest witness, the one whose testimony can establish crucial matters of fact, to that border's present transformations.

SEMANTICS

Modest_Witness@Second_Millennium.FemaleMan©_Meets_OncoMouse™

> But as a woman who spends her working days creating fictions and monsters, how can I feel I am committing calumny against Judah? I believe in the truth of what is perhaps figurative, although Moshe Idel has found recipe after recipe, precise as the instructions for building a yurt or baking French bread, for making golems.
>
> —Marge Piercy, *He, She and It*

The above speaker, from Marge Piercy's novel *He, She and It*, is Malkah, a lusty grandmother and a community defense-system software designer in a near-future Jewish freetown. The independent town, Tikva, makes high-value specialty software and is menaced with a takeover by global conglomerates. Malkah helped program a cyborg in human form, Yod, designed by her colleague Avram to help defend the threatened Jewish community. To give her cyborg child his history, Malkah writes a story about the golem brought into being by the chief rabbi of Prague in 1600, Judah Loew, a man learned in Torah, Talmud, and Kabbala. Malkah tells about the Jewish Renaissance; about the active Jewish presence in Europe's Scientific Revolution; and about the powerful systems of early modern European sexual, racial, and religious exclusions that played midwife to the golem. Male, Jewish, and nonhuman, both Judah Loew's golem and Piercy's cyborg test the limits of humanity and the power of words as instruments and as tropes. The cyborg and golem also inhabit the heavily trafficked zones between the figurative and the literal, in and out of what we call science. Indeed, these nonhuman beings make clear that, at root, there is no literal meaning or entity innocent of troping.

Malkah, writer of stories and software, spends her days making monsters and fictions. She has transgressed important limits, both in helping with the

illegal crafting of Yod in the first place and in subsequently rendering him more human by programming him to be capable of love. In a kind of immodest intervention, she field-tests this last point by bringing the cyborg into her bed. Malkah is a witness to the history of her people, her family, and her town. No neophyte with the technology essential to making and transforming knowledge—and no stranger to the problems of assuring credible witness in a contentious world—Malkah tests meanings, tools, and kinship. Dedicated to the experimental way of life, this grandmother is the ideal ungentlemanly guardian spirit for Part II, Semantics.

Semantics is about contents and meanings, tropes and topics. In this section, such heavy loads are carried by three chief figures—the modest witness, the FemaleMan, and OncoMouse. They are transmogrifications or trans-substantiations of each other; they are kin, tied to each other by the passage of bodily substance. By the end of this argument, I want my readers to understand that this book is a family romance, or scholarly soap opera, set in a kind of critical General Hospital or theoretical Dallas, where pregnancies come to term from timely couplings of the kind that fill the daily newspapers in fin-de-siècle California.[1] Seeming at first sight to have little to do with each other, from just a slightly different point of view the figures of the modest witness, FemaleMan, and OncoMouse take shape within a common, materialized narrative field.[2] We will meet them separately in the first two chapters of Semantics.

The modest witness is a figure in the stories of science studies as well as of science. S/he is about telling the truth, giving reliable testimony, guaranteeing important things, providing good enough grounding—while eschewing the addictive narcotic of transcendental foundations—to enable compelling belief and collective action. The FemaleMan is the chief figure in the narrative field of feminism in this book. S/he is about the contingent and disrupted foundational category of woman, doppelganger to the coherent, bright son called man. OncoMouse is a figure in the story field of biotechnology and genetic engineering, my synecdoche for all of technoscience. My tendentious point is that the apparatuses of cultural production going by the names of science studies, antiracist feminism, and technoscience have a common circulatory system. In short, my figures share bodily fluids, no less than do the zoons taking common nourishment on the stolon of a colonial tunicate. The fluids of my figures are mixed in the time machine where they all meet, the computing machine of my e-mail address, named Second Millennium.

1

MODEST_WITNESS@SECOND_MILLENNIUM

A man whose narratives could be credited as mirrors of reality was
a modest man: his reports ought to make that modesty visible.
—Steven Shapin and Simon Schaffer, *Leviathan and the Air-Pump*

Modest Witness

The modest witness is the sender and receiver of messages in my e-mail address. So let
us investigate how this subject position is woven into the nets traced here. The
modest witness is a figure in the narrative net of this book, which works to *refig-
ure* the subjects, objects, and communicative commerce of technoscience into
different kinds of knots.[1] I am consumed by the project of materialized refigura-
tion; I think that is what's happening in the worldly projects of technoscience
and feminism. A figure collects up the people; a figure embodies shared mean-
ings in stories that inhabit their audiences. I take the term *modest witness* from the
important book by Steven Shapin and Simon Schaffer (1985), *Leviathan and the
Air-Pump: Hobbes, Boyle, and the Experimental Life*. In order for the modesty,
referred to in the epigraph above, to be visible, the man—the witness whose
accounts mirror reality—must be invisible, that is, an inhabitant of the potent
"unmarked category," which is constructed by the extraordinary conventions
of self-invisibility. In Sharon Traweek's wonderfully suggestive terms, such a
man must inhabit the space perceived by its inhabitants to be the "culture of no
culture"[2] (1988).

This is the culture within which contingent facts—the real case about the
world—an be established with all the authority, but none of the considerable
problems, of transcendental truth. This self-invisibility is the specifically mod-
ern, European, masculine, scientific form of the virtue of modesty. This is the
form of modesty that pays off its practitioners in the coin of epistemological and

23

social power. This kind of modesty is one of the founding virtues of what we call modernity. This is the virtue that guarantees that the modest witness is the legitimate and authorized ventriloquist for the object world, adding nothing from his mere opinions, from his biasing embodiment. And so he is endowed with the remarkable power to establish the facts. He bears witness: he is objective; he guarantees the clarity and purity of objects. His subjectivity is his objectivity. His narratives have a magical power—they lose all trace of their history as stories, as products of partisan projects, as contestable representations, or as constructed documents in their potent capacity to define the facts.[3] The narratives become clear mirrors, fully magical mirrors, without once appealing to the transcendental or the magical. In what follows, I would like to queer the elaborately constructed and defended confidence of this civic man of reason in order to enable a more corporeal, inflected, and optically dense, if less elegant, kind of modest witness to matters of fact to emerge in the worlds of technoscience.

Robert Boyle (1627–1691) is memorialized in the narratives of the scientific Revolution and of the Royal Society of London for Improving Natural Knowledge as the father of chemistry and, even more important, father of the experimental way of life. In a series of crucial developments in the 1650s and 1660s in post-civil war Restoration England, Boyle played a key role in forging the three constitutive technologies for such a new life form: "a *material technology* embedded in the construction and operation of the air-pump; a *literary technology* by means of which the phenomena produced by the pump were made known to those who were not direct witnesses; and a *social technology* that incorporated the conventions experimental philosophers should use in dealing with each other and considering knowledge-claims" (Shapin and Schaffer 1985:25).[4] Experimental philosophy—science—could only spread as its materialized practices spread. This was a question not of ideas but of the apparatus of production of what could count as knowledge.

At the center of this story is an instrument, the air-pump. Embedded in the social and literary technologies of proper witnessing, and sustained by the subterranean labor of its building, maintenance, and operation, the air-pump acquired the stunning power to establish matters of fact independent of the endless contentions of politics and religion. Such contingent matters of fact, such "situated knowledges," were constructed to have the earth-shaking capacity to ground social order *objectively*, literally. This separation of expert knowledge from mere opinion as the legitimating knowledge for ways of life, without appeal to transcendent authority or to abstract certainty of any kind, is a founding gesture of what we call modernity. It is the founding gesture of the separation of the technical and the political. Much more than the existence or nonexistence of a

vacuum was at stake in Boyle's demonstrations of the air-pump. As Shapin and Schaffer put it, "The matter of fact can serve as the foundation of knowledge and secure assent insofar as it is not regarded as man-made. Each of Boyle's three technologies worked to achieve the appearance of matters of fact as *given* items. That is to say, each technology functioned as an *objectifying resource*" (1985:77). The three technologies, metonymically integrated into the air-pump itself, the neutral instrument, factored out human agency from the product. The experimental philosopher could say, "It is not I who say this; it is the machine" (77). "It was to be nature, not man, that enforced assent" (79). The world of subjects and objects was in place, and scientists were on the side of the objects. Acting as objects' transparent spokesmen, the scientists had the most powerful allies. As men whose only visible trait was their limpid modesty, they inhabited the culture of no culture. Everybody else was left in the domain of culture and of society.

But there were conditions for being able to establish such facts credibly. To multiply its strength, witnessing should be public and collective. A public act must take place in a site that an be semiotically accepted as public, not private. But "public space" for the experimental way of life had to be rigorously defined; not everyone could come in, and not everyone could testify credibly. What counted as private and as public was very much in dispute in Boyle's society. his opponents, especially Thomas Hobbes (1588–1679), repudiated the experimental way of life precisely because its knowledge was dependent on a practice of *witnessing* by a special community, like that of clerics and lawyers. Hobbes saw the experimentalists as part of private, or even secret, and not civil, public space. Boyle's "open laboratory" and its offspring evolved as a most peculiar "public space," with elaborate constraints on who legitimately occupied it. "What in fact resulted was, so to speak, a public space with restricted access" (Shapin and Schaffer 1985:336).

Indeed, it is even possible today, in special circumstances, to be working in a top-secret defense lab, communicating only to those with similar security clearances, and to be *epistemologically* in public, doing leading-edge science, nicely cordoned off from the venereal infections of politics. Since Boyle's time, only those who could disappear "modestly" could really witness with authority rather than gawk curiously. The laboratory was to be open, to be a theater of persuasion, and at the same time it was constructed to be one of the "culture of no culture's" most highly regulated spaces. Managing the public/private distinction has been critical to the credibility of the experimental way of life. This novel way of life *required* a special, bounded community. Restructuring that space—materially and epistemologically—is very

much at the heart of late-twentieth-century reconsiderations of what will count as the best science.

Also, displaying the labor expended on stabilizing a matter of fact comprised its status. The men who worked the bellows in Boyle's home laboratory were *his* men; they sold their labor power to him; they were not independent. "As a free-acting gentleman, [Boyle] was the author of their work. He spoke for them and transformed their labor into his truth" (Shapin 1994:406). Unmasking this kind of credible, unified authorship of the labor required to produce a fact showed the possibility of a rival account of the matter of fact itself—a point not lost on Boyle's famous opponent, Thomas Hobbes. Furthermore, those actually physically present at a demonstration could never be as numerous as those virtually present by means of the presentation of the demonstration through the literary device of the written report. Thus, the rhetoric of the modest witness, the "naked way of writing," unadorned, factual, compelling, was crafted. Only through such naked writing could the facts shine through, unclouded by the flourishes of any human author. Both the facts and the witnesses inhabit the privileged zones of "objective" reality through a powerful writing technology. And, finally, only through the routinization and institutionalization of all three technologies for establishing matters of fact could the "transposition onto nature of experimental knowledge" be stably effected (Shapin and Schaffer 1985:79).

All of these criteria for credibility intersect with the question of modesty. Transparency is a peculiar sort of modesty. The philosopher of science Elizabeth Potter, of Mills College, gave me the key to this story in her paper "Making Gender/Making Science: Gender Ideology and Boyle's Experimental Philosophy"[5] (forthcoming). Shapin and Schaffer attended to the submerging, literally, as represented by engravings of the regions under the room with the visible air-pump, of the labor of the crucial artisans who built and tended the pump—and without whom nothing happened—but they were silent on the structuring and meaning of the specific civil engineering of the modest witness. They took his masculine gender for granted without much comment. Like the stubbornly reproduced lacunae in the writing of many otherwise innovative science studies scholars, the gap in their analysis seems to depend on the unexamined assumption that gender is a preformed, functionalist category, merely a question of preconstituted "generic" men and women, beings resulting from either biological or social sexual difference and playing out roles, but otherwise of no interest.

In a later book, Shapin (1994) does look closely at the exclusion of women, as well as of other categories of nonindependent persons, from the preserves of gentlemanly truth-telling that characterized the relations of civility and science

in seventeenth-century England. As "covered" persons, subsumed under their husbands or fathers, women could not have the necessary kind of honor at stake. As Shapin noted, the "covered" status of women was patently social, not "biological," and understood to be such, irrespective of whatever beliefs a seventeenth-century man or woman might also hold about natural differences between the sexes.[6] Shapin saw no reason to posit that gender was at stake, or remade, by any of the processes that came together as the experimental way of life. The preexisting dependent status of women simply precluded their epistemological, and for the most part their physical, presence in the most important scenes of action in that period in the history of science. The issue was not whether women were intelligent or not. Boyle, for example, regarded his aristocratic sisters as his equal in intellectually demanding religious discussions. The issue was whether women had the independent status to be modest witnesses, and they did not. Technicians, who were physically present, were also epistemologically invisible persons in the experimental way of life; women were invisible in both physical and epistemological senses.

Shapin's questions are different from mine. He notes exclusions, but his focus is on other matters. In contrast, my focus in this chapter is to ask if gender, with all its tangled knots with other systems of stratified relationships, was at stake in key reconfigurations of knowledge and practice that constituted modern science. If Shapin perhaps erred in seeing only conservation, my excesses will be in the other direction.

There are several ways to contest Shapin's judgment that gender was merely conserved, and not redone, or at least hardened in consequential ways, in the seventeenth-century meeting of science and civility. In this regard, historians emphasize the critical role of the defeat of the hermetic tradition in the establishment of scientific mechanistic orthodoxy and the correlated devaluation of much that was gendered feminine (which did not necessarily have to do with real women) in science. The virulence of the witch hunts in Europe in the sixteenth and seventeenth centuries, and the involvement of men who saw themselves as rationalist founders of the new philosophy, testifies to the crisis in gender in that molten period in both knowledge and religion.[7] David Noble (1992:205–43) points out that the "disorderly" public activities of women in the period of religious and political turmoil before the Restoration, as well as women's association with the alchemical tradition, made wise gentlemen scramble to dissociate themselves from all things feminine, including oxymoronic independent women, after mid-century, if not before.

Shapin (1994:xxii) is openly sympathetic to efforts to foreground the voices and agencies of the excluded and silenced in history, but he is emphatic

about the legitimacy of doing the history of what he only half jokingly calls "Dead White European Males" where their activities and ways of knowing are what mattered—and not just to themselves. I agree completely with Shapin's insistence on focusing on men, of whatever categories, when it is their doings that matter. Masculine authority, including the seventeenth-century gentlemanly culture of honor and truth, has been widely taken as legitimate by both men and women, across many kinds of social differentiation. It would not serve feminism to obscure this problem. I do not think Shapin or Shapin and Schaffer should have written their books about women; and besides, Shapin (1994) has a great deal that is interesting to say about the agencies of, among others, Boyle's aristocratic and pious sisters in religious and domestic realms. Without focusing on "Dead White European Males" it would be impossible to understand gender at all, in science or elsewhere. However, what I think Shapin does not interrogate in his formulations was whether and how precisely the world of scientific gentlemen was *instrumental* in both sustaining old and in crafting new "gendered" ways of life. Insofar as the experimental way of life built the exclusion of actual women, as well as of cultural practices and symbols deemed feminine, into what could count as the truth in science, the air-pump was a technology of gender at the heart of scientific knowledge. It was the general absence, not the occasional presence, of women of whatever class or lineage/color—and the historically specific ways that the semiotics and psychodynamics of sexual difference worked—that gendered the experimental way of life in a particular way.

My question is, How did all this matter to what could count as knowledge in the rich tradition we know as science? Gender is always a relationship, not a preformed category of beings or a possession that one can have. Gender does not pertain more to women than to men. Gender is the relation between variously constituted categories of men and women (and variously arrayed tropes), differentiated by nation, generation, class, lineage, color, and much else. Shapin and Schaffer assembled all the elements to say something about how gender was one of the products of the air-pump; but the blind spot of seeing gender as women instead of as a relationship got in the way of the analysis. Perhaps Shapin in his later book is right that nothing very interesting happened to gender in the meeting of civility and science in the experimental way of life, with its practices of truth-telling. But I suspect that the way he asked his questions about excluded categories precluded having much to say about the two questions that vex me: (1) In what ways in the experimental way of life was gender in-the-making? (2) Did that matter or not, and how or how not, to what could count as reliable knowledge in science during and after the seventeenth century? How did gender-in-the-making become part of negotiating the continually vexed boundary

between the "inside" and the "outside" of science? How did gender-in-the-making relate to establishing what counted as objective and subjective, political and technical, abstract and concrete, credible and ridiculous?

The effect of the missing analysis is to treat race and gender, at best, as a question of empirical, preformed beings who are present or absent at the scene of action but are not generically constituted in the practices choreographed in the new theaters of persuasion. This is a strange analytical aberration, to say the least, in a community of scholars who play games of epistemological chicken trying to beat each other in the game of showing how all the entities in techno-science are constituted *in* the action of knowledge production, not *before* the action starts.[8] The aberration matters, for, as David Noble argues in his synthesis on the effect of Western Christian clerical culture on the culture and practice of science, "any genuine concern about the implications of such a culturally distorted science-based civilization, or about the role of women within it, demands an explanation. For the male identity of science is no mere artifact of sexist history; throughout most of its evolution, the culture of science has not simply excluded women, it has been defined in defiance of women and their absence. . . . How did so strange a scientific culture emerge, one that proclaimed so boldly the power of the species while at the same time shrinking in horror from half the species?" (1992:xiv).

Elizabeth Potter, however, has a keen eye for how men became man in the practice of modest witnessing. Men-in-the-making, not men, or women, already made, is her concern. Gender was *at stake* in the experimental way of life, she argues, not predetermined. To develop this suspicion, she turns to the early-seventeenth-century English debates on the proliferation of genders in the practice of sexual cross-dressing. In the context of anxieties over gender manifested by early modern writers, she asks how Robert Boyle—urbane, celibate, and civil—avoided the fate of being labeled a *haec vir*, a feminine man, in his insistence on the virtue of modesty? How did the masculine practice of modesty, by appropriately civil (gentle)men, enhance agency, epistemologically and socially, while modesty enforced on (or embraced by) women of the same social class simply removed them from the scene of action? How did some men become transparent, self-invisible, legitimate witnesses to matters of fact, while most men and all women were made simply invisible, removed from the scene of action, either below stage working the bellows that evacuated the pump or offstage entirely? Women lost their security clearances very early in the stories of leading-edge science.

Women were, of course, literally offstage in early modern English drama, and the presence of men acting women's roles was the occasion for more than a

little exploring and resetting of sexual and gender boundaries in the foundational settings of English drama in the sixteenth and seventeenth centuries. As the African American literary scholar Margo Hendricks (1992, 1994 and 1996) tells us, Englishness was also at stake in this period, for example, in Shakespeare's *Midsummer Night's Dream*.[9] And, she notes, the story of Englishness was part of the story of modern gendered racial formations, rooted still in lineage, civility, and nation, rather than in color and physiognomy. But the discourses of "race" that were cooked in this cauldron, which melted nations and bodies together in discourses on lineage, were more than a little useful throughout the following centuries for demarcating the differentially sexualized bodies of "colored" peoples around the world, locally and globally, from the always unstably consolidated subject positions of self-invisible, civil inquirers.[10] Gender and race never existed separately and never were about preformed subjects endowed with funny genitals and curious colors. Race and gender are about entwined, barely analytically separable, highly protean, *relational* categories. Racial, class, sexual, and gender formations (not essences) were, from the start, dangerous and rickety machines for guarding the chief fictions and powers of European civil manhood. To be unmanly is to be uncivil, to be dark is to be unruly: Those metaphors have mattered enormously in the constitution of what may count as knowledge.

Let us attend more closely to Potter's story. Medieval secular masculine virtue—noble manly valor—required patently heroic words and deeds. The modest man was a problematic figure for early modern Europeans, who still thought of nobility in terms of warlike battles of weapons and words.[11] Potter argues that in his literary and social technologies, Boyle helped to construct the new man and woman appropriate to the experimental way of life and its production of matters of fact. "The new man of science had to be a chaste, modest, heterosexual man who desires yet eschews a sexually dangerous yet chaste and modest woman" (forthcoming).[12] Female modesty was of the body; the new masculine virtue had to be of the mind. This modesty was to be the key to the gentleman-scientist's trustworthiness; he reported on the world, not on himself. Unadorned "masculine style" became English national style, a mark of the growing hegemony of the rising English nation. An unmarried man in Puritan England, which valued marriage highly, Boyle pursued his discourse on modesty in the context of the vexed *hic mulier/haec vir* (masculine woman/feminine man) controversies of the late sixteenth and early seventeenth centuries. In that anxious discourse, when gender characteristics were transferred from one sex to another, writers worried that third and fourth sexual kinds were created, proliferating outside all bounds of God and Nature. Boyle could not risk his modest witness's being a *haec vir*. God forbid the experimental way of life have queer foundations.

Two additional taproots for the masculinity of Boyle's brand of modesty exist: the King Arthur narratives and the clerical monastic Christian tradition. Bonnie Wheeler (1992) argues that the first reference to the Arthur figure in the sixth century referred to him as a *vir modestus*, and the qualifier followed Arthur through his many literary incarnations. This tradition was probably culturally available to Boyle and his peers looking for effective new models of masculine reason. *Modestus* and *modestia* referred to measure, moderation, solicitude, studied equilibrium, and reticence in command. This constellation moves counter to the dominant strand of Western heroism, which emphasizes self-glorification by the warrior hero. The *vir modestus* was a man characterized by high status and disciplined ethical restraint. *Modestia* linked high class, effective power, and masculine gender. Wheeler finds in the King Arthur figure "one alternative norm of empowered masculinity for post-heroic culture" (1992:1).

David Noble emphasizes the reappropriation of clerical discourse in a Royal Society sanctioned by crown and church. "As an exclusively male retreat, the Royal Society represented the continuation of the clerical culture, now reinforced by what may be called a scientific asceticism" (Noble 1992:231). The kind of gendered self-renunciation practiced in this masculine domain was precisely the kind that enhanced epistemological-spiritual potency. Despite the importance of marriage in the Protestant Reformation's attack on the Catholic church, even celibacy in the experimental way of life was praised by lay Puritans of the early Restoration, and especially by Robert Boyle, who served as a model of the new scientist. Potter quotes Boyle's praise of male chastity in the context of man's right to a priesthood rooted in reason and knowledge of the natural world. As Potter puts it, female chastity served male chastity, which allowed men to serve God undistractedly through experimental science. For Boyle, "the laboratory has become the place of worship; the scientist, the priest; the experiment, a religious rite" (Potter forthcoming).

Within the conventions of modest truth-telling, women might watch a demonstration; they could not witness it. The definitive demonstrations of the working of the air-pump had to take place in proper civil public space, even if that meant holding a serious demonstration late at night to exclude women of his class, as Boyle did. For example, reading Boyle's *New Experiments Physico-Mechanical Touching the Spring of the Air*, which describes experiments with the air-pump, Potter recounts a demonstration attended by high-born women at which small birds were suffocated by the evacuation of the chamber in which the animals were held. The ladies interrupted the experiments by demanding that air be let in to rescue a struggling bird. Boyle reports that to avoid such difficulties, the men later assembled at night to conduct the procedure and attest to the

results. Potter notes that women's names were never listed among those attesting the veracity of experimental reports, whether they were present or not. Several historians describe the tumult caused in 1667 at the Royal Society when Margaret Cavendish (1623–1673), Duchess of Newcastle, generous patron of Cambridge University, and a substantive writer on natural philosophy who intended to be taken seriously, requested permission to visit a working session of the all-male society.[13] Not wanting to offend an important personage, "the leaders of the society ultimately acceded to her request, arranging for her to visit several scientific demonstrations by, among others, Hooke and Boyle" (Noble 1992:231). There was no return visit, and the first women admitted to the Royal Society, after lawyers' advice made it clear that continued exclusion of women would be illegal, entered in 1945, almost 300 years after Cavendish's unwelcome appearance.[14]

Enhancing their agency through their masculine virtue exercised in carefully regulated "public" spaces, modest men were to self-invisible, transparent, so that their reports would not be polluted by the body. Only in that way could they give credibility to their descriptions of other bodies and minimize critical attention to their own. This is a crucial epistemological move in the grounding of several centuries of race, sex, and class discourses as objective scientific reports.[15]

All of these highly usable discourses feed into the conventions of masculine scientific modesty, whose gendering came to be more and more invisible (transparent) as its masculinity seemed more and more simply the nature of any nondependent, disinterested truth-telling. The new science redeemed Boyle's celibate, sacred-secular, and nonmartial man from any gender confusion or multiplicity and made him a modest witness as the type specimen of modern heroic, masculine action—of the mind. Depleted of epistemological agency, modest women were to be invisible to others in the experimental way of life. The kind of visibility—of the body—that women retained glides into being perceived as "subjective," that is, reporting only on the self, biased, opaque, not objective. Gentlemen's epistmological agency involved a special kind of transparency. Colored, sexed, and laboring persons still have to do a lot of work to become similarly transparent to count as objective, modest witnesses to the world rather than to their "bias" or "special interest." To be the object of vision, rather than the "modest," self-invisible source of vision, is to be evacuated of agency.[16]

The self-invisibility and transparency of Boyle's version of the modest witness—that is, the "independence" based on power and on the invisibility of others who actually sustain one's life and knowledge—are precisely the focus of late-twentieth-century feminist and multiculutural critique of the limited, biased forms of "objectivity" in technoscientific practice, insofar as it produces

itself as "the culture of no culture." Antiracist feminist science studies revisit what it meant, and means, to be "covered" by the modest witnessing of others who, because of their special virtue, are themselves transparent. "In the beginning," the exclusion of women and laboring men was instrumental to managing a critical boundary between watching and witnessing, between who is a scientist and who is not, and between popular culture and scientific fact. I am not arguing that the doings of Boyle and the Royal Society are the whole story in crafting modern experimental and theoretical science; that would be ridiculous. Also, I am at least as invested in the continuing need for stabilizing contingent matters of fact to ground serious claims on each other as any child of the Scientific Revolution could be. I am using the story of Boyle and the experimental way of life as a figure for technoscience; the story stands for more than itself. My claim is double: (1) There have been practical inheritances, which have undergone many reconfigurations but which remain potent; and (2) the stories of the Scientific Revolution set up a narrative about "objectivity" that continues to get in the way of a more adequate, self-critical technoscience committed to situated knowledges. The important practice of credible witnessing is still at stake.

A further central issue requires compressed comment: the structure of heroic action in science. Several scholars have commented on the proliferation of violent, misogynist imagery in many of the chief documents of the Scientific Revolution.[17] The modest man had at least a tropic taste for the rape of nature. Science made was nature undone, to embroider on Bruno Latour's (1987) metaphors in his important *Science in Action*. Nature's coy resistance was part of the story, and getting nature to reveal her secrets was the prize for manly valor—all, of course, merely valor of the mind. At the very least, the encounter of the modest witness with the world was a great trial of strength. In disrupting many conventional accounts of scientific objectivity, Latour and others have masterfully unveiled the self-invisible modest man. At the least, that is a nice twist on the usual direction of discursive unveiling and heterosexual epistemological erotics.[18] In *Science, the Very Idea!* Steve Woolgar (1988) keeps the light relentlessly on this modest being, the "hardest case" or "hardened self" that covertly guarantees the truth of a representation, which ceases magically to have the status of a representation and emerges simply as the fact of the matter. That crucial emergence depends on many kinds of transparency in the grand narratives of the experimental way of life. Latour and others eschew Woolgar's relentless insistence on reflexivity, which seems not to be able to get beyond self-vision as the cure for self-invisibility. The disease and the cure seem to be practically the same thing, if what you are after is another

kind of world and worldliness. Diffraction, the production of difference patterns, might be a more useful metaphor for the needed work than reflexivity.

Latour is generally less interested than his colleague in forcing the Wizard of Oz to see himself as the linchpin in the technology of scientific representation. Latour wants to follow the action in science-in-the-making. Perversely, however, the structure of heroic action is only intensified in this project—both in the narrative of science and in the discourse of the science studies scholar. For the Latour of *Science in Action*, technoscience itself is war, the demiurge that makes and unmakes worlds.[19] Privileging the younger face as science-in-the-making, Latour adopts as the figure of his argument the double-faced Roman god, Janus, who, seeing both ways, presides over the beginnings of things. Janus is the doorkeeper of the gate of heaven, and the gates to his temple in the Roman Forum were always open in time of war and closed in times of peace. War is the great creator and destroyer of worlds, the womb for the masculine birth of time. The action in science-in-the-making is all trials and feats of strength, amassing of allies, forging of worlds in the strength and numbers of forced allies. All action is agonistic; the creative abstraction is both breathtaking and numbingly conventional. Trials of strength decide whether a representation holds or not. Period. To compete, one must either have a counterlaboratory capable of winning in these high-stakes trials of force or give up dreams of making worlds. Victories and performances are the action sketched in this seminal book. "The list of trials becomes a thing; it is literally reified" (Latour 1987:92).

This powerful tropic system is like quicksand. *Science in Action* works by relentless, recursive mimesis. The story told is told by the same story. The object studied and the method of study mime each other. The analyst and the analysand all do the same thing, and the reader is sucked into the game. It is the only game imagined. The goal of the book is "penetrating science from the outside, following controversies and accompanying scientists up to the end, being slowly led out of science in the making" (15). The reader is taught how to resist both the scientist's and the false science studies scholar's recruiting pitches. The prize is not getting stuck in the maze but exiting the space of technoscience a victor, with the strongest story. No wonder Steven Shapin began his review of this book with the gladiator's salute: "Ave, Bruno, morituri te salutant" (1988:533).

So, from the point of view of some of the best work in mainstream science studies of the late 1980s, "nature" is multiply the feat of the hero, more than it ever was for Boyle. First, nature is a materialized fantasy, a projection whose solidity is guaranteed by the self-invisible representor. Unmasking this figure, s/he who would not be hoodwinked by the claims of philosophical realism and

the ideologies of disembodied scientific objectivity fears to "go back" to nature, which was never anything but a projection in the first place. The projection nonetheless tropically works as a dangerous female threatening manly knowers. Then, another kind of nature is the result of trials of strength, also the fruit of the hero's action. Finally, the scholar too must work as a warrior, testing the strength of foes and forging bonds among allies, human and nonhuman, just as the scientist-hero does. The self-contained quality of all this is stunning. It is the self-contained power of the culture of no culture itself, where all the world is in the sacred image of the Same. This narrative structure is at the heart of the potent modern story of European autochthony.[20]

What accounts for this intensified commitment to virile modesty? I have two suggestions. First, failing to draw from the understandings of semiotics, visual culture, and narrative practice coming specifically from feminist, postcolonial, and multicultural oppositional theory, many science studies scholars insufficiently examine their basic narratives and tropes. In particular, the "self-birthing of man," "war as his reproductive organ," and "the optics of self-origination" narratives that are so deep in Western philosophy and science have been left in place, though so much else has been fruitfully scrutinized. Second, many science studies scholars, like Latour, in their energizing refusal to appeal to society to explain nature, or vice versa, have mistaken other narratives of action about scientific knowledge production as functionalist accounts appealing in the tired old way to preformed categories of the social, such as gender, race, and class. Either critical scholars in antiracist, feminist cultural studies of science and technology have not been clear enough about racial formation, gender-in-the-making, the forging of class, and the discursive production of sexuality *through the constitutive practices of technoscience production themselves*, or the science studies scholars aren't reading or listening—or both. For the oppositional critical theorists, both the facts and the witnesses are constituted in the encounters that are technoscientific practice. Both the subjects and objects of technoscience are forged and branded in the crucible of specific, located practices, some of which are global in their location. In the intensity of the fire, the subjects and objects regularly melt into each other. It is past time to end the failure of mainstream and oppositional science studies scholars to engage each other's work. Immodestly, I think the failure to engage has not been symmetrical.

Let me close this meditation on figures who can give credible testimony to matters of fact by asking how to queer the modest witness this time around so that s/he is constituted in the furnace of technoscientific practice as a self-aware, accountable, anti-racist FemaleMan, one of the proliferating, uncivil, late-twentieth-century children of the early modern *haec vir* and *hic mulier*. Like

Latour, the feminist philosopher of science Sandra Harding is concerned with strength, but of a different order and in a different story. Harding (1992) develops an argument for what she calls "strong objectivity" to replace the flaccid standards for establishing matters of fact instaurated by the literary, social, and material technologies inherited from Boyle. Scrutiny of what constitutes "independence" is fundamental. "A stronger, more adequate notion of objectivity would require methods for systematically examining all of the social values shaping a particular research process, not just those that happen to differ between members of a scientific community. Social communities, not either individuals, or 'no one at all,' should be conceptualized as the 'knowers' of scientific knowledge claims. Culture wide beliefs that are not critically examined within scientific processes end up functioning as evidence for or against hypotheses" (Harding 1993:18).

Harding maintains that democracy-enhancing projects and questions are most likely to meet the strongest criteria for reliable scientific knowledge-production, with built-in critical reflexivity. That is a hope in the face of, at best, ambiguous evidence. It is a hope that needs to be made into a fact by practical work. Such labor would reconstitute the relationships we call gender, race, nation, species, and class in unpredictable ways. Such reformed semiotic, technical, and social practice might be called, after Deborah Heath's term for promising changes in standards for building knowledge in a molecular biology she studies ethnographically, "modest interventions" (forthcoming).

So, agreeing that science is the result of located practices at all levels, Harding concurs with Woolgar that reflexivity is a virtue the modest witness needs to cultivate. But her sense of reflexivity is closer to my sense of diffraction and to Heath's modest interventions than it is to Woolgar's rigorous resistance to making strong knowledge claims. The point is to make a difference in the world, to cast our lot for some ways of life and not others. To do that, one must be in the action, be finite and dirty, not transcendent and clean. Knowledge-making technologies, including crafting subject positions and ways of inhabiting such positions, must be made relentlessly visible and open to critical intervention. Like Latour, Harding is committed to science-in-the-making. Unlike the Latour of *Science in Action*, she does not mistake the constituted and constitutive practices that generate and reproduce systems of stratified inequality—and that issue in the protean, historically specific, marked bodies of race, sex, and class—for preformed, functionalist categories. I do not share her occasional terminology of macrosociology and her all-too-self-evident identification of the social. But I think her basic argument is fundamental to a different kind of strong program in science studies, one that really does not flinch from an ambitious project of symmetry that is committed as much to knowing

about the people and positions from which knowledge can come and to which it is targeted as to dissecting the status of knowledge made.

Critical reflexivity, or strong objectivity, does not dodge the world-making practices of forging knowledges with different chances of life and death built into them. All that critical reflexivity, diffraction, situated knowledges, modest interventions, or strong objectivity "dodge" is the double-faced, self-identical god of transcendent cultures of no culture, on the one hand, and of subjects and objects exempt from the permanent finitude of engaged interpretation, on the other. No layer of the onion of practice that is technoscience is outside the reach of technologies of critical interpretation and critical inquiry about positioning and location; that is the condition of articulation, embodiment, and mortality. The technical and the political are like the abstract and the concrete, the foreground and the background, the text and the context, the subject and the object. As Katie King (1993) reminds us, following Gregory Bateson, these are questions of pattern, not of ontological difference. The terms pass into each other; they are shifting sedimentations of the one fundamental thing about the world—relationality. Oddly, embedded relationality is the prophylaxis for both relativism and transcendence. Nothing comes without its world, so trying to know those worlds is crucial. From the point of view of the culture of no culture, where the wall between the political and the technical is maintained at all costs, and interpretation is assigned to one side and facts to the other, such worlds can never be investigated. Strong objectivity insists that both the objects and the subjects of knowledge-making practices must be located. Location is not a listing of adjectives or assigning of labels such as race, sex, and class. Location is not the concrete to the abstract of decontextualization. Location is the always partial, always finite, always fraught play of foreground and background, text and context, that constitutes critical inquiry. Above all, location is not self-evident or transparent.

Location is also partial in the sense of being *for* some worlds and not others. There is no way around this polluting criterion for strong objectivity. Sociologist and ethnographer Susan Leigh Star (1991) explores taking sides in a way that is perhaps more readily heard by science studies scholars than Harding's more conventional philosophical vocabulary. Star is interested in taking sides with some people or other actors in the enrollments and alliance formations that constitute so much of technoscientific action. Her points of departure are feminist and symbolic interactionist modes of inquiry that privilege the kind of witness possible from the point of view of those who suffer the trauma of not fitting into the standard. Not to fit the standard is another kind of oxymoronically opaque transparency or invisibility: Star would like to see if this kind is conducive to crafting a better modest witness. Not fitting a standard is not the same thing as existing in a

world without that standard. Instructed by the kinds of multiplicity that result from exposure to violence, from being outside a powerful norm, rather than from positions of independence and power, Star is compelled by the starting point of the monster, of what is exiled from the clean and light self. And so she suspects that the "voices of those suffering from the abuses of technological power are among the most powerful analytically" (Star 1991:30).

Star's own annoying but persistent allergy to onions, and the revealing difficulty of convincing service people in restaurants that such a condition is real, is her narrative wedge into the question of standardization. In order to address questions about power in science and technology, Star looks at how standards produce invisible work for some while clearing the way for others, and at how consolidated identities for some produce marginalized locations for others. She adopts what she calls a kind of "cyborg" point of view: Her "cyborg" is the "relationship between standardized technologies and local experience," where one falls "between the categories, yet in relationship to them" (39).

Star thinks "that it is both more analytically interesting and more politically just to begin with the question *cui bono*, than to begin with a celebration of the fact of human/non-human mingling" (43). She does not question the fact of the implosion of categorical opposites; she is interested in who lives and dies in the force fields generated. "Public" stability for some is "private" suffering for others; self-invisibility for some comes at the cost of public invisibility for others. They are "covered" by what is conventionally made to be the case about the world. I think that such coverings reveal the grammatical structure of "gender," "race," "class," and similar clumsy categorical attempts to name how the world is experienced by the nonstandard, who nonetheless are crucial to the technologies of standardization and others' ease of fitting.

In Star's account, we are all members of many communities of practice. Multiplicity is in play with questions of standardization, and no one is standard or ill fitted in all communities of practice. Some kinds of standardization matter more than others, but all forms work by producing those that do not fit as well as those who do. Inquiry about technoscience from the point of view of Star's monsters does not necessarily focus on those who do not fit, but rather on the contingent material-semiotic articulations that bring such ill-fitting positions into being and sustain them. Star's monsters also ask rather uncivilly how much it costs, and who pays, for some to be modest witnesses in a regime of knowledge-production while others get to watch. And monsters in one setting set the norm in others; innocence and transparency are not available to feminist modest witnesses.

Double vision is crucial to inquiring into the relations of power and standards that are at the heart of the subject- and object-making processes of

technoscience. Where to begin and where to be based are the fundamental questions in a world in which "power is about *whose* metaphor brings worlds together" (Star 1991:52). Metaphors are tools and tropes. The point is to learn to remember that we might have been otherwise, and might yet be, as a matter of embodied fact. Being allergic to onions is a niggling tropic irritant to the scholarly temptation to forget one's own complicity in apparatuses of exclusion that are constitutive to what may count as knowledge. Fever, nausea, and a rash can foster a keen appreciation of located knowledges.

So I close this evocation of the figure of the modest witness in the narrative of science with the hope that the technologies for establishing what may count as the case about the world may be rebuilt to bring the technical and the political back into realignment so that questions about possible livable worlds lie visibly at the heart of our best science.

Millennial Children, Lynn Randolph, oil on canvas, 58" x 72", 1992

Stalked by hyenas and mocked by a dancing clown-devil with a leering death mask for a stomach, two embracing girls kneel on the flaming ground outside the burning city of Houston on the banks of an oil-polluted bayou. Facing the viewer, these millennial children ask if there can still be a future on this earth. Vultures perch on the limbs of a blasted tree, its roots miming the bird feet of the cavorting demon, whose stomach is a portrait of George Bush. Smoking towers of a nuclear power plant loom in the background, and a Stealth bomber dives toward the ground out of a lightning-scorched sky. Reds, blacks, and slashing yellows dominate the large canvas, relieved by the sepia flesh and pastel dresses of the children and the greens of the not-yet-burned bushes. The girls are whole, firm, and flanked by diminutive guardian angels. Sober in their regard, the children are not destroyed, but they are menaced by the apocalypse that engulfs the world. They are in the dangerous borderlands between reality and nightmare, between the comprehensive futurelessness that is only a dire possibility and the blasted futures of hundreds of millions of children that are a fierce reality now. These are the children whose witness calls the viewer to account for both the stories and the actualities of the millennium.

Second Millennium

> They did not know for sure, but they suspected that the dances
> were beyond nasty because the music was getting worse and worse
> with each passing season the Lord waited to make Himself known.
> —Toni Morrison, *Jazz*

> I have not written a narrative Leviathan. Did you really want
> another one?
> —Sharon Traweek, "Border Crossings"

From a millennarian perspective, things are always getting worse. Evidence of decay is exhilarating and mobilizing. Oddly, belief in advancing disaster is actually part of a trust in salvation, whether deliverance is expected by sacred or profane revelations, through revolution, dramatic scientific breakthroughs, or religious rapture. For example, for radical science activists like me, the capitalist commodification of the dance of life is always advancing ominously; there is always evidence of nastier and nastier technoscience dominations. An emergency is always at hand, calling for the need for transformative politics. For my twins, the true believers in the church of science, a cure for the trouble at hand is always promised. That promise justifies the sacred status of scientists, even, or especially, outside their domains of practical expertise. Indeed, the *promise* of technoscience is, arguably, its principal social weight. Dazzling promise has always been the underside of the deceptively sober pose of scientific rationality and modern progress within the culture of no culture. Whether unlimited clean energy through the peaceful atom, artificial intelligence surpassing the merely human, an impenetrable shield from the enemy within or without, or the prevention of aging ever materializes is vastly less important than always living in the time zone of amazing promises. In relation to such dreams, the impossibility of ordinary materialization is intrinsic to the potency of the promise. Disaster feeds radiant hope and bottomless despair, and I, for one, am satiated. We pay dearly for living within the chronotope of ultimate threats and promises.

Literally, *chronotope* means topical time, or a *topos* through which temporality is organized. A topic is a commonplace, a rhetorical site. Like both place and space, time is never "literal," just there; *chronos* always intertwines with *topos*, a point richly theorized by Bakhtin (1981) in his concept of the chronotope as a figure that organizes temporality. Time and space organize each other in variable

relationships that show any claim to totality, be it the New World Order, Inc., the Second Millennium, or the modern world, to be an ideological gambit linked to struggles to impose bodily / spatial / temporal organization. Bakhtin's concept requires us to enter the contingency, thickness, inequality, incommensurability, and dynamism of cultural systems of reference through which people enroll each other in their realities. Bristling with ultimate threats and promises, drenched with the tones of the apocalyptic and the comic, the gene and the computer both work as chronotopes throughout *Modest_Witness@Second_Millennium.*

So, replete with such costs, the Second Millennium is this book's space-time machine; it is the machine that circulates the figures of the modest witness, the FemaleMan, and OncoMouse in a common story. The air-pump is itself a chronotope closely related to my mechanical-millennial address. Both machines have to do with a narrative space-time frame associated with millennarian hopes for new foundations. The air-pump was an actor in the drama of the Scientific Revolution. The device's potent agency in civil matters and its capacity to bear witness exceeded that of most of the humans who attended its performances and looked after its functioning. Those humans to whom could be attributed a power of agency approaching that of the air-pump and its progeny over the next centuries had to disguise themselves as its ventriloquists. Their subjectivity had to become their objectivity, guaranteed by their close kinship with their machines. Inhabiting the culture of no culture, these modest witnesses were transparent spokesmen, pure mediums transmitting the objective word made flesh as facts. These humans were self-invisible witnesses to matters of fact, the new world's guarantors of objectivity. The narrative frames of the Scientific Revolution were a kind of time machine that situated subjects and objects into dramatic pasts, presents, and futures.

If belief in the stable separation of subjects and objects in the experimental way of life was one of the defining stigmata of modernity, the implosion of subjects and objects in the entities populating the world at the end of the Second Millennium—and the broad recognition of this implosion in both technical and popular cultures—are stigmata of another historical configuration. Many have called this configuration "postmodern." Suggesting instead the notion of the "metamodern" for the current moment, Paul Rabinow (1992a) rejects the "postmodern" label for two main reasons: (1) Foucault's three axes of the modern episteme—life, labor, and language—are all still very much in play in current knowledge-power configurations; and (2) the collapse of metanarratives that is supposed to be diagnostic of postmodernism is nowhere in evidence in either technoscience or transnational capitalism. Rabinow is correct about both of these important points, but for my taste he does not pay enough attention to the

implosion of subjects and objects, culture and nature, in the warp fields of current biotechnology and communications and computer sciences as well as in other leading domains of technoscience. This implosion issuing in a wonderful bestiary of cyborgs is different from the *cordon sanitaire* erected between subjects and objects by Boyle and reinforced by Kant. It is not just that objects, and nature, have been shown to be full of labor, an insight insisted on most powerfully in the last century by Marx, even if many current science studies scholars have forgotten his priority here. More pregnantly, in the wombs of technoscience, as well as of postfetal science studies, chimeras of humans and nonhumans, machines and organisms, subjects and objects, are the obligatory passage points, the embodiments and articulations, through which travelers must pass to get much of anywhere in the world. The chip, gene, bomb, fetus, seed, brain, ecosystem, and database are the wormholes that dump contemporary travelers out into contemporary worlds. These chimeras are not close cousins of the air-pump, although the air-pump is one of their distant ancestors.

Instead, entities like the chip, gene, bomb, fetus, seed, brain, ecosystem, and database are more like OncoMouseTM. And those who attest to matters of fact are less like Boyle's modest man than they are like the FemaleMan$^©$. We will meet both of these genetically strange, inflected, proprietary beings soon, as they are made to encounter each other and discover their kinship. Bruno Latour (1993) suggested the useful notion of the *amodern* for the netherlands in which the really interesting chimeras of humans and nonhumans gestate. But, for my taste, he still sees too much continuity in the late twentieth century with Boyle's practice. I think something is going on in the world vastly different from the constitutional arrangements that established the separations of nature and society proper to "modernity," as early modern Europeans and their offspring understood that historical configuration; and recent technoscience is at the heart of the difference. Instead of naming this difference—postmodern, metamodern, amodern, late modern, hypermodern, or just plain generic Wonder Bread modern—I give the reader an e-mail address, if not a password, to situate things in the net.

But, obviously, I did not name my e-mail address innocently. I am appealing to the disreputable history of Christian realism and its practices of figuration; and I am appealing to the love/hate relation with apocalyptic disaster-and-salvation stories maintained by people who have inherited the practices of Christian realism, not all of whom are Christian, to say the least. Like people allergic to onions eating at McDonald's, we are forced to live, at least in part, in the material-semiotic system of measure connoted by the Second Millennium, whether or not we fit that story. Following Eric Auerbach's arguments in *Mimesis* (1953), I consider

figures to be potent, embodied—incarnated, if you will—fictions that collect up the people in a story that tends to fulfillment, to an ending that redeems and restores meaning in a salvation history. After the wounding, after the disaster, comes the fulfillment, at least for the elect; God's scapegoat has promised as much. I think contemporary technoscience in the United States is deeply engaged in producing such stories, slightly modified to fit the conventions of secular realism.

In that sense the "human genome" in current biotechnical narratives regularly functions as a figure in a salvation drama that promises the fulfillment and restoration of human nature. As a symptomatic example, consider a short list of titles of articles, books, and television programs in the popular and official science press about the Human Genome Project to map and sequence all of the genes on the 46 human chromosomes: "Falling Asleep over the Book of Life," "Genetic Ark," "Gene Screening: A Chance to Map our Body's Future," "Genesis, the Sequel," "James Watson and the Search for the Holy Grail," "A Guide to Being Human," "Thumbprints in Our Clay," "In the Beginning Was the Genome," "A Worm at the Heart of the Genome Project," "Genetics and Theology: A Complementarity?" "Huge Undertaking—Goal: Ourselves," "The Genome Initiative: How to Spell 'Human'", "Blueprint for a Human," *The Code of Codes, Gene Dreams, Generation Games, Mapping the Code, Genome*, and, finally, on the BBC and NOVA television, "Decoding the Book of Life." Genes are a bit like the Eucharist of biotechnology. Perhaps that insight will make me feel more reverent about genetically engineered food.

Instrinsic to placing my modest witnesses in a conventional millennarian machine is the evocation of the impending time of tribulations. There is no shortage of such narratives of disasters in the technical and popular cultures of technoscience. The time machine of the Second Millennium churns out expectations of nuclear catastrophe, global economic collapse, planetary pandemics, ecosystem destruction, the end of nurturing families, private ownership of the commons of the human genome, and many other kinds of silent springs. Of course, just as within any other belief system, all these things look eminently real, eminently possible, perhaps even inevitable, once we inhabit the chronotope that tells the story of the world that way. I am not arguing that such threats aren't threatening. I am simply trying to locate the potency of such "facts" about the contemporary world, which is so enmeshed in technoscience, with its threats and its promises. There is no way to rationality—to actually existing worlds—outside stories, not for our species, anyway. This book, like all of my writing, is anxious much more than it is optimistic. I am not arguing for complacency when I list the narrative setup of threats and promises, only for taking seriously

that no one exists in a culture of no culture, including the critics and prophets as well as the technicians. We might profitably learn to doubt our fears and certainties of disasters as much as our dreams of progress. We might learn to live without the bracing discourses of salvation history. We exist in a sea of powerful stories: They are the condition of finite rationality and personal and collective life histories. There is no way out of stories; but no matter what the One-Eyed Father says, there are many possible structures, not to mention contents, of narration. Changing the stories, in both material and semiotic senses, is a modest intervention worth making. Getting out of the Second Millennium to another e-mail address is very much what I want for all mutated modest witnesses.

The Laboratory, or The Passion of OncoMouse, Lynn Randolph, oil on masonite, 10" x 7", 1994

Modest_Witness@Second_Millennium.FemaleMan©_Meets_OncoMouse™ was revised, literally, under the portrait of The Laboratory, or The Passion of OncoMouse. Set in the simultaneously globally distributed and parochial timescape of the end of the Second Christian Millennium, this is a book about the figurations, tools, tropes, and articulations of technoscience as I have lived it in the United States in the 1990s. The biotechnical, biomedical laboratory animal is one of the key figures inhabiting my book, world, and body. Figures cohabit with subjects and objects inside stories. Figures take up and transform selves. Lynn Randolph painted her transspecific human-mouse hybrid in response to the first draft of "Mice into Wormholes." That paper, now Part II, Chapter 2, of this book, examines sticky threads extruding from the natural-technical body of the world's first patented animal—OncoMouse™, a breast cancer research model produced by genetic engineering. As a model, the transgenic mouse is both a trope and a tool that reconfigures biological knowledge, laboratory practice, property law, economic fortunes, and collective and personal hopes and fears. In Randolph's rendering, the white, female, breast-endowed, transspecific, cyborg creature is crowned with thorns. She is a Christ figure, and her story is that of the passion. She is a figure in the sacred-secular dramas of technoscientific salvation history, with all of the disavowed links to Christian narrative that pervade U.S. scientific discourse. The laboratory animal is sacrificed; her suffering promises to relieve our own; she is a scapegoat and a surrogate. She is the object of transnational technoscientific surveillance and scrutiny, the center of a multicolored optical drama. Her passion transpires in a box that mimes the chamber of the air-pump in Robert Boyle's house in seventeenth-century England. Small animals expired in that experimental chamber to show to credible witnesses the workings of the vacuum air-pump so that contingent matters of fact might ground less deadly social orders. This mouse is a figure in secularized Christian salvation history and in the linked narratives of the Scientific Revolution and the New World Order—with their promises of progress; cures; profit; and, if not of eternal life, then at least of life itself. Randolph's OncoMouse invites reflection on the terms and mechanism of these noninnocent genetic stories. Her figure invites those who inhabit this book to take up and reconfigure technoscientific tools and tropes in order to practice the grammar of a mutated experimental way of life that does not issue in the New World Order, Inc.

2

FEMALEMAN©_MEETS_ONCOMOUSE™

Mice into Wormholes: A Technoscience Fugue in Two Parts

Part 1. Kinship

FIRST MATHEMATICAL EPIGRAPH—A PROPORTION
TRANSURANIC ELEMENTS:TRANSGENIC ORGANISMS::
THE COLD WAR:THE NEW WORLD ORDER

Trained in molecular and development biology, I identify professionally as a historian of science. I have applied for a visa for an extended stay in the permeable territories of anthropology—as a resident alien or a cross-specific hybrid, naturally. But my real home is the ferociously material and imaginary zones of technoscience, into which I and hundreds of millions of people on this planet have been interpellated, whether we like it or not. The *Oxford English Dictionary* notes that "to interpellate" means to break in on, to interrupt a person in speaking or acting. The term also means to appeal or petition; to hail; or to intercept, cut off, or prevent. *Interpellation* became obsolete in English before 1700, but the term was reimported back into anglophone practice from the French in the twentieth century in the context of a special kind of interrupting or hailing: calling on a minister in a legislative chamber to explain the policies of the ruling government. Interpellation, then, has several tones, which resonate among French and English speakers. These tones sound here in my warping of the French philosopher Louis Althusser's theory of how ideology constitutes its subjects out of

49

concrete individuals by "hailing" them. According to Althusser (1971:171, 194), interpellation occurs when a subject, constituted in the very act, recognizes or misrecognizes itself in the address of a discourse. Althusser used the example of the policemen calling out, "Hey, you!" If I turned my head, I am a *subject* in that discourse of law and order; and so I am *subject* to a powerful formation. *How* I mis/recognize myself—will I be harassed by a dangerous armed individual with the legal power to invade my person and my community; will I be reassured that the established disorder is in well-armed hands; will I be arrested for a crime I too acknowledge as a violation; or will I see an alert member of a democratic community doing rotating police work?—speaks volumes both about the unequal positioning of subjects in discourse and about different worlds that might have a chance to exist.

With a double meaning typical of most interesting words, *interpellation* is also an interruption in the body politic that insists that those in power justify their practices, if they can. It is also best not to forget that "they" might be "we." Whoever and wherever we are in the domains of technoscience, our practices should not be deaf to troubling interruptions. Interpellation is double-edged in its potent capacity to hail subjects into existence. Subjects in a discourse can and do refigure its terms, contents, and reach. In the end, it is those who mis/recognize themselves in discourse who thereby acquire the power, and responsibility, to shape that discourse. Finally, technoscience is more, less, and other than what Althusser meant by ideology; technoscience is a form of life, a practice, a culture, a generative matrix. Shaping technoscience is a high-stakes game.

It is the nonhyphenated energy of technoscience that makes me adopt the term.[1] This condensed signifier mimes the implosion of science and technology into each other in the past two hundred years around the world. I want to use technoscience to designate dense nodes of human and nonhuman actors that are brought into alliance by the material, social, and semiotic technologies through which what will count as nature and as matters of fact get constituted for—and by—many millions of people. All the actors in technoscience are not scientists and engineers, and scientists and engineers are an unruly lot. They are not pawns in a morality play about modern damnation or apocalyptic salvation put on for the benefit of scientifically illiterate critical theorists or euphoric, jacked-in apologists for technohype. Perhaps most important, technoscience should not be narrated or engaged only from the points of view of those called scientists and engineers. Technoscience is heterogeneous cultural practice that enlists its members in all of the ordinary and astonishing ways that anthropologists are now accustomed to describing in other domains of collective life.

Technoscience also designates a condensation in space and time, a speeding

up and concentrating of effects in the webs of knowledge and power. In what gets politely called modernity and its afterlife (or half-life), accelerated production of natural knowledge pervasively structures commerce, industry, healing, community, war, sex, literacy, entertainment, and worship. The world-building alliances of humans and nonhumans in technoscience shape subjects and objects, subjectivity and objectivity, action and passion, inside and outside in ways that enfeeble other modes of speaking about science and technology. In short, technoscience is about worldly, materialized, signifying and significant power. That power is more, less, and other than reduction, commodification, resourcing, determinism, or any of the other scolding words that much critical theory would force on the practitioners of science studies, including cyborg anthropologists.

I belong to the "culture" whose members answer to the "hey, you!" issuing from technoscience's authoritative practices and discourses. My people answer that "hey, you!" in many ways: We squirm, organize, revel, decry, preach, teach, deny, equivocate, analyze, resist, collaborate, contribute, denounce, expand, placate, withhold. The only thing my people cannot do in response to the meanings and practices that claim us body and soul is remain neutral. We must cast our lot with some ways of life on this planet, and not with other ways. We cannot pretend we live on some other planet where the cyborg was never spat out of the womb-brain of its war-besotted parents in the middle of the last century of the Second Christian Millennium.

The cyborg is a cybernetic organism, a fusion of the organic and the technical forged in particular, historical, cultural practices. Cyborgs are not about the Machine and the Human, as if such Things and Subjects universally existed. Instead, cyborgs are about specific historical machines and people in interaction that often turns out to be painfully counterintuitive for the analyst of technoscience. The term cyborg was coined by Manfred Clynes and Nathan Kline (1960) to refer to the enhanced man who could survive in extraterrestrial environments. They imagined the cyborgian man-machine hybrid would be needed in the next great technohumanist challenge—space flight. A designer of physiological instrumentation and electronic data-processing systems, Clynes was the chief research scientist in the Dynamic Simulation Laboratory at Rockland State Hospital in New York. Director of research at Rockland State, Kline was a clinical psychiatrist. Their article was based on a paper the authors presented at the Psychophysiological Aspects of Space Flight Symposium sponsored by the U.S. Air Force School of Aviation Medicine in San Antonio, Texas. Enraptured with cybernetics, Clynes and Kline thought of cyborgs as "self-regulating man-machine systems" (1960:27). One of their first cyborgs was a standard white laboratory rat implanted with an osmotic pump designed to inject chemicals continuously.[2] Exchanging knowing glances with their primate kin, rodents will

reappear in this essay at every turn. Beginning with the rats who stowed away on the masted ships of Europe's age of exploration, rodents have gone first into the unexplored regions in the great travel narratives of Western technoscience.[3]

Consequently, my people are akin to field mice who have entered the anomaly in evolutionary space—a wormhole—called the laboratory. Like the science-fictional wormhole in an episode of the television show *Deep Space Nine*, the laboratory continues to suck us into uncharted regions of technical, cultural, and political space. Passing through the wormhole of technoscience, the field mice emerge as the finely tailored laboratory rodents—model systems, animate tools, research material, self-acting organic-technical hybrids—through whose eyes I write this essay. Those mutated murine eyes give me my ethnographic point of view. Cyborg anthropology attempts to refigure provocatively the border relations among specific humans, other organisms, and machines. The interface between specifically located people, other organisms, and machines turns out to be an excellent field site for ethnographic inquiry into what counts as self-acting and as collective empowerment. I call that field site the culture and practice of technoscience. The optical tube of technoscience transports my startled gaze from its familiar, knowing, human orbs into the less certain eye sockets of an artifactual rodent, a primal cyborg figure for the dramas of technoscience. I want to use the beady little eyes of a laboratory mouse to stare back at my fellow mammals, my hominid kin, as they incubate themselves and their human and nonhuman offspring in a technoscientific culture medium.

The relocated gaze forces me to pay attention to kinship. Who are my kin in this odd world of promising monsters, vampires, surrogates, living tools, and aliens? How are natural kinds identified in the realms of late-twentieth-century technoscience? What kinds of crosses and offspring count as legitimate and illegitimate, to whom and at what cost? Who are my familiars, my siblings, and what kind of livable world are we trying to build?

Cross-overs, mixing, and boundary transgressions are a favorite theme of late-twentieth-century commentators in the United States, and I can't pretend to be an exception. So let me pursue technoscience's blasted family pedigrees by means of the first epigraph, a mathematical joke about transgression in the form of a statement of proportion:

TRANSURANIC ELEMENTS:TRANSGENIC ORGANISMS::
THE COLD WAR: THE NEW WORLD ORDER

The expanded form of the proportion reads: The transuranic elements (such as plutonium produced by nuclear reactors) are to transgenic organisms (such as

the genetically engineered mice and tomatoes produced in biotechnological laboratories) as the Cold War (fueled by its core generator of nuclear culture) is to the New World Order (driven by its dynamic generator of transnational enterprise culture).

In *Secrets of Life, Secrets of Death*, Evelyn Keller (1992a) explored the scientific and psychoanalytic connections between the midcentury search for the "secret" of the atom that resulted in nuclear physics and weapons and the search for the "secret" of life that issued in molecular genetics and genetic engineering. Plumbing all those "secrets" is one of the major narratives of erotic transgression in technoscience. Walking through the museum of the Los Alamos National Laboratories in New Mexico in 1993, I was arrested by the exhibit about the first atomic bombs built at Los Alamos during the Manhattan Project. The display was rather mouse-nibbled and time-worn; it looked like old news. The more glitzy projects in recent years in and around Los Alamos have been informatics development for GenBank© as part of the Human Genome Project at the National Labs and the artificial life research associated with the nearby Santa Fe Institute. In the national science policy of the New World Order, nuclear weapons research—albeit still quite a going concern—is almost, but not quite, an embarrassment even at the birthplace of the atomic bomb.[4] National security discourse in the 1990s turns on creating a chain reaction between technoscience and enterprise. The National Laboratories are supposed to become breeder reactors for competitiveness whose decay products are at least as world threatening as those of plutonium[239].[5]

What interests me about the proportion that links plutonium with genetically engineered organisms and situates them in their historical chronotopes, World War II through the Cold War of the 1940s through the 1980s, and the New World Order of the early 1980s to the present, is the question of taxonomy, category, and the natural status of artifactual entities—kinship, in short. Kinship is a technology for producing the material and semiotic effect of natural relationship, of shared kind.

TRANSURANIC ELEMENTS

In 1869 the Russian chemist Dimitri Ivanovich Mendeleyev published his work on the periodic law and the periodic table of the elements that ordered the 63 elements then known by properties that seemed to repeat as a function of atomic weights. Later, chemists argued that the table is ordered by atomic number, or the number of protons in the nucleus, and not by atomic weights (neutrons plus protons). Then Niels Bohr's early-twentieth-century atomic model

interpreted the recurring properties of the elements as a function of quantum numbers, that is, the number of electrons in the "outer shell" of an atom

For my purposes here the important issue is that in all of its interpretations, the periodic table predicted several unknown elements that were subsequently discovered, or made, to occur and whose properties fit prognostications nicely. Setting up relationships diagonally, vertically, horizontally, and transitionally, the table stood for traditional family values in the culture of chemistry. The periodic table of the elements still hangs in every chemistry lecture hall I have ever seen. More than merely an authoritative historical artifact that graphically displays the power of science to order fundamental properties of matter for the millions of students who have spent uncounted hours under its sign, the periodic table continues to generate knowledge in the experimental way of life. The periodic table is a potent taxonomic device for what my people understand as nature. The kinship relations of the elements are a natural-technical object of knowledge that semiotically and instrumentally puts terrans in their proper place.

Uranium is the naturally occurring earthly element with the highest atomic number, 92. Uranium is where the evolution of the elements that make up the solar system stopped. In that sense, uranium represents a kind of "natural limit" to the family of terran elements as well. But every child who has bitten into an apple in the Atomic Cafe knows that elements with higher atomic numbers than uranium have existed on earth since 1940, when Glenn Seaborg and his associates made the first transuranium elements, including plutonium, whose atomic number is 94. In order to make explosive Pu^{239}, the first self-sustaining nuclear generating reactor, or breeder reactor, was built by Enrico Fermi and others on a squash court at the University of Chicago in 1942 in the context of the Manhattan Project. Pu^{239} fueled the device that was tested at Alamogordo, New Mexico, on July 16, 1945, and the bomb called "Fat Man" that exploded over Nagasaki on August 9, 1945.[6]

As I wrote this sentence in 1994, bomb-grade Pu^{239} was refueling threats of renewed war on the Korean peninsula as North Korea refused inspection of its nuclear-power reactor refueling process. International regulatory mechanisms are not containing the rogue element's production and use in the post–Cold War era. An illegal trade in bomb-grade materials from the former Soviet Union is a growing international problem of unknown dimensions. The amount of plutonium, not to mention other kinds of radioactive waste, produced on earth since 1940 is truly staggering, and no end of production is in sight. Globally, by 1995, weapons-grade plutonium in active and dismantled bombs totaled 270 metric tons. The commercial stockpile of plutonium from nuclear reactor wastes and spent fuel had reached 930 metric tons in 1995 and was expected to total 2,130

tons by 2005. In the absence of a waste disposal system *anywhere* that is commensurate with the problem, the global civil sector in the 1990s produces about as much plutonium as was amassed during the entire Cold War.[7] The end of the Second Millennium threatens to be much more than a narrative device, and witnessing the story is more than a joke on addresses in the Net.

Two things stand out simultaneously in the presence of the transuranic elements: First, they are ordinary, natural offspring of the experimental way of life, whose place in the periodic table was ready for them. They fit right in. Second, they are earthshaking artificial productions of technoscience whose status as aliens on earth, and indeed in the entire solar system, has changed who we are fundamentally and permanently. Nothing changed and too much changed when plutonium joined the terran family. The transuranic elements—embedded in the semiotic, technical, political, economic, and social apparatus that produces and sustains them on earth—are among the chief instruments that have remade the third planet from the sun into a global system. The transuranic elements have forced humans to recognize their problematic kinship with each other as fragile earthlings at a scale of shared vulnerability and mortality barely suspected on that squash court in Chicago but explicitly ritualized at Alamogordo when J. Robert Oppenheimer quoted from the *Bhagavad Gita*, "I am become Death, the shatterer of worlds" (quoted in Kevles 1977:333). Now a worldwide-disseminated nuclear fuel and one of the deadliest toxic substances ever encountered, plutonium has done more to construct species being for hominids than all the humanist philosophers and evolutionary physical anthropologists put together. And, as the dogeared exhibit at Los Alamos brought home to me, this is old news.

TRANSGENETIC ORGANISMS

The shiny news in the 1990s, as every Business Monday section of the important newspapers shows, is transgenic organisms produced in another kind of breeder reactor, the biotechnological laboratory, in transnational enterprise culture. In the mideighteenth century, the Swedish naturalist Linnaeus constructed a hierarchy of taxonomic categories above the level of the species (genus, family, class, order, kingdom) and introduced the binary system of nomenclature that gives all living terrans a genus and a species name. Species, whether regarded as conforming to an archetype or as descending from a common stock, were taken to be natural taxonomic entities whose purity was protected by a natural envelope. In 1859 in *The Origin of Species*, Charles Darwin provided both an evolutionary narrative and a plausible mechanism that unified diverse bases for

classification and accounted for both the transformation and the relative constancy of species. In the midtwentieth century, the neo-Darwinian synthesis powerfully imported population genetics into evolutionary thinking. In that potent account, genetic change is evolutionary change; mutation and the variation in gene frequencies in populations constitute both stuff and engine of life. Evolutionary theory and genetics unified life on earth, as the periodic table placed Earth's elements into stable families. Humans are interpellated into both of these species-defining kin networks.

On the day I wrote the preceding paragraph, May 19, 1994, front pages of newspapers all over the United States reported that the U.S. Food and Drug Administration had given its final approval to Calgene, Inc., a California biotech company, to put its genetically engineered tomato, the Flavr Savr, on the market. Like those radioactive isotopes whose long half-lives are all too worthy of note, Flavr Savr's chief characteristic is that it does not decay as fast as nonaltered tomatoes. Although Calgene has claimed the Flavr Savr is not a transgenic organism, since the gene normally responsible for decay is genetically engineered to be reversed and so nonfunctional in the new product, I consider Flavr Savr strictly trangenic because it bears a gene for a bacterial enzyme inserted to act as a marker to verify successful insertion of the altered functional gene of interest. Where I live, the *San Jose Mercury News* reminded readers at the end of its news story on Flavr Savr that they could record their own opinions on the Mercury Center, the newspaper's online bulletin board, in the folder called Science and Medicine. It cost $9.95 per month in 1994 to subscribe to the Mercury Center, an America Online service. Joined by the two great mediators at the end of the Second Millennium—the Market and the Net—biologics and informatics occupy the same regions of technoscientific space in more ways than one.

The techniques of genetic engineering developed since the early 1970s are like the reactors and particle accelerators of nuclear physics: Their products are "trans." They themselves cross a culturally salient line between nature and artifice, and they greatly increase the density of all kinds of other traffic on the bridge between what counts as nature and culture for my people. Transported, terran chemical and biological kinship gets realigned to include the extraterrestrial and the alien. Like the transuranic elements, transgenic creatures, which carry genes from "unrelated" organisms, simultaneously fit into well-established taxonomic and evolutionary discourses and also blast widely understood senses of natural limit. What was distant and unrelated becomes intimate. By the 1990s, genes are us; and we seem to include some curious new family members at ever level of the onion of biological, personal, national, and transnational life. What could be more natural by the 1990s than

worldwide commercial, familial, biotechnical, and cinematic genetic traffic?

Transgenic organisms are at once completely ordinary and the stuff of science fiction. I use them metonymically to mark world-shaping changes in biology since the 1970s. Thus, transgenic organisms are indicator species, or perhaps canaries in the gold mines of the New World Order, Inc. In 1993, the first issue of a new journal, *Transgene*, noted that more than 2,500 titles in the current MED-LINE database used the word *transgenic* in the title, up from 10 to 20 papers per year in the early 1980s (Cruse and Lewis 1993). More than 60 percent of all of the biological and biomedical research funded federally in the United States by the mid-1990s used the techniques of molecular biology and molecular genetics. Two conclusions from that statistic are obvious: (1) Molecular biology has major creative importance in practically every area of biology and medicine; and (2) fundable questions in the life sciences have conformed drastically to those compatible with the practice of biology as molecular biotechnics. The organism has been retooled materially in the New World Order, Inc., as well as semiotically. The implications of U.S., Western European, and Japanese hegemony in this process are global. Based on articles published in the worldwide scientific literature in 1991, Table 2.1 gives a minimal comparative picture of scientific power.[8] Without invoking any notions of conspiracy, I think the conclusion that the technoscientific agenda for everybody is set by the economically dominant powers, especially the United States, is inescapable. It is also inescapable that sizable resources go into technoscience in every area of the planet, and, dominant or not, many actors are on the stage. The story is not closed.

"Developing" nations, as well as the major world financial and political powers, perceive that the stakes in biotechnology in general and genetic research in particular are high (Juma 1989; Shiva 1993). For example, modeling its plans after the European Molecular Biology Organization, Egypt is building the Mubarak City for Scientific Research (ScienceScope 1994a). Strapped for money, the Egyptian government is initially constructing only one of the eight planned institutes. Significantly, the first priority is the Institute of Genetic Engineering and Biotechnology. The government budgeted 100 million Egyptians pounds (U.S. $36 million), as compared to less than $1 million per year spent by the Egyptian state on academic scientific research. (That $1 million does not include foreign grants, the main source of research money in Egypt, another index of who sets the worldwide scientific agenda.) The scramble for the control of genes—the sources and engines of biological diversity in the regime of technobiopower—drives venture capitalists, crafters of international treaties, makers of national science policies, bench scientists, and political activists alike. The control of genes means access both to naturally occurring

FEMALEMAN© _MEETS_ ONCOMOUSE™

NATION OR REGION	ALL SCIENTIFIC AND TECHNICAL FIELDS	BIOMEDICAL ARTICLES	BIOLOGICAL ARTICLES
United States	35.1	38.9	37.6
United Kingdom	7.5	7.6	6.9
Germany	6.8	6.3	5.4
France	4.8	5.1	3.3
Italy	2.8	2.3	1.4
Rest of Western Europe	10.7	13.3	11.0
Japan	8.5	7.9	7.5
Near East and Africa	1.6	0.9	3.1
Israel	0.9	0.8	1.1
India	2.0	1.4	2.1
Central and S. America	1.4	1.5	2.3
Australia and New Zealand	2.5	2.2	6.1
Former Soviet Union	6.7	6.9	2.2
Other Eastern and Central European	2.1	2.0	1.2
East Asian newly industrialized countries	1.1	0.6	0.7

Source: Adapted from NSB 1993:423-25.

TABLE 2.1 PERCENT SHARE OF WORLD TECHNOSCIENTIFIC LITERATURE

diversity and to the material, social, and semiotic technology to recraft its riches to produce beings new to Earth.[9] Which new beings, for whom, and out of whom seem to me to be pressing questions lying at the heart of democracy, social justice, economy, agriculture, medicine, labor, and environment.

As the apparatus for the production and sustenance of high-atomic-weight fissionable materials interpellated diverse peoples into a kind of global species on the "whole Earth" or "spaceship Earth," so also the semiotic, technical, and social systems for conceiving and propagating transgenic organisms interpellate diverse peoples into a transnational enterprise culture that I call the New World Order, Inc. In this timescape, species being is technically and literally brought into being by transnational, multibillion-dollar, interdisciplinary, long-term pro-

jects to provide exhaustive genetic catalogs as maps to industrial, therapeutic, conservationist, military, ethical, and even cosmetic action.

Furthermore, the "trans" action is not limited to splicing among and within the genomes of organisms. Marked with the stigmata of a dream, a symptom, and an ordinary research project, in a kind of ultimate genetic transspecific cross, scientific efforts to splice carbon-based life forms to silicon-based computer systems take many shapes, from the merely ideological to the technically productive. A college biology textbook opens its chapter on the nervous system with a photomicrograph of a nerve cell growing on the surface of a Motorola 68000 microprocessor chip (Campbell 1993:982). That particular "trans" join, producing a classical cyborg in the dimensions of microns, is unadulterated pedagogical ideology. The cell would be just as happy growing on an etched glass surface, and no "information"—beyond tactile cues for the cell and belief-system cues for the students—is passing between organic and silicon "microprocessors."

More technically functional in its approach, merging silicon-patterning techniques borrowed from microelectronics with combinatorial biochemistry, a biotech startup company in Palo Alto, California, called Affymetrix is developing a chip that anchors arrays of nucleotide sequences. The chips will be tools for detecting aberrant genetic sequences in large-scale automated diagnostic tests, a major investment areas for current biotechnology (Alpers 1994). One of the members of the board of directors of Affymetrix, Paul Allen, was a cofounder of the software giant Microsoft. Microsoft's other cofounder, William H. Gates III, one of the richest men in the world in the mid-1990s, gave the University of Washington $12 million in 1992 to attract Leroy Hood from Cal Tech in order to found a new department of molecular biotechnology. One of the most important innovators of automated protein and DNA analytic technologies in the world, Hood brought thirteen senior scientists with him to Washington and built a department famous for its interdisciplinary collaborations of computer scientists and geneticists. In 1992 Hood joined other biotechnology master players to found the company Darwin Molecular in Seattle. Using the complex splice between computer sciences and molecular biology, including DNA sequencing technology, to mimic natural-selection systems, this incorporated twentieth-century Darwin works to design drugs that mimic those produced in biological evolution.[10]

Two related considerations emerge for me from this idiosyncratic meditation on a mathematical proportion. One concerns the problem of purity of type and the thematics of the mixed and the alien in U.S. culture, and the other touches on how to represent technoscience.

A transgenic organism contains genes transplanted from one strain or species—or even across taxonomic kingdoms, for example, from fish to tomatoes, fireflies to tobacco, bacteria to humans, or vice versa—to another. Transgenic border-crossing signifies serious challenges to the "sanctity of life" for many members of Western cultures, which historically have been obsessed with racial purity, categories authorized by nature, and the well-defined self. The distinction between nature and culture in Western societies has been a sacred one; it has been at the heart of the great narratives of salvation history and their genetic transmutation into sagas of secular progress. What seems to be at stake is this culture's stories of the human place in nature, that is, genesis and its endless repetitions. And Western intellectuals, perhaps especially natural scientists and philosophers, have historically been particularly likely to take their cultural stories for universal realities. It is a mistake in this context to forget that anxiety over the pollution of lineages is at the origin of racist discourse in European cultures as well as at the heart of linked gender and sexual anxiety. The discourses of transgression get all mixed up in the body of nature. Transgressive border-crossing pollutes lineages—in a transgenic organism's case, the lineage of nature itself—transforming nature into its binary opposite, culture. The line between the acts, agents, and products of divine creation and human engineering has given way in the sacred-secular border zones of molecular genetics and biotechnology. The revolutionary continuities between natural kinds instaurated by the theory of biological evolution seem flaccid compared to the rigorous couplings across taxonomic kingdoms (not to mention nations and companies) produced daily in the genetic laboratory.

In opposing the production of transgenic organisms, and especially opposing their patenting and other forms of private commercial exploitation, committed activists appeal to notions such as the integrity of natural kinds and the natural *telos* or self-defining purpose of all life forms.[11] From this perspective, to mix and match genes as if organisms were legitimate raw material for redesign is to violate natural integrity at its vital core. Transferring genes between species transgresses natural barriers, compromising species integrity. These same activists and others also emphasize many other arguments for opposition to various biotechnological practices in the New World Order, Inc. The objections include increasing capital concentration and the monopolization of the means of life, reproduction, and labor; appropriation of the commons of biological inheritance as the private preserve of corporations; the global deepening of inequality by region, nation, race, gender, and class; erosion of indigenous peoples' self-determination and sovereignty in regions designated as biodiverse

while indigenous lands and bodies become the object of intense gene prospecting and proprietary development; inadequately assessed and potentially dire environmental and health consequences; misplaced priorities for technoscientific investment funds; propagation of distorted and simplistic scientific explanations, such as genetic determinism; intensified cruelty to and domination over animals; depletion of biodiversity; and the undermining of established practices of human and nonhuman life, culture, and production without engaging those most affected in democratic decision-making. I take all of those objections very seriously, and all of them are taken up, if inadequately, in this book, but I do not think simply naming the concerns either decides the direction of effects or describes the cross-cultural polyphony through which scientific practice is constituted worldwide. Effects and practices are multilayered and context-specific, and it is too easy for all parties to fall into dogma where fundamental cultural and material values are both not shared and at stake. What must not be lost from sight in all of this complexity, however, is that power, profit, and bodily rearrangements are at the heart of biotechnology as a global practice. The stakes are immense, just as they are in nuclear culture. Whether or not they are the result of transgressive reproductive scenarios, transgenics and plutonium belong to the world's important First Families.

For the moment, however, I want to focus only on the Western theme of purity of type, natural purposes, and transgression of sacred boundaries. The history and current politics of racial and immigration discourses in Europe and the United States ought to set off acute anxiety in the presence of these supposedly high ethical and ontological themes. I cannot help but hear in the biotechnology debates the unintended tones of fear of the alien and suspicion of the mixed. In the appeal to intrinsic natures, I hear a mystification of kind and purity akin to the doctrines of white racial hegemony and U.S. national integrity and purpose that so permeate North American culture and history. I know that this appeal to sustain other organisms' inviolable, intrinsic natures is intended to affirm their difference from humanity and their claim on lives lived on their terms and not "man's." The appeal aims to limit turning all the world into a resource for human appropriation. But it is a problematic argument resting on unconvincing biology. History is erased, for other organisms as well as for humans, in the doctrine of types and intrinsic purposes, and a kind of timeless stasis in nature is piously narrated. The ancient, cobbled-together, mixed-up history of living beings, whose long tradition of genetic exchange will be the envy of industry for a long time to come, gets short shrift. More fundamentally, in the midst of a nation where race is everywhere reproduced and enforced, everywhere unspeakable and euphemized, and everywhere deferred and treated obliquely—as in talk of drug wars,

urban underclasses, diversity, illegal aliens, wilderness preservation, terrorist viruses, immune defenses against invaders, and crack babies—I cannot hear discussion of disharmonious crosses among organic beings and of implanted alien genes without hearing a racially inflected and xenophobic symphony. Located in the belly of the monster, I find the discourses of natural harmony, the nonalien, and purity unsalvageable for understanding our genealogy in the New World Order, Inc. Like it or not, I was born kin to Pu^{239} and to transgenic, transspecific, and transported creatures of all kinds; that is the family for which and to whom my people are accountable. It will not help—emotionally, intellectually, morally, or politically—to appeal to the natural and the pure.

Perhaps it is perverse for me to hear the dangers of racism in the *opposition* to genetic engineering and especially transgenics at just the moment when national and international coalitions of indigenous, consumer, feminist, environmental, and development nongovernmental organizations have formed to oppose "patenting, commercialization and expropriation of human, animal and plant genetic materials."[12] Although the moral, scientific, and economic issues are far from simple, I oppose patenting of animals, human genes, and much plant genetic material. Genes for profit are not equal to science itself, or to economic health. Genetic sciences and politics are at the heart of critical struggles for equality, democracy, and sustainable life. The global commodification of genetic resources is a political and scientific emergency, and indigenous people are among the key actors in biopolitics, just as they have had to be in nuclear culture. But the tendency by the political "left"—my area of the political spectrum—to collapse molecular genetics, biotechnology, profit, and exploitation into one undifferentiated mass is at least as much of a mistake as the mirror-image reduction by the "right" of biological—or informational—complexity to the gene and its avatars, including the dollar.

Tunneling into my collective racial anxieties in the midst of thinking about tomatoes with a long shelf life and fissionable heavy elements with distressing half-lives points to a wormhole into the poorly charted and contested semiotic practices for representing technoscience. Resisting the separation of science and technology, the word *technoscience* itself makes clear that category fusions are in play. There is one other category separation, in particular, that seems ill fitted to do much useful work in representing technoscience: that between science and politics, science and society, or science and culture. At the very least, one such category cannot be used to explain the other, and neither can be reduced to the status of context for the other. But the taxonomic trouble goes deeper than that. The bifurcated categories themselves are reifications of multifaceted, heterogeneous, interdigitating practices and their relatively stable sedimentations, all of

which get assigned to separate domains for mainly ideological reasons. Fortified with this belief, I want to insist on four matters in my own efforts, which are perhaps less committed to *representing* technoscience, as if such an epistemological copying practice were possible. than to *articulating* clusters of processes, subjects, objects, meanings, and commitments.

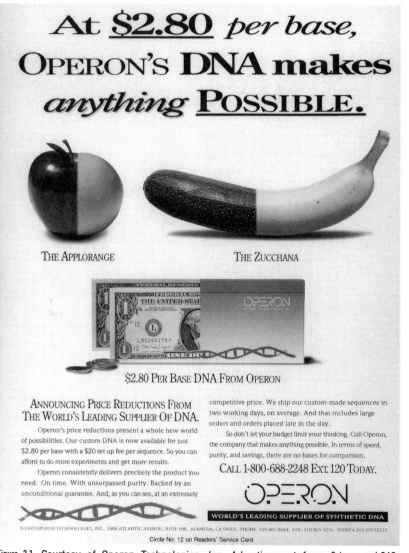

Figure 2.1 Courtesy of Operon Technologies. Inc. Advertisement from Science. vol.260. April 9. 1993.

First, I call attention to the figures and stories that run riot throughout the domains of technoscience. Not only is no language, including mathematics, ever free of troping; not only is facticity always saturated with metaphoricity; but also, any sustained account of the world is dense with storytelling. "Reality" is not compromised by the pervasiveness of narrative; one gives up nothing, except the illusion of epistemological transcendence, by attending closely to stories. I am consumed with interest in the stories that inhabit us and that we inhabit; such inhabiting is finally what constitutes this "we" among whom communication is to be possible.

Second, I am convinced that technoscience engages promiscuously in materialized refiguration; that is, technoscience traffics heavily in the passages that link stories, desires, reasons, and material worlds. Materialized refiguration is an eminently solid process, even to the point of the practice of objectivity, not some merely textual dalliance. An Operon Technologies, Inc., advertisement in *Science* magazine from April 9, 1993, makes the point visually and verbally [Figure 2.1]. The ad's text announces, "At $2.80 per base, Operon's DNA makes anything possible." The manifest content is that this company, "the world's leading supplier of synthetic DNA," will cheaply manufacture specific nucleic-acid sequences custom tailored for your lab. The latent content is that this product promises marvelous transformations. The point of technical virtuosity and infinite possibility is orthographically emphasized by the use of three different font styles—as well as the bold, underline, caps, italics, and shadow features—to highlight elements in a mere nine-word sentence. Like a genie from *Arabian Nights*, Operon will grant your wishes; anything is possible. Synthetic DNA bears those kinds of promises. If DNA signifies "life itself"[13] in the semiotic orders of biotechnology, synthetic DNA is especially open to realizing the future, and to realizing profit from your investment in that future. The company promises "speed, purity, and savings," all technical matters of great moment for the bench scientist. The center of the full-page color ad is filled by three genetically engineered mutants, each of which is at once ordinary and fantastic. The "applorange" is a spliced apple and orange; the zucchana is a spliced zucchini squash and a banana; and best of all, and most "real" of all, the $2.80 is spliced to the DNA sequence provided by Operon Technologies, Inc. An added orthographic touch, the ubiquitous double helix, sign of life itself, is spiced perfectly to the words *one dollar* under George Washington's portrait in a seamless join between the textual systems of nucleotide base pairing and U.S. currency denominations. The manifest content of the splicing of the dollar and the DNA helix is to highlight the specific savings from using a particular supplier of a commodity needed

for your research. The latent content is the graphic literalism that biology—life itself—is a capital-accumulation strategy in the simultaneously marvelous and ordinary domains of the New World Order, Inc. In the processes of materialized

Figure 2.2 Courtesy of Quadrant. Advertisement from Science.

refiguration of the kinship between different orders of life, the generative splicing of synthetic DNA and money produces promising transgenic fruit. Specifically, natural kind becomes brand or trademark, a sign protecting intellectual property claims in business transactions; we will meet this corporeal refiguration again in the score for the technoscience fugue.

Third, with many others doing contemporary technoscience studies, I believe that science is cultural practice and practical culture.[14] The laboratory is a special place, not for any epistemological reasons that might still comfort positivist philosophers, dyspeptic mathematicians, and their molecular biological sidekicks but because the laboratory is an arrangement and concentration of human and nonhuman actors, action, and results that change entities, meanings, and lives on a global scale. And the laboratory is not the only site for shaping technoscience.[15] Far from depleting scientific materiality, worldliness, and authority in establishing knowledge, the "cultural" claim is about the presence, reality, dynamism, contingency, and thickness of technoscience. Culture denotes not the irrational but the meaningful.

The British biotechnology firm Quadrant, at least, seems unworried by a picture of science as practice and culture [Figure 2.2]. Its *Science* advertisement from 1993, "Molecular Biology made simpler," is a cartoon depiction of multiracial laboratory workers, male and female, old and young, who are cutting, sawing, gluing, sweeping up after themselves, measuring, weighing, inspecting, and otherwise manipulating macromolecules. One laggard scientist appears to be smoking a joint while lying in a crook of his molecule. A business-suited man with a briefcase—undecidably a scientific-equipment salesman or the head of the lab headed for meetings in Washington, D.C.—is scurrying out a door marked "Genetic Research." The lab is patently a place for the collective craft work of knowledge-making, where Quadrant's restriction enzymes for cutting up nucleic acids in the right place would be welcome tools to relieve the tedium of work in a molecular biology lab. Quadrant gives a completely ordinary picture of specifically located practice and culture, except for one detail. The molecules are so macro that they are giant. The scientists have stepped through Alice's looking glass, and they have become very small indeed, so small that they are dwarves in a gigantic world of helical objects. The tiny people and the giant molecules inhabit this consummately ordinary scene of daily work: Again we see the simultaneously mundane and fantastic truth of technoscience, where a change of scale refigures fundamental relationships (Latour 1983). A final touch of magic completes the scene of reassuring ordinariness in this wonderful ad— nowhere to be seen among the pulleys, saws, and magnifying glasses are the chief tools that are the functional equivalent of the air-pump in every molecular

biology laboratory at the end of the twentieth century, namely, the gaggle of computerized instruments without which all the workers in this lab might as well take their DNA to the beach.[16]

Yet I think it is not the thickness, fantasy, or ordinariness but the contestability of science as practice and culture that galls the guardians of the old orthodoxy. I suspect that some scientists and philosophers are dismayed by the insistence that science is cultural practice because that account makes ample room for a motley crew of interlopers to take part in shaping and unshaping what will count as scientific knowledge, for whom, and at what cost.[17] In the "culture and practice" account, maintaining boundaries can no longer be rendered invisible, but boundary-maintaining is hardly proscribed. Far from it. Boundary maintenance, as well as splicing and joining, requires work, including, but not limited to, the semiotic, logical, and rhetorical work of convincing people who are both like and different from oneself; such labor is practice and culture in action. The lines between the inside and the outside of science, or between the goodness or badness of specific technoscientific accounts of the world, remain important; the lines simply no longer appear to be prethought in the minds of the gods, or drawn once and for all by heroes in mythic times like those of the Scientific Revolution. The gods might still think in numbers and draw in geometries, but if they do, they are in for the same kind of rude culture and practice analysis as that meted out to dabblers in slimy biological brews or professional watchers of furry mammals.[18] As Xerox Palo Alto Research Center computer scientist and philosopher Brian Smith put it in the context of discussing the far-reaching consequences of paying attention to the ongoing work it takes to establish and maintain the identity of a microprocessor, such as Intel's 486, Motorola's 68000, or Pentium chips, "You have to stop being what you were when you start paying attention to the work it takes to maintain your clear distinctions."[19] Establishing identities is kinship work in action. And, lest the metaphor of labor exhaust all of my readers, as Quadrant knows too, playfulness and pleasure are very much part of the practice and culture of technoscientific boundary-making, erasing, and testing. The labor and the play tie together humans and nonhumans—technological, chemical, and organic—in a vastly underdetermined drama.

So, in the practice and culture account, the worlds of science and technology have many more movers and shakers, and what counts as too many or the wrong kind of participants and interlocutors has to be established through multifaceted engagement where the sites of action, power, interpretation, reason, and authority are at stake. The fantastic and the ordinary commingle promiscuously. Boundary lines and rosters of actors—human and nonhuman—remain perma-

FEMALEMAN© _MEETS_ONCOMOUSE™

nently contingent, full of history, open to change. To be meaningful, the universal must be built out of humans and nonhumans. The relations of democracy and knowledge are up for materialized refiguring at every level of the onion of doing technoscience, not just after all the serious epistemological action is over. I believe that last statement is a fact; I know it is my hope and commitment. This position is not relativism; it is a principled refusal of the stacked deck that forces choice between loaded dualities such as realism and relativism.

Fourth and last in my score for orchestrating the action in technoscience is the dubiously mixed physical and biological metaphor of the force of implosion and the tangle of sticky threads in transuranic and transgenic worlds. The point is simple: The technical, textual, organic, historical, formal, mythic, economic, and political dimensions of entities, actions, and worlds implode in the gravity well of technoscience—or perhaps of any world massive enough to bend our attention, warp our certainties, and sustain our lives. Potent categories collapse into each other. Analytically and provisionally, we may want to move what counts as the political to the background and to foreground elements called technical, formal, or quantitative, or to highlight the textual and semiotic while muting the economic or mythic. But foreground and background are relational and rhetorical matters, not binary dualisms or ontological categories. The messy political does not go away because we think we are cleanly in the zone of the technical, or vice versa. Stories and facts do not naturally keep a respectable distance; indeed, they promiscuously cohabit the same very material places. Determining what constitutes each dimension takes boundary-making and maintenance work. In addition, many empirical studies of technoscience have disabled the notion that the word *technical* designates a clean and orderly practical or epistemological space. Nothing so productive could be so simple.

Any interesting being in technoscience, such as a textbook, molecule, equation, mouse, pipette, bomb, fungus, technician, agitator, or scientist, can—and often should—be teased open to show the sticky economic, technical, political, organic, historical, mythic, and textual threads that make up its tissues. "Implosion" does not imply that technoscience is "socially constructed," as if the "social" were ontologically real and separate; "implosion" *is* a claim for heterogeneous and continual construction through historically located practice, where the actors are not all human. While some of the turns of the sticky threads in these tissues are helical, others twist less predictably. Which thread is which remains permanently mutable, a question of analytical choice and foregrounding operations. The threads are alive; they transform into each other; they move away from our categorical gaze. The relations among the technical, mythic, economic, political, formal, textual, historical, and organic are not causal. But the

articulations are consequential; they matter. Implosion of dimensions implies loss of clear and distinct identities, but not loss of mass and energy. Maybe to describe what gets sucked into the gravity well of a massive unknown universe, we have to risk getting close enough to be permanently warped by the lines of force. Or maybe we already live inside the well, where lines of force have become the sticky threads of our own bodies.

I think that is where I live, beyond warping and committed to mucking about in the biological; and so I want to continue Part 1 on kinship with the introduction of two sibling figures who have been covertly informing the fugue of this essay from the start: the FemaleMan© and OncoMouse™. Their exchange of glances structures my point of view; we have been commercially, biologically, textually, and politically interpellated into the same public and private family networks. Members of a transgenic clan, these commercially branded figures highlight questions of intellectual property rights, originals and substitutes, authorship, invention, capitalism in postmodernity, its relays between subject and object, and the struggle for a transformed commons in technoscience. I will begin with the four clone sisters in Joanna Russ's novel, *The Female Man*, who appeared in New York City in 1975, a couple of years after the first gene-splicing successes inaugurated the practice of deliberate genetic engineering. By August 1973, DNA from *Xenopus laevis*, the South African clawed frog who had inhabited embryology laboratories for many decades, was being transcribed into messenger RNA in a bacterium, *Escherichia coli*, which seems in the twentieth century to be as abundant in plastic culture bottles in molecular biology labs as in its traditional haunts in the lumen of the human gut. Promising that one day soon genes from one creature could be made to function in the bodies of vastly different organisms, these experiments were the direct ancestor to those that gave terran existence to my second sibling figure, OncoMouse™, whose public debut as Harvard-owned rodent intellectual property and transgenic breast cancer model came in 1988.[20]

THE ELDER SIBLING——THE FEMALEMAN©

JANET Janet Evason appeared on Broadway at two o'clock in the afternoon in her underwear. She didn't lose her head.... "I am from the future." Just sit there long enough and the truth will sink in.... And I thought, you know, that I would make a small joke. So I said to her: "Take me to your leader."

JAEL "Alas! those who were shocked at my making love that way to a
 man are now shocked at my making love to a machine; you
 can't win."

JOANNA "Wanting isn't having. She'll refuse and the world will be itself
 again. I waited confidently for the rebuke, for the eternal order to
 reassert itself (as it had to, of course)—for it would in fact take a
 great deal of responsibility off my hands.... Later we got better."

JEANNINE "Goodbye Politics, hello politics"
 (Russ 1975; 23, 200, 208-09, 209).

I adopt the FemaleMan© as my surrogate, agent, and sister not because she
is an unmarked feminist utopian solution to a supposed universal masculine
domination rooted in a coherent and singular masculine subject—far from it.
The Female Man is the antithesis of a utopian or dystopian novel; the book, in
form and content, is the disruption of the expectations of those and many other
central gendered categories of linguistic production in white European and
American writing technologies. Russ's generic title figure is as much a disrup-
tion of the story of the universal Female as of the universal Man. Therefore, s/he
is a good participant in the nonmodern conversations we need to have about
figuration and worldly practice in technoscience.[21]

I have made a tiny little typographical amendment to Joanna Russ's version
of the oxymoronic hominid: I write it "FemaleMan" to highlight this being's
unexpected kinship to other sociotechnically—genetically/historically—
manipulated creatures, such as OncoMouse. Like OncoMouse[TM], the
FemaleMan© lives after the implosion of informatics, biologics, and economics.
If we date the implosion from the first successful genetic engineering experi-
ments in the early 1970s, Russ's Female Man lived at the flash point of that
momentous collapse of organisms, information, and the commodity form of
life. Russ set the tone for me when she opened Part Eight of *The Female Man*
with the words of Jael, the techno-enhanced warrior woman: "Who am I? I
know who I am but what's my brand name?" (Russ 1975:157). Sibling to Jael,
the Femaleman© is generic woman "enterprised up." In my ongoing engage-
ment with feminist standpoint theory, I would be hard pressed to find a less
innocent position from which to think.

Although they never attain the mythic singularity of Man, the four main

characters of Russ's novel are a clone, and so they are genetically identical—or almost so, since one of them was the subject of genetic surgery. In my imagination, they might have been cloned by Cetus, the first of the new biotechnology companies, founded in Berkeley, California, in 1971, and released in a pilot marketing project.[22] Interrogating Man, the chief Enlightenment figure of the sacred image of the Same, Russ wrote her title as the "Female Man" to highlight the fact that there has never been any such thing as a "woman" who made it into the really good stories. The generic that must be qualified does not count as a self-contained type with its own natural telos; s/he is a generic scandal. Like most beings banished from the categories of culture and consigned to those of biology (as if that were a fate to be dreaded!), even as an individual woman, much less as a time-syncopated clone, her boundaries are messed up from the start. S/he wouldn't know what to make of opposition to genetic engineering based on a doctrine of natural kinds. The *female* man is literally a contradiction in kind. But s/he does insist on being in the good stories as a real hero and not as plot space for someone else's action. "Remember: I didn't and don't want to be a 'feminine' version or diluted version or a special version or a subsidiary version or an ancillary version, or an adapted version of the heroes I admire. I want to be the heroes themselves. What future is there for a female child who aspires to being Humphrey Bogart?" (Russ 1975:206). Natural-technical entities—human, technological, and organic—with problematic selfhood boundaries might turn out to be in the best stories of all.

By insisting on the FemaleMan©, I also ascribe the copyright to the figure and the text, that is, to the work rather than to the author. It seems only just by the late twentieth century to mistake the creature for the creator and to relocate agency in the alienated object.[23] The history of copyright, with its roots in doctrines of property in the self, invites my confusion of creator and creature by its very effort to draw a clear line between subject and object, original and copy, valued and valueless. I hope the original author will forgive me.

In *Authors and Owners*, a book about the establishment of modern copyright law in booksellers' court battles in eighteenth-century England in a matrix of commercial printing and marketing developments coupled to legal and literary discourses about property, originality, and personality, Mark Rose provides the keys for this technoscience fugue for scoring the mutations in branding subjects, objects, and texts. "Copyright is founded on the concept of the unique individual who creates something original and is entitled to reap a profit from those labors" (Rose 1993:2). But before the modern concept of an author with legally enforceable rights to intellectual property could make sense, literary production and consumption went through changes like those of land: the literary commons were

FEMALEMAN©_MEETS_ONCOMOUSE™

"enclosed," and collective processes of production were appropriated by and to individual owners, who came to appear as sole authors and as proprietors of the self. Individual genius came to be seen as the source of originality and value in a work; the person stamped its products with the force of its mind and soul. The older ideas of a literary commons and of writing as copying faithfully or as reworking the models of nature and of the classics gave way to conceptions of originality and of the bounded individual with property in the self. The many actors involved in making a literary text gave place to the inspired author of a work. Literature was commodified in new and socially powerful ways that reached to the heart of what would count as a person and a person's products. Rose argues that the discourse of original genius was rare in England in 1710 but orthodox by 1770; in parallel, authors' rights in their literary works were first established in the Statute of Anne in 1710, and the extent and limits of those rights were clarified across the century, culminating in *Donaldson v. Beckett* in 1774.

The representation of the author as proprietor of the work and of the self rested on the Lockean idea of property, which originated "in acts of appropriation from the general state of nature" (Rose 1993:5). Locke (1690) argued that man has property in his person and that he mixes his labor with nature to make other property. In tension with what Locke himself probably understood, this formulation has been taken conventionally to mean that "the act of appropriation thus involved solely the individual in relation to nature" (6). Property, on this account, was not a social invention but a natural right, exercised by the objectification of the person in his works.

This was a discourse of origins and foundations that also drew the key distinctions between public and private. Copyright was interpreted as a precedent for a common-law right to privacy in a famous 1890 *Harvard Law Review* essay. The author's unpublished works were the individual's private thoughts. Rose uses this development to argue that the mingling of "matters of privacy with matters of property" in copyright explains why copyright "is sometimes treated as a form of private property and sometimes as an instrument of public policy for the encouragement of learning" (Rose 1993:140). The duality between what is to be held in common as public and what is private is embedded in the U.S. Constitution, which aims "to promote the Progress of Science and useful Arts, by securing for limited Time to Authors and Inventors the exclusive Right to their respective Writings and Discoveries."[24]

In the context of copyright decisions pertaining to information and computer sciences—especially in relation to the design and ownership of ways of structuring connections across heterogeneity, facilitating widespread access and

agency and enforcing standardization—legal scholar Margaret Chon (1993) excavates the U.S. Constitution's clause on patents and copyrights. Her goal is to recuperate an idea of progress in the wake of the dangers and insights evident within postmodernity. Her arguments apply broadly to the interrogation of the possibility of a reconfigured commons in technoscientific knowledge. She argues that the U.S. Constitution—showing a touching faith in the benign nature of knowledge rooted in ceaseless innovation—granted inventors and authors intellectual property protection for a specific purpose, "to promote the Progress of Science and the useful Arts." The rights of inventors and authors were thus heavily dependent on a larger value, which was ineluctably collective. Chon insists that postmodern critiques of Enlightenment progress and reason do not invalidate a commitment to technoscientific forms of knowledge-making but impose acidly deconstructive questions that open up the possibility of relocated and permanently heterogeneous and revisable terms for what may count as progress and knowledge, for whom, and at what cost. Without giving up the hard project of world-building, her analysis upsets the boundaries of owners and works that were invented in eighteenth-century doctrines of nature, society, property, and agency.

In consequence, a promising deconstructive sense of accountability and collective agency and responsibility in technoscience—politics—follows from Chon's work. This politics has many geometries, is never finally sure of its subjects and objects, and is premised on the virtues of difference and listening as well as on articulation—that is, boundary-making and domain-connecting action in the world. In the face of the ambiguously undead and lively figures, human and nonhuman, that populate technoscience, Chon insists on a culturally complex stewardship in knowledge-making. She argues for a public trust for designing, holding, and processing information in all its globally materialized— institutionalized and embodied—refigurations. Essential to her view is that a much-expanded array of "persons (not just authors and inventors) have a stake in—and what could be termed a fundamental right of access to—this trust" (Chon 1993: 102).[25] At stake are the core meanings of *liberty*, a too precipitously abandoned word in the current archives of science studies and cultural theory.[26]

We live in a world where "all areas of federal intellectual property are blending into each other; [where] the subject matter of intellectual property, rather than knowledge itself, seems expansible over all space" (Chon 1993:146). Chon's constitutional revisionism, nicely situated in the writings of James Madison, who introduced copyright and patent clauses at the Constitutional Convention, and Thomas Jefferson, one of the first patent commissioners, aims to establish knowledge—and all that knowledge implies in the domains of techno-

biopower—as a fundamental right. Blessed with a feminist postmodernist's impious and normative irony, Chon uses the founding fathers, reviled and enshrined for their doctrines of property in the self, to argue that "property inheres in the first instance in an individual's freedom to use the knowledge of others rather than an individual's freedom to exclude others from the use of knowledge" (104).

So, both copyright and authors are fairly recent institutions that rework the collective material and semiotic processes that constitute public and private life. Indeed, in modernist formulations indebted to eighteenth-century literary, legal, constitutional, and corporate mutations, the self creates itself through writing. The author authors self. Subject, verb, and object: this kind of writing mimes creation. Its authenticity is warranted by its brand: ©Self. The tiny amendment that moves the © from the author or the author's assignees to the work is the modest step from the systems of commodification of text and code of the English eighteenth century to those of the United States in the late twentieth century. There, along with about a half-dozen other institutions in the technoscientifically powerful nations, GenBank©, birthed at the Los Alamos National Laboratories, structures and contains the database that is "us," the human genome in its materialized and textualized form as DNA sequence information. Our authenticity is warranted by a database for the human genome. The molecular database is held in an informational database as legally branded intellectual property in a national laboratory with the mandate to make the text publicly available for the progress of science and advancement of industry. This is Man the taxonomic type become Man the brand. In the collapse of sign and referent, of the representation and the real, that characterizes entities in the chronotope called postmodernity, the genome itself is both database and material substance, in GenBank© and in the mortal flesh. DNA has become a postmodern sign for "the code of all future codes, whose cubed effectivity was ultimately the capacity to abolish the modern's epistemological barrier between representation and the real" (Christie 1993: 180).[27] This is the world in which the FemaleMan© lives among the other undead, trying to fashion a workable doctrine of property, commons, liberty, and knowledge. She seems to be poor material to ground a new constitutional story, but I find her confused status promising, even progressive.

My version of Russ's version of the figure of Man is triply qualified, triply inauthentic, and therefore classically unworthy of serving to anchor important origin stories: First is the suspicious modifier *female*; next is the compression of words, yielding a spliced hybrid that signals a subject that looks suspiciously like an object; third, in the misplaced sign of intellectual property, is the proof that the authoring type or kind has become the reification of its own creative powers.

Type has become brand. Therefore, with a raging sense of humor, the FemaleMan© animates my kind of origin story. Located noninnocently in the commercial publishing circuits of U.S. academic feminism, science studies, and cultural studies, I could not find a more fitting agent to inspect both my own position and the other wares on display in technoscience. The FemaleMan© ironically and oxymoronically reembodies the collective processes of making feminism, and of making science, that are decontextualized and privately appropriated in the markets of texts, products, and authors. S/he is part of a bushy shrub of feminist reinterpretations of what counts as subject and object. Like transuranic elements and trangenic organisms, the FemaleMan© fits too easily into ready-made taxonomic categories, and like those other transgressors, s/he is a venereal disease in the body of natural kinds. With OncoMouse™ and other natural obscenities, s/he is a fallen woman. Therefore, s/he might help us rethink the terms and possibilities of a reestablished commons in knowledge and its fruits, more survivable property laws, and an expansive and inclusive technoscientific democracy.

With the admonition to her literary offspring to "trot through Texas and Vermont . . . take your place bravely on the book racks of bus terminals and drugstores," and "do not get glum when you are no longer understood. . . . for on that day, we will be free," Russ copyrighted her story about the four Js in 1975 (Russ 1975:213-14). I take this book as the founding text in anglophone feminist SF, not because it is the first but because it, like *Frankenstein*,[28] so decisively fractured the technical, narrative, and figural expectations proper to its ethnospecific, but widely distributed, genre. The form was its content, with a witty and ferocious vengeance.[29] This book of feminist fabulation, or speculative feminism, or science fiction, made gender a patent scandal of the imagination, the intellect, nature, language, and history—all those hoary categories in the romances of modernity.[30] As Samuel R. Delany put it, *The Female Man* is "almost a textbook on various rhetorical modes—rhapsody, polemic, satire, fantasy, foreground action, psychological naturalism, reverie, and invective" (1977:193). The linguistic and genetic miscegenation of both Russ's *Female Man* and my FemaleMan© is a tool for provoking a little technical and political intercourse, or criminal conversation, or reproductive commerce, about what counts as nature, for whom, and at what cost. This is the kind of conversation that prepares one for life in the narrative webs of the New World Order, Inc., biopower, the Second Millennium, and the Net.

Joanna, Jeannine, Janet, and Jael are genetically identical women living in alternate worlds who come together in Joanna's time, the United States in the 1970s. Although limited by their unexplored racial parochialism—a seemingly constant attribute adhering to duplicitously universal categories like Man and

the Female Man in white discourse of the 1970s, not to mention to these categories enterprised up in the 1990s—together the four Js constitute a sustained inquiry into potent standard categories and into the status of each other's and the ideal reader's assumptions about identity and nature. The four Js are an oxymoron, an impossible chimera, a partially marked universal, a generic scandal. Profane at every level, they are a scandal to the Sacred Image of the Same.

An observer dropping into New York City without warning, Janet Evason, wife to Vittoria and mother to Yuki, is a Safety and Peace Officer, killer of four, in an all-women society on the problematically utopian Whileaway. Janet is a wonderfully revealing unreliable witness and a powerfully strong Female Man; her appeal to feminists like me is legendary. But if Whileaway were in my and Joanna's geographical timescape, Russ tells us that Janet's haunts would be in the Mashopi Mountains near Wounded Knee. The leitmotif of unacknowledgeable genocidal violence in a self-styled utopian nation's stories resonates in that location, where the last overt massacre in the post-Civil War dispossession of the Native Americans of the Western territories occurred at Pine Ridge near Wounded Knee Creek in 1890. Publishing in 1975, Russ belonged to a generation of feminists for whom Wounded Knee also meant the reoccupation of that specific land by American Indian Movement and Oglalla Sioux activists in 1973 in protest over genocidal poverty, disease, and lack of sovereignty caused by continuing federal Indian policy. Janet's utter incomprehension of the sexual and gender customs of Joanna's world and her denial of the alleged act of genocidal violence against men that the warrior-woman Jael tells her founded natural law and cultural practice on Whileaway run throughout the book. Natural-technical history is at stake for the FemaleMan© and for the Female Man in all of her versions. Janet's attractiveness must not be confused with innocence. Her own sociotechnical origin story of Whileaway begins with "'Humanity is unnatural!' exclaimed the philosopher Dunyasha Bernadetteson (A.C. 344-426) who suffered all her life from the slip of a genetic surgeon's hand which had given her one mother's jaw and the other mother's teeth—orthodontia is hardly ever necessary on Whileaway." The chronicle ends with, "Meanwhile, the ecological housekeeping is enormous." A.C. is "after the catastrophe," that is, after the rupture that initiates the specific history into which a subject is interpellated (Russ 1975:12–14). What constituted the catastrophe remains contested.

But who would trust Jael, the razor-clear Alice Reasoner, a near-future soldier enhanced to fight deadly sex wars, who makes love to Davy, a stunningly Nordic male house machine? (Weldon 1994). Collecting her sibling-selves into

one place to face their condition, Jael makes a mockery of the pieties of the other clone sisters. Yet her orthodoxies are no more certain than theirs. Janet prefers the story of the plague that destroyed men and left women, literally, to their own devices.

The displaced Whileawayan Janet, who comes from a society in which the principal sexual taboo is against love across the generations, tests the order of the universe in making love to the decisive and too-young woman Laura Rose. Russ's heroes always seem to be rescuing girls; at least someone does it. Throughout *The Female Man*, however, Janet has to deal with being stuck with the ever shockable Jeannine; that's the fate of clone sisters diffracted through the slits of different timescapes onto the page. It's called "sisterhood" in old-fashioned anglo feminist tracts. It's called "conversations" in savvy versions of 1990s feminist theory (King 1994).

Born into the cloying, post–World War II, white U.S. middle class, in which conventional sexism luxuriated like bacteria in the absence of Lysol®, Joanna is the authorlike figure condemned to live in an "actually existing" prosperous, democratic system of male domination. "Actually existing socialism" of the same Cold War period had met its match. Cataloging the traits of the woman-erasing world-machine she inhabits, Joanna exacts petty revenge: "I committed my first revolutionary act yesterday. I shut the door on a man's thumb. . . . Horrible. I must find Jael. Women are so petty (translate: we operate on too small a scale)" (Russ 1975:203).

In a brief passage late in the novel, Joanna finds herself in Miss Evason's shoes. Throughout the story, Janet had been the one enmeshed in a disturbing affair with the teenaged mistress of heroic adventure fantasy, Laura Rose. But in Part Nine, the "Book of Joanna," Laura is in Joanna's world. "She's the girl who wanted to be Genghis Khan. When Laura tried to find out who she was, they told her she was 'different' and that's a hell of a description on which to base your life. . . . Is 'different' like 'deteriorate'? How can I eat or sleep? How can I go to the moon?" (Russ 1975: 307–08). Already an adult, Joanna met the young Laura. "Now having Brynhildic fantasies about her was nothing . . . , but bringing my fantasies into the real world frightened me very much. . . . She was radiant with health and life, a study in dirty blue jeans. I knelt down by her chair and kissed her on the back of her smooth, honeyed, hot neck. . . . Wanting isn't having. She'll refuse and the world will be itself again. I waited confidently for the rebuke, for the eternal order to reassert itself (as it had to, of course)—for it would in fact take a great deal of responsibility off my hands. *But she let me do it. . . .* Now they'll tell me I'm a Lesbian. I mean that's why I am dissatisfied with things. . . . Later we got better" (Russ 1975:208). Indeed they got quite good—

at the important process of bringing into the real world the terrifying process of questioning what was supposed to be Real and Unreal. Responsibility, not innocence, was the result of "that first, awful, wrench of the mind."

Meanwhile, ever eager to please, Jeannine tries to make herself marriageable (to organic men) in a perpetually cramped WASP world in which World War II did not happen and the Great Depression never ended. That war enabled much of the subsequent "American" sociotechnical progress including the riff of certain kinds of feminism that lead me to mistake author and work in a misplaced commercial brand. Jeannine did not have the benefit of such an explosively progressive time machine. World War II was the wormhole into the New World Order, Inc., where Jeannine's world's sex/gender system was reconstituted by the triple integration from zero to infinity of NatureTM multiplied by CultureTM, forming the solid body of late-twentieth-century history. When Jeannie's adventures with her unruly other possible selves finally terminate in her comic "goodbye to Getting Married, goodbye to The Supernaturally Blessed Event," she is able to forego the divine temptations of Politics, the great zone of polar opposites and of the dream of being taken out of oneself and transported to another, truer, Self. Divested of Politics, she can engage the dirty and vastly more promising reproductive technologies of politics. Her goodbye to the salvation story of Man the Husband became her little air-pump for evacuating the material fictions of gender, along with its typographical conventions, and for establishing matters of fact without recourse to transcendental approval. This is a salutary attitude for voyagers in technoscience.

Good sex with a machine; even better lesbian sex; nerve-racking, cross-generational, same-sex love; the merging of ova and error-prone genetic surgery; the rejection of heterosexual marriage; and, above all, testing what counts as Real and Unreal: all of these are acts to think with in Russ's unsettling writing technology.[31] In the chronotope of Man the Modern, however, maybe even more than for Man the Hunter, all of these are unnatural acts in another sense. Modern Fictional Man revels in such transgressions; modest witness that he is, this Man—textually, of course—gets off on them. But the FemaleMan$^©$ does something else with *The Female Man*'s provocative unnatural acts. S/he tinkers with the story technology so that the implosion of nature and convention might issue in a diffracted sort of family romance, one that includes a technobastard called OncoMouseTM. Together, in this chapter at least, and maybe "trotting through Texas and Vermont" and out into a wider world, they will make an unlikely, or perhaps uncanny, team to challenge the power of the commodified body to occupy the future.

Available to researchers only from Du Pont, where better things for
better living come to life.[32]

OncoMouse™ is my sibling, and more properly, male or female, s/he is my sister. Her essence is to be a mammal, a bearer by definition of mammary glands, and a site for the operation of a transplanted, human, tumor-producing gene—an oncogene—that reliably produces breast cancer.[33] Although her promise is decidedly secular, s/he is a figure in the sense developed within Christian realism: S/he is our scapegoat; s/he bars our suffering; s/he signifies and enacts our mortality in a powerful, historically specific way that promises a culturally privileged kind of salvation—a "cure for cancer." Whether I agree to her existence and use or not, s/he suffers, physically, repeatedly, and profoundly, that I and my sisters may live. In the experimental way of life, s/he is the experiment. S/he also suffers that we, that is, those interpellated into this ubiquitous story, might inhabit the multibillion-dollar quest narrative of the search for the "cure for cancer."

If not in my own body, then surely in those of my friends, I will someday owe to OncoMouse™ or her subsequently designed rodent kin a large debt. So, who is s/he? Gestated in the imploded matrices of the New World Order, OncoMouse™ is many things simultaneously. One of a varied line of transgenic research mice, s/he is an animal model system for a disease, breast cancer, that women in the United States have a one in eight chance of getting if they live into old age. Self-moving in Aristotle's defining sense, s/he is a living animal and so fit for the transnational discourses of rights emerging from green social movements, in which the consequences of the significant traffic between the materialized, ethnospecific categories of nature and culture are as evident as they are in patent offices and laboratories. OncoMouse™ is an ordinary commodity in the exchange circuits of transnational capital. A kind of machine tool for manufacturing other knowledge-building instruments in technoscience, the useful little rodent with the talent for mammary cancer is a scientific instrument for sale like many other laboratory devices.

Above all, OncoMouse™ is the first patented animal in the world.[34] By definition, then, in the practices of materialized refiguration, s/he is an invention. Her natural habitat, her scene of bodily/genetic evolution, is the technoscientific laboratory and the regulatory institutions of a powerful nation-state. Crafted through the ordinary practices that make metaphor into material fact, her status as an invention who/which remains a living animal is what makes her a vampire, subsisting in the realms of the undead. Vampires are narrative figures with specific category-crossing work to do. The essence of vampires, who, like Victor Frankenstein's monster, normally do their definitive labor on wedding

FEMALEMAN© _MEETS_ ONCOMOUSE™

nights, is the pollution of natural kinds. The existence of vampires tropes the purity of lineage, certainty of kind, boundary of community, order of sex, closure of race, inertness of objects, liveliness of subjects, and clarity of gender. Desire and fear are the appropriate reactions to vampires. Figures of violation as well as of possibility and of escape from the organic-sacred walls of European Christian community, vampires make categories travel. From the points of view crafted in their Christian narrative sources from at least the end of the eighteenth century, vampires are ambiguous—like capital, genes, viruses, transsexuals, Jews, gypsies, prostitutes, or anybody else who can figure corporate mixing in a rapidly changing culture that remains obsessed with purity (Geller 1992; Gelder 1994). No wonder queer theorists and novelists alike find vampires to be familiar kin (Gomez 1991; Case 1991). So do Du Pont's advertising copy writers. Whether s/he proves to be otherwise productive or not, OncoMouseTM has already done major semiotic work.

Buying and selling, breeding and selecting, experimenting on, and contesting the treatment of lab animals are not new activities, but the controversies surrounding the patenting and marketing of "the Harvard mouse" were densely covered in the popular and scientific press in Europe and the United States. The heightened sense of controversy around OncoMouseTM is the fruit of the New World Order's floridly regenerated narratives of original transgression in the Garden of the Genome, even if the universal singular (the genome) polluted here belongs to a genetically compromised mouse, or rather belongs to the licensee of the patent-holder. Inventions do not have property in the self; alive and self-moving or not, they cannot be legal persons, as corporations are. On April 12, 1988, the U.S. Patent and Trademark Office issued a patent to two genetics researchers, Philip Leder of Harvard Medical School and Timothy Stewart of San Francisco, who assigned it to the president and trustees of Harvard College. In an arrangement that has become a trademark of the symbiosis between industry and academia in biotechnology since the late 1970s, Harvard licensed the patent for commercial development to E. I. du Pont de Nemours & Co. With an unrestricted grant to Philip Leder for the study of genetics and cancer, Du Pont had been a major sponsor of the research in the first place.

Du Pont then made arrangements with Charles River Laboratories in Wilmington, Massachusetts, to market OncoMouseTM. In its 1994 *Price List,* Charles River listed five versions of these mice carrying different oncogenes, three resulting in mammary cancers. Oncomice can get many kinds of cancer, but breast cancer has been semiotically most potent in news stories and in the original patent. Cost ranged from $50 to $75 per animal, an amount that could

not recoup the original investment even if sales were brisk, which they have not been for many reasons.[35] In Du Pont's view, its pricing was conservative because

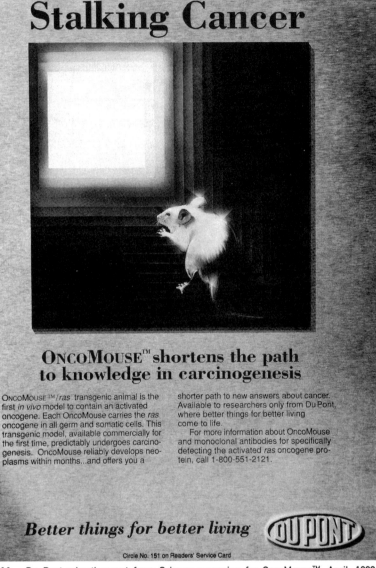

Figure 2.3 Du Pont advertisement from Science magazine for OncoMouse™, April, 1990. Courtesy of Du Pont NEN products. On May 19, 1995 Du Pont announced its intent to divest its medical products business. The former Du Pont NEN products business will become NEN life science products.

its long-range goals were for effective cancer therapies, toward which the corporation hoped transgenics would be a step, but only if researchers could afford to use them.[36] Altered in their germ line, the offspring of transgenic mice bear the transplanted genes in all their cells. Continued testing to make sure the new genes are not lost or mutated is necessary. Testing transgenic creatures to ensure their identity as a technoscience product is similar in principle to the testing that a microprocessor such as Intel's Pentium or Motorola's 68000 must undergo. Charles River provides a host of services critical to sustaining the identity and utility of its mice: colony maintenance and development, genetic analysis by polymerase chain reaction, sample collection, cryopreservation and storage, rederivation, and customized projects.

The mice at Charles River, and in laboratories everywhere, are also sentient beings who have all the biological equipment, from neuronal organization to hormones, that suggest rodent feelings and mousy cognition, which, in scientific narratives, are kin to our own hominid versions. I do not think that fact makes using the mice as research organisms morally impossible, but I believe we must take noninnocent responsibility for using living beings in these ways and not to talk, write, and act as if OncoMouse™, or other kinds of laboratory animals, were simply test systems, tools, means to brainier mammals' ends, and commodities. Like other family members in Western biocultural taxonomic systems, these sister mammals are both us and not-us; that is why we employ them. Exceeding the economic traffic, there is an extensive semiotic-corporeal commerce between us. The alliance between FemaleMan© and OncoMouse™ is only one incarnation of the exchange system. Because patent status reconfigures an organism as a human invention, produced by mixing labor and nature as those categories are understood in Western law and philosophy, patenting an organism is a large semiotic and practical step toward blocking nonproprietary and nontechnical meaning from many social sites—such as labs, courts, and popular venues. Technoscience as cultural practice and practical culture, however, requires attention to all the meanings, identities, materialities, and accountabilities of the subjects and objects in play. That is what kinship is all about in my "ethnographic" fugue.

In its April 27, 1990, advertisement for OncoMouse™ in *Science* magazine, Du Pont featured its artifactual rodent under the title for a series of the chemical corporation's ads called "Stalking Cancer." [Figure 2.3] The series played on the fundamental, if numbingly conventional, biopolitical metaphor of war and the hunt. Diseases are targeted in an ever escalating arms race with infectious alien invaders and treasonous selves. OncoMouse™ is a weapon in a specific long-term campaign—the U.S. national war on cancer, declared by Richard Nixon in 1972.[37] Propelled by federal money through the National

Institutes of Health and later by substantial corporate investment, this material-semiotic conflict has lavishly underwritten the last quarter-century's exploits in molecular biotechnology. In that sense transgenics are as much a war baby as plutonium. From conception to fruition, both these millennial offspring required massive public spending, insulated from market forces, and major corporations' innovations in their previous practice. In the strongest possible sense, OncoMouse™ is a technological product whose natural habitat and evolutionary future are fully contained in that world-building space called the laboratory. Denizen of the wonderful realms of the undead, this little murine smart bomb is also, in the strongest possible sense, a cultural actor. A tool-weapon for "stalking cancer," the bioengineered mouse is simultaneously a metaphor, a technology, and a beast living its many-layered life as best it can. This is the normal state of the entities in technoscience cultures, including ourselves. In science, as Nancy Stepan (1986) pointed out for nineteenth-century studies of sex and race, a metaphor may become a research program. I would only add that a research program is virtually always also a very mobile metaphor.

In the advertising image, a radiant white laboratory mouse, who seems to be glancing back to lock her gaze with that of the reader of the ad, as if s/he were in a diorama in a natural history museum, while also keeping her other eye on the goal ahead, is climbing steps that lead to a square of blinding light above her. It looks as if s/he might be inside a camera climbing to the open shutter. S/he is our surrogate on a quest journey, but s/he is also in the dark passages of a birth canal before s/he emerges into the light of pure forms. An Enlightenment figure who belongs in the genre of Scientific Revolution narratives, OncoMouse™ could also be a character in Luce Irigaray's (1985) feminist psychoanalytic and philosophical commentary, titled "Hystera," on Plato's allegory of the cave. Irigaray rereads Plato's myth to figure the womb passage for the treasured Western masculine fantasy of the second birth, of children of the mind rather than children of the body, or, here, of legitimate corporate issue rather than unauthorized natural offspring. Marx too had a great deal to say about such rebirths into the realm of pure capital.

The ad multiplies the stigmata of the kinds of property that this significant white mouse grounds, naturalizes, and normalizes in her origin story. The ad itself is copyrighted by the corporate person and, therefore, author, Du Pont. Indeed, Du Pont is credited with inventing the form of the modern corporation, and, no stranger to the laws of literal kinship, the giant company was run by du Ponts for well over a hundred years.[38] The mouse itself is patented and licensed. And the name, OncoMouse™, under which the animal is marketed is trademarked under the Federal Trademark Act of 1946, as amended in 1988. "A

trademark is a distinctive mark, motto, device, or emblem that a manufacturer stamps, prints, or otherwise affixes to goods so that they may be vouched for" (OTA 1989:44). Such marks brand one form of intellectual property important in technoscience generally and biotechnology specifically.

Du Pont's mutated famous slogan—OncoMouse™ is "available to researchers only from Du Pont, where better things for better living come to life"—signals a recent metamorphosis of the industrial chemical giant. In a complex pattern of diversifications, acquisitions, and investments, like other large chemical and oil companies Du Pont began to commit sizable resources to biotechnological research in both pharmaceuticals and agriculture about 1980, including the building of an $85-million-dollar, in-house agricultural research lab that was one of the largest in the country (Wright 1986:352).[39] Following its first entry into pharmaceuticals in 1964, in the last quarter of the twentieth century Du Pont began dealing seriously in the promising undead entities proper to the regime of biotechnopower in a New World Order that depends on strategies of flexible accumulation at the turn of the Second Christian Millennium. Narrative timescapes proliferate promiscuously in the flesh of my sentences, outmaneuvered only by the fecund moves of multinational techno-science. David Harvey elaborated the theory of flexible accumulation to describe the emergence of "new sectors of production, new ways of providing financial services, new markets, and above all, greatly intensified rates of com-mercial, technological, and organizational innovation" (1989:147).[40] Biotechnology and genetic engineering make the most sense in this framework.

In 1991, Delaware-based Du Pont was the largest chemical producer in the United States; and with $40 billion in total sales, it was also the seventh-largest exporter in the United States. Pharmaceuticals and medical products repre-sented one of six principal business segments of the huge corporation. Du Pont's total 1990 research budget for all categories was an impressive $1.4 billion, up from $475 million in 1980. In 1981 Du Pont acquired New England Nuclear (NEN), which brought the chemical company into medical radioisotopes and other biotechnology research products. Valued at about $1 billion in 1995 (about 2 percent of the total value of Du Pont), the medical products division is the unit that housed OncoMouse™. In 1991 Du Pont and Merck entered a joint ven-ture to establish an independent drug company, involved in, among other things, *in vivo* diagnostic agents. New Jersey-based Merck is the world's largest pharmaceutical company, with 18 drugs in 1991 that generated over $100 mil-lion each in sales. Besides a huge domestic market in the United States, pharma-ceuticals have continued to show a trade surplus of exports over imports since the 1980s, when the United States became a net importer of high-technology

products (NSB 1993:xxix). "Drugs" are important to national policy in more ways than one. In 1990 Merck spent 11 percent of sales on research and development ($854 million), that is, 5 percent of all global pharmaceutical research. Technoscience is not cheap. Besides its joint venture with the very established Du Pont, Merck is also paired up with one of the new breed of biotechnical firms, Repligen, to develop an AIDS vaccine.[41] OncoMouse™ has had powerful godparents in the extended company family.

Just as Janet and Jael, younger clone sisters of the FemaleMan©, were locked in a struggle over the origin story of Whileaway, and especially over the role of violence, ways of telling the history of Du Pont are tussles over meanings, purposes, violations, and origins. Seeking to comprehend the nature of no nature, where nature and culture are spliced together and enterprised up, my genealogy of the house of OncoMouse™ is no stranger to contested lineages and narrative devices. I am using Du Pont and OncoMouse™ allegorically and figuratively to tell a story, not because these actors are the most important ones in technoscience in general or molecular biology in particular, any more than *The Female Man* has to be the first or best feminist science-fiction novel or the material clue to the troubling commodity circuits of 1980s and 1990s academic feminism. I engineer the mutations of Russ's four Js into the FemaleMan©, with all of their dilemmas in accounting for their ancestry and their hopes, for the same reason that I narrate the exploits of Du Pont and its mousy acquisition—because they can signify and incarnate, perhaps more than explain, the world into which I have been interpellated. OncoMouse™ and its academic-corporate family are like civic sacraments: signs and referents all rolled into one fleshy mystery in a secularized salvation history of civilian and military wars, scientific knowledge, progress, democracy, and economic power.

SIGNIFYING SYNTHETICS

With that admission, I can risk telling my allegorical story of Du Pont as a history of the semiotic material production of the key synthetic objects and processes that characterize the last century of the Second Christian Millennium: nylon, plutonium, and transgenics.[42] Each of these revolutionary new world citizens was enabled, respectively, by synthetic organic chemistry, transuranic nuclear generation, and genetic engineering. A constantly self-reinventing Du Pont figures centrally in all three theaters of action. Du Pont's roots were nourished with the sale of blasting powder to Thomas Jefferson in 1811 to clear the forest from Monticello and of the same substance to the U.S. government in the War of 1812. Throughout the nineteenth century, the company made the

FEMALEMAN© _MEETS_ ONCOMOUSE™

explosive nitrogenous powder that blasted the railroad tunnels and the gold mines that undergirded the conquest of the continent by the United States. In the context of competitive crises and the invention of the corporate forms of monopoly capital, Du Pont reorganized in 1902–1903; and by 1906 Du Pont controlled 70 percent of the U.S. explosives market. But with the founding of the Eastern Laboratory in New Jersey in 1902 and of the Experimental Station outside Wilmington soon after, the enterprise was already mutating from an explosives manufacturer to a diversified chemical company. In response to antitrust litigation as well as internal investment decisions, Du Pont energetically diversified and divested parts of itself throughout the twentieth century. Throughout those reinventions of its identity, after AT&T and General Electric, Du Pont became one of the first U.S. innovators—and one of the most powerful—of industrial technoscientific research and development.

Du Pont entered polymer technology before 1900 with its production of cellulose nitrate as smokeless gunpowder. In the first decades of the twentieth century, Du Pont made several important cellulose-based products, including celluloid and cellophane. Du Pont's research strategy changed fundamentally in 1926–1927 when it invested $300,000 in a new research pattern that included $20,000 for "pure," rather than "applied," chemical research in materials science. In the new laboratory called Purity Hall, condensation polymerization yielded a fiber that figured in World War II and then changed the texture of the everyday world after the war—nylon, first commercialized in 1938. With the Manhattan Project, and the following reorganization of national science, the dominance of industrial funding of U.S. science decisively ended, only to begin to be reasserted in the last years of the twentieth century. Throughout the transitions the elemental nitrogen in explosives, textile fibers, and DNA fibers has circulated many times over, turning a profit with each cycle.

Du Pont had its part to play in the Manhattan Project too, but a part in which plutonium, not nitrogen, was the key explosive element. Du Pont executives dreaded the onset of World War II, did not want to get mired in the short-term profits and headaches of war production at the long-term cost of highly advantageous new research products, and planned for the company's postwar reconstruction even before the United States had joined the conflict. Nonetheless, as requested, Du Pont took on an alternate track for the production of bomb-grade plutonium from the works at Oak Ridge, Tennessee. Du Pont built the Hanford Engineering Works in Washington, employed 40,000 people, carried off a major engineering and production feat, and had an unparalleled understanding of atomic power in all its scientific and managerial complexities by the end of the war. But, getting out of nuclear production as soon as it could,

Du Pont wanted no part of the postwar atomic power industry, with its inevitable limitations on proprietary control because of the national security aspects of its materials and processes and with the industry's permanent dependence on the government. Ultimately becoming one of the most polluted places on the global nuclear map, the Hanford facility continued to produce plutonium for decades after the war. But after it gleefully ceded the plutonium-making business at Hanford and atomic power generation in general to General Electric, that story was no longer Du Pont's problem. Du Pont would go nowhere where patents would not smooth the way; the company did not want markets dominated by the government, especially in an uncertain new industry. The science-based products emerging from organic chemistry provided Du Pont's steadier star.

At the end of the 1980s OncoMouseTM, the third key synthetic being midwifed by Du Pont's changing research and investment policies, joined its nylon and plutonium older siblings. Like transuranics, however, transgenics had no permanent place in Du Pont's corporate family. On May 19, 1995, Du Pont announced its intention to divest its medical products businesses, which contained the transgenic mammals and their authorizing patent. The corporation reinvents itself again, but my narrative must return to the patent story and its context for more insight about the anatomy of citizenship in technoscience. Dissecting OncoMouseTM shows important aspects of the history of patenting practices in biology and sharpens the focus on the difficulty of achieving or preserving a multicultural, democratic, biotechnological commons.

PATENT ACTS

The Committee Reports accompanying the U.S. Patent Act of 1952 made clear that Congress "intended patentable subject matter to include 'anything under the sun that is made by man'" (OTA 1989:5). The 1952 act changed the original 1790 patent law language from the word *art* to *process* in the broad intellectual property protection provided by the 1790 act for "any new and useful art, machine, manufacture, or composition of matter, or any new and useful improvement [thereof]" (OTA 1989:4). The legal power to enclose nature, if only it were mixed with human labor, was broad indeed in the founding documents of the United States. In European-derived worlds, nature and labor (culture) have a hoary pedigree as salient categories, held together in relations of transformation and foundation. Even so, the Patent and Trademark Office did not always consider living organisms, which could be owned and manipulated in a myriad of legally recognized ways, not least in the system of human slavery, to be patentable under the law. Improvers of agriculture and husbandry were not authors and inventors until very recently.

FEMALEMAN©_MEETS_ONCOMOUSE™

In 1930, the Plant Patent Act changed that status for producers of nonsexually generating plants. The point was not the transcendental power of sex to guard its practitioners from being considered patentable material. Rather, adequate control of the patentable process was precluded at that time by the seeming inability of such seedy plants to reproduce true to type. When that technical difficulty was overcome, intellectual property protection, embodied in the Plant Variety Protection Act of 1970, was not far behind. Bugos and Kevles argue that advances in biological specificity and control over reproduction shaped the evolution of intellectual property protection for plants. In the United States in the absence of specificity and control over the germ plasm of plants, "private breeders were content to let their public counterparts to bear the principal costs of plant innovation and to exploit the public product for market purposes. The greater the degree of specificity and control, the stronger the incentive for private breeders to invest in innovation, because they could define it and thus seek to protect and enforce their rights in it" (Bugos and Kevles 1992:103).

Control of sexual reproduction was hardly the stopping point in deciding just when to enclose the commons in germ plasm in this particular way. Food crops are perhaps the most lively area of transgenic research worldwide in the 1990s. In late 1991, federal agencies had applications for field testing about twenty transgenic food crops.[43] Techniques are being widely adopted for fine-tuning agriculture to the productive processes of transnational agribusiness and food processing. Herbicide-resistant crops are probably the largest area of active plant genetic engineering. I find myself especially drawn by such engaging new beings as the tomato with a gene from a cold-sea-bottom-living flounder, which codes for a protein that slows freezing, and the potato with a gene from the giant silk moth, which increases disease resistance. DNA Plant Technology, Oakland, California, started testing the tomato-fish antifreeze combination in 1991.[44]

Mostly involving questions about safety and about consumers' rights to know (e.g., through product labeling at the point of marketing), controversies surrounding these beings may be followed in *The Gene Exchange*, put out by the National Wildlife Federation. Safety (at least for consumers, if not for workers—if the trouble the United Farm Workers have had in making anyone care about farm laborers' safety in pesticide use in the California grape fields is any evidence) and rights-to-know are established liberal discourses in the United States. Of course, safety and right-to-know issues are strongly shaped by class and race formations. Whose safety and whose right to know, and to know what and when, have everything to do with whether it is easy or hard for regulators to hear various social actors. Going another giant step into the sacred spaces of the laboratory and the technoscience curriculum, putting the questions at the point

of research design, as well as at the point of recruitment and training of knowledge producers, rather than at the point of product testing and marketing, provokes the most amazing defensive reactions among the elites of technoscience.

The struggle is over who gets to count as a rational actor, as well as an author of knowledge, in the dramas and courts of technoscience. In the United States, it is very hard to ask directly if new technologies and ways of doing science are instruments for increasing social equality and democratically distributed well-being. Those questions are readily made to seem merely ideological, while issues of safety and labeling can be cast as themselves technical, and so open to rational (objective, negotiated, adjudicated, liberal) resolution. The power to define what counts as technical or as political is very much at the heart of technoscience. To produce belief that the boundary between the technical and the political, and so between nature and society, is a real one, grounded in matters of fact, is a central function of narratives of the Scientific Revolution and progress. My goal is to help put the boundary between the technical and the political back into permanent question as part of the obligation of building situated knowledges inside the materialized narrative fields of technoscience.

In a more Puritan vein, my scopophilic curiosity about and frank pleasure in the recent doings of flounders and tomatoes must not distract attention from what is entailed by such new kinship relations in the conjoined realms of nature and culture. Large commercial stakes, with attendant national and international intellectual property issues, are involved. Hunger, well-being, and many kinds of self-determination—implicated in contending agricultural ways of life with very different gender, class, racial, and regional implications—are very much at stake (Hobbelink 1991). Like all technoscientific facts, laws, and objects, seeds only travel with their apparatus of production and sustenance.[45] The apparatus includes genetic manipulations, biological theories, seed genome testing practices, credit systems, cultivation requirements, labor practices, marketing characteristics, legal networks of ownership, and much else. These apparatuses can be contested and changed, but not easily. Seeds are brought into being by, and carry along with themselves wherever they go, specific ways of life as well as particular sorts of dispossession and death. Such points should be second nature to any citizen of the republic of technoscience, but they bear repeating. Genes R Us in ways that have nothing to do with the narrow meaning of genetic determinism and everything to do with entire worlds of practice. It's all in the family.

Here, my story must leave the critical struggle for the germ plasm of seeds and turn back to the trajectory that made a white mouse into an invention. As late as 1980, even though many biotechnical *processes* were patented, such as alcohol or acetic acid fermentation and vaccine production, the Patent and

Trademark Office (PTO) ruled that microorganisms themselves, even if modified by the gene-splicing techniques developed in the 1970s, were still "products of nature" and so not patentable. But in 1980 the Supreme Court overruled the PTO in the case of Diamond v. Chakrabarty.[46] The result was a patent for a genetically modified bacterium that breaks down petroleum. A living organism became a patentable "composition of matter." The court saw Chakrabarty's bacterium as a product of human ingenuity, of labor mixed with nature in that magical, constitutional way that legally turns the human being into nature's author or inventor and not simply its inhabitant, owner, or steward. This kind of human authorship, attained merely by modifying or crating a gene and relegating all the rest of the biological entity to irrelevance, is dependent on the doctrine of genetic programming, where the genome alone is seen as the master designer, or natural author, of the whole organism. The human just substitutes for the gene in an orgy of autonomous invention and authorship.

Several other significant events around 1980 in the United States marked the status of biotechnology in the transition from the economies and biologies of the Cold War era to the New World Order's secular theology of enhanced competitiveness and ineluctable market forces. Intensifying changes begun in the Carter administration, which in 1979 emphasized an economic-incentive-oriented approach to environmental regulation, the Reagan administration immediately began to dismantle statutory controls, including those affecting recombinant-DNA technology. While the National Institutes of Health dismantled mildly restrictive, safety-oriented controls on recombinant-DNA research, which never applied to industry in any case, the National Science Foundation (NSF) initiated several grants programs for fostering university-industry cooperation in research and development. In 1980 Congress passed the Patent and Trademarks Amendments Act, which granted title to nonprofit and small businesses whose research was federally funded, opening the way for universities to benefit commercially from tax-supported research performed on campus. Also in 1980, Stanford University and the University of California at San Francisco were awarded the Stanley Cohen-Herbert Boyer patent (applied for in 1974) on the basic technique of gene splicing, which has undergirded all genetic engineering. In 1980 Genentech—the California biotechnology firm founded in 1976 by Herbert Boyer, an academic geneticist, and Robert Swanson, a venture capitalist—made its initial public stock offering, an event that substantially raised general awareness of the commercial significance of genetic engineering (OTA 1989:30).[47] In 1981 the Economic Recovery Tax Act gave economic incentives to cooperative arrangements between academia and industry, and in 1982 the Department of Commerce "began to promote the use of tax shelters for joint

research and development ventures for investors and industry" (Wright 1986:338). In addition, new export markets for high-technology goods began to develop in the 1980s, and chemicals and pharmaceuticals were areas in which the United States had a growing surplus in a generally dismal balance-of-trade picture.

Susan Wright's densely documented and incisively argued paper ties together the technical, economic, political, and social dimensions of the major transformation that has taken place in molecular biology since the 1970s. Wright named the period from 1979 to 1982 "the cloning gold rush," as large investments poured into genetic engineering directly from multinationals based in Europe and the United States as well as through the rapidly appearing small biotechnological enterprises. Although the biotech firms have received a great deal of the credit and blame for the rapid commercialization of molecular biology, Wright argues that they have been "highly dependent on universities for expertise and on multinational oil, chemical and pharmaceutical corporations for capital" (1986:304).[48] The story of Du Pont, Harvard, and OncoMouse™ is a little piece of this specific story. As rates of increase of federal support for basic science declined, direct industrial support of university biological research developed strongly. In 1980 the federal government funded 68 percent of academic research and development in science as a whole; by 1993 the figure was down to 56 percent. In constant dollars, all academic research and development directly funded by industry between 1980 and 1993 grew 265 percent (NSB 1993:xviii). Although industry performs 68 percent of all U.S. technoscientific research and development (R&D), universities still do 62 percent of what gets classified as basic research, much of which is in biology. About 54 percent of all university R&D dollars go to the life sciences, which have been leaders in the reorganization of the institutional form of scientific practice in the past fifteen years.

Industrial support of biology has taken many forms, including major commercially funded research institutes connected to the scientifically powerful university campuses. From the early twentieth century, U.S. biological research in universities was funded by capital accumulated by giant corporations but mediated through philanthropic organizations such as the Rockefeller and Carnegie foundations. After World War II, the huge increase in the size of American basic science was funded overwhelmingly by federal tax dollars. In 1981 the Massachusetts Institute of Technology (MIT) accepted $125 million from a private businessman to host the Whitehead Institute for molecular biological research (Yoxen 1984:182).[49] At that time, the Whitehead Institute seemed to many academic biologists to have troubling implications in relation to autonomy, intellectual integrity, and conflicts of interest. By the 1990s, arrangements like the Whitehead Institute were avidly

sought if they did not already exist, and hardly a serious molecular geneticist exists without commercial connections of some kind. For example, the University of Maryland announced in 1994 that it planned to build a $53 million Medical Biotechnology Center to house both academic and industrial researchers under one roof; this was only the latest in a string of such arrangements. The explicit idea was "to give scientists at start-ups cheap access to equipment and advice. . . . In exchange, Maryland will collect rent and receive stock in participating firms" (Science Scope 1994b; 1071).[50] The university researchers would be free of academic duties. Harvard planned a similar facility to open in 1996. Meanwhile, federal policy is clear about using science and technology to achieve national competitiveness goals. In the early 1990s, the government established a $12.5 billion budget for cross-cutting interagency initiatives, with $4.3 billion of that earmarked for biotechnology in 1993 (NSB 1993:xix). Compare that amount with $1 billion interagency dollars for computing and communications.

From the mid-1970s on, the social norms in biological research and communication changed from expert-communal and public ideals (if hardly always practice) to approved private ownership of patentable results, widespread direct business ties of university biological faculty and graduate students to corporations, marked convergence of "basic" and "applied" contents of research questions, and greater secrecy in research practice. From 1987 to 1991, the number of university-industry licensing agreements more than doubled, and one-quarter of patents awarded to universities between 1969 and 1991 were awarded in 1990-1991. The 100 largest universities got 85 percent of the patents (NSB 1993:xxxvii, 152-53). Formal cooperative research and development agreements between federal labs and private industry increased from 108 in 1987 to 975 in 1991 (NSB 1993:119). In 1993, showing a huge increase across the 1980s, more than 1,000 university-industry research centers in all scientific areas existed, spending about $3 billion/year on R&D, 41 percent of that for chemical or pharmaceutical research. Federal or state tax dollars contributed to building 72 percent of those centers (NSB 1993:xxii, 121). In 1994, the new director of the National Institutes of Health (NIH), Nobel prize winner Harold Varmus, as he looked for new ways to link NIH, academia, and industry, was quoted as saying, "We're not interested in giving grants to Merck. We're interested in giving grants to small businesses" (Schrage 1994:3D). I think that comment was supposed to reassure worried radical science activists who think economic competitiveness might be getting out of hand as a goal of national health research policy. It is hard to find solace in such reassurance. Meanwhile, health-related research and development commanded 13 percent of the total U.S.

R&D budget in 1993, that is, about $28 billion (NSB 1993:105).

Capital also squirts directly into industrial biotechnology. Every year between 1990 and 1994 in California's Silicon Valley, "more money has been invested in new biotechnology and health-care companies in the valley than in any of the industries that currently dominate the economy" (Wolf 1994:1D). Indeed, in this region famous for its computer and information technoscience, twice as much venture capital flowed into biotechnology and the life sciences in 1993 than into all of computers, peripherals, semiconductors, and communications combined (Wolf 1994:1D). The original biotechnology companies, such as Genentech, spun off several other startups and joint ventures. There were 29 companies in the area in 1980 developing drugs and diagnostic products; there were 129 such firms in 1993. Nationally, in the third quarter of 1993, for the first time more venture capital sloshed into the trough feeding the life sciences than the information sciences (Wolf 1994:9D).

Although biotechnology has not yet produced many successful products, and the economic dream nourishing the huge investments is more luminous than its results so far, molecular biology, including the Human Genome Project, has germinated its share of millionaire scientists since Genentech's Herbert Boyer in 1976. For example, in 1992 J. Craig Ventor left NIH, where he did research on technology for DNA sequencing, to help found Human Genome Sciences, Inc., of Bethesda, Maryland, to commercialize the technology. Ventor's shares were valued at $9.2 million in November 1993, when the company began to offer shares on the public stock exchange, and $13.4 million by January 1994. Other Human Genome Project scientists have also founded companies based significantly on tax-supported research results. The names of the companies fuse the magical and the mundane, just as the Alice-in-Wonderland scene of laboratory work in Quadrant's ad image did: Millennium Pharmaceuticals; Darwin Molecular Technologies; Mercator Genetics, Inc. (Fisher 1994:9A).[51]

The corporatization of biology is not a conspiracy, and it is a mistake to assume all of its effects are necessarily dire. For example, I believe ease of technology transfer from academic research to other areas of social practice ought to be very important. I also insist that research priorities *and systems of research* must be shaped *from the start* by people and priorities from many areas of social practice, including, but not dominated by, profit-making industry. Each issue merits careful analysis and interrogation of one's own assumptions as well as those of others. Nonetheless, I agree with Sheldon Krimsky, who argued on the basis of his Tufts University Biotechnology Study from 1985 to 1988, that "the greatest loss to society is the disappearance of a critical mass of elite, independent, and

FEMALEMAN© _MEETS_ONCOMOUSE™

commercially unaffiliated scientists. . . . The stage is set for what University of Washington Professor Philip Bereano aptly described as 'the loss of capacity for social criticism'" (Krimsky 1991:79).

PUBLIC ACTORS

The capacity for multisided, democratic criticism and vision that fundamentally shape the way science is done hardly seems to be on the political agenda in the United States, much less in the R&D budget of universities, in-house government labs, or industries—even while *how*, in fact, science is done is being reshaped in revolutionary ways. Hardly surprisingly, the National Science Board's 1993 edition of *Science and Engineering Indicators*, in the section on American public attitude to and knowledge about science and technology, did not even try to conceptualize or measure democratic participation in technoscience. Studies asked how many citizens follow the science and technology news (maybe 15 percent), whether folks had a high regard for U.S. scientific leadership (seems so), and whether or not people understood the ozone layer and DNA (sort of). The "public" was conceptualized as a passive entity with "attitudes" or "understandings" but not as a bumptious technoscientific actor. There were no measurements or analyses reported for such things as serving on science policy bodies; participating in workplace or community design projects; engaging in debates in education about science and technology; contributing to formulating and following up on impact statements; organizing technoscience-oriented action groups; writing novels or composing music that engage beliefs and practices in technoscience; articulating technoscientific issues in class, race, and gender justice goals; participating in international study groups or non-governmental organizations (NGOs) on technoscientific issues; taking courses in science and mathematics for pleasure and continuing education; and so on.

Indeed, the spectrum of science policy discourse in the United States in the 1990s makes even mentioning such things appear to be evidence of hopeless naïveté and nostalgia for a moment of critical, public, democratic science that never existed. Whether it existed in the past or not, such a technoscience—committed to projects of human equality; modest, universal material abundance; self-critical knowledge projects; and multispecies flourishing—must exist now and in the future. And lots more is going on in this vein in the present than the National Science Board knows how to count. I believe wealth is created by collective practice, figured by Marx as labor but needing a messier metaphoric descriptive repertoire. Even a narrow view, however, that looks only to tax dollars feeding technoscience, instead of to all of collectively produced wealth that

is eaten, digested, expanded, and excreted by technoscience, must insist on radically reconstituted public participation and critical discourse. If technoscience is to develop truly situated knoweldges and strong standards of objectivity that take account of all of its webs of human and nonhuman actors and consequences, then at a minimum questions about content and availability of jobs, richness and strength of what counts as scientific knowledge, cultural breadth among scientists and engineers and their constituents, distribution of wealth, standards of health, environmental justice, decision-making structures, sovereignty questions, and biodiversity ought to vie with "competitiveness" for sexy luminosity in the eyes of molecular biologists and other politicians.[52]

In fact, the United States is particularly backward in practicing technoscientific democracy or, in Sandra Harding's terms, nurturing strong objectivity. Technoscientific democracy does not necessarily mean an antimarket politics, and certainly not an antiscience politics. But such democracy does require a *critical* science politics at the national, as well as at many other kinds of local, level. "Critical" means evaluative, public, multiactor, multiagenda, oriented to equality and heterogeneous well-being. Nostalgia for "pure research" in mythical ivory towers is worse than ahistorical and ideological. A better use of our time, critical skills, and imaginations might come from considering hope-giving, on-the-ground practices toward building a democratic technoscience taking place both under our noses and in distant lands. We might try to figure out how to be interpellated into a different sort of molecular politics.

Richard Sclove, the executive director of the Loka Institute in Amherst, Massachusetts, which promotes democratic science and technology analysis, exchange, and action, argues that "the 'consensus conference' model of technology assessment pioneered in Denmark and now being widely adopted in Europe" might just give us the needed hail (Sclove 1994).[53] I believe the model has wide implications for scientific research, and not just for technology as an end product. Three groups essentially control how technoscience is done in the United States: the Pentagon and national weapons laboratories, the organized scientific research community, and business. From time to time, organized public interest groups also have an impact. None of these groupings is homogeneous, and their listing does not imply a conspiracy to produce antidemocratic technoscience. However, there is a conspicuous absence of serious citizen agency in shaping science and technology policy. By contrast, the Danes have pioneered a practice of establishing panels of ordinary citizens, selected from pools of people who indicate an interest, but not professional expertise or a commercial or other organized stake, in an area of technology. Meeting several times at government expense, the independent panels act somewhat like juries.

The fifteen citizens hear testimony, cross-examine experts, read briefings, deliberate among themselves, and issue reports to a national press conference. The process takes about six months.

The first stage is a preparatory weekend, when the panel discusses a background paper prepared by the Danish Board of Technology, which is roughly analogous to the U.S. Office of Technology Assessment, and formulates questions to put to relevant experts at the subsequent consensus conference. The board assembles a panel of widely divergent scientific and technical experts and of representatives from trade unions, environmental organizations, women's groups, or whoever else had an organized or professional stake in the issues to be discussed. These "stakeholders" prepare written statements, which the panel reads in advance. The panel may ask for further written information or clarification. The final consensus conference is a three-day event that brings the expert/stakeholder and lay panels together in a forum open to the media and the public. The experts and stakeholders speak for about twenty minutes each and are cross-examined by the lay panel. On the last day, the citizen panel prepares its concluding report, "summarizing the issues on which it could reach consensus and characterizing any remaining points of disagreement" (Sclove 1994). Beyond the national press conference where the report is first publicized, the results are spread through leaflets, local debates, and videos. The degree of scientific and technical literacy encouraged in ordinary people—as well as the degree of respect for citizens' considerations encouraged among technical and professional people—built into the consensus conference is stunning to anyone inhabiting the depleted democratic air of U.S. technoscience.

In 1992, a Danish consensus conference was held on genetic manipulation in animal breeding—precisely the area that produced transgenic mice. Sclove reports that the Danish government subsidized over 600 local debates organized around the conference report. In an opinion that influenced subsequent Danish legislation, the biotechnology consensus conference reached the opinion that it is ethical to develop transgenic animals for developing cancer treatments in human beings but unethical to develop such organisms to be pets. The issue of patenting was not addressed. The particular conclusions would not please everyone, and the process is not perfect. But the practice is far superior to what passes for scientific and technical assessment in the United States. The process embodied in the consensus conference is part of what I mean by fostering situated knowledge.

COOPERATING MICE AND MOLECULES

The corporatization of biology could not have happened if mice and molecules

did not cooperate too, and so they and their kind were actively solicited to enter new configurations of biological knowledge. The technical and intellectual success of the new biology is stunning by whatever measure.[54] Much has been written about how the reconstitution of biological explanations and objects of knowledge in terms of code, program, and information since the 1950s has fundamentally recast the organism as a historically specific kind of technological system.[55] Nineteenth-century scientists materially constituted the organism as a laboring system, structured by a hierarchical division of labor, and an energetic system fueled by sugars and obeying the laws of thermodynamics. For us, the living world has become a command, control, communication, intelligence system (C^3I in military terms) in an environment that demands strategies of flexible accumulation (Dawkins 1982).[56] Artificial life programs, as well as carbon-based life programs, work that way. These issues are about metaphor and representation, but they are about much more than that. Not only does metaphor become a research program, but also, more fundamentally, the organism for us is an information system and an economic system of a particular kind. For us, that is, those interpellated into this materialized story, the biological world *is* an accumulation strategy in the fruitful collapse of metaphor and materiality that animates technoscience. We act and are inside *this* world, not some other. We are subject to, subjects in, and accountable for *this* world. The collapse of metaphor and materiality is a question not of ideology but of modes of practice among humans and nonhumans that configure the world—materially and semiotically—in terms of some objects and boundaries and not others. The world might be different, but it is not. The heterogeneous practices of technoscience are not deformed by some ontologically different "social" bias or ideology from the "outside." Rather, biology is built from the "inside"—both the kind of inside pictured by Quadrant in its magical ad and the kind of inside I have tried to signal with the term *implosion*—into materialized figurations that can only be called life as it is really lived.

OncoMouse™ makes technical and semiotic sense in the world of corporate biology, where the author of life as a writer of patentable (or copyrightable) code. Such authors and innovators might be naturally evolving organisms, or the scribblers and inventors might be the scientists who interact with critters to nudge their codes in more useful directions to (some) people. Because they provide a manipulable, mammalian model for human biology and disease, mice have been especially valuable as genetic research organisms for a long time.[57] That fact is evident in the *Encyclopedia of the Mouse Genome I*, a special 1991 issue of the journal *Mammalian Genome*. Playing on the belief that everything that really matters to an organism is in its "program," the *Science* magazine advertisement for the

Encyclopedia offered "The Complete Mouse (some assembly required)." Patents are only one form of intellectual property protection for transgenic animals, and not the most common form. No U.S. patents were granted for five years after OncoMouse[TM]'s debut in 1988 prompted protest from animal-rights groups and environmentalists. The European Patent Office initially rejected the application for a patent for the Harvard oncomouse but did grant it on the second round, in 1992. On December 29, 1992, the U.S. government ended a self-imposed moratorium on patenting transgenic animals when the Patent and Trademark Office granted patents to three organizations for novel transgenic mice. By January 1993, over 180 applications for transgenic animal patents were pending.

Custom-tailoring transgenic mice for specific projects is both routine, for procedures already established, and a leading-edge research area, capable of providing tools to address some of the most interesting questions in biology. For example, intricately engineered "knockout mice," with particular genes eliminated and various control mechanisms installed, have become indispensable tools in genetics, immunology, and developmental biology (Barinaga 1994). Researchers who make a useful mouse have been inundated by their colleagues with requests for the beasts. "Since the researchers were reluctant to get into the mouse breeding business, their universities awarded companies, including GenPharm International, a biotech firm in Mountain View, California, licenses to market the animals" (Anderson 1993:23). David Winter, the president of GenPharm, considers the technique of custom-making a rodent so routine that he calls it "dial-a-mouse" (Cone 1993:A16). Since about 1990, laboratories have begun cranking out custom-made research mice in significant numbers, and firms like GenPharm began buying up the rights. "Marketing gimmicks, complete with catchy names, have emerged. Scientists can call (800) LAB-RATS to take their pick of regular rodents or seven strains of transgenic ones" (Cone 1993:A17). Business writer Michael Schrage quotes GenPharm corporate development director Howard B. Rosen: "'We do 'custom-tailor' mice. We view them as the canvas upon which we do these genetic transplantations'" (Schrage 1993:3D). Using mice as model systems for genetic engineering in biomedicine, instead of bacterial or yeast systems, matters. "This transition will have as big an impact on the future of biology as the shift from printing presses to video technology has had on pop culture. A mouse-based world looks and feels different from one viewed through microorganisms" (Schrage 1993:3D). The analogy to inscription technologies and conventions of literacy could not be more apt.

Traditionally, biologists have enjoyed a kind of commons in research materials that they exchanged with each other. GenPharm International and the other companies, however, were in business to make a profit.[58] Their pricing

policies have been controversial. Not only did transgenic mice in 1992 cost $150 each, about ten times the price of a mouse from Jackson Laboratories of Bar Harbor, Maine, the institution that produced, standardized, and supplied laboratory mice for decades, but also, requiring researchers to pay for every rodent used, the company forbade breeding with their mice. Costs for researchers could easily run into thousands of dollars, and grant money has never been tighter. Biologists reacted to this enclosure of their own commons aggressively. The scientists' lobbying led GenPharm to change its policies. By May 1993, scientists at nonprofit institutions could breed their mice for an annual fee of $1,000; biotech companies must pay $10,000 to breed GenPharm mice. This developing system of enclosing the commons in genetically engineered materials is driven in part by university technology-transfer offices seeking to make a profit from contracts, patenting, licensing, and royalties (Anderson 1993; Cone 1993). At the same time, Jackson Laboratories plans to open a federally funded nonprofit mouse repository to distribute mice deposited there at cost. Patented and other exclusively licensed animals are unlikely to be deposited at the Jackson Labs.[59] A small corner of larger contestations for a biological commons, this aspect of biology remains molten and changeable.

Predictably, as genetically engineered mice diversify to fit research protocols and biomedical production, the ubiquitous technoscientific object called a database accompanies the fleshy rodents in a kind of higher-order mimesis of their biochemical genomes.[60] Oak Ridge National Laboratories is creating a "computer database for mutated mice" so that researchers can find the animals they need (Cone 1993:A17). More fundamentally, the entire mouse genome is a central research object in the context of the Human Genome Project. Recursively miming each other at every level, mice and humans are siblings in these projects, just as OncoMouse[TM] and the FemaleMan[©] are kin in the wormhole of this chapter. A biochemical genome is already a kind of second-order object, a structure of a structure, a conceptual structure of a chemical entity; and the electronic genome databases represent still another order of structure, another structuring of information. The genome is a historically specific collective construct, built by and from humans and nonhumans. To be "made" is not to be "made up." In my view, constructivism is about contingency and specificity but not epistemological relativism. The reality and materiality of the genome is simultaneously semiotic, institutional, machinic, organic, and biochemical. The development of computer databases for handling data from the various genome sequencing projects, with their Niagara Falls of sequence information and physical and genetic maps at finer and finer degrees of resolution, requires advanced informatics research and complex interdisciplinary negotiations.[61] In a material sense, like the human genome,

the mouse genome is part of that technical-semiotic zone called cyberspace.

Science magazine implicitly recognized that location in its covers for its special October "Genome Issues," beginning in 1990. Each cover has a version of Vesalius's Renaissance anatomical drawings of Man, who is variously reinscribed with the signs of computer data structures. The October 1, 1993, issue is most explicit for my reading of mice and humans in genetic cyberspace. A photographically realistic furry brown mouse peers over a computer graphic of a barrel-shaped gene in a colorized, stylized space semiotically familiar to computer-game players or fans of science-fiction films. In the foreground, the viewer sees the back of a Vesaliuslike human figure, stripped to the musculature and drawn with Renaissance conventions in black and white. The human and mouse avatars exchange glances with each other across the structured cyberscape of an electronic genome. Inside the issue is the prize: a foldout map of the mouse genome as it was known by press time, published by Life Technologies, with detailed guides to mouse-human homologies and the power of the mouse as the model for the human.[62] Like the readers of *National Geographic Magazine*, the readers of *Science* are members of scientific societies equipped with the best maps for going where no one has gone before.

Cyberspace is the spatio-temporal figure of postmodernity and its regimes of flexible accumulation. Like the genome, the other higher-order structures of cyberspace, which are displaced in counterintuitive ways from the perceptual assumptions of bodies in mundane space, are simultaneously fiercely material realities and imaginary zones. These are the zones that script the future, just as the new instruments of debt scheduling and financial mobility script the future of communities around the globe.[63] The genome is a figure of the "already written" future, where bodies are displaced into proliferating databases for repackaging and marketing in the New World Order, Inc. The promise of the genome is its capacity to occupy the future. Contesting for the shape and content of such promises is the job of displaced, uncanny figures like the FemaleMan©.

But s/he needs the help of OncoMouse™, her double in intellectual property capers that establish who gets to count as nature's author. Mice and humans in technoscience share too many genes, too many work sites, too much history, too much of the future not to be locked in familial embrace. Like the creatures in *Science* magazine's genomic cyberspace, OncoMouse™ and the FemaleMan© exchange glances while I look out on the world from their impious eyes to scrutinize what counts as constitutional foundations and natural acts these days in the republic of U.S. biology.

To conclude this section, rather than picking up her OncoMouse™ sidekick at Du Pont's authorized marketing agent, Charles River Laboratories, the

FemaleMan© meets her murine buddy cruising in another part of the city of science. In the early 1990s, looking like early incarnations of Disney's Mickey Mouse, OncoMouse™ appeared on the cover as the mascot of the *Disease Pariah News* (DPN), an irreverent AIDS-activist publication in its fifth issue. Just above the explanation of OncoMouse™'s adoption was *Disease Pariah News's* Golden Pariah Award to Senator Joe McCarthy's righthand man, Roy Cohn, who, having spent his life rooting out queers from public life, denied having AIDS to the day of his death. Golden Pariahs are awarded to folks with HIV who have been especially "traitorous to the community." Oncomice, said *DPN*, "produce nice organic tumors with no chemical aftertaste. They are nature's pariahs. Anyway we felt sorry for them and decided to elevate them to official mascot status." Opposite the welcome to OncoMouse™ was the advice column by Aunt Kaposi, who urged her flock to "ritualize your perversions, perfect your pitch, and most importantly, stigma with style. . . . I'm still thinking of you—you with my blood" (*DPN* 5:14).

I think the Harvard mouse, and Du Pont's soon-to-be-divested undead rodent, landed on its feet from the ongoing struggles for a livable technoscience. In *Disease Pariah News's* world, OncoMouse™ stands a fit witness, adopted by a fit community, one that is unlikely to wall itself off from the rough-and-tumble worlds of science and medicine. A categorically queer family, my OncoMouse™ and the FemaleMan© have a lot of refiguring to do. Where there is no room for nostalgia, purity, conspiracy theories of technoscience, appeals to culturally transcendent reason or dehistoricized nature, or any other reductionism, Joanna Russ's four Js give solid guidance: "Goodbye Politics. Hello politics. . . .Later we got better." It's not the too-young Laura Rose whom my author figure, the FemaleMan©, embraces in transgenic love but an adopted rodent who is a model for herself in the wormholes of commercial, bodily, and epistemological transactions at the end of the millennium.

Part 2. Natural Acts

SECOND MATHEMATICAL EPIGRAPH—AN INTEGRATION:

$$\int_0^\infty \int_0^\infty \int_{1945}^\Omega \text{NATURE}^{\text{TM}}\text{CULTURE}^{\text{TM}} \ dN \ dC \ dt = \text{NEW WORLD ORDER, INC.}$$

According to hoary beliefs in my world, mathematics is the language of nature and the foundation of science. At the origin of things, the creator wrote in mathematical symbols, and the continuing mythic status of math cannot be

missed by any schoolchild. But like any rich language, mathematics can sustain paranoid fantasies. My epigraph here is one such anxiously excessive misreading of the world. Like all paranoias, this fantasy, at once concrete and abstract, seems to fill all space and time. The triple integration, from zero to infinity, of all the instances of nature commodified multiplied by all the instances of culture commodified describes the closed volume of the space-time universe of the New World Order, Inc., the imploded material and imaginary chronotope of postmodernity. A mark of the paranoid is an excessive concern with order. My formal neurotic fantasy is a mathematical fiction. It is a way of troping a world whose vast normality—the massive, established disorder of it all—invades our dreams and demands our action. If we can trope this world, we can—literally—make it swerve, make it turn.

An inhabitant of the nature of no nature, OncoMouseTM is, in Paul Rabinow's terms, an instance of the "operationalization of nature" (Rabinow 1992b:244). That is much the same thing as Marilyn Strathern's "nature enterprised-up," where "the natural, innate property and the artificial, cultural enhancement become one" (Strathern 1992:39). In these implosions, we are also within reach of Sharon Traweek's high-energy physicists' "culture of no culture," where a rich human and nonhuman apparatus of the production and sustenance of technoscience appears to its most elite practitioners to be the realm of extreme objectivity, of culture-free natural law and empirical fact (Traweek 1988:162). What are all these "empty," fully operationalized spaces about? In the fabled country called the West, nature, no matter how protean and contradictory its manifestations, has been the key operator in foundational, grounding discourses for a very long time. The foil for culture, nature is the zone of constraints, of the given, and of matter as resource; nature is the necessary raw material for human action, the field for the imposition of choice, and the corollary of mind. Nature has also served as the model for human action; nature has been a potent ground for moral discourse. To be unnatural, or act unnaturally, has not been considered healthy, moral, legal, or, in general, a good idea. Can "empty" or "enterprised-up" nature continue to fulfill all these discursive tasks?

Perversely, the answer is yes. Nature in technoscience still functions as a foundational resource but in an inverted way, that is, through its artifice. In a gesture of materialized deconstruction that literary Derrideans might envy, the technoscience foundational narrative inverts the inherited terms of nature and culture and then displaces them decisively. In the generative empty spaces charted by contemporary critical theorists of technoscience, a nature fully evacuated by the air-pump of enterprise is still mutter/matter to the seminal act of

choice. How does the story work? Precisely as fully artifactual, the nature of no nature gives back the certainty and legitimacy of the engineered, of design, strategy, and intervention. The nature of no nature is the resource for *naturalizing* technoscience with its vast apparatuses for representing and intervening, or better, representing *as* intervening (Hacking 1983).

To illustrate this moral-technical discourse, I will again let biotechnology, especially genetic engineering, metonymically stand for all of technoscience. I will turn for instruction to a 1989 high school textbook designed to introduce U.S. students to *Advances in Genetic Technology* (Drexler et al. 1989). With the eyes of OncoMouse™ and the Femaleman©, let us go back to school to learn a little biology. Textbooks and pedagogy might have low status in the hierarchy of luminous scientific entities and practices—way below knockout mice and the top quark—but they are the focus of extraordinary technical, literary, economic, and political coalitions and struggles in the United States. And that is not new. Sociologist Eric Engels examined a large body of pre-World War II U.S. biology texts and educators' writings. Content with the great divide between nature and culture, biology textbooks tend to explain the "social" in terms of the "natural." Biology texts, in educating "adolescents," itself a twentieth-century category, about the living world "constructed that world in particular ways generally consistent with commodification, capital accumulation, the bureaucratization of society, the strengthening of professional and technocratic authority, the marginalization of people of color and women, and the privileging of heterosexuality and the nuclear family" (Engels 1991:abstract).

Current struggles over biology textbooks touch every one of those points. Reformers understand that biology, at its technical and scientific heart, is a subject in civics; biology teaches the great mimetic drama of social and natural worlds. That is its function in urban schools in an industrial democracy. This history, like that of intellectual property, reaches deep into the republic to touch themes of democracy and liberty. Charles Rosenberg examined U.S. schoolbooks on health and the body in the middle third of the nineteenth century, when "textbooks of physiology and hygiene developed into an increasingly standard form." Other sciences taught in schools in that period, such as geology and geography, also "were (and are) freighted with a variety of meanings, but images of the body and related concepts of health and disease are even more richly inscribed with social—and emotional—resonance" (Rosenberg 1995:176–77). Philip Pauly explored how biology, a subject "that was both ostentatiously objective and intensely value laden" (1991:662), became a central part of the high school curriculum in New York City in the early decades of this century, and from there a part of education throughout the United States. In this

FEMALEMAN© _MEETS_ ONCOMOUSE™

process, biology's themes and images became an established aspect of middle-class culture. Many science educators in 1900 did not consider biology a fit subject for young people. Their objections were addressed by reformers who argued that biology would help prepare liberal, secular, and humanistic youth who understood the great scheme of natural development and evolution in progressive terms that stressed experimentation and cooperation, not conflict.

My first employment after graduate school in Yale's Department of Biology was in a General Science Department in a large state university from 1970–1974. There my job explicitly was to teach biology and the history of science to "non-science majors," a wonderful ontological category, to make them better citizens. I was part of a team of young faculty led by a senior teacher who had designed a course to fill an undergraduate general education science requirement for hundreds of students each year. In the middle of the Pacific Ocean, home of the Pacific Strategic Command that was so critical to the Vietnam War with its electronic battlefield and chemical herbicides, the University of Hawaii biology course aimed to persuade students that natural science alone, not politics or religion, offered hope for secular progress not infected by ideology. I and the other younger members of the course staff could not teach the subject that way. Our post-Enlightenment epistemological confidence was much messier than that. For us, science and history had a much more contradictory, and more interesting, texture than did the allegory of purity and prophylactic separation we were supposed to teach. Many of my graduate school biology faculty and fellow graduate students were activists against the war partly because we were acutely aware of how intimately science, including biology, was woven into that conflict—and into every aspect of our lives and beliefs. Without for a minute giving up our commitments to biology as knowledge, many of us left that period of activism and teaching committed to understanding the historical specificity and conditions of solidity of what counts as nature, for whom, and at what cost. It was the epistemological, semiotic, technical, and material connection—not the separation—of science and cultural-historical specificity that riveted our attention. Biology was interesting not because it transcended historical practice in some positivist epistemological liftoff from Earth but because natural science was part of the lively action on the ground.

I still use biology, animated by heterodox organisms burrowing into the nooks and crannies of the New World Order's digestive systems, to persuade my readers and students about ways of life that I believe might be more sustainable and just. I have no intention of stopping and no expectation that this rich resource will or should be abandoned by others. Biology is a political discourse, one in which we should engage at every level of the practice—technically, semi-

otically, morally, economically, institutionally. And besides all that, biology is a source of intense intellectual, emotional, social, and physical pleasure. Nothing like that should be given up lightly—or approached only in a scolding mode.

The copyright to *Advances in Genetic Technology* is held by the Biological Sciences Curriculum Study (BSCS), the same group that redesigned U.S. biology instruction in the late 1950s after Sputnik shocked the U.S. establishment into attention to science instruction as a national priority. The genetic engineering textbook project was funded by the National Science Foundation; Monsanto Agricultural Products Company; E. I. Du Pont de Nemours & Co.; Ward's Natural Science Establishment, Inc.; and CIBA-Geigy Corporation. By the late 1980s, the threat to national security, from which sprang the charge to the nation's science educators, was perceived to be from the highly competitive transnational systems of production and marketing intrinsic to "high technology." Every U.S. presidential administration since Carter's has emphasized technoscience as the key to the future of the civilian economy and national power, as they could imagine it. The combination of actors producing the new textbook is emblematic of the New World Order. The financial movers and shakers of the project included a long-established scientific supply house to the nation's thousands of schools —no small market; major agribusiness and medical biotechnological corporations; and the principal federal science agency for biological research as well as for programs in ethics and values in science and technology. Advisory committee members and authors came from the U.S. Office of Technology Assessment, the Air Academy High School, the University of California, CIBA-Geigy of the North Carolina Research Triangle Park, the BSCS, Monsanto, University of Iowa Hospitals and Clinics, and various other high schools and universities. Over 800 high schools participated in the project. This lineup is not a conspiracy; it is a historically specific apparatus for the production of NatureTM and CultureTM. It is about free enterprise as natural acts. It is above all about choice, and we all know that only the irrational, traditional, and benighted are against choice. Choice is supposed to define liberty. The issue is, which and whose choices?

Biotechnology corporations not only fund textbooks; they also fund high school science labs and experiments in the financially strapped U.S. schools of the 1990s, a time when a public school bond issue has about as much chance of passing in an election as gay teachers have of being honored by fundamentalist Christian preachers. For example, between 1989 and 1993 the Genentech Foundation, the nonprofit branch of the biotech company, provided more than $130,000 to schools in San Mateo County, California, to do state-of-the-art lab experiments in genetic engineering. Social impacts of the research were part of

FEMALEMAN© _MEETS_ONCOMOUSE™

the curriculum, and the program was tailored for all levels of ability. The equipment to do genetic experiments is expensive, for example, $5,000 for a minimum lab test kit, a figure way beyond public school science budgets. The hands-on program has been very successful. One fifteen-year-old student was quoted as saying, "Cutting frogs was the 1960s, but this is the future" (Aratani 1993:2B). I think science activists, including myself, also have to figure out what was the 1960s and what is the future.

Highlighting the inverted foundational narrative of nature and culture, Lesson One in *Advances in Genetic Technology* is titled "Natural Genetic Engineering." The point is excruciatingly simple: Nature is a genetic engineer. Using the ability of *Agrobacterium tumefaciens* microorganisms that have a bit of circular DNA called the Ti plasmid to infect the leaves of *Kalanochoe*, a common houseplant, causing crown gall disease, the lesson leads students through a combination of their own experiments and analysis of those of plant scientists. Nature, the scientists, and the students seem to be doing much the same thing. The Ti plasmid integrates into the chromosomes of the plant cells, carrying genes across organic kingdoms. The adult scientists do various gene transfers and splicings. The students grow bacterial cultures under various conditions and infect plant leaves. Mimesis reigns implicitly, and nature started it all off. At the end of the chapter, the student is invited to "review the following concepts," beginning with the principles that "genetic rearrangement occurs naturally" and "natural genetic rearrangement is one source of the variation that occurs in nature." The review list ends with a cautionary note that puts the students in a world full of legitimate regulatory structures: "Experiments that involve potentially biohazardous material must be conducted in accordance with established safety measures" (Drexler et al. 1989:11).

Lest an important aspect of the mimetic process be missed, the first chapter, like several of the others, ends with a section on "Careers in Biotechnology." In this foundational chapter, the career is "plant geneticist." The first line is, "Imagine transforming a plant to make it better than it already is—to make it able to grow to maturity without being killed by insects, viruses, or herbicides" (12). It sounds very nurturing. The person chosen to model this particular career choice is Maud Hinchee, a white woman with a Ph.D. in botany from the University of California at Davis who now works at Monsanto's Life Sciences Research Center in Saint Louis.[64] One of the textbook's coauthors, Dr. Hinchee is pictured with a pipette and a petri dish alongside another woman scientist who looks to be Asian or Asian American. Throughout the career portrait, Hinchee is referred to as "Maud." Despite hard work, "the fascination and intrigue of working in harmony with nature make biotechnological research an

enjoyable and challenging career for Maud." The penultimate point reassures anyone who worries about the nature of woman as scientist in the New World Order: "She is married and the mother of one child." One can have everything, and I can forget all those impassioned meetings and informal conversations among women scientists on my campus and elsewhere about ongoing problems of gender discrimination, child care, and intricate biological and career clock synchronization. We get Hinchee's leisure-time activities too, from gardening to jogging. Choice and fulfillment are the marks of a life lived in accordance with nature. *Agrobacterium tumefaciens* on *Kalanochoe* leaves seem to ground a satisfying yuppie culture.

Career issues get high-profile attention in the American Association for the Advancement of Science's publication, *Science*. For the last three years, the news staff of the journal has published well-researched and imaginatively conceived special issues both on women (all colors) and on minorities (the main available genders) in science. Those issues have contained first-rate science writing, and they have addressed U.S. science patterns critically, comparatively, and internationally. Like other publications in technoscience, *Science* is also full of commercial culture, and ads often foreground the attractions of the biotechnical way of life. Of special interest, however, are the lavish multipage advertising supplements such as "Careers in Pharmaceuticals and Biotechnology," "Careers in Pharmaceuticals and Biotechnology: West Coast," "Futures in Academic and Industrial Science for BS and MS Scientists," and "Euroscience at Work: Career Opportunities in European Pharmaceuticals and Biotechnology" (Timpane 1992; 1994a; 1994b; 1995). The graphically well-designed supplements were authored, like news articles, and they were replete with information and analysis. There was no line between advertising, news, and science studies scholarship. The specific companies' ads interwoven with Timpane's text stressed creativity, freedom, opportunity, gender equality, multiculturalism, scientific excitement, and advantages universities would be hard pressed to match, including high salary ranges and stock options. Timpane tells us that in 1992 the average income for a Ph.D. scientist in teaching was $48,000; for a Ph.D. scientist in industry, the average was $61,000. Academic researchers averaged $51,200. The NIH advertised alongside Pfizer and SmithKline Beecham Pharmaceuticals, which announced the theme of "exploring nature's exquisite order." Against a beautiful blue image of the cloud-wrapped whole Earth, centered inside a gleaming liquid droplet suspended delicately from the terminal lumen of a lab pipette, Lilly's ad urged prospective employees to "share our worldwide commitment to discovery." NASA, Lilly, the reader: They all inherit the great travel narratives of Europe's imperial Age of Discovery. "Land ho! my job." The lines

demarcating commercial culture, basic science, natural history for the citizen, business news, visual arts, personal testimonials, and science policy are very blurry in genetics and biotechnology, including at the level of the semiotic details of publishing. I still go to archives to maintain my credentials as a historian of science, but it is getting to be a quaint activity compared to reading the ad supplements and business pages prepared by first-rate nonacademic writers, scholars, and artists.

Lesson Two of *Advances in Genetic Technology*, "The Tools of the Genetic Engineer," explicitly leads the student from natural genetic engineering to the process in the laboratory. Framed by the story of how growth hormone produced through genetic engineering helped solve the health problems of one family, the lesson gives students a hands-on gene engineering experience, using paper-clip DNA models. Here the metaphors of tools and factories abound, and the career portrait section takes the high school sophomore "Rob" into an exciting summer job at FastGro Seed Company. "A lot of my friends from school will be doing the same thing," (Drexler et al. 1989:21). That is another important kind of mimesis in the reproduction of technoscience. Choice feels more natural when lots of other folks make the same ones. I don't want to be petty, but I couldn't help but notice that the male person in Lesson Two was coded unambiguously as a budding engineer, and the female person in Lesson One was a happy dual-career mother nurturing plants to save them from mean viruses and herbicides. Still, someone should have told Rob that castrating endless corn plants in the hot Midwestern summer might dampen his enthusiasm for science, whereas Hinchee's life looks pretty good. Let's just hope Rob didn't enter into a mimetic relation with his research organisms. Under the planned experimental regime, such identity formations could do real damage to a delicate mammalian male adolescent.

Both OncoMouse™ and *Advances in Genetic Technology* teach us that universal nature itself is fully artifactual. This intimately culturally particular lesson is firmly located in a durable, ethnospecific, naturalizing discourse that continues to justify "social" orders in terms of "natural" legitimations. Thus, the new nature of no nature gives back the limpid image of the world as engineered and engineering, as artifactual, as the domain of design, strategy, choice, and intervention—*all without transcendental moves*. That is this world's sacred secular magic, just as it has been since the founding stories of the Scientific Revolution.

Advances in Genetic Technology does not ignore controversy and value conflict. Indeed, they are the subject of Lesson Four, "Ethics and Genetic Engineering." Mimesis still reigns, as in any good naturalistic discourse: Just as the scientists modeled their activity on natural genetic engineering, the ethicists model their

discourse on nature. But recall, nature is a technics through and through. Bonnie Spanier (1991) shows how that belief system and practical commitment is intrinsic to the plot, examples, metaphors, experimental exercises, and arguments of one of the best recent college textbooks in molecular biology, in which an equation is lovingly elaborated: biology = molecular biology = molecular genetics = genetic engineering (Darnell, Lodish, and Baltimore 1986). This equation is much more than a "mere" metaphor; it is a research practice, representational convention, epistemological conviction, health belief, and commercial premise. The nature of no nature is to be a technical artifact, and bioethics takes the collapse of trope and materiality very seriously. Therefore, in *Advances in Genetic Technology*, ethics is a technical discourse about values clarification and choice. The chapter provides an exercise in rational ethical analysis for translating conflicting moral values into public policy. Ethical analysis mimes scientific analysis; both are based on sound facts and hypothesis testing; both are technical practices. Not surprisingly the career portrait section notes that most people working in bioethics have a "'terminal degree,' the highest academic degree offered in their discipline. That is usually the doctoral degree" (Drexler et al. 1989:30). Examples are philosopher, lawyer, health care professional, and social scientist. Citizens, like nature, are themselves technical workers. Is a "terminal degree" the point at which better things for better living come to life?

Like biotechnology itself, including genetic engineering, ethics is also now a literal industry, funded directly by the new developments in technoscience. Ethics experts have become an indispensable part of the apparatus of technoscience production. Syndicated business and science writer for the *Los Angeles Times*, consultant, and research associate at M.I.T. Michael Schrage quotes Arthur Caplan, the director of the University of Minnesota Center for Biomedical Ethics: "'Just the Human Genome Project alone is the Full Employment Act for bioethicists,'" (Schrage 1992). The National Institutes of Health National Center for Human Genome Research sets aside 3 percent for "ELSI"—ethical, legal, and social implications—and state governments also fund ethical and policy research in human genome and other biotechnological areas. Caplan estimated that by 1992 there were about 2,000 bioethicists, mostly drawn from the academic specialties of theology and philosophy but beginning to be produced by custom-tailored programs. Schrage sharpened his analysis with the observations of Lawrence Gostin, executive director of the American Society of Law and Medicine: "I think ethics is becoming a commodity. . . . While we like to think about the ethical consequences of new technologies, we have never thought about the ethical consequences of having an ethics industry" (Schrage 1992). Schrage presciently analogized the budding bioethics industry, with its

bright future in jobs, to the intellectual property rights field, whose stock has also risen out of obscurity with the stars of biotechnology and computer sciences.

I am certainly not arguing that the textbook lesson is giving the students bad advice.[65] I am merely meditating on the layers of mimesis in an origin story. If such mediation makes the students nervous, then maybe there can be a crack in the enterprise of decontextualized choice and of strategy for strategy's sake. What if *Advances in Genetic Technology* were read in a high school English class to illustrate the structure of foundation narratives as well as in a science class to illustrate the structure of the natural-technical world? And what if the biology text were read in lab classes as itself a moral discourse and not just a science book that has a wannabe chapter on the techniques of moral reasoning? What if the study and crafting of fiction and fact happened *explicitly*, instead of covertly, in the same room, and in all the rooms? Would the graduates of that pedagogy have a keener grasp of what it might take to build a practice of situated knowledges or strong objectivity, where the simultaneously enabling and endangering stories never slipped from loving grasp within the daily toolkit of on-the-ground technoscientific practice?

Perhaps a different "career choice in biotechnology" from that of Maud Hinchee can close this meditation. I only have a few lines in a textbook about Hinchee, and I am concerned not with claims about her as a real person but with her paradigmatic semiotic function in a text. The contrasting career that I will present is also gleaned from scientific publishing sites, but in this case my sources include personal interactions, colleagues in common, graduate school experiences in the same department that are an academic generation apart, and the scientist's oral performances. I still, of course, have not "the real person" but discourse, albeit with more modalities that engaged my own on more levels.

Martha Crouch is a tenured professor in the Biology Department at Indiana University. Prepared by a Ph.D. in biology from Yale, this young white woman rapidly became a prominent researcher in plant molecular and cell biology in a major Midwestern university in the heartland of American agriculture. She studied the dynamics of pollen tubule formation during fertilization. Crouch won several prestigious, substantial grants, totaling over $1 million over a few years, to support her lab, which housed technicians, graduate students, and postdocs. Like most leading molecular plant biologists in the big universities today, she also regularly consulted for agribusiness research companies such as Calgene and Unilever.

With a long-term interest in natural history, Crouch was also an activist in movements for environmental justice, biodiversity conservation, and sustainable life-support practices within the complex webs of social nature, where the

inhabitants, all of them historically specific, are both human and nonhuman. She founded the Bloomington Rainforest Action Group, and she coedited the *Forest-Watch Newsletter*, a citizens' journal for sustainable ecology. Progressively, she found fewer and fewer ways to do her "pure research" or her professional consulting that did not contribute to the deeper commodification of nature and the expansion of systems of agribusiness—the production of a nature of no nature. She judged that such research contributed to deepening and widely distributed human inequality in the United States and abroad, intractable hunger, and environmental destruction for humans and nonhumans.

Specifically, Crouch became aware that her consulting for Unilever was related to the company's development of clonally propagated oil palm plantations in Asia and Central America. Educating herself on the issue, Crouch judged that such plantations displace indigenous people from their rainforest lands and ways of life, rehired them as very-low-wage laborers on agricultural factory plantations that contributed to water pollution in their processing plants, displaced healthier fats in local as well as international diets, put smaller-scale producers out of business, and contributed to loss of genetic diversity by replacing multispecies forests with monoculture oil palm. Crouch came to the conclusion that this story was typical, rather than exceptional, in the integration of molecular biology and industry (Crouch 1995a).

She began to question her pleasure in the playful world of pure science, and she judged that one of the ways that scientists like her are inhibited from developing a broad critical approach to their work *as part of their core science* is by learning to craft an identity that encourages a permanently childlike innocence. In the lab itself, even to a significant degree in industrial sites that are replete with campuslike signifiers, in exchange for extraordinarily hard work and total commitment, the scientist is free, privileged, allowed to play for a living—and highly rewarded for being on the "cutting edge." This is another aspect of the culture of no culture; like Peter Pan, forever latent and androgynous, one does not grow up to the complex erotics of a more fraught technoscientific practice. Crouch felt that the psychological and practical separation of the political and the technoscientific, which was essential to the ordinary canons of objective scientific practice, and which functioned to keep her science and her activism apart, represented an immature technoscientific subject formation (Crouch 1991; 1994a and b). In Sandra Harding's terms, she was developing a practice of stronger objectivity.

Crouch's response to her critique was carefully to alert the people in her lab so that they could make their own decisions and plans and then to publish a letter resigning her grants and explaining the reasons in *The Plant Cell*, the most

FEMALEMAN© _MEETS_ONCOMOUSE™

prestigious journal in her field, in the issue after the one in which she and her coworkers published the lead scientific report, which was featured on the cover (Crouch 1990). Crouch's decision was made at a time when her university was raising $30 million for an Institute for Molecular and Cellular Biology. She did not resign her tenure but committed herself to teaching biology as part of environmental justice, including courses on the significantly low-status topic of food: how it is produced, who gets it, and under what conditions. Conscious that she had perhaps a couple of years of credibility based on her research reputation, she also undertook an extensive speaking schedule among her colleagues to try to build a more activist engagement in the core issues of technoscience and sustainable life systems.

I am not arguing that Maud Hinchee is wrong and Martha Crouch is right. Though slanted toward Crouch's, my own judgment is somewhere between each person's position as it is described here. I want somehow for all the parts to hold together, and I believe responsible and important work, evaluated by canons of strong objectivity, can and must be done in research labs. Crouch was severely criticized by some of her colleagues (one compared her to Hitler for unleashing the forces of unreason and impeding the flow of dollars to true science!) and appreciated by others, including many graduate students in plant molecular biology who continue to invite her to speak to them. I agree with some of Crouch's critics and not others. That is also not the point. What I am arguing is that the multiple implosions made inescapable by late-twentieth-century technoscience include the political and the technical as well as the natural and the social, and that these implosions have deep consequences for the *practice* of scientific objectivity. Situated knowledges make much stronger demands on the reproductive apparatuses of technoscience—the key literary, material, and social reproductive technologies—than decontextualized values-clarification techniques practiced by Ph.D.s and role models provided by female scientists, of whatever race, nation, or class. Crouch models a responsible life in science, one that can be questioned at many levels and one that offers hope. She does not model the practice of pure science in the nature of no nature, where only applications, but not basic research systems and fabrics of knowledge, are approved for critical cultural analysis.

I am not so much against mimesis in storytelling as I am convinced that the play of mimicry has got to be a lot less reassuring for the already powerful. "Choice" is less the metaphor I seek for how to behave in technoscience than "engagement," or even, at the risk of piety in the permanently contingent games of mimesis that I want to play, "commitment." Commitment cannot take place in the empty spaces of NatureTM and CultureTM, and the all-too-full spaces of

foundational, unmarked Nature and Culture have been permanently sucked out of the world. Such foundations are unlamented by those they marked as nonstandard or branded as resource for the action of the hero. The FemaleMan© is especially clear about that. So, commitment after the implosions of technoscience requires immersion in the work of materializing new tropes in an always contingent practice of grounding or worlding. Refigured as a dispersed and unnatural FemaleMan and as an undead rodent looking back at us as it climbs toward the always promising and always blinding light of technoscience, the new actors in scientific narratives have got to do better than repeat a seventeenth-century English disappearing act into the vacuum space of the culture of no culture.

Following Susan Leigh Star's (1991) lead, the question I want to ask my sibling species, a breast-endowed cyborg like me, is simple: *Cui bono?* For whom does OncoMouse™ live and die? If s/he is a figure in the strong sense, then s/he collects up the whole people. S/he is significant. That makes such a question as *cui bono?* unavoidable. Who lives and dies—human, nonhuman, and cyborg—and how, because OncoMouse™ exists? What does OncoMouse™ offer when, between 1980 and 1991, death rates in the United States for African American women from breast cancer increased 21 percent, while death rates for white women remained the same. Both groups showed a slight increase in incidence of the disease.[66] Who fits the standard that OncoMouse™ and her successors embody? Does s/he contribute to deeper equality, keener appreciation of heterogeneous multiplicity, and stronger accountability for livable worlds? Is s/he a promising figure, this utterly artifactual, self-moving organism? Is the suffering caused to the research organisms balanced by the relief of human suffering? What would such balance mean, and how should the question inflect practices in the machine-tool industry of science—that is, designing research protocols? These questions cannot have simple, single, or final answers. However, a serious commitment to refusing both the culture of no culture and the nature of no nature means these questions have to be asked, *as a constitutive part of technoscientific practice*, and not primarily by professional values-clarification technicians with terminal degrees. It is past time to perform another kind of reversal and displacement of nature and culture than that effected by *Advances in Genetic Technology*.

It is necessary to return to the point where Margaret Chon (1993) brought us, in her rethinking of the U.S. Constitution's patents and copyrights clause and the approaches of James Madison and Thomas Jefferson to intellectual property and liberty, in order to tie our search for a technoscientific commons together with approaches to the teaching of biology. In many ways, *Advances in Genetic Technology* is a good textbook and not a straw opponent. It has a hands-on

approach, a commitment to diverse role models, and a sense of legitimate conflict about social and ethical issues. It also designs experiments that do not cost a lot of money. But this textbook still subscribes to the foundational principle that undermines what Michael Flower, a science studies scholar and developmental biologist at Portland State University, calls a "politicoscientific community." That is, *Advances in Genetic Technology* accepts the foundational ontological divide between the social and the technical, between science and society, between the technical and the political. The practice of science and the ethical issues are cleanly separated into different chapters; each is conceived in a technicist manner; and the mimetic work is all done unconsciously and ideologically. Drawing from current scholarship in science studies and feminist theory, Flower argues for a more promising constitutional premise for the republic of technoscience; he calls it "technoscientific liberty" (Flower 1994; n.d.).[67]

Flower thinks of liberty as "relational power . . . seeking to reconfigure the possibilities of action" in the practical world of science. "Articulate" and "communal," liberty is achieved in solidarity. For Flower, liberty is at stake in sciencein-the-making, not in the realm of the already settled. Technoscience is about "world-binding narratives that connect humans and nonhumans" into consequential patterns. Liberty is not the principle of stripped-down choice animating the "free market" of the New World Order, Inc., but "the struggle within and about the 'politics of technoscientific truth' of our world." Technoscientific liberty takes shape in strong, contestatory democratic practice, "and in the creation of technoscientific ends achieved by citizen activity. This means that creation of *politicoscientific community* is one of the chief tasks of participatory public action and a goal toward which liberty-tuned science pedagogy would be directed." Technoscience is civics, in the strong sense, at the heart of what can count as knowledge. "If constitutive technoscience is a source of fresh politics, it always operates . . . [by changing the] human / nonhuman polity." Liberty resides in the active processes of putting humans and nonhumans together and taking them apart in the practical-theoretical work of doing technoscience. Some worlds flourish as a result, and others do not. Accountability inside of and for those processes are the heart of science, ethics, and politics. World-binding material networks are where the action is, where the important passions and struggles are. Flower insists that "the associations that matter with respect to liberty are not only with other persons, but with non-human things and beings as well." The kind of technoscientific literacy required to engage in these processes is bracing and challenging. My FemaleMan© and the Du Pont-*Disease Pariah News*'s OncoMouse™ would have a secure, if bumptious, future in that polity.

These displaced sibling figures would also do well in Michael Flower's sci-

ence classes at Portland State. They would engage in the natural acts laid out in his and his colleague William Becker's Science in the Liberal Arts Curriculum (SLAC), a project funded by a grant from the National Science Foundation.[68] The NSF officer for the grant called its approach "deep reform." The doing of science is the focus, and doing science means doing the work of boundary maintenance and boundary crossing that does not ask permission from the border police guarding the line between the technical and the political as well as the human and the nonhuman. From the first year, and at all levels of difficulty in the various branches for those who specialize in science and those who do not, the curriculum emphasizes "investigative, 'hands-on' and data-rich labs; collaborative inquiry; alternatives to lecture; facil[itation of] students' coming to know how scientists know; themes common to several sciences; and situ[ating] the questions and aims of science in social, political, historical, and ethical contexts" (Becker and Flower 1993). For example, in 1994–1995 students in the Natural Science Inquiry course worked under a contractual arrangement with the Portland City Council to fashion an Environmental Quality Index for the city. Students in the fall term did background work, and students in the winter term wrote the report. Both groups had to "grapple with raw and interpreted data, past reports from city bureaus and their consultants, and monographs on such topics as air quality, ground water, transportation, and energy policy." The point is to place students inside technoscience, where their own work matters and where they have a chance to experience and be accountable for the heterogeneous skills and embodiments of technoscience-in-the-making. The purpose is to build a stronger technoscientific democracy (Barker 1984).

Students are hailed, interpellated, into technoscience, where they are subject to and subjects in a world-making discourse but within an apparatus committed to culturally rich and historically specific liberty. The power-knowledge nexus is called to account at the heart of doing science, not in the leisure time reserved for official social relevance. Students bind worlds of humans and nonhumans together in promiscuous disregard for what is supposed to be politics and what science; rather, they learn a high regard for the hard and sustaining work of problem development, inquiry that depends on colleagues, struggles for meaning and goals, and building multidisciplinary and practical knowledge. There is no public with "attitudes" to measure here but an emerging pedagogical wormhole for transporting the citizens of technoscience into unexplored regions of a truly new and democratic world order, limited.

"Constructivism" in Flower's sense is anything but disengaged "relativism," with its attenuated and idealist sense of difference. From the standpoint of technoscientific liberty, consequences matter; knowledge is at stake; freedom

FEMALEMAN©_MEETS_ONCOMOUSE™

and agency are in the making; and there is no possible transcendent resolution of questions by appeal to context-independent disembodied entities, whether they be called God, reason, or nature. Contexts are dynamic material webs of human and nonhuman actors. Flower's way of teaching science is part of building situated knowledges and strong objectivity. Flower's practice is akin to what physicist Karen Barad calls "agential realism" (1995a).[69]

Barad reads Niels Bohr's philosophy-physics in the context of contemporary feminist science studies to develop a strong account of natural-social agency in scientific knowledge. Growing out of human and nonhuman "intra-action" (Barad's word), "agency" is not about "subjectivity" that can be in any sense separate from "objectivity." Agency is about knowledge and accountability for boundaries and objects; that is, about "agential realism." Eschewing all romantic appropriations of quantum physics that evade strong knowledge claims, Barad argues that Bohr's interpretation of the experimental-theoretical nexus of quantum mechanics is crucial to understanding how an observation and agencies of observation cannot in principle or in practice be independent. With Bohr, Barad argues that experiments are constructed events for which definite conditions for the repeatability of phenomena can be communicated. That is, objectivity and determinate relations depend upon specific intra-actions for which an ideological divide between nature and society and claims of observer independence of measurements are deeply misleading. All measurements depend on embodied choices of apparatus, conditions for defining and including some variables and excluding others, and historical practices of interpretation. "Agencies of observation" are not liberal opinion-bearers but situated entities made up of humans and artifacts in specific relationship. "Objectivity is literally embodied . . . wholeness is about the inseparability of the material and the cultural. Wholeness requires that delineations, differentiation, distinctions be drawn; differentness is required of wholeness" (Barad 1995a; 24, 29).[70] Reality is the fruit of intra-action, where material and semiotic apparatuses cannot be separated; and *which* material and semiotic apparatuses will be in play at are at stake.

So, for Barad, reality is not independent of our explorations of it, and reality is a matter not of opinion but of the material consequences of constructing particular apparatuses of bodily production. The wormholes of current technoscience are such apparatuses of bodily production. Identities—of humans and nonhumans—are destabilized in these wormholes; as Barad reminds us, identity is always formed in intra-action.

Let us put these deliberations back inside the focal practice of "Natural Acts," namely, teaching biology, that eminently civic science. Scott Gilbert (forthcoming) revisits the story of the founding of courses in Western civiliza-

tion in the U.S. university out of the World War I War Studies Course that taught American soldiers about the European civilization they were crossing the Atlantic to fight for. Over the next decades, Western Civ became an initiation rite and unifying body of study in the university experience across many differences of race, gender, and class. In the explosion of critical reflexive discourses across the humans sciences in the past few decades, partly rooted in feminist and multicultural opposition to the modes of unity and knowledge built into the worldview and power relations that made Western civilization possible, that course has disappeared as a broadly shared experience. No course of study in the humanities, arts, or social sciences has taken—or seems able to take—the place of Western Civ. But, Gilbert argues, biology is another matter. Biology departments across the nation are seeing their student majors expanding exponentially and their introductory courses filled with students from all over the university. Biological narratives, theories, and technologies seem relevant to practically every aspect of human experience at the end of the twentieth century. The biological body—and its mirror twin, the informational body—is the wormhole through which explorers will be hurtled into unexplored territories in the New World Order. OncoMouseTM and the FemaleMan$^{©}$ both know that in their most intimate genomes.

While other disciplines fragmented in massive practical and epistemological identity crises, Gilbert claims, biology "has become vigorous, multidisciplinary, and well funded. Its reliance on living matter has kept it from going the route of physics, and its existence within a country suspicious of evolution has kept it from embracing postmodernism. It cannot afford to say that it does not have a more valid, truth-seeking, program than the Creationists. Biology salvages one of the most fundamental components of the 'Western Civ' tradition, the discovery of truth" (forthcoming:18). Fueled by important social concerns, large infusions of capital, epistemological confidence, international relevance, and the sheer excitement and fascination of the subject, every area of biology is expanding. Those areas include "molecular biotechnology, computer-aided prosthetics manufacture, rational drug design, transgenic crops, or environmental monitoring systems" but also many other approaches to development, evolution, neurobiology, genetics, ecology, and behavior.

I think Gilbert is right; biology (along with information and computer practices in their broadest sense) is now and will become even more the locus of the most widely shared university experience. That fact is full of consequences. Never has there been a time when engaging the heterogeneous practices of constructing biological knowledge has been more important. I also think Gilbert is in nonidentical agreement with Flower and Barad. The truths of biol-

FEMALEMAN© _MEETS_ ONCOMOUSE™

ogy are historically crafted in practices where materiality and semiotics, encompassing the dynamic agency of humans and nonhumans, cannot be disentwined. Teaching Christian creationism as science is child abuse as well as bad biology, but teaching biology as an ahistorical representation of objects separate from their "agencies of observation" is equally debilitating. Those agencies all demand attention to technical, political, economic, textual, and oneiric fields of force. In the wormhole of biology as technoscience we may expect to see the most startling natural acts, modestly witnessed by conjoined siblings such as OncoMouse™ and the FemaleMale©. The question is what kind of civic and familial orders of humans and nonhumans will be built into such natural acts.

3

A FAMILY REUNION

FemaleMan© and OncoMouse™ are both creatures of genetic technologies and, along with the modest witness, of writing technologies. Within specific instrument-physical-narrative fields, and only in such located fields, even if the field domains are globally distributed, the nature of my three revamped figures is to be arti-facts, tools, and substitutes. They are agents, in the double sense, for some worlds rather than others. Inside the stories where they circulate, they trouble kind and force a rethinking of kin. Gender, that is, the generic, is askew in the transgenic mouse and the oxymoronic hominid. They do not rest in the semantic coffins of finished categories but rise in the ambiguous hours to trouble the virginal, coherent, and natural sleepers. They visit Robert Boyle in his sanitized, night-time, restricted, public spaces. Lively, self-moving entities, they are undead and unsaved; they are profane. The transgenic mice and the four Js of the world inhabit an unfixed but not infinite material-semiotic field where possible lives are at stake. Russ's Female Man was the four Js, a clone, four white women, genetically identical, living alternate histories, inhabiting different chronotopes, but meeting in a time warp. OncoMouse and its transgenic kin are composite organisms, tailored tools whose boundary crossing is like the FemaleMan's. Both OncoMouse and the FemaleMan are unnatural; both force a revaluation of what may count as nature and artifact, of what histories are to be inhabited, by whom, and for whom.

I am joined in a family romance with the (onco)mice of all species and (female)men of all genders in the worlds of technoscience. We are sibling species filling barely differentiated, multidimensional niche space. We gestated together in the manly and natural time machines of modernity and enlightenment only to

be decanted unfinished into another kind of story. I need my sibling species to get me through this life story; our bodies share substance; we are kin. Let me summarize the ties that bind the FemaleMan$^©$ and OncoMouseTM together, with each other and with my witnesses, the readers and writers of this book.

First, as genetic clones and transgenic creatures, OncoMouseTM and FemaleMan$^©$ are the products of genetic technology, the issue of the new reproductive technologies that reach far beyond human procreation. As offspring of these reproductive technologies, OncoMouseTM and FemaleMan$^©$ display problematic kinds of individuality and coherence. Understanding identity as an effect with consequences is not a fancy theoretical point for them; it is rather ordinary common sense; it is what they need to get through the day.

Second, they are both products of writing technologies, one of SF literary and publishing practices, one of laboratory inscription practices — and each set of practices is crucial for the literacies proper to technoscience. And, as products of writing technologies, both OncoMouseTM and the FemaleMan$^©$ are no strangers to the property form of existence; for them, to be commodity is to be. Ontologists have shied away from such bad objects in the history of philosophy. Oncologists and feminists are right at home. At least at one of its modern origins, in late-eighteenth-century European discourse, feminism depended on the logic of property in the self. But, happily and despite some depressing lapses, such origins have not resulted in true breeding.

Third, OncoMouseTM and the FemaleMan$^©$ are queer. Unsaved entities, fugitives from Christian sacred-secular salvation history, offspring of writing machines, vectors of infection for natural subjects, FemaleMan$^©$ and OncoMouseTM are, nonetheless, the modest witnesses of matters of fact in technoscience. The are the *haec vir* and *hic mulier* of the late-twentieth-century discourse on who may be a citizen and who an agent in the making of new worlds. They are the witnesses whose word counts as reliable testimony in the emerging courts of artifactual nature. Their objectivity is indisputable; their subjectivity is another matter. Their constructedness, their always unfinished articulations, are not in opposition to their reality; that is the condition of their reality; it is fast becoming the sign of reality as such. That is not what traditional philosophical realism and its associated doctrines of representation meant. But it is what agential realism, strong objectivity, and situated knowledges assume.

Fourth, OncoMouseTM and the FemaleMan$^©$ gestated in the wombs of modernity and enlightenment, but their existence warps the matrix of their origin. Nature and Society, animal and man, machine and organism: The terms collapse into each other. The great divide between Man and Nature, and its gendered corollary and colonial racial melodrama, that founded the story of

modernity has been breached. The promises of progress, control, reason, instrumental rationality — all the promises seem to have been broken in the children. Man hardly was imagined before he lost his place; nature was barely tamed before she took her revenge; the empire was barely consolidated before it struck back. The action in technoscience mixes up all the actors; miscegenation between and among humans and nonhumans is the norm. The family is a mess. There is hardly a bell curve in sight. Racial purity, purity of all kinds, the great white hope of heliocentric enlightenment for a truly autochthonous Europe, the self-birthing dream of Man, the ultimate control of natural others for the good of the one — all dashed by a bastard mouse and a matched set of unmanly, fictional humans. I find all this to be edifying. Maybe in these warped conditions, a more culturally and historically alert, reliable, scientific knowledge can emerge.

Fifth, OncoMouse™ and the FemaleMan© come together in the energetically imploded conversation about constructivism and naturalism in transnational science studies and in multiracial, multicultural feminism. That intercourse is the excuse for *Modest_Witness@Second_Millennium*'s existence. OncoMouse™ and the FemaleMan© seem to be co-conspirators in the moral and intellectual terrorism that has been loosed on natural foundations and self-confident rationality. Contingent foundations and situated conversations — located knowledges — are what are left, and that is surely hygienic (Butler 1992; Haraway 1988; King, 1994). Katie King reminds is that "'located' is not equivalent to 'local' even if it is appropriately partial" (1993). That is the same kind of point that Latour or Shapin and Schaffer make when they remind us that science travels only as practices, as cultural apparatus, not as disembodied truth; but travel it does. King goes on: "Nor does 'global' always mean universal, singular, ahistorical; it can't, if there are layers of globals" (1993). With some of her roots in savvy reading of Joanna Russ, King extends this crucial logical-political point for her reading of "local homosexualities and global gay formations." Remembering that located does not necessarily mean local, even while it must mean partial and situated, and that global means not general or universal but distributed and layered, seems the fundamental point to me for binding together the co-constitutive insights of cultural studies, antiracist feminist studies, and science studies.

The FemaleMan© and OncoMouse™ are, finally, modest witnesses to world-changing matters of fact and to the machines that metonymically produce them. That is the real semantic burden of Part II, which focuses on the first of a menagerie of figures inhabiting this book. It is time to turn from the layered, proliferating play of semantics to the physiological systems, the operating mechanisms, called pragmatics. How do critical theoretical practices deal with the materialized semiotic fields that are technoscientific bodies?

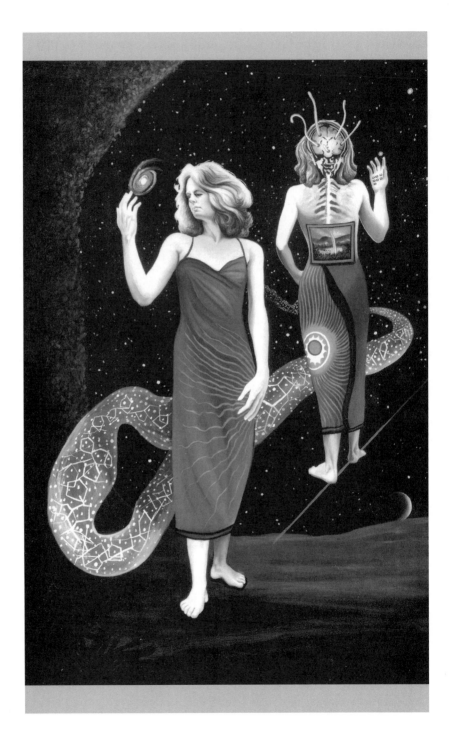

THREE

PRAGMATICS

TECHNOSCIENCE IN HYPERTEXT

Self-Consortium, Lynn Randolph, oil on canvas, 36" x 24", 1993

Also from "The Ilusas [deluded women]: Representations of Women Who Are Out of Bounds," Randolph's 1993 work Self-Consortium draws from the imagery and narrative patterns of science fiction (SF). Randolph writes, "In this painting, a young woman and her cloned android or trans-individual move inside and outside inner and outer space with a large serpentine strand of DNA. Like the spider woman who spins her web out of her own body, the clone flaunts her electronic bio-constructedness" (1993:7). Androids, clones, DNA strands, second selves, biotechnical serpents, artifactual cyborg bodies, spider woman: These entities belong in the transcultural population needed for feminist accounts of technoscience's dangers and pleasures. The doubled woman's spiral DNA is also the spiral snake of a galaxy of stars, and she touches a spinning microgalaxy on her fingertips as if it were an impossible mirror in which she sees the back of her android double. The self-consortium

practiced here could hardly be mistaken for the well-bounded, self-contem-plative, self-making man from other mythic times in Western stories about the constitution of identity, self, and person. The physiology of Randolph's SF body gives important clues to the pragmatics of meaning-making addressed in Part III. Technoscience in Hypertext. The figure in Self-Consortium is consort, spouse, associate, business partner, conversational companion, cabal. Consorting with the devil — always an erotic, cognitive, social, and technical exercise — seems inescapably part of spinning a web of meaning out of the tissues of the body's codes. Consorting with the self requires a nice assemblage of ontologically heterogeneous partners — a good image for engaging the capital-intensive consortiums of the New World Order. Pragmatics is the physiology of that kind of material and symbolic consorting.

PRAGMATICS

Technoscience in Hypertext

Considered from the point of view of pragmatics, a linguistic struc-
ture is a system of behavior.
> — Charles Morris, *Foundation of the Theory of Signs*[1]

You cannot spill coffee on this text, or glance back at an
earlier chapter, or suspend judgment, or just let it wash over you:
you have to interact with the thing.
> — Marilyn Strathern, *Knowing Oceania*

Hypertext is a useful metaphor for the reading and writing practices I want to empha-
size in Part III, Pragmatics. Anthropologist Marilyn Strathern's wonderful, irri-
tated remark about hypertext mystification (Strathern 1994) is a good place to
begin my own ambivalent engagement with this problematic metaphor and
technology. Computer software for organizing networks of conceptual links,
hypertext both represents and forges webs of relationships. Hypertext actively
produces consciousness of the objects it constitutes. Practice makes perfect, in
consciousness, as in agency. As any good technology does, hypertext "realizes"
its subjects and objects. In short, hypertext is an ordinary bit of the material-dis-
cursive apparatus for the production of technoscientific culture.

At its most literal and modest, hypertext is a computer-mediated indexing
apparatus that allows one to craft and follow many bushes of connections among
the variables internal to a category. Hypertext is easy to use and easy to construct,
and it can change common sense about what is related to what. Helping users
hold things in material-symbolic-psychic connection, hypertext is an instrument
for reconstructing common sense about relatedness. Perhaps most important,

hypertext delineates possible paths of action in a world for which it serves simultaneously as a tool and metaphor. Making connections is the essence of hypertext. Hypertext can inflect our ways of writing fiction, conducting scholarship, and building consequential networks in the world of humans and nonhumans.

Mosaic was the name for software developed at the National Center for Supercomputer Applications at the University of Illinois that allowed computer users to gain access to the cobbled-together and dispersed resources of the Internet through hypertext-based browse protocols. The university, which holds the copyright, made the software freely available to users of desktop computers in homes and offices worldwide. In late 1994, about two million copies had been downloaded, and the rate of new downloadings from the Internet was about 50,000 copies per month. Also by late 1994, major corporations such as AT&T, Digital Equipment Corporation, and Time-Warner, Inc., had obtained licenses and were commercially developing the software for a wide range of uses. Mosaic's offspring and their competitiors will likely be the medium for global information distribution at the heart of business, academic, and cultural action in a world where chances of life and death are systematically reshaped by "computers."

Of course, "computers" is metonymic for the articulations of humans and nonhumans through which potent "things" like freedom, justice, well-being, skill, wealth, and knowledge are variously reconstituted. "The computer" is a trope, a part-for-whole figure, for a world of actors and actants, and not a Thing Acting Alone. "Computers" cause nothing, but the human and nonhuman hybrids troped by the figure of the information machine remake worlds. Software sufficiently powerful to revolutionize how computers are used—that is, how further hybrids of humans and nonhumans take shape and act—are, unfortunately, called "killer applications." Comparable only to the importance of word-processor and spreadsheet software, Mosaic-like browsers are likely to be such "killer applications" that reconfigure practice in an immense array of domains.[2] Mosaic was about the power to make hypertext and hypergraphic connections of the sort that produce the global subject of technoscience as a potent form of historical, contingent, specific human nature at the end of the millennium. Contesting how such subjects and hybrids are put together and taken apart is a critical feminist technoscientific practice.

Because of hypertext's physical/symbolic power to inflect the way we make the associations implicated in forging new "human universals," I adopt the metaphor for the webs of consequential, contingent connections explored in Part III of *Modest_Witness@Second_Millennium*. Pragmatics is meaning-in-the-making; pragmatics is the physiology of semiotics. In the 1930s, Charles Morris, the codifier of semiotics as it was practiced in the United States, could still argue

that only organisms were sign interpreters. "Since most, if not all, signs have as their interpreters living organisms, it is a sufficiently accurate characterization of pragmatics to say that it deals with the biotic aspects of semiosis, that is, with all the psychological, biological, and sociological phenomena which occur in the functioning of signs" (Morris 1938:30). In the 1990s, when it takes resolve to avoid the experience of machines as sign interpreters, only fossils make such organicist assumptions. The myriad, daily negotiations among humans and nonhumans that make up the consensus called technology are at least as important to characterizing sign interpreters as are the life science discourses Morris lists. However, for technoscientific citizens at the end of the millennium, neither people, animals, plants, protists, environments, nor artifacts can be represented by the impoverished schemata by which Morris imagined organisms. In the 1990s, across the former divide between subjects and objects and between the living and nonliving, meaning-in-the-making—the physiology of semiotics—is a more cyborg, coyote, trickster, local, open-ended, heterogeneous, and provisional affair. Sign interpreters are ontologically dirty; they are made up of provisionally articulated, temporally dispersed, and spatially networked actors and actants. In the most literal and materialist sense, connections and enrollments are what matter.

Making connections is the kind of physiology in feminist science studies that I want to foster. I want feminists to be enrolled more tightly in the meaning-making processes of technoscientific world-building. I also want feminists—activists, cultural producers, scientists, engineers, and scholars (all overlapping categories)—to be recognized for the articulations and enrollments we have been making all along within technoscience, in spite of the ignorance of most "mainstream" scholars in their characterizations (or lack of characterizations) of feminism in relation to both technoscientific practice and technoscience studies.

However, I also adopt the hypertext metaphor to put pressure on the sore spots in my soul that this figure inflames. Located in the subject position structured for me by the Internet address that is my book title, I am condemned to follow through with the consequences of my imagery. Although the metaphor of hypertext insists on making connections as practice, the trope does not suggest which connections make sense for which purposes and which patches we might want to follow or avoid. Communication and articulation disconnected from yearning toward possible worlds does not make enough sense. And explicit purposes—politics, rationality, ethics, or technics in a reductive sense—do not say much about the furnace that is personal and collective yearning for just barely possible worlds.

Paul Edwards (1994) details the trouble in his provocative argument about

the similarities of poststructuralist theories of intertextuality, where meaning does not flow from the author/subject, to theories of the social construction of science, such as actor/network theory and the role of inscription devices, where meaning and knowledge also do not flow from scientists-as-creators. Edwards argues that the laudable common efforts to devise an approach to signification that does not depend upon the subject-as-creator—a project for which the metaphor and tool of hypertext is very useful—perversely end up importing unexamined psychologistic assumptions about cognitive abilities and the structure of minds. These assumptions typically have deep roots in behaviorism and artificial intelligence research, which provide impoverished representations of cognitive and social processes for humans and nonhumans alike. These representations reach back to the beginnings of U.S. semiotics, in which communication was theorized as a problem in control systems. The fundamental task was to understand, without mentalistic assumptions, how systems of signs affect behavior patterns. Organisms and machines alike were repositioned on the same ontological level, where attention was riveted on semiosis, or the process by which something functioned as a sign. "Semiotics, then, is not concerned with the study of a particular kind of object, but with ordinary objects in so far (and only in so far) as they participate in semiosis" (Morris 1938:4).

These assumptions are problematic for the further development of science studies, for which a more usable—that is, psychologically, technologically, and politically lively—theory of actors, agents, actants, and practice is urgently needed. Decentering the godlike, individualist, voluntarist, human subject should not require a radical temperance project mandating abstinence from the strong drugs of networked desire, hope, and—in bell hooks's (1990) provocative term for an affective and political sensibility—"yearning."

Examining the limitations of hypertext for figuring social action, where questions of comprehension and significance cannot be ignored, Edwards explores the notion of "hypertension." I am informed by his arguments. Cognition and communication need such a third term, which allows the fruitful blurring of boundaries between outside and inside, human and machine, subject and object, that poststructuralism and science studies have developed. We do not need the automatism of crypto-behaviorism to explore the boundary blurring. Both people and things are more interesting and odder than that. Both people and things have a nonreducible trickster quality that resists categories and projects of all kinds. Yearning is fed from the gaps in categories and from the quirky liveliness of signs.

So, the figure of hypertext in this book should incite an inquiry into which connections matter, why, and for whom. Who and what are with and for whom?

These are practical, pragmatic, semiotic, technical questions. The figure should likewise incite our lust for just barely possible worlds outside the explicit logic of any Net. The hypertext-based World Wide Web is the package of Internet services, developed by the European Laboratory for Particle Physics (CERN) high-energy physicists for following networks of textual and graphic data, that is used by Web browsers like Mosaic and Netscape, for example. This Web is less my trope for feminist pragmatics than is bell hooks's figure of yearning translated into a worldwide tissue of coalitions for a more livable technoscience.

Informatics hybridizes with biologics in the New World Order. Thus, in order to sketch an effective pragmatics for a mutated modest witness, I must splice my hypertext trope to a figure derived from biology. Totipotent stem cells are those cells in an organism that retain the capacity to differentiate into any kind of cell. Stem cells can regenerate the whole array of cell types possible for that life form. The genome and the nongenomic apparatus of a stem cell remain unfixed, undetermined, multitalented. After irradiation, the stem cells of the hematopoietic system must be restored if the many cell types of the blood and immune system are to reappear. After wounding, stem cells in some organisms can regenerate lost organs or even whole beings. Stem cells are the nodes in which the potential of entire worlds is concentrated.

Objects like the fetus, chip/computer, gene, race, ecosystem, brain, database, and bomb are stem cells of the technoscientific body. Each of these curious objects is a recent construct or material-semiotic "object of knowledge," forged by heterogeneous practices in the furnaces of technoscience. To be a construct does NOT mean to be unreal or made up; quite the opposite. Out of each of these nodes or stem cells, sticky threads lead to every nook and cranny of the world. Which threads to follow is an analytical, imaginative, physical, and political choice. I am committed to showing how each of these stem cells is a knot of knowledge-making practices, industry and commerce, popular culture, social struggles, psychoanalytic formations, bodily histories, human and nonhuman actions, local and global flows, inherited narratives, new stories, syncretic technical/cultural processes, and more.

For example, a seed contains inside its coat the history of practices such as collecting, breeding, marketing, taxonomizing, patenting, biochemically analyzing, advertising, eating, cultivating, harvesting, celebrating, and starving. A seed produced in the biotechnological institutions now spread around the world contains the specifications for labor systems, planting calendars, pest-control procedures, marketing, land holding, and beliefs about hunger and well-being. Similarly, in Joseph Dumit's argument, a database is a technical and utopic object that structures future accessibility. A database "is an ideal place where all ele-

ments are equal in the grid—and everyone can access all of them."[3] The database is a condensed site for contestations over technoscientific versions of democracy and freedom. Both the genome and the brain are databases—literally—built in the experimental, multidisciplinary, documentary, proprietary, information-management, and other practices of the Human Genome Project and the Human Brain Mapping Project.[4]

I cannot follow here each of my stem cells, much less the much larger set that would be needed for the excessive account of technoscience that I crave. But I try to work out at least some of the knots that constitute genes, databases, chips/computers, seeds, cyborgs, races, and fetuses. My accounts are clearly not exhaustive, nor are they rigorously causal, but they are intended to be more than merely suggestive about the connective tissues, lubricants, codes, and actors in the worlds we must care about. The articulations among the stem cells, and within each of them, are links that matter in what gets affectionately called the "real world." How do technoscientific stem cells link up with each other in expected and unexpected ways and differentiate into entire worlds and ways of life? How do the differently situated human and nonhuman actors and actants encounter each other in interactions that materialize worlds in some forms rather than others? My purpose is to argue for a practice of situated knowledges in the worlds of technoscience, worlds whose fibers infiltrate deep and wide throughout the tissues of the planet, including the flesh of our personal bodies.

4

GENE

Maps and Portraits of Life Itself

Get a Life! SimLife, the genetic playground, allows you to build
ecosystems from the ground up and give life to creatures from the
depths of your imagination. Test your creations' adaptive abilities
by turning their environment into either a paradise where life is
easy or a wasteland where only the strongest survive. Play with
genetics, food webs, mutation, extinction, and natural disasters to
witness the effects on the gene pool, the ecosystem, and life itself.
It's up to you to keep your species off the endangered list! Give life
to different species in the Biology Lab and customize their look
with the icon editor.

—*Science News*[1]

They are suffering from an advanced case of hardening of
the categories.

—Helen Watson-Verran, "Re-negotiating What's Natural"

Creation Science

The user manual for the Maxis computer game SimLife opens its first chapter,
"Getting Started," with the words of Supreme Court Justice Oliver Wendell
Holmes, "All life is an experiment" (Bremer 1992:9).[2] That grounding juridical
point is equally the foundation of this chapter on the comedic portraiture and
cartography of "life itself." The pedagogic task is to learn the rules of the game.
My focus is on advertising, joking, and gaming dimensions of genetic portrai-
ture and mapping. These contemporary practices have taproots into the geo-

metric matrices of spatialization and individualization constructed in early modern Europe. The matrices emerged from the instrumental, epistemological, and aesthetic innovations of perspectivism, which became prominent in the narrative time called the Renaissance. "Perspectivism conceives of the world from the standpoint of the 'seeing eye' of the individual. It emphasizes the science of optics and the ability of the individual to represent what he or she sees as in some sense 'truthful,' compared to superimposed truths of mythology or religion" (Harvey 1989:245). Perspectivism engages particular sorts of troping that have been hard to acknowledge for their practitioners. I want to take an "incredible journey" through some of the circulatory tubules in the taproots of spatialization and individualization to see how the carbon-silicon fused flesh of technoscientific bodies at the end of the Second Christian Millennium get their semiotic trace nutrients.[3]

The popular Maxis Corporation games SimAnt, SimEarth, SimCity, SimCity 2000, and SimLife are all map-making games based on computer simulation software. In these games, as in life itself, map-making is world-making. Inside the still persistent Cartesian grid conventions of cyber-spatializations, the games encourage their users to see themselves as scientists within narratives of exploration, creation, discovery, imagination, and intervention. Learning data-recording practices, experimental protocols, and world design is seamlessly part of becoming a normal subject in this region of technoscience. Cartographic practice inherently is learning to make projections that shape worlds in particular ways for various proposes. Each projection produces and implies specific sorts of perspective.

The Maxis games invite an explicit equation with the specifically Christian readings of the creation discourse rooted in Genesis.[4] *The SimEarth Bible* is the title of that game's strategy book. James Lovelock, author of the Gaia hypothesis on which SimEarth is based, endorses the manual in the preface. The *Bible's* introduction then tells the reader that SimEarth is "a laboratory on a disk for curious people to experiment with" (Wilson 1991:xviii). The author of the manual is frankly Christian in his theistic beliefs about evolution, but the game and the strategy manual are deeply enmeshed in "Judeo-Christian" mimesis—that is, Christian salvation history—even in totally secular interpretations. So too is the perspectivism, which was critical to the history of Western early modern and Renaissance art and map-making, enabled by a Judeo-Christian point of view. And what was "point of view" before the implosion of biologics and informatics has become, since the impaction in narrative and material space-time, "pov." Thus, pov is the cyberspace version of secularized creation science's optical practice.

This respectable creation science is not about opposition to biological evolution or promotion of divine special creation; quite the opposite. The creation science of the Maxis games, and of much of contemporary technoscience, including molecular biology, genetic engineering, and biotechnology, is resolutely up to the minute in the practice of leading-edge science. Secular creationism is intrinsic to this science's narratives, technologies, epistemologies, controversies, subject positions, and anxieties. The parochial contests with the more popularly understood "creation science," the kind that disputes biological evolution and posits biblical time against geological time, could not occur outside the intimately shared premises of perspectivism and creationism in the broader sense.

"Give life to different species in the Biology Lab and customize their look with the icon editor," urges the SimLife advertisement. This is a kind of paint-by-bit game that fills portrait galleries in the cyber-genealogies of life itself. Getting into the spirit of the thing, I call the narrative software of my chapter SimRenaissance™. As usual, I am interested in the official versions of scientific creationism in life worlds after the implosion of informatics and biologics.

My point of view—or pov—in this examination of perspective technologies is that of the chief actor and point of origin in the drama of life itself—the gene. The pov of the gene gives me a curious vertigo that I blame on the god-like perspective of my autotelic entity. Recursive autocontemplation of the self-same could be responsible for more than dizziness. The gene is the subject of the portraits and maps of life itself in the terminal narrative technology proper to the end of the Second Millennium. Sociobiologist Richard Dawkins, another source of inspiration for the Maxis game-makers, explained that the body is merely the gene's way to make more copies of itself, in a sense, to contemplate its own image. If that is not only slightly heretical Christian theology, I am not genetically Catholic. "Evolution is the external and visible manifestation of the differential survival of alternative *replicators*. Genes are replicators; organisms and groups of organisms . . . are vehicles in which replicators travel about "(Dawkins 1982:82).[5] Mere living flesh is derivative; the gene is the alpha and omega of the secular salvation drama of life itself. This is barely secular Christian Platonism. As always, ensconced in a generically less than mature, if aging, marked body, I am consumed with curiosity about the regions where the lively subject becomes the undead thing.

Life Itself

I adopt and, according to the rules of the game, mutate the term *life itself* from Sarah Franklin's enormously insightful work (1993b and forthcoming).[6]

GENE

The instrumentalization of life proceeds by means of cultural practices—sociopolitical, epistemological, and technical. Informed by Foucault's arguments about biopower and the history of the concept of life, Franklin analyzes how nature becomes biology, biology becomes genetics, and the whole is instrumentalized in particular forms. (See Foucault 1970; 1978; Canguilhem 1989; Oyama 1985; Duden 1993). "Life," materialized as information and signified by the gene, displaces "Nature," preeminently embodied in and signified by old-fashioned organisms. From the point of view of the gene, a self-replicating autogenerator, "the whole is not the sum of its parts, [but] the parts summarize the whole" (Franklin 1995:67). Or rather, within both the organic and synthetic databases that are the flesh of life itself, genes are not really parts at all. They are another kind of thing, a thing-in-itself where no trope can be admitted. Thus, the genome, the totality of genes in an organism, is not a whole in the traditional, "natural" sense but a congeries of entities that are themselves autotelic and self-referential. Thus, the "selfish gene" made famous by Richard Dawkins (1976) is a tautology. In this view, genes are things-in-themselves, outside the lively economies of troping. To be outside the economy of troping is to be outside finitude, morality, and difference, to be in the realm of pure being, to be One, where the word is itself. No wonder the pov of the gene makes me dizzy. God tricks do that to you if you are not used to the perspective. Or if you know the perspective too well . . .

Maxis Corporation's SimLife is simultaneously original and mimetic in more ways than one. After the implosion of informatics and biologics, simulation is not derivative and inferior but primary and constitutive. "All life is an experiment." At the origin of things, life is constituted and connected by recursive, repeating streams of information. As Franklin taught me to see, these flows, not the blood ties connecting bodies in another regime of nature, are the circulatory systems that constitute kinship—replete with all of its transhybridities and reworkings of race, species, family, nation, individual, corporation, and gender—at the end of the Second Christian Millennium.

In the game of life itself, "it's up to you to keep your species off the endangered list!" Although the ad intends "species" in this passage to refer to all the creatures the player has "created," the ambiguity that suggests keeping one's own species—*Homo sapiens*—off the endangered list resonates nicely. Fetishism has never been more fun, as undead substitutes and surrogates proliferate. But fetishism comes in more than one flavor. Nature known and remade as Life through cultural practice figured as technique within specific proprietary circulations is critical to Franklin's and my spliced argument. I hope Marx would recognize his illegitimate daughters, who, in the ongoing comedy of

epistemophilia, only mimic their putative father in a pursuit of undead things into their lively matrices. Marx, of course, taught us about the fetishism of commodities. Commodity fetishism is a specific kind of reification of historical human integrations with each other and with an unquiet multitude of nonhumans, which are called nature in Western conventions. In the circulation of commodities within capitalism, these interactions appear in the form of, and are mistaken for, things. Fetishism is about interesting "mistakes"—really denials—where a fixed thing substitutes for the doings of power-differentiated lively beings on which and on whom, in my view, everything actually depends. In commodity fetishism, inside the mythic and fiercely material zones of market relations, things are mistakenly perceived as the generators of value, while people appear as and even become ungenerative things, mere appendages of machines, simply vehicles for replicators. Without question, contemporary genetic technology is imbricated with the classical commodity fetishism endemic to capitalist market relations. In proprietary guise, genes displace not only organisms but people and nonhumans of many kinds as generators of liveliness. Ask any biodiversity lawyer whether genes are sources of "value" these days, and the structure of commodity fetishism will come clear.

Fetishism of the Map

However, in this chapter I am arguing primarily not about commodity fetishism but about another and obliquely related flavor of reification that transmutes material, contingent, human and nonhuman liveliness into maps of life itself and then mistakes the map and its reified entities for the bumptious, nonliteral world. I am interested in the kinds of fetishism proper to worlds without tropes, to literal worlds, to genes as autotelic entities. Geographical maps are embodiments of multifaceted historical practices among specific humans and nonhumans. Those practices constitute spatiotemporal worlds; that is, maps are both instruments and signifiers of spatialization. Geographical maps can, but need not, be fetishes in the sense of appearing to be nontropic, metaphor-free representations, more or less accurate, of previously existing, "real" properties of a world that are waiting patiently to be plotted. Instead, maps are models of worlds crafted through and for specific practices of intervening and particular ways of life.

In Greek, *trópos* is a turn or a swerve; tropes mark the nonliteral quality of being and of language. Metaphors are tropes, but there are many more kinds of swerves in language and in worlds. Fundamentally, models are more interesting in technoscience than metaphors. Models, whether conceptual or physical, are tropes in the sense of instruments built to be engaged, inhabited, lived. Models can become fetishes in psychoanalytic, scientific, and economic senses.

GENE

Curiously, fetishes—themselves "substitutes," that is, tropes of a special kind—produce a particular "mistake"; fetishes obscure the constitutive tropic nature of themselves and of worlds. Fetishes literalize and so induce an elementary material and cognitive error. Fetishes make things seem clear and under control. Technique and science appear to be about accuracy, freedom from bias, good faith, and time and money to get on with the job, not about material-semiotic troping and so building particular worlds rather than others. Fetishized maps appear to be about things-in-themselves; nonfetishized maps index cartographies of struggle or, more broadly, cartographies of noninnocent practice, where everything does not always have to be a struggle.[7]

The history of cartography can look like a history of figure-free science and technique, not like a history of "troping," in the sense of worlds swerving and mutating through material cultural practice, where all of the actors are not human. Accuracy can appear to be a question of technique and to have nothing to do with inherently nonliteral tropes. Such a "real" world that preexists practice and discourse seems to be merely a container for the lively activities of humans and nonhumans. Spatialization as a never-ending, power-laced process engaged by a motley array of beings can be fetishized as a series of maps whose grids nontropically locate naturally bounded bodies (land, people, resources—and genes) inside "absolute" dimensions such as space and time.[8] The maps are fetishes in so far as they enable a specific kind of mistake that turns process into nontropic, real, literal things inside containers.

People who work with maps as fetishes do not realize they are troping in a specific way. That "mistake" has powerful effects on the formation of subjects and objects. Such people might well know explicitly that map-making is essential to enclosing entities (land, minerals, populations, etc.) and readying them for further exploration, specification, sale, contract, protection, management, or whatever. These practices could be understood as potentially controversial and full of desires and purposes, but the maps themselves would seem to be a reliable foundation, free of troping, guaranteed by the purity of number and quantification, outside of yearning and stuttering. Questions of "value," that is, tropes, could be understood to pertain to decisions to learn to make certain kinds of maps and to influence the purposes to which charts would be put. But the map-making itself, and the maps themselves, would inhabit a semiotic domain like the high-energy physicists' culture of no culture, the world of the nontropic, the space of clarity and uncontaminated referentiality, the kingdom of rationality. That kind of clarity and that kind of referentiality are god tricks. Inside the god trick, the maps could only be better or worse, accurate or not, but they could not be *themselves* instruments for and sediments of troping. From the point of view of

fetishists, maps—and scientific objects in general—are simply and purely technical and representational, rooted in processes of potentially bias-free discovery and nontropic, even if conventional, naming. "Scientific maps could not be fetishes; fetishes are only for perverts and primitives. Scientific people are committed to clarity; they are not fetishists mired in error. My gene map is a nontropic representation of reality, that is, of genes themselves." Such is the structure of denial in technoscientific fetishism.

That is how the mistake works. And perhaps worst of all, while denying denial in a recursive avoidance of the tropic—and so unconscious—tissue of all knowledge, fetishists mislocate "error." Scientific fetishists place error in the admittedly irreducibly tropic zones of "culture," where primitives, perverts, and other laypeople live, and not in the fetishists' constitutional inability to recognize the trope that denies its own status as figure. In my view, contingency, finitude, and difference—but not "error"—inhere in irremediably tropic, secular liveliness. Error and denial inhere in reverent literalness. For this chapter, error inheres in the literalness of "life itself" rather than in the unapologetic swerving of liveliness and worldly bodies-in-the-making. Life itself is the psychic, cognitive, and material terrain of fetishism. By contrast, liveliness is open to the possibility of situated knowledges, including technoscientific knowledges.

Metaphors of Possession

In order to prepare to taste the special flavor of fetishism that can, but need not, pervade gene mapping, I will illustrate the argument of the last paragraphs with a classic problem for map-makers in technoscientific traditions: delineating the boundaries of land that can be possessed and juridically administered through the institutions of property, title, and contract. Based in the Department of History and Philosophy of Science at Melbourne University in Australia, Helen Watson-Verran works "where knowledge systems overlap" (Watson-Verran and Turnbull 1995:131), specifically where European Australians and Aboriginal Australians must find ways to negotiate such things as land title and school math curricula. In the 1990s these negotiations occur in a postcolonial world, where "indigenous" ways of knowing have gained some usable recognition in national and international tribunals in which European-derived kinds of knowledge used to be the sole forms treated as rational.

Even more challenging to most Western ideas about knowledge, science itself is now widely regarded as an indigenous, and polycentric, knowledge practice. That is natural science's strength, not its weakness. Such a claim is not about relativism, where all views and knowledges are somehow "equal," but quite the opposite. To see scientific knowledge as located and heterogeneous practice,

GENE

which might (or might not) be "global" and "universal" in specific ways rooted in ongoing articulatory activities that are always potentially open to critical scrutiny from disparate perspectives, is to adopt the worldly stance of situated knowledges. Such knowledges are worth living for. From the standpoint of situated knowledge, strong objectivity—reliable, partially shareable, trope-laced, worldly, accountable, noninnocent knowledge—can be a fragile human achievement. But from the stance of the god trick of scientific creationism, only fetishism—the culture of no culture, the language of no language, the trope of no trope, the one self-referential word—is possible.

Watson-Verran (1994) discusses the epistemological and practical problems experienced by English Australian pastoralists in their current negotiations with Wik Aboriginal Australians over joint land ownership in the absence of shared metaphorical toolkits for figuring property. "Boundaries"—place and space—are very much at issue. "In June 1992 the full bench of the High court of Australia . . . ruled that the land of Australia and the surrounding islands had been owned by indigenous people before 1770 when British officials claimed the land for the British Crown. They further ruled that in places where native title had not been extinguished by ceding control over the land, it was still in force" (Watson-Verran 1994:1).[9] The main problem for the Cape York Euro-Australian sheep herders—besides being forced into these negotiations in the first place by the High Court ruling on native title—is that they don't know how to recognize that their own practices of proprietorship (legal, rational contracts) rest on metaphors. "The pastoralists are having trouble. They know that there are no metaphors or images involved in public knowing of the land which underlies ownership. Behind ownership there are just the rigid facts of quantifying the land" (Watson-Verran 1994:5). Just the maps; just the facts.

Like good Western scientists, the English Australian herders, holding their leases high, believe such quantification "spatializes," that is, removes land (or anything else) from the status of mere concrete "place," mired in all the tropic particularities of bodies, and puts the land in the category of enumerated objective property, recognizable across cultures, with all the rights of exclusiveness pertaining to quantified, rationally defined entities whose value is able to circulate in appropriate markets. What too many map-makers forget is that spatialization is social practice, and there are several ways to spatialize. The perspectivism in the history of cartography and the metaphysics in the history of Western categories of definite objects with quantifiable properties are both "naturalized," or better "rationalized"—literally—to be free of tropes.

When "indigenous" systems of knowing get mandatory legal recognition *as rational knowledge*, and rational knowledge is understood to be relentlessly tropic,

"Western" subjects tend to succumb to epistemological arteriosclerosis, or, in Watson-Verran's terms, "hardening of the categories" (Watson-Verran 1994:4). It is particularly hard for Westerners to see themselves as indigenous subjects. But unless they come to see the tropes and stories in their own practices of legally holding property and learn to negotiate among contending narratives and figures without the trump card of epistemological fetishism—the-thing-in-itself—the pastoralists might lose their rights to feed their sheep. Holding land is a question of situated knowledges, but "enmeshed in their rigid facts the pastoralists have no basis for imagining a joint title" (Watson-Verran 1994:5).

The Aboriginal Australians in Watson-Verran's account have the opposite problem. Wik spatialization practices involve recursive layers of stories and metaphors that tie land and people together in interconnected networks, which certainly have to do with ownership of the land but not with exclusion and possession in the same ways that would make sense to European geographers, lawyers, and leaseholders. "As the Wik see it they 'own' the land in the strongest possible sense, and they confidently expect the High Court to ratify this ownership. Their clans, distributed across the area, came into being with the land itself. . . . Owning the land is owning and publicly articulating stories through which the land is meaningful as ontic interconnected place. And in the stories are the multiple and complex metaphors which comprise the stuff of negotiating in Aboriginal Australia. In contrast to the pastoralists, on the Wik side it is likely that there are far too many who have ideas on how to negotiate" (Watson-Verran 1994:5). But metaphors do not travel easily for the Aboriginal peoples; metaphors are owned by particular clans and encode the interests of specific groups. Negotiating metaphoric travel is an important and dangerous work. Watson-Verran concludes that the Wik "have the epistemic resources for devising a radical form of land title acknowledging disparate ways of knowing land" (Watson-Verran 1994:5). This kind of spatialization will be more and more critical in the domains of diversity traversed by "global" technoscience, most certainly including genetics, biotechnology, and biodiversity. Local knowledge and systematicity are not opposed, but the kinds of systematicity and kinds of tropes are very much at stake.

The Euro-Australian pastoralists probably think their own High Court must have lost its mind and given in to politically exigent, "multicultural" relativism. But the work of Watson-Verran and her Deakin University science studies colleague David Turnbull indicates that there is a much more interesting issue of *knowledge* and possible, but difficult, *articulation of disparate knowledges* at stake, one that cannot be reduced to a vulgar, right-wing sense (and old left sense) of the constitutive knowledge-power, knowledge-practice relationship

GENE

(Watson-Verran and Turnbull 1995; see also Turnbull 1993). Watson-Verran and Turnbull illustrate this deeply interesting issue of both radical contingency and communicability of knowledges by looking at discussions over the mathematics curriculum in Aboriginal schools.

The authors sketch three sets of stabilized practices through which a particular group of Aboriginal Australians, the Yolngu, join people and land in formally related, dynamic patterns. For example, "all Australian Aboriginal peoples use a formalized recursive representation of kinship as the major integrated standardized form in much the same way that the formalized recursion of tallying—number—constitutes an integrative standardized form of knowledge in Western societies" (Watson-Verran and Turnbull 1994:132). The Aboriginal practices are analogous to European-derived methods of quantitative reasoning, but the two kinds of cognitive work rely on constitutionally different ways of making categories. Specifically, "English has its speakers designating entities in the sense of spatiotemporal entities. In contrast, Yolngu language has speakers designating relations between connoted entities"(133). The metaphoric, or more broadly tropic, core in each kind of cognitive practice is invisible to its users until practitioners from the different communities have to interact with each other "mathematically." Then "trading zones" and "boundary objects" have to be established (Galison 1989; Star and Greisemer 1989).

This kind of problem is familiar in every area of human activity, such as interdisciplinary work in high-energy physics or neurobiology, and hardly requires "cross-cultural" examples. Indeed, despite initial appearances deriving from untenable philosophies of science and colonialist traditions, the comparison of Yolngu and European quantitative reasoning is not "cross-cultural" or "anthropological." Nor is the comparison between science and culture. Rather, the comparison is inside science studies, where the distinction between science and ethnoscience is not meaningful and where science is knowledge-crafting practice that is always historically specific. Two consequences follow from that switch in viewing analytical practices: (1) Full of tropes, mathematics is specific material-semiotic practice at every level of its being, without ceasing to be of fundamental interest in terms of processes of cognition and products of formal knowledge. Mathematical knowledge is situated knowledge. (2) Epistemological issues embedded in interactions between different groups of formal thinkers arise differently when power relations are relatively equal compared to when they are sharply hierarchized, and power relations are dynamic in the history of comparative epistemology. Renegotiating what counts as knowledge, and as property, emerged not from spontaneous multicultural goodwill but from specific organization, articulation, and struggle by people locally and glob-

ally, in processes that have produced new kinds of indigenous subjects on the world stage as well as in national courts.[10]

When Western and Yolngu formal knowledge practices come together in designing a mathematics curriculum in the 1990s—where colonialist relativism that sees only science and ethnoscience is no longer easy—each side has to assimilate something of the other. "In the process, Yolngu look for and emphasize metaphor in Western knowledge. Science looks for and emphasizes codification and develops a grid in which two systems can be seen in ratio" (Watson-Verran and Turnbull 1994:134). The confrontation and exchange in power-laced practical circumstances make the work of codification, situating, and mobilization of categories explicit for all parties, changing everybody and everything in the process, including the categories. This kind of articulation precludes fetishism—nothing gets to be self-identical. The maps and the facts turn out to be tropic to the core and *therefore* part of knowledge practices.

Corporealization and Genetic Fetishism

Gene mapping is a particular kind of spatialization of the body, perhaps better called "corporealization." If commodity fetishism is the kind of mistaken self-identity endemic to capital accumulation, and hardening of the categories is the form of self-invisible circulatory sclerosis in important areas of scientific epistemology, what flavor of fetishism is peculiar to the history of corporealization in the material and mythic times of Life Itself? As before, the goal of the question is to ferret out how relations and practices get mistaken for nontropic things-in-themselves in ways that matter to the chances for liveliness of humans and nonhumans.

In order to sort out analogies and disanalogies, let us return briefly to commodity fetishism. The Hungarian Marxist philosopher Georg Lukács defined this kind of reification as follows: "Its basis is that a relation between people takes on the character of a thing and thus acquires a 'phantom objectivity,' an autonomy that seems so strictly rational and all-embracing as to conceal every trace of its fundamental nature: the relation between people" (1971:83). Marx defined commodity fetishism as "the objective appearance of the social characteristics of labour" (1976:176). Corporealization, however, is not reducible to capitalization or commodification, although in capitalist societies the multiple reaction sites joining and separating the processes remain both crucial and badly understood, partly because of ideological preconceptions held by everybody, on all sides, who has studied (or refused to study) the linkages and partly because of the daunting complexity of the issues.

I am defining corporealization as the interactions of humans and nonhumans in the distributed, heterogeneous work processes of technoscience. The

GENE

nonhumans are both those made by humans, for example, machines and other tools, and those occurring independently of human manufacture. The work processes result in specific material-semiotic bodies—or natural-technical objects of knowledge and practice—such as cells, molecules, genes, organisms, viruses, ecosystems, and the like. The work processes also make humans into particular kinds of subjects called scientists. The bodies are perfectly "real," and nothing about corporealization is "merely" fiction. But corporealization is tropic and historically specific at every layer of its tissues.

Cells, organisms, and genes are not "discovered" in a vulgar realist sense, but they are not made up. Technoscientific bodies, such as the biomedical organism, are the nodes that congeal from interactions where all the actors are not human, not self-identical, not "us." The world takes shape in specific ways and cannot take shape just any way; corporealization is deeply contingent, physical, semiotic, tropic, historical, international. Corporealization involves institutions, narratives, legal structures, power-differentiated human labor, technical practice, analytic apparatus, and much more. The processes "inside" bodies—such as the cascades of action that constitute an organism or that constitute the play of genes and other entities that go to make up a cell—are interactions, not frozen things. For humans, a word like *gene* specifies a multifaceted set of interactions among people and nonhumans in historically contingent, practical, knowledge-making work. A gene is not a thing, much less a "master molecule" or a self-contained code. Instead, the term *gene* signifies a node of durable action where many actors, human and nonhuman, meet.

Commodity fetishism was defined so that only humans were the real actors, whose social relationality was obscured in the reified commodity form. But "corporeal fetishism," or more specifically gene fetishism, is about mistaking *heterogenous* relationality for a fixed, seemingly objective thing. Strong objectivity, in Sandra Harding's terms, and situated knowledge, in my terms, are lost in the pseudo-objectivity of gene fetishism, or any kind of corporeal fetishism that denies the ongoing action and work that it takes to sustain technoscientific material-semiotic bodies in the world. The gene as fetish is a phantom object, like and unlike the commodity. Gene fetishism involves "forgetting" that bodies are nodes in webs of integrations, forgetting the tropic quality of all knowledge claims. Thus, my claim about situated knowledges and gene fetishism can itself become fixed and dogmatic and seem to stand for and by itself, outside of the articulations that make the claim sensible. That is, when the stuttering and swerving are left out, a process philosophy can be just as fetishistic as a reductionist one. Both scientists and nonscientists can be gene fetishists, and U.S. culture in and out of laboratories is rife with signs of such fetishism as well as of resistance to it.

The mistake of gene fetishism has consequences similar to the mistake of property fetishism among the Australian pastoralists who could not see the tropic, and therefore interactional, structure of their relationship to land, contract, individuality, and reason. In important disputes, for example over genetic intellectual property or over the definitions and relevant actors in contests over biodiversity, how the participants understand technoscience and its products, such as the gene, matters immensely. Corporeal fetishism can operate at the level of ideas about what an organism is (a vehicle for replicators) or at the level of what the boundaries between science and other kinds of cultural practice are. Sharp separation of technoscience into the technical and the political is a symptom of corporeal fetishism, where interactions among heterogeneous actors are mistaken for self-identical things to which actions might be applied but which are not *constituted* by inter-actions.

With a little help from Marx, Freud, and Whitehead, let me precipitate from the preceding pages what has been left in solution until now, that is, the intertwining triple strands—economic, psychoanalytic, and philosophical—in the gene fetishism that corporealizes "life itself" through its symptomatic practices in molecular genetics and biotechnology, for example, in the Human Genome Project (medicine), biodiversity gene prospecting (environmentalism and industry), and transgenics (agriculture and pharmaceuticals). I do not mean that scientists in these areas necessarily practice gene fetishism. Corporealization need not be fetishized, need not inhabit the culture of no culture and the nature of no nature. Under widespread epistemological, cultural, psychological, and political economic conditions, however, fetishism is a common syndrome in technoscientific practice.

I have already discussed Marx's theory of commodity fetishism, and it takes little imagination to trace its working in the transnational market circulations where genes, those 24-karat-gold macromolecular things-in-themselves, seem to be themselves the source of value. This kind of gene fetishism rests on the denial and disavowal of all the natural-social articulations and agentic relationships among researchers, farmers, factory workers, patients, policy-makers, molecules, model organisms, machines, forests, seeds, financial instruments, computers, and much else that bring "genes" into material-semiotic being. There is nothing exceptional about genetic commodity fetishism, where focus on the realm of exchange hides the realm of production. The only little amendment I made to Marx was to remember all the nonhuman actors too.[11] The gene is objectified in and through all of its naturalsocial (one word) articulations, and there is nothing amiss in that. Such objectification is the stuff of real worlds. But the gene is fetishized when it seems to be itself the source of

value, and those kinds of fetish-objects are the stuff of complex mistakes, denials, and disavowals.[12]

The hardest argument for me to make is that there is a psychoanalytic quality to gene fetishism, at least in cultural, if not in personal psychodynamic, terms, but I am driven to this extreme by the evidence. According to Freud, a fetish is an object or part of the body used in achieving libidinal satisfaction. In the classical psychoanalytic story about the fear of castration and masculine subject development, fetishism has to do with a special kind of balancing act between knowledge and belief. The fetishist-in-the-making, who must be a boy for the plot to work, at a critical moment sees that the mother has no penis but cannot face that fact because of the terrible ensuing anxiety about the possibility of his own castration. The youngster has three choices—become a homosexual and have nothing to do with the terrifying castrated beings called woman, get over it in the recommended Oedipal way, or provide a usable penis-substitute—a fetish—to stand in as the object of libidinal desire. The fetishist knows and does not know that the fetish is not what it must be to allay the anxiety of the all-too-castratable subject.

For Freud, the penis-substitute is the objectification inherent in a process of disavowal of the mother's (real) castration. The fetish is a defense strategy. "To put it plainly: the fetish is a substitute for the woman's (mother's) phallus which the little boy once believed in and does not wish to forego—we know why" (Freud 1963:205). Or, as Laura Mulvey put it, "Fetishism, broadly speaking, involves the attribution of self-sufficiency and autonomous powers to a manifestly 'man' derived object. . . . The fetish, however, is haunted by the fragility of the mechanisms that sustain it. . . . Knowledge hovers implacably in the wings of consciousness" (1993:7). The fetishist is not psychotic: he "knows" that his surrogate is just that. Yet he is uniquely invested in his power-object. The fetishist, aware he has a substitute, still believes in—and experiences—its potency; he is captivated by the reality effect produced by the image, which itself mimes his fear and desire.

Since technoscience is, among other things, about inhabiting stories, Freud's account of fetishism casts light on an aspect of the fixations and disavowals necessary to belief in "life itself." Life itself depends on the erasure of the apparatuses of production and articulatory relationships that make up all objects of attention, including genes, as well as on denial of fears and desires in technoscience. Disavowal and denial seem hard to avoid in the subject formation of successful molecular geneticists, where reality must be seen to endorse the specific practices of intervention built into knowledge claims. We saw an example in Part II, chapter 2, in the textbook *Advances in Genetic Technology*, when nature, the original genetic engineer, did first what scientists merely copied, in careers and in investment strategies as well as in experiments.

The odd balancing act of belief and knowledge that is diagnostic of fetishism, along with the related cascade of mimetic copying practices that accompany fascination with images, is evident in many of the biotechnological artifacts that pepper *Modest_Witness@Second_Millennium*—including textbooks, advertisements, editorials, research reports, conference titles, and more. Belief in the self-sufficiency of genes as "master molecules," or as the material basis of life itself, or as the codes of codes, not only persists but dominates in libidinal, instrumental-experimental, explanatory, literary, economic, and political behavior in the face of the knowledge that genes are never alone, are always part of an interactional system. That system at a minimum includes the proteinaceous architecture and enzymes of the cell as the unit of structure and function, and in fact also includes the whole apparatus of knowledge production that concretizes (objectifies[13]) interactions in the historically specific form of "genes" and "genomes." There is no such thing as disarticulated information—in organisms, computers, phone lines, equations, or anywhere else. As the biologist Richard Lewontin put it, "First, DNA is not self-reproducing, second, it makes nothing, and third, organisms are not determined by it" (1992:33). This knowledge is entirely orthodox in biology, a fact that makes "selfish gene" or "master molecule" discourse symptomatic of something amiss at a level that might as well be called "unconscious."[14]

But if I am to invoke Freud's story, I need a particular kind of balancing act between belief and knowledge, one involving a threat to potency and wholeness at critical moments of subject formation.[15] Can gene fetishism be constructed to involve that kind of dynamic? Cautiously, leaving aside entirely the domain of individual psychosexual dynamics and focusing on the social-historical subject of genetic knowledge, I think that such an account makes rough sense, at least analogically.[16] But first, I have to rearrange Freud's account to dispute what he thought was simply true about possession of the "phallus," that signifier of creative wholeness and power. Freud thought women really did not have it; that was the plain fact the fetishist could not face. But since I am a woman and so can't be an orthodox fetishist anyway, I rely on feminism to insist on a stronger objective claim, namely, that women are whole, potent, and "uncastrated." Freud got it wrong, even while he got much of the symbolic structure right in male-dominant conditions. With sound reason, but with unfortunate consequences in the history of theory, Freud and a few other good men (and women), confused the penis and the phallus after all.[17]

My correction is necessary to make the analogy to gene fetishism. Organisms are "whole" in a specific, nonmystical sense; that is, organisms are nodes in webs of dynamic articulations. Neither organisms nor their con-

decoy

stituents are things-in-themselves. Sacred or secular, all autotelic entities are defenses, alibis, excuses, substitutes—dodges from the complexity of material-semiotic objectifications and apparatuses of corporeal production. In my story, the gene fetishist "knows" that DNA, or life itself, is a surrogate, or at best a simplification that readily degenerates into a false idol. The substitute, life itself, is a defense for the fetishist, who is deeply invested in the switch, against the knowledge of the actual complexity and embeddedness of all objects, including genes. The fetishist ends up believing in the code of codes, the book of life, and even the search for the grail.[18] Only half jokingly, I see the molecular biological fetishist to be enthralled by a phallus-substitute, a mere "penis" called the gene, which defends the cowardly subject from the too scary sight of the relentless material-semiotic articulations of biological reality, not to mention sight of the wider horizons leading to the real in technoscience. Perhaps acknowledging that "first, DNA is not self-reproducing, second, it makes nothing, and third, organisms are not determined by it" is too threatening to all the investments, libidinal and otherwise, at stake in the material-semiotic worlds of molecular genetics these days. So the fetishist sees the gene itself in all the gels, blots, and printouts in the lab and "forgets" the natural-technical processes that produce the gene and genome as consensus objects in the real world. The fetishist's balancing act of knowledge and belief is still running in the theater of technoscience.[19]

The third strand in my helical spiral of gene fetishism is spun out of what Whitehead called the "fallacy of misplaced concreteness" (1948:52).[20] Beginning with an examination of the still astonishing concatenation of theoretical, mathematical, and experimental developments that mark the European seventeenth century as "the Century of Genius," Whitehead foregrounded the importance to the history of Western natural science of two principles: (1) simple location in space-time, and (2) substance with qualities, especially primary qualities defined by their yielding to numerical, quantitative analysis. These were the fundamental commitments embedded in seventeenth-century and subsequent Western practices of spatialization, including cartography; and the role of these principles in the history of philosophical and scientific mechanism is not news. Whitehead wrote in 1925, when mechanism, the wave-particle duality, the principle of continuity, and simple location had been under fruitful erosion in physics for decades, dating conventionally from Maxwell's midnineteenth-century equations founding electromagnetic field theory and continuing with the developments in quantum physics in the 1920s and 1930s, tied to work by both Niels Bohr in wave mechanics and Albert Einstein on the light quantum, among other critical transformations of physical theory.

Whitehead had no quarrel with the utility of the notion of simple location and the attention to primary qualities of simple substances—unless these abstract logical constructions were mistaken for "the concrete." Albeit expressed in his own arcane terminology, "the concrete" had a precise meaning for Whitehead, related to his approach to "an actual entity as a concrescence of prehensions." Stressing the processual nature of reality, he also called actual entities actual occasions. "The first analysis of an actual entity, into its most concrete elements, discloses it to be a concrescence of prehensions, which have originated in the process of becoming" (Whitehead 1969:28). His notion of objectifications is very close to that held by my mutated modest witness: "A nexus is a set of actual entities in the unity of the relatedness constituted by their prehensions of each other, or—what is the same thing conversely expressed—constituted by their objectifications in each other" (1969:28). Objectifications had to do with the way "the potentiality of one actual entity is realized in another actual entity" (1969:28). Prehensions could be physical or conceptual, but such articulations, such reachings into each other in the tissues of the world, constituted the most basic processes for Whitehead. Without at present going further into his special terminology, I ally myself with Whitehead's analysis to highlight the ways that gene fetishists mistake the abstraction of the gene for the concrete entities and nexuses that *Modest_Witness@Second_Millennium* monomaniacally affirms.[21]

So, gene fetishism is compounded of a political economic *denial* that holds commodities to be sources of their own value while obscuring the sociotechnical relations among humans and between humans and nonhumans that generate both objects and value; a *disavowal*, suggested by psychoanalytic theory, that substitutes the master molecule for a more adequate representation of units or nexuses of biological structure, function, development, evolution, and reproduction; and a philosophical-cognitive *error* that mistakes potent abstractions for concrete entities, which themselves are ongoing events. Fetishists are multiply invested in all of these substitutions. The irony is that gene fetishism involves such elaborate surrogacy, swerving, and substitution, when the gene as the guarantor of life itself is supposed to signify an autotelic thing in itself, the code of codes. Never has avoidance of acknowledging the relentless tropic nature of living and signifying involved such wonderful figuration, where the gene collects up the people in the materialized dream of life itself.

Developing a notion belonging to the same family as gene fetishism, Sarah Franklin defined genetic essentialism "as a scientific discourse . . . with the potential to establish social categories based on an essential truth about the body" (Franklin 1993c:34, cited in Nelkin and Lindee 1995:201n8). Franklin is excruciatingly alert to how that essential truth about the body congeals in the

GENE

material cultural practice of technoscience. Dorothy Neklin and Susan Lindee explored the many faces of genetic essentialism in popular U.S. culture. "Genetic essentialism reduces the self to a molecular entity, equating human beings, in all their social, historical, and moral complexity, with their genes" (Nelkin and Lindee 1995:2). Stressing what is implicit in this splendid characterization, I would add two things. First, genes, as well as people, are misrepresented in genetic, or corporeal, fetishism. Indeed, the mistake of gene fetishism, which takes the gene as a nontropic thing-in-itself, sets up and justifies the mistake of genetic essentialism in Nelkin and Lindee's explicit sense. "Life itself" is a cascading series of self-invisible displacements, denied tropes, reified relationships. Second, popular culture most certainly includes activity inside laboratories and their associated institutions.

Inside and outside laboratories, genetic fetishism is condensed, replicated, ironized, indulged, disrupted, consolidated, examined. Gene fetishists "forget" that the gene and gene maps are ways of enclosing the commons of the body — of corporealizing—in specific ways, which, among other things, often put commodity fetishism into the program of biology at the end of the Second Millennium. In the following section, I would like to savor the anxious humor of a series of scientific cartoons and advertisements about the gene in order to see how joking practice works where gene fetishism prevails. We move from Maxis's SimLife to maps and portraits of the genome itself.

Genome

A word found readily in science news and business sections of ordinary newspapers, *Genome* is also the title of "the story of the most astonishing scientific adventure of our time" by two *Wall Street Journal* staff writers (Bishop and Waldholz 1990).[22] In a human being, the genome, or the full set of genes in the cell nucleus contained on chromosomes derived from both parents, contains about six billion base pairs of DNA, representing copies from each parent of 50,000 to 100,000 genes plus a large amount of noncoding DNA. The *Oxford English Dictionary* traces the first use of the term *genome* to the early 1930s, when the word designated the chromosomal genetic complement but without the references to databases, programs, instrumentation, and information management that permeate 1990s genome discourse. My reading of comic portraiture and cartography—the story of life itself—picks up after the implosion of informatics and biologics, especially genetics, since the 1970s.

Still absent from Webster's 1993 unabridged dictionary, *genome* progressively signifies a historically new entity engendered by the productive identity crisis of nature and culture. The cultural productions of the genome produce a category

crisis, a generic conundrum in which proliferating ambiguities and chimeras animate the action in science, entertainment, domestic life, fashion, religion, and business. Of course, the pollution works both ways; culture is as mouse-eaten as nature is by the gnawings of the mixed and matched, edited and engineered, programmed and debugged genome. Borderlands are often especially heavily polluted and policed; they are also especially full of interesting traffic and powerful hopes. The gene and the genome constitute such borderlands on the maps of technoscience. The gene, a kind of stem cell in the technoscientific body, is enmeshed in a hypertext that ramifies and intersects richly with all the other nodes in the web.

In a quarter-long seminar at the University of California Humanities Research Center in the winter of 1991, much time was spent on the Human Genome Project. One philosopher in the seminar put his finger on potent double meanings when he understood the science studies scholars, who were suggesting the term *the cultural productions of the genome* as the title for a conference, to be referring to musical, artistic, educational, and similar "cultural productions" emerging from popularization and dissemination of science. The science studies professionals meant, rather, that the genome was radically "culturally" produced, and no less "natural" for all that. The gene was the result of the work of construction at every level of its very real being; it was constitutively artifactual. "Technoscience *is* cultural practice" might be the slogan for mice, scientists, and science analysts. No one understands that more clearly than the marketing department for the Maxis Corporation's SimLife game, from whom the first epigraph of this chapter was taken. It remains to be seen whether the rush-hour traffic across the boundaries of nature and culture in genome discourse constitutes a case of fluid practice or a particularly grave case of hardening of the categories in technoscience.

Let me tell a parochial story, which travels widely, about turgid and hardened entities. Like toys in other games, Genes R Us, and "we" (who?) are our self-possessed products in an apotheosis of technological humanism. There is only one Actor, and we are It. Nature mutates into its binary opposite, culture, and vice versa, in such a way as to displace the entire nature/culture (and sex/gender) dialectic with a new discursive field. In that field, the actors who count are their own instrumental objectifications. Context is content with a vengeance; autonomy and automaton interface intimately. Nature is the program; we replicated it; we own it; we are it. Nature and culture implode into each other and disappear into the resulting black hole. ManTM makes himself in a cosmic act of onanism. The nineteenth-century transfer of God's creative role to natural processes, within a multiply stratified, hegemonically Christian,

GENE

industrial culture committed to relentless constructivism and productionism, bears fruit in a comprehensive biotechnological harvest in which control of the genome is control of the game of life itself—legally, mythically, and technically. The stakes are very unequal chances for life and death on the planet. If it were

Figure 4.1 Courtesy of E-C Apparatus Corporation. Cartoon by Wally Neibart.

150

written today, *Of Mice and Men* might be titled *Of OncoMouse*TM *and Man*TM—
or *FemaleMan*$^{©}$ *Meets OncoMouse*TM.

Attending to how the permeable boundary between science and comedy
works in relation to the genome—and at the risk of giving comfort to those
who still think the cultural production of the genome means its populariza-
tion—I want to pursue my story literally by reading the comics. My structuring
text is a family of three images, all cartoon advertisements for lab equipment
drawn by Wally Neibart and published in *Science* magazine in the early 1990s. I
am reminded of David Harvey's (1989:63) observation that advertising is the
official art of capitalism. Advertising also captures the paradigmatic qualities of
democracy in the narratives of life itself. Finally, advertising and the creation of
value are close twins in the New World Order, Inc. The cartoons explicitly play
with creation, art, commerce, and democracy.

The Neibart cartoons suggest who "we," reconstituted as subjects in the
practices of the Human Genome Project, are called to be in this hyperhumanist
discourse: ManTM. This is man with property in himself in the historically spe-
cific sense proper to the New World Order, Inc. Following an ethical and
methodological principle for science studies that I adopted many years ago, I
will critically analyze, or "deconstruct," only that which I love and only that in
which I am deeply implicated. This commitment is part of a project to excavate
something like a technoscientific unconscious, the processes of formation of the
technoscientific subject, and the reproduction of this subject's structures of plea-
sure and anxiety. Those who recognize themselves in these webs of love, impli-
cation, and excavation are the "we" who surf the Net in the sacred/secular quest
rhetoric of this chapter.

Interpellated into its stories, I am in love with Neibart's comic craft. His car-
toons are at least as much interrogations of gene fetishism as they are sales
pitches. In his wonderful cartoon image advertising an electrophoresis system, a
middle-aged, white, bedroom-slipper- and-lab-coat-clad man cradles a baby
monkey wearing a diaper[23] [Figure 4.1]. Addressing an audience outside the
frame of the ad, the scientist holds up a gel with very nice protein fragment sep-
aration generated by the passage of charged molecules of various sizes through
an electrical field. The gel is part of a closely related family of macromolecular
inscriptions, which include the DNA polynucleotide separation gels, whose
images are familiar icons of the genome project. In my reading of this ad, the
protein fragment gel metonymically stands in for the totality of artifacts and
practices in molecular biology and molecular genetics. These artifacts and prac-
tices are the components of the apparatus of bodily production in biotechnol-
ogy's materializing narrative. My metonymic substitution is warranted by the

GENE

dominant molecular genetic story that still overwhelmingly leads unidirectionally from DNA (the genes) through RNA to protein (the end product). In a serious and persistent joke on themselves, the kind of joke that affirms what it laughs at, molecular biologists early labeled this story the Central Dogma of molecular genetics. The Central Dogma has been amended over the years to accommodate some reverse action, in which information flows from RNA to DNA. "Reverse transcriptase" was the first enzyme identified in the study of this "backward" flow. RNA viruses engage in such shenanigans all the time. HIV is such a virus; and the first (briefly) effective drugs used to treat people with AIDS inhibit the virus's reverse transcriptase, which reads the information in the viral genetic material, made of RNA, into the host cell's DNA. Even while marking other possibilities, the enzyme's very name highlights the normal orientation for control and structural determination in higher life forms. And even in the reverse form, Genes R Us. This is the Central Dogma of the story of Life Itself.

In the Neibart cartoon, while the scientist speaks to us, drawing us into the story, the monkey's baby bottle is warming in the well of the electrophoresis apparatus. The temperature monitor for the system reads a reassuringly physiological 37°C, and the clock reads 12:05. I read the time as five minutes past midnight, the time of strange night births, the time for the undead to wander, and, as Evelyn Keller suggested, the first minutes after a nuclear holocaust. Remember the clock that the *Bulletin of Atomic Scientists* used to keep time in the Cold War; for many years it seemed that the clock advanced relentlessly toward midnight. As Keller argued persuasively, the bomb and the gene have been choreographed in the last half of the twentieth century in a complex dance that intertwines physics and biology in their quest to reveal "secrets of life and secrets of death" (Keller 1992a:39–55).

In the electrophoresis system ad, of course, Neibart's image suggests a reassuring family drama, not the technowar apocalypse of secular Christian monotheism or the Frankenstein story of the unnatural and disowned monster. But I am not reassured: All the conventional rhetorical details of the masculinist, humanist story of man's autonomous self-birthing structure the ad's narrative. The time, the cross-species baby, the scientist father, his age, his race, the absence of women, the appropriation of the maternal function by the equipment and by the scientist: All converge to suggest the conventional tale of the second birth that produces Man. It's not *Three Men and a Baby* here but *A Scientist, a Machine, and a Monkey*. The technoscientific family is a cyborg nuclear unit. As biologist—and parent—Scott Gilbert insisted when he saw the ad, missing from this lab scene are the postdocs and graduate students, with their babies, who might really be there after midnight. Both monkey and molecular inscription

stand in for the absent human product issuing from the reproductive practices of the molecular biology laboratory. The furry baby primate and the glossy gel are tropes that work by part-for-whole substitution or by surrogacy. The child produced by this lab's apparatus of bodily production, this knowledge-producing

Figure 4.2 Courtesy of E-C Apparatus Corporation. Cartoon by Wally Neibart.

technology, this writing practice for materializing the text of life, is—in fruitful ambiguity—the monkey, the protein gel (metonym for man), and those interpellated into the drama, that is, us, the constituency for E–C Apparatus Corporation's genetic inscription technology.

I over-read, naturally; I joke; I suggest a paranoid reading practice. I mistake a funny cartoon, one I like immensely, for the serious business of real science, which surely, my professional self duplicitously asserts, has nothing to do with such popular misconceptions. But jokes are my way of working, my nibbling at the edges of the respectable and reassuring in technosciences and in science studies. This nervous, symptomatic, joking method is intended to locate the reader and the argument on an edge. On either side is a lie—on the one hand, the official discourses of technoscience and its apologists; on the other hand, the fictions of conspiracy fabulated by all those labeled "outsider" to scientific rationality and its marvelous projects, magical messages, and very conventional stories. In the end, the joke is on us. Inside and outside are lies. The edge is all there is, and we, inhabitants of the hypermodern cities of technoscience, are surely on it in the late twentieth century. As John Varley (1986) put it in his paranoid SF story, all we have to do is "Press Enter • ".

My interest is relentlessly in images and stories and in the worlds, actors, inhabitants, and trajectories they make possible. In the biotechnological discourse of the Human Genome Project, the human is produced in a specific historical form, which enables and constrains certain forms of life rather than others. The technological products of the several genome projects are cultural actors in every sense of the term. Technoscience's work is cultural production.[24]

Portrait™

A second Wally Neibart cartoon for a *Science* ad makes an aspect of this point beautifully—literally [Figure 4.2]. In its evocation of the world of (high) art, this ad is a deliberate pun on science as (high) cultural production. But that should not prevent the analyst from conducting another, quasi-ethnographic sort of "cultural" analysis. I think Neibart subtly invites a critical reading; I think he is laughing at gene fetishism as well as using it. Our same balding, middleaged, white, male scientist—this time dressed in a double-breasted blue blazer, striped shirt, and slacks—is bragging about his latest acquisition to a rapt, younger, business-suit-clad, white man with a full head of hair. They get as close to power dressing as biologists, still new to the corporate world, seem to manage. The two affluent-looking gentlemen are talking in front of three paintings in an art museum. Or at least they are in an art museum if the *Mona Lisa* has not been relocated recently as a result of the accumulated wealth of the truly Big Men in

informatics and biologics. After all, in 1994 William H. Gates III, the chairman and founder of the Microsoft Corporation, purchased a rare Leonardo da Vinci notebook, *Codex Hammer*, with over 300 illustrations and scientific writings done by the artist from 1506 to 1510 in Florence and Milan, for a record $30.8 million in a manuscript auction (Vogel 1994:A1, A11).[25]

None of Neibart's three paradigmatic portraits of man on display is of a male human being, nor should they be. The self-reproducing mimesis in screen projections usually works through spectacularized difference. One painting in Neibart's ad is da Vinci's *Mona Lisa*; the second is Pablo Picasso's *Woman with Loaves* (1906); the third, gilt framed like the others, is a superb DNA sequence autoradiograph on a gel. The Italian Renaissance and modernist paintings are signs of the culture of Western humanism, which, in kinship with the Scientific Revolution, is narratively at the foundations of modernity and its sense of rationality, progress, and beauty—not to mention its class location in the rising bourgeoisie, whose fate was tied progressively to science and technology. Like the humanist paintings, the sequence autoradiograph is a self-portrait of man in a particular historical form. Like the humanist paintings, the DNA gel is about technology, instrumentation, optics, framing, angle of vision, lighting, color, new forms of authorship, and new forms of patronage. Preserved in gene banks and cataloged in databases, genetic portraits are collected in institutions that are like art museums in both signifying and effecting specific forms of national, epistemological, aesthetic, moral, and financial power and prestige. The potent ambiguities of biotechnical, genetic, financial, electrical, and career power are explicitly punned in the ad: "I acquired this sequence with my EC650 power supply." The E-C Apparatus Corporation offers "the state-of-the-art in Power Supplies"—in this case, a constant power-supply device.

The unique precision and beauty of original art become replicable, everyday experiences through the power of technoscience in successful proprietary networks. The modernist opposition between copies and originals—played out in the art market with particular force—is erased by the transnational postmodern power of genetic identification and replication in both bodies and labs, *in vivo* and *in vitro*. Biotechnical mimesis mutates the modernist anxiety about authenticity. "Classic sequence autoradiographs are everyday work for E-C Electrophoresis Power Supplies." No longer oxymoronically, the ad's text promises unlimited choice, classical originality, 18 unique models, and replicability. At every stage of genome production, in both evolutionary and laboratory time, database management and error reduction in replication take the place of anxiety about originality.

But a calmed opposition between copy and original does not for a minute

subvert proprietary and authorial relations to the desirable portrait in all its endless versions, although the subjects of authorial discourse have mutated, or at least proliferated. Just as I am careful to credit Neibart and seek permission to reprint, E-C is careful to confirm authorial and property relations of the beautiful framed DNA sequence autoradiograph, which is reproduced in the ad "courtesy of the U.S. Biochemical Corporation using Sequenase[TM] and an E-C Power Supply."[26] E-C used the molecular portrait of man with permission, just as I did, in the escalating practices of ownership in technoscience, where intellectual and bodily property become synonymous. The "great artist" of the technohumanist portrait is a consortium of human and nonhuman actants: a commercially available enzyme, a biotech corporation, and a power-supply device. Since there is no credit given, copyright protection for reproducing images of the Renaissance and modernist humanist paintings seems to have lapsed. Like the art portraiture, the scientific portrait of man as gel and database signifies genius, originality, identity, the self, distinction, unity, and biography. In eminently collectible form, the gel displays difference and identity exhaustively and precisely. Human beings are collected up into their paradigmatic portrait. No wonder aesthetic pleasure is the reward. The autoradiograph reveals the secrets of human nature. Intense narrative and visual pleasure is intrinsic to this technoscientific apparatus, as it is to others, that nonetheless try to ensure that their productions can only be officially or "scientifically" discussed in terms of epistemological and technological facticity and nontropic reality. Genes *are* us, we are told through myriad "cultural" media, from DNA treated with reagents like Sequenase[TM] and run on gels to property laws in both publishing and biotechnology. Narrative and visual pleasure can be acknowledged only in the symptomatic practices of jokes and puns. Displayed as "high science," explicit "knowledge" must seem free of story and figure. Such technohumanist portraiture is what guarantees man's second birth into the light and airy regions of mind. This is the structure of pleasure in gene fetishism.

The strong bonding of biotechnology with the Renaissance, and especially with Leonardo da Vinci, demands further dissection. Commenting on the potent mix of technique, ways of seeing, and patronage, a venture capitalist from Kleiner Perkins Caufield & Byers summed up the matter when he observed that biotechnology has been "for human biology what the Italian Renaissance was for art" (Hamilton 1994:85). Leonardo, in particular, has been appropriated for stories of origin, vision and its tools, scientific humanism, technical progress, and universal extension. I am especially interested in the technoscientific preoccupation with Leonardo and his brethren in the "degraded" contexts of business self-representation, advertising inside the scientific community, science news

illustration, conference brochure graphics, science popularization, magazine cover art, and comic humor.

Consider Du Pont's remarkable ad that begins, "Smile! Renaissance™ non-rad DNA labeling kits give you reproducible results, not high back-

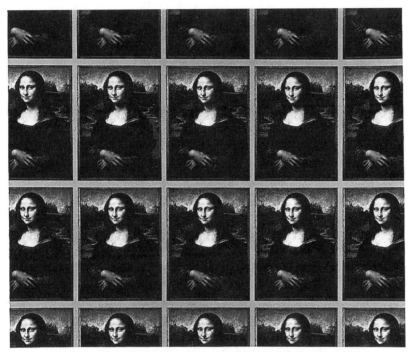

Smile! Renaissance™ non-rad DNA labeling kits
give you reproducible results, not high backgrounds.

Are you repeating experiments just to reduce backgrounds? Then look into Renaissance™ non-radioactive DNA labeling and detection products from DuPont NEN? And get low backgrounds and reproducible results the first time, and every time.

³²P EasyTides™ 24 hr at -80°C
Chemiluminescence 20 min at room temp.

1.8 μg Molt-4 total RNA was probed via Northern Blot hybridization with labeled GAPDH.

• Sensitive HRP-luminol systems for colony/plaque lifts and Northern, Southern, and Western blots.
• Results in minutes.
• Guaranteed one-year shelf life.
• Backed by full protocol and comprehensive technical service.
• Now available: Random Primer Fluorescein dUTP Labeling Kit and Oligonucleotide 3′ End Labeling kit (Fluorescein ddUTP).

DuPont gives you a choice of radioactive and now non-radioactive labeling and detection products. For information, or orders call 1-800-551-2121. For information by fax, call 1-800-666-6527 and request number 9002.

All DuPont products are manufactured under an ISO 9001 quality system registered by UL and approved by BSI.

United States 1-800-551-2121 • Canada 1-800-387-8391 • Australia +61 (008) 257149 • Belgium +32 (02) 7242717
Denmark +45 31506010 • France (01) 6982 5450 • Germany +49-6172-872600 • Italy (02) 25302 481/483
Japan +81 (03) 5421-1354 • Latin America/Asia Pacific Fax +1 (617) 426-2464 • Netherlands +31 (073) 206550
Sweden +46 (08) 7503700 • Switzerland +41 (01) 8410330 • United Kingdom +44 (0438) 724037

〈DUPONT〉

DuPont NEN

Figure 4.3 Du Pont advertisement from Science magazine. Courtesy of Du Pont NEN products. On May 19, 1995 Du Pont announced its intent to divest its medical products business. The former Du Pont NEN products business will become NEN life science products.

GENE

grounds."[27] [Figure 4.3] The text occurs underneath a color reproduction of Andy Warhol's giant nine-foot-two-inch by seven-foot-10.5-inch 1963 photo-silkscreen, in ink and synthetic polymer paint, that "clones" the *Mona Lisa*.[28] Filling in a grid of five *Mona Lisa*'s across and six down, Warhol's multiplied version is entitled *Thirty Are Better Than One*. In Warhol's and Du Pont's versions, the paradigmatic, enigmatically smiling lady is replicated in a potentially endless clone matrix. Without attribution, Du Pont replicates Warhol replicates da Vinci replicates the lady herself. And Renaissance™ gets top billing as the real artist because it facilitates replicability. But how could Warhol, of all the artists who ever lived, object to his work being anonymously appropriated for commodity marketing under the sign of "debased" high art and high science enterprised up? In the Du Pont ad, the only mark of intellectual property is—in a comic, but probably unintended, recursive self-parody—Renaissance™. The mythic chronotope itself bears the trademark of the transnational biotechnology corporation. Recursively, the brand marks detection and labeling tools, for the code of codes, for life itself.

Leonardo is also my patron and father figure for a little-known genetic investigation, the dog genome project. Leonardo's drawing of the human figure of perfect proportions called the *Vitruvian Man* (ca. 1485-1490) illustrates countless announcements of Human Genome Project convergences and mapping breakthroughs. So when a cartoon called "Leonardo da Vinci's Dog" appeared anonymously in 1994 in my university mailbox, I realized at once that the dog of perfect proportions for the canine genome project had appeared from heaven[29] [Figure 4.4]. Companion to human beings, partner in work, and surrogate in medical research, the dog turns out to be perfectly proportioned for life itself. The actual dog genome is of potential interest to veterinarians dealing with disease, dog breeders seeking diagnostic tools to identify undesirable traits, and evolutionary biologists studying complex behaviors conditioned by multiple genes (Mestel 1994).[30] It is this last interest that merits more comment under the sign of the canine surrogate to the Vitruvian Man. Leonardo's dog's escapades take place in the chronotope defined by material and narrative tools such as Renaissance™.

Well-maintained dog breeds are the Mormons of the canine world. That is, the family histories, the genealogies, of anatomically and behaviorally distinct kinds of dogs are known for many generations and for large numbers of individuals. Human geneticists accustomed to working with truncated family pedigrees can only be envious.[31] Moreover, even for the most resolute believer in the genetic determination of many aspects of human behavior, it is a vain dream to expect to be able to find and study most of the critical genes. The unlikeli-

hood of actually identifying more than a very few behavioral genes in human beings and locating them on genetic, chromosomal, and molecular maps rises astronomically for notoriously complex behaviors such as "intelligence" or "aggression." Controlled breeding of humans is out of the question. Ask any marriage counselor. Further, even describing human behavior in terms remotely useful to a genetic investigation is hopelessly controversial, even among those who are not convinced that characteristically human behavior

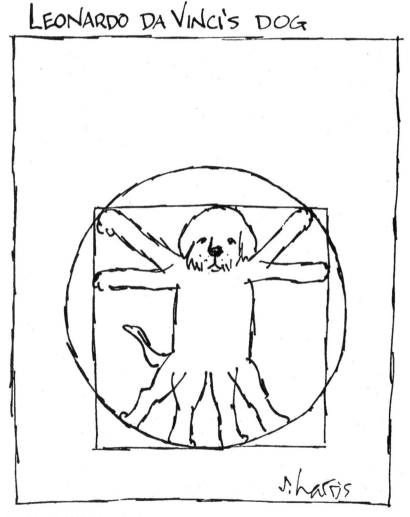

LEONARDO DA VINCI'S DOG

Figure 4.4 © 1996 Sidney Harris.

owes much more to developmental, cultural, economic, and experiential aspects of life than to genes. In the eyes of large sections of the public and of other scientists, human behavioral genetics always teeters on the edge of pseudo-science and frank ideology.

However, dogs are another matter. Little controversy arises in ascribing a great deal of complex canine behavior to genes. After all, dogs have been subject to intense selection by breeders for specific patterns of behavior. Important and distinct behaviors such as pointing, retrieving, water rescue skills, and herding are unlikely to be conditioned by single genes. Dog behavioral genetics ought to be a rich world for those looking to understand the interaction of several genes related to the development of complex, specific behaviors. That this goal may be far in the future does not reduce its feasibility in principle.

With the goal of understanding the evolution of breeds, Jasper Rine at the University of California at Berkeley; Elaine Ostrander, now at the University of Washington; and George Sprague at the University of Oregon launched the dog genome project in 1991.[32] They sought knowledge of the genes implicated in both anatomy and behavior. The ensuing story of the border collie Gregor and the Newfoundland Pepper and their offspring, scattered among scientists and dog lovers on the U.S. West Coast, is the story of canine genome discourse. The dog genome is large and uncharted, and the intrepid researchers have to do the genetic, chromosomal, and molecular mapping practically from scratch and on modest budgets. They also have to socialize quite a lot with the dogs. But then, that is the stuff of good scientific narrative and the occasion of a lot of hard work, called knowledge-making practices by science studies scholars.

If I lived in another mythic time than the New World Order, Inc., the dog genome project would elicit only my curiosity and support. But in the time of Renaissance[TM], I admit to paranoid fears that the study of the genetics of complex, polygenic behaviors in any "model" species bodes little good for those of us who want mutated discourses about the determinants of complex behavior to flourish—for dogs, worms, yeast, mice, and people. In a time of florid fundamentalist hereditarian and genetic discourse—including sober comments about the genetics of homelessness made by an officer of a major national scientific association and the publication of well-received racist and classist tracts on the correlation of IQ, genetic inheritance, and social power[33]—we need to learn how to engage in knowledge-making practices in genetics, as well as in other cultural domains, that produce critical and cross-cutting multidisciplinary, multispecies, and multicultural savvy. We need a critical hermeneutics of genetics *as a constitutive part of scientific practice* more urgently than we need better map resolution for genetic markers in yeast, human, or canine genomes.

Without becoming prudish and prohibitive, *how* can we develop this kind of critical relation to the technoscientific knowledge-making practices that touch on the most easily ideologized and abused aspects of life in the regimes of technobiopower? How do we move from reified taxonomic exercises that constitute "aggression" and "intelligence" as materialized, measurable entities to sciences held to higher standards of critical objectivity, beginning at the level of category formation? How do we learn *inside the laboratory and all of its extended networks* that there is no category independent of narrative, trope, and technique? To pretend otherwise is symptomatic of an advanced case of hardening of the categories. Can reading the comics be a little part of the solution to epistemological and political plaque formation? I like to think of Leonardo's dog as a sign of hope that the next brochure for a conference on human genetics will show a little more savvy about its appropriations of the signs of the Renaissance that link science, genius, wealth, power, high art, and career power.

In the Company of Genes

Aside from the dubious society of dogs, the company the gene keeps is definitely upscale. Fetishes come in matched sets. Master molecule of the Central Dogma and its heresies, the gene affiliates with other power-objects of technoscience's knowledge production: neuroimaging, artificial intelligence, artificial life, high-gloss entertainment, high technology, high expectations. The ten-part series "Science in the 90s," which ran from January 5, 1990, to May 8, 1990, gives a broad sense of what counts as cutting-edge technoscience for the news writers and editors of *Science*. In general, the excitement came from high tech/high science, prominently including neuroscience, computing and information sciences, and molecular genetics. The boring and discouraging notes came from (very brief) consideration of such matters as ongoing racial and sexual "imbalance" in who does technoscience and the troubles that arise when "politics" gets into the career of a scientist.

Overwhelmingly, the chief power sharer in the gene's new world community is the nervous system. Even the *UNESCO Courier* carries the news that links mind and origins, neuron and gene, at the helm of life itself: "No one would deny that, within the highly organized framework of a human being, two 'master elements' account for most of our characteristics—our genes and our neurons. Furthermore, the nature of the dialogue between our genes and our neurons is a central problem of biology" (Gros 1988:7).[34]

Every autumn since 1990, *Science*, the magazine of the American Association for the Advancement of Science (AAAS), has put out a special issue updating its readers on progress in genome mapping, and especially in the

Human Genome Project. The table of contents of the first special issue highlights the tight coupling of genetic and nervous systems in the discourse of millennial science.[35] Citing a recent example of homicidal mania, *Science* editor Daniel Koshland Jr. introduced the issue with the argument that hope for the mentally ill—and for society—lies in the high cultures of neuroscience and genetics. Necessary to the topological diagrams of life itself, the tie to informatics is made explicit: "The irrational output of a faulty brain is like the faulty wiring of a computer, in which failure is caused not by the information fed into the computer, but by incorrect processing of that information after it enters the black box" (Koshland 1990:189). Besides the articles on the genome project and the map insert, the issue contains a research news piece called "The High Culture of Neuroscience" and eight reports from neurobiology, spanning the range from molecular manipulation of ion channels to a study of primate behavior to a psychological assessment of human twins reared apart.

Located in the potent zones where molecular genetics and neurobiology ideologically converge, this last study on twins reared apart lists as its first author Thomas Bouchard, a former student of Arthur Jensen (Bouchard et al. 1990). Jensen promoted the idea of the linkage of genetic inheritance, IQ, and race in a famous 1969 *Harvard Educational Review* article. The special gene-map issue of *Science* was the first major professional journal to publish Bouchard's controversial work, which ascribes most aspects of personality and behavior to genes. Many of Bouchard's papers had been rejected through peer review, but he brought his message successfully to the popular media anyway. Following *Science*'s publication of his study, Bouchard's ideas gained authority and prominence in public debates about genetics and behavior (Nelkin and Lindee 1995:81–82; Jensen 1969).

Cartography, the high science of the Age of Exploration, tropically organizes the first *Science* gene map issue from the design of its cover to the content of its prose. Collectively labeled "The Human Map," the cover is a collage of mapping icons—including a Renaissance anatomical human dissection by Vesalius, a Mendelian genetic-cross map superimposed on the great scientist's facial profile, a radioactively labeled region of metaphase chromosomes, a linkage map and a bit of sequence data rendered by the cartographical conventions that have emerged in the genome projects, a flow diagram through the outline of a mouse body, and a computer-generated colored-cell map of an unidentified abstract territory. The cover design is explained inside: "Just as the ancient navigators depended on maps and charts to explore the unknown, investigators today are building maps and charts with which to explore new scientific frontiers."[36]

The reference to the Renaissance cartographers, a common rhetorical

device in genome discourse, is not idle. Genomics "globalizes" in specific ways. Species being is materially and semiotically produced in gene-mapping practices, just as particular kinds of space and humanity were the fruit of earlier material-semiotic enclosures. Traffic in bodies and meanings is equally at stake. The orthodox stories of the Renaissance and early modern Europe are useful to my narrative of genome mapping as a process of bodily spatialization akin to enclosing the commons in land, through institutions of alienable property, and in authorship, through institutions of copyright. Harvey points out that the introduction of the Ptolemaic map into Florence from Alexandria in 1400 gave Europeans the critical means to see the world as a global unity (Harvey 1989:244–52). The Ptolemaic map and its offspring were the air-pumps of scientific geography, embedded in material, literary, and social technologies that made the "global" a mobile European reality. "Mathematical principles could be applied, as in optics, to the whole problem of representing the globe on a flat surface. As a result it seemed as if space, though infinite, was conquerable and containable for purposes of human occupancy and action" (Harvey 1989:246). The elaboration of perspective techniques in midfifteenth-century Florentine art was entwined with the construction of individualism and perspectivism critical to modern spaces and selves. The sixteenth-century Flemish cartographer Gerardus Mercator, after whom at least one biotechnological corporation is named, crafted projections of the globe geared to navigation on the high seas in a period of intense world exploration by Europeans. All of these practices constituted a major reworking of conceptions of space, time, and person. And all of these practices are in the family tree of genetic mapping, which once again is a local practice enabling certain sorts of power-charged global unity. No wonder Mercator's grids and projections are part of the scientific unconscious of biotechnology researchers and advertisers.

Bruno Latour discusses the mobilization of worlds through mapping practices; cartography is a metaphor and a technology of the highest importance (Latour 1987:215–57). Cartography is perhaps the chief tool-metaphor of technoscience. "Mapping Terra Incognita (*Humani Corporis*)," the news story toward the less technical front of *Science*'s first special issue on the genome project, has all of the expected allusions to Vesalius's Renaissance anatomy (Culliton 1990:210-12). This kind of ubiquitous new world imagery, like the extended propaganda for cybernetics in the United States in the 1950s and 1960s, indicates a "disturbed passage point" through which many popular and technical projects get loosely associated with the high gloss of molecular biology and biotechnology (Bowker 1993). The second article on genome mapping in the special issue, "Mapping the Human Genome: Current Status" (Stephens et al.

GENE

1990), charts another kind of intersection, one Latour called an "obligatory passage point."[37] This node represents the fruit of the mobilization of resources and the forging of alliances among machines, people, and other entities that force others to pass through *here*, and nowhere else. The sociotechnical achievements of molecular biology are a node through which many *must* pass:

Figure 4.5 Courtesy of New England Biolabs. Concept and design by Mycoff, Inc.

paleoanthropologists who wish to resolve evolutionary arguments, physicians who wish to diagnose and treat disease, developmental biologists who seek resolution of their questions, ideologists who proclaim legitimation for or exemplary condemnation of technoscience. Molecular biology does not just claim to be able to decode the master molecule; it installs the tollbooths for a great deal of collateral traffic through nature.

The human genome map inserted into the special issue of *Science* in 1990 inaugurated the practice of annually giving each subscriber-member of the AAAS a personal copy of the most up-to-date chart available. The practice reverberates with *National Geographic*'s presentation to subscribers of the new Robinson projection map of the globe in its January 1988 issue, which featured on the front cover the holographic portrait of the endangered planet Earth at the dawn of the decade to save man's home world. (A holographic ad for McDonald's, with appropriate words from the transnational fast-food chain's founder, graced the back cover.) Just as all subscribers to *National Geographic* are automatically members of a scientific society, and so patrons of research, all subscribers to *Science* are members of the AAAS and share symbolically in its ideological and material privileges. As subscribers, "we" are the constituents of technoscience, a mapping practice of the highest order. With over 150,000 subscribers, *Science* reaches about three times the number as does *Nature*, its British sibling and nearest world-class competitor. *National Geographic,* of course, reaches millions.

In a mid-1990s ad for DNA-cutting enzymes, New England Biolabs astonishingly invokes the imploded global bodies materialized by both *National Geographic* and the Human Genome Project [Figure 4.5]. The Global Native embodies the Global Gene. Once more, difference is mapped and enclosed; art, science, and business join in the dance. From the left side of the page, against a black background the body of a beautiful young woman with generically (and oxymoronically) "indigenous" facial features flows forward. Her body *is* the mapped terran globe, shaped to her lovely female contours, and she is its soul. Of the earth, she moves through it as both its spirit and flesh. Arms raised in a dance gesture, the native woman is clothed with the tissue of the mapped planet, which billows out into a semicircle continuous with her graceful figure. Marked off by its geometric coordinates, the projection map shows the bulge of West Africa and the Atlantic Ocean. The seas are dotted with the great sailing clipper ships of Europe's age of exploration and marked with the fabulous Latin names bestowed by the navigators' culture. The map-woman is an animated Mercator projection.

The earth is both the woman's body and her dress, and the color-enhanced regions highlighting the beige tones of the swirling hemispherical

GENE

corpus/fabric are like style elements in a *United Colors of Benetton* celebration of global multiculturalism. To remember the slave trade and the middle passage across the region of the world shown on this lovely map seems a petty thing to do. The woman-earth's body confronts text at the midline of the page: "Mapping the Human Genome." The earth and the genome are one, joined in the trope of the technoscientific map. "Advanced by a diverse range of 8-base

Figure 4.6 © 1996 Sidney Harris.

Cutters," the new cartography will be enabled by New England Biolabs' restriction enzymes. Map, woman, earth, goddess, science, body, inscription, technology, life, the native: All are collected in an aestheticized image like a Navajo sand painting that places the holy people inside the four sacred mountains. Who said master narratives, universalism, and holism were dead in the New World Order's extended networks? Advanced by all of the code-analyzing restriction enzymes given by the globalized history of race and gender, naturalization has never been more florid. But I doubt that is what New England Biolabs meant to signify in its ad promising "exceptional purity and unmatched value essential for success in your genomic research."

In short, biotechnology in general and the Human Genome Project in particular aim high. No wonder the Human Genome Project's apologists have called it biology's equivalent to putting a man on the moon. Where else could he go with all that thrust? The Human Genome Project is discursively produced as, once more, "one small step...." At this origin, this new frontier, man's footprints are radioactive traces in a gel; at the dawn of hominization, the prints were made in volcanic dust at Laetoli in Ethiopia; at the dawn of the space age, a white man, acting as surrogate for mankind, walked in moon dust. All of these techno-scientific travel narratives are about freedom; the free world; democracy; and, inevitably, the free market.

Representation, Recursion, and the Comic

Under the signifiers of freedom and democracy, a third Neibart cartoon on this theme completes this comic chapter's catalog of the savvy artist's potent jokes. Two senior white male scientists in business suits, one the same successful fellow who acquired the technohumanist portrait of man in the form of a DNA separation gel, stand with their hands clenched above their heads in the sign of victory on the stage above the cheering mob at a political convention [Figure 4.6]. The figures in the crowd wave the red, white, and blue banners inscribed with name of their constituencies: DNA, protein, ACGT, RNA, PCR, and all the other molecular actors in the genomic drama. "With 90% of the vote already in, it is a landslide" for the E-C Apparatus Corporation's power supply. The joke makes the concretized entities of the biotechnological laboratory into the voters in the democracy of science. The molecules and processes—themselves the feat of the scientists in the scene we have learned to read through the pages of *Science in Action* (Latour 1987) and *Leviathan and the Air-Pump* (Shapin and Schaffer 1985)—are the actors with a vengeance. The sedimented feats of technoscientific virtuosity authorize their ventriloquists under the sign of freedom and choice. Clearly, this is material subject construction, Oedipal or not.

GENE

Jokingly ironized in the Neibart cartoon, this scene is also gene fetishism at its most literal. Literary, social, and material technologies converge to make the objects speak, just as Shapin and Schaffer showed us in the story of Robert Boyle's air-pump. In the culture of no culture conjugated with the nature of no nature, the objects speak with a withering directness. For all their inventiveness in making fabulous natural/cultural hybrids that circulate fluidly in vast networks, many actants in genome discourse seem "to be suffering from an advanced case of hardening of the categories."

It is not new to link the stories of science and democracy, any more than it is new to link science, genius, and art, or to link strange night births and manly scientific creations. But the interlocking family of narratives in the contemporary U.S. technoscientific drama is stunning. The Neibart cartoon must be read in the context of *Science 85's* cover of a decade ago, "The American Revolution." The magazine cover featured the chip and the gene, figured, as always, as the double helix, against the colors of red, white, and blue, signifying the New World Order, Inc., of nature "enterprised up" (Strathern 1992:39), where free trade and freedom implode. This warped field is where, to misquote the U.S. Supreme Court chief justice with whom I founded this chapter's juridical order, "Life Itself is always an experiment." It is, at the least, a real venture in marketing through the wormholes.

What, then, are advertisements in technoscience doing? Do the ads in magazines such as *Science* matter, and if so, how? Can I really make a case for reading these materials as even gently ironic rather than simply celebratory and instrumental in strengthening gene fetishism? Is anxious humor enough to force the trope into the open and disrupt literalism? Who besides me is anxiously laughing or crying at these ads? Fundamentally, these are empirical questions; and I do not know much about the many ways in which ad designers in technoscience produce their work, how graphic artists' views do and do not converge with scientists' or corporate managers' discourse, or how readers appropriate and rework ad images and text. I do know that the ads are more than pretty designs and helpful information.

Even though many of the ads contain considerable technical information, I do not think a very good case can be made for seeing these ads principally as sales strategies. The companies that supply the key equipment and products to modern biological and engineering labs have more effective mechanisms for informing and servicing clients. Company and product name recognition is enhanced, and I would not argue against modest functionalist economic readings of such ads. At the least, urged to find out more about potentially powerful tools, readers get toll-free phone numbers and reader-response cards for ordering catalogs.

At least as significantly, the readers of these ads taste the pleasures of narrative and figuration, of recognizing stories and images of which one is part. Advertising is not just the official art of capitalism; advertising is also a chief teacher of history and theology in postmodernity. The debates about historical and literary canons should be taking place in graphic artists' studios in corporations as well as in classrooms. The ads draw from and contribute to a narrative and visual world that activates the unconscious mechanisms that issue in the possibility of a joke. The joke is a sign of successful interpellation, of finding oneself constituted as a subject of knowledge and power in these precise regions of sociotechnical space. Whoever is inside that joke is inside the materialized narrative fields of technoscience, where better things for better living come to life. These ads work by interpellation, by calling an audience into the story, more than by informing instrumentally rational market or laboratory behavior. Such

"Here it is in Genesis: 'He took one of Adam's ribs, and made the rib into a woman.' Cloning, if I ever heard it. "

Figure 4.7 © 1996 Sidney Harris. Cartoon from Science magazine. March 1, 1991.

interpellation is the precondition of any subsequent rationality, in epistemology or in other such duplicitous free markets. In the Book of Life Itself, fetishism in all its flavors is comic to the end.

Finally, the Neibart cartoons critically comment on—or complicitously appeal to—the comic in quite another sense than "funny." In the literary analysis of the comic mode in drama, "comic" means reconciled, in harmony, secure in the confidence of the restoration of the normal and noncontradictory. For example, Shakespeare's comedies are not funny; rather, their endings restore the normal and harmonious, often through the ceremonies of marriage through which opposites are brought together. The comic does not recognize any contradictions that cannot be resolved, any tragedy or disaster that cannot be healed. The comic mode in technoscience is reassuring in just this way.[38] For those who would reassure us, the comic is just the right mode for approaching the end of the Second Christian Millennium.

Hardly surprisingly, edgy and nervous I have no choice but to end by jokingly repeating myself in a comic recursion that restores few harmonies. In a March, 1991, *Science* cartoon by Sidney Harris, a white male researcher in a lab coat reads out loud to a white female scientist, similarly dressed, both surrounded by their experimental animals and other equipment: "Here it is in Genesis:'He took one of Adam's ribs and made the rib into a woman.' Cloning, if I ever heard it" [Figure 4.7]. WomanTM cultured from the osteoblasts of ManTM: This Genesis replicates salvation history compulsively, repeating *in saecula saeculorum* "a few words about reproduction from an acknowledged leader in the field."[39]

Figuring the implosion of informatics and biologics, this bastard scriptural quotation comes from a Logic General Corporation ad for its early 1980s software duplication system. [Figure 4.8] In the foreground, under the earth-sun logo of Logic General a biological white rabbit has her paws on the grid of a computer keyboard. The long-eared rodent is generally a cultural sign of fecundity, and "breeding like rabbits" is a popular figure of speech. But Logic General's hare evokes especially the pregnancy-test bunny made famous in the history of reproductive medicine. Like Du Pont's OncoMouseTM, who is climbing toward the blindingly bright open shutter of a camera, this rabbit is peering at a luminous icon of technoscientific illumination, but with Logic General we are not in a biological laboratory. Looking into the screen of a video display terminal, the organic rabbit faces its computer-generated image, who also locks its cybergaze with the reader of the ad. In her natural electronic habitat, the virtual rabbit is on a grid that insists on the world as a game played on a chesslike board, or Cartesian grid, made up of a square array of floppy disks. The disks constitute a

kind of Mercator™ projection at the end of the Second Millennium. The replication-test bunny is a player in SimLife. Returning to the opening epigraph to this chapter, I remember its version of the injunction to be fruitful and multiply: "Give life to different species in the Biology Lab and customize their look with the icon editor."

We don't believe the facts about diskette reproduction should be left to rumor and streetcorner conversation. So here's the straight talk about software duplication from the experts at Logic General.

Logic General can satisfy software duplication orders of literally any size and complexity at a most competitive cost. Our years of experience as a leading distributor and duplicator of magnetic media,

combined with the latest automated high-speed production equipment, give us the edge.

Our synergistic approach to software duplication, a real partnership with each client, helps us tailor each order to cost, performance and system parameters with unique flexibility and precision.

And the accuracy, reliability and quality of each

Logic General-duplicated diskette is guaranteed, 100%.

Of course, this isn't the whole story. To learn more, call Logic General. Where all software is re-created equal.

LOGIC GENERAL CORPORATION
31999 Aurora Road
Cleveland, OH 44139

A FEW WORDS ABOUT REPRODUCTION FROM AN ACKNOWLEDGED LEADER IN THE FIELD.

Call toll-free: (800) 321-8908. In Ohio, (216) 349-2800.

CIRCLE 106

Figure 4.8 A Few Words about Reproduction. Courtesy of Logic General Corporation.

GENE

Like OncoMouse™, both the pregnancy-test and the replication-test rabbits in the Logic General ad are cyborgs—compounds of the organic, technical, mythic, textual, economic, and political—and they call us, interpellate us, into a world in which we are reconstituted as technoscientific subjects. Inserted into the matrices of technoscientific maps, we may or may not wish to take shape there. But, literate in the reading and writing practices proper to the technical-mythic territories of the laboratory, we have little choice. We inhabit these narratives, and they inhabit us. The figures and the stories of these places haunt us, literally. The reproductive stakes in Logic General's text—and, in general, in the inscription practices in the laboratory—are future life forms and ways of life for humans and nonhumans. The genome map is about cartographies of struggle—against gene fetishism and for livable technoscientific corporealizations.

Where else is there to go from here in the net the *Modest_Witness@Second_Millennium* has been surfing but to another haunting cyborg, which also troubles copying practices in the gravity well produced by the implosion of informatics and biologics, that is, to that *neuvo huevo*, the fetus?

FETUS

The Virtual Speculum in the New World Order

These are the days of miracle and wonder
This is the long-distance call
The way the camera follows us in slo-mo
The way we look to us all
The way we look to a distant constellation
That's dying in a corner of the sky
These are the days of miracle and wonder
And don't cry, baby, don't cry
It was a dry wind
And it swept across the desert
And it curled into the circle of birth
And the dead sand
Falling on the children
The mothers and the fathers
And the automatic earth

. . .

Medicine is magical and magical is art
The Boy in the Bubble
And the baby with the baboon heart

And I believe
These are the days of lasers in the jungle
Lasers in the jungle somewhere
Staccato signals of constant information
A loose affiliation of millionaires

And billionaires and baby
These are the days of miracle and wonder
This is the long-distance call

Paul Simon, "The Boy in the Bubble"[1]
© Paul Simon/Paul Simon Music (BMI)

In its ability to embody the union of science and nature, the embryo might be described as a cyborg kinship entity.
— Sarah Franklin, "Making Representations"

The fetus and the planet Earth are sibling seed worlds in technoscience. If NASA photographs of the blue, cloud-swathed whole Earth are icons for the emergence of global, national, and local struggles over a recent natural-technical object of knowledge called the environment, then the ubiquitous images of glowing, free-floating human fetuses condense and intensify struggles over an equally new and disruptive technoscientific object of knowledge, namely "life itself." Life as a system to be managed—a field of operations constituted by scientists, artists, cartoonists, community activists, mothers, anthropologists, fathers, publishers, engineers, legislators, ethicists, industrialists, bankers, doctors, genetic counselors, judges, insurers, priests, and all their relatives—has a very recent pedigree.[2] The fetus and the whole Earth concentrate the elixir of life as a complex system, that is, of life itself. Each image is about the origin of life in a postmodern world.

Both the whole earth and the fetus owe their existence as public objects to visualizing technologies. These technologies include computers, video cameras, satellites, sonography machines, optical fiber technology, television, microcinematography, and much more. The global fetus and the spherical whole Earth both exist because of, and inside of, technoscientific visual culture. Yet, I think, both signify touch. Both provoke yearning for the physical sensuousness of a wet and blue-green Earth and a soft, fleshy child. That is why these images are so ideologically powerful. They signify the immediately natural and embodied, over and against the constructed and disembodied. These latter qualities are charged against the supposedly violating, distancing, scopic eye of science and theory. The audiences who find the glowing fetal and terran spheres to be powerful signifiers of touch are themselves partially constituted as subjects in the material-semiotic process of viewing. The system of ideological oppositions between signifiers of touch and vision remains stubbornly essential to political and scientific debate in modern Western culture. This system is a field of mean-

ings that elaborates the ideological tension between body and machine, nature and culture, female and male, tropical and northern, colored and white, traditional and modern, and lived experience and dominating objectification.

The Sacred and the Comic

Sometimes complicitous, sometimes exuberantly creative, Western feminists have had little choice about operating in the charged field of oppositional meanings structured around vision and touch. Small wonder, then, that feminists in science studies are natural deconstructionists who resolutely chart fields of meanings that unsettle these oppositions, these setups that frame human and nonhuman technoscientific actors and sentence them to terminal ideological confinement (see, for example, Treichler and Cartwright 1992). Because the fruit issuing from such confinement is toxic, let us try to reconceive some of the key origin stories about human life that congeal around the images of the fetus. In many domains in contemporary European and U.S. cultures, the fetus functions as a kind of metonym, seed crystal, or icon for configurations of person, family, nation, origin, choice, life, and future. As the German historian of the body Barbara Duden put it, the fetus functions as a modern "*sacrum*," that is, as an object in which the transcendent appears (Duden 1993). The fetus as sacrum is the repository of heterogeneous people's stories, hopes, and imprecations. Attentive to the wavering opposition of the sacred versus the comic, the sacramental versus the vulgar, scientific illustration versus advertising, art versus pornography, the body of scientific truth versus the caricature of the popular joke, the power of medicine versus the insult of death, I want to proceed here by relocating the fetal sacrum onto its comic twin.

In this task, I am instructed by feminists who have studied in the school of the masters. Two feminist cartoons separated by twenty years, and a missing image that cannot be a joke, will concern me most in this chapter's effort to read the comics in technoscience. Set in the context of struggles over the terms, agents, and contents of human reproduction, all three of my images trouble a reductionist sense of "reproductive technologies." Instead, the images are about a specifically feminist concept called "reproductive freedom." From the point of view of feminist science studies, freedom projects are what make technical projects make sense—with all the specificity, ambiguity, complexity, and contradiction inherent in technoscience. Science projects are civics projects; they remake citizens. Technoscientific liberty is the goal. Keep your eyes on the prize.[3]

The first image, a cartoon by Anne Kelly that I have named *Virtual Speculum*, is a representation of Michelangelo's painting *Creation of Adam* on the ceiling of the Sistine Chapel[4] [Figure 5.1. *Virtual Speculum*]. *Virtual Speculum* is a

caricature in the potent political tradition of "literal" reversals, which excavate the latent and implicit oppositions that made the original picture work. In Kelly's version, a female nude is in the position of Adam, whose hand is extended to the creative interface with not God the Father but a keyboard for a computer whose display screen shows the global digital fetus in its amniotic sac. A female Adam, the young nude woman is in the position of the first man. Kelly's figure is not Eve, who was made from Adam and in relation to his need.[5] In *Virtual Speculum*, the woman is in direct relation to the source of life itself.

The cartoon seems to resonate in an echo chamber with a Bell Telephone advertisement that appeared on U.S. television in the early 1990s, urging potential long-distance customers to "reach out and touch someone." The racial-ethnic markings of the cast of characters varied in different versions of the ad. The visual text showed a pregnant woman, who is undergoing ultrasonographic visualization of her fetus, telephoning her husband, the father of the fetus, to describe for him the first spectral appearance of his issue. The description is performative: that is, the object described comes into existence, experientially, for all the participants in the drama. Fathers, mothers, and children are constituted as subjects and objects for each other and the television audience. Life itself becomes an object of experience, which can be shared and memorialized. Proving herself to be a literate citizen of technoscience, the pregnant woman interprets the moving gray, white, and black blobs on the televised sono-

Figure 5.1 Cartoon from Norwegian Feminist Journal, NYTT OM KVINNEFORSKNING, No. 3, 1992

gram as visually obvious, differentiated fetus. Family bonding is in full flower in Bell Telephone's garden of creation. Surrogate for the absent father, the mother touches the on-screen fetus, establishing a tactile link between both parents-to-be and child-to-be. Here are interactive television and video of a marvelous kind. The mother-to-be's voice on the phone and finger on the screen are literally the conduits for the eye of the father. These are the touch and the word that mediate life itself, that turn bodies and machines into eloquent witnesses and storytellers.

Through advertising, Bell Telephone puts us inside the dramatic scenarios of technology and entertainment, twins to biomedicine and art. In the ad, reproductive technology and the visual arts—historically bound to the specific kinds of observation practiced in the gynecological exam and the life-drawing class—come together through the circles of mimesis built into communications practices in the New World Order. Life copies art copies technology copies communication copies life itself. Television, sonography, computer video display, and the telephone are all apparatuses for the production of the nuclear family on screen. Voice and touch are brought into life on screen.

Kelly's cartoon works off the fact, which remains odd to women of my menopausal generation, that in many contemporary technologically mediated pregnancies, expectant mothers emotionally bond with their fetuses through learning to see the developing child on screen during a sonogram.[6] And so do fathers, as well as members of Parliament and Congress.[7] The sonogram is literally a pedagogy for learning to see who exists in the world. Selves and subjects are produced in such "lived experiences." Quickening, or the mother's testimony to the movement of the unseen child-to-be in her womb, has here neither the experiential nor the epistemological authority it did, and does, under different historical modes of embodiment. In Kelly's version, the bonding produced by computer-mediated visualization also produces subjects and selves; the touch at the keyboard is generative—emotionally, materially, and epistemologically. But things work both similarly and differently from the way they do on the Sistine Chapel ceiling or in the Bell Telephone TV advertisement.

In *Virtual Speculum* the grayish blobs of the television sonogram have given place to the defined anatomical form of the free-floating fetus. Kelly's on-screen fetus is more like an *in vivo* movie, photograph, or computer-graphic reconstruction—all of which are received at least partly within the conventions of post-Renaissance visual realism, which the bloblike sonographic image has great difficulty invoking. The televised sonogram is more like a biological monster movie, which one still has to learn to view even in the late twentieth century. By contrast, to those who learned how to see after the revolution in

painting initiated in the fifteenth and sixteenth centuries in northern and southern Europe, the free-floating, anatomically sharp, perspectivally registered fetal image appears self-evident at first viewing. Post-Renaissance anatomical realism and late-twentieth-century computer-generated corporeal realism still share many, although not all, viewing conventions and epistemologial assumptions.

The fetus like the one in *Virtual Speculum* is the iconic form that has been made so familiar by the exquisite, internationally distributed images produced by the Swedish biomedical photographer Lennart Nilsson. Endoscopic intrauterine fetal visualization began in the 1950s, well before sonograms were part of the cultural terrain. The visible fetus became a public object with the April 1965 *Life* magazine cover featuring Nilsson's photograph of an intrauterine eighteen-week-old developing human being encased in its bubblelike amniotic sac. The rest of the Nilsson photos in the *Life* story, "The Drama of Life Before Birth," were of extrauterine abortuses, beautifully lit and photographed in color to become the visual embodiment of life at its origin. Not seen as abortuses, these gorgeous fetuses and their descendants signified life itself, in its transcendent essence and immanent embodiment. The visual image of the fetus is like the DNA double helix—not just a signifier of life but also offered as the-thing-in-itself. The visual fetus, like the gene, is a technoscientific sacrament. The sign becomes the thing itself in ordinary magico-secular transubstantiation.

Nilsson's images have spiked the visual landscape for the past thirty years, each time with announcements of originary art and technology, originary personal and scientific experience, and unique revelations bringing what was hidden into the light. Nilsson's photographs are simultaneously high art, scientific illustration, research tool, and mass popular culture. The 1965 "Drama of Life Before Birth" was followed by the popular coffee-table-format book, *A Child Is Born* (Nilsson 1977); the NOVA television special in 1983, "The Miracle of Life"; the lavishly illustrated book (Nilsson 1987) on the immune system, including images of developing fetuses, *The Body Victorious*; and the August 1990 *Life* cover photo of a seven-week-old fetus, with the caption "The First Pictures Ever of How Life Begins" and the accompanying story, "The First Days of Creation."[8] Finally, moving from conception through breastfeeding, *A Child Is Born* was issued in 1994 as a compact-disk adaptation whose content-rich multimedia design offers interactive features as part of the visual fetal feast (Nilsson and Hamberger 1994).[9] Truly, we are in the realm of miracles, beginnings, and promises. A secular terrain has never been more explicitly sacred, embedded in the narratives of God's first Creation, which is repeated in miniature with each new life.[10] Secular, scientific visual culture is in the immediate service of the narratives of Christian realism. "These are the days of miracle and wonder." We

are in both an echo chamber and a house of mirrors, where, in word and image, ricocheting mimesis structures the emergence of subjects and objects. It does not seem too much to claim that the biomedical, public fetus—given flesh by the high technology of visualization—is a sacred-secular incarnation, the material realization of the promise of life itself. Here is the fusion of art, science, and creation. No wonder we look.

The Kelly cartoon is practically an exact tracing of its original. Looking at Kelly's cartoon returns the reader of comics to Michelangelo's *Creation of Adam*. [Figure 5.2. *Creation of Adam*] For "modern" viewers, the entire ceiling of the Sistine Chapel signifies an eruption of salvation history into a newly powerful visual narrative medium. [Figure 5.3. The Sistine Chapel Floor.] Accomplished between 1508 and 1512 under the patronage of Pope Julius II, the ceiling's frescos mark a technical milestone in mastering the Renaissance problem of producing a convincing pictorial rendering of narrative. The gestures and attitudes of the human body sing with stories. Part of the apparatus of production of Christian humanism, which has animated the history of Western science, European early modern or Renaissance painting developed key techniques for the realization of man. Or, at least, such techniques provide a key way "modern man" tells his history.

Although I will not trace them, innovations in literary technology are also part of this story. Eric Auerbach (1953) places the critical mutation in Dante's *Divine Comedy*, with its powerful figurations of salvation history that locate promised transcendental fulfillment in the material tissues of solid narrative flesh. Figurations are performative images that can be inhabited. Verbal or visual, figurations are condensed maps of whole worlds. In art, literature, and science, my subject is the technology that turns body into story, and vice versa, producing both what can count as real and the witnesses to that reality. In my own mimetic critical method, I am tracing some of the circulations of Christian realism in the flesh of technoscience. I work to avoid the terms *Judeo-Christian* or *monotheist* because the visual and narrative materials throughout *Modest_Witness@Second_Millennium* are specifically secular Christian renditions of partially shared Jewish, Muslim, and Christian origin stories for science, self, and world. But I am also trying to trace the story within a story, within which we learn to believe that fundamental revolutions take place. I am trying to retell some of the conditions of possibility of the stories technoscientific humans continue to tell ourselves. It is doubtful that historical configurations conventionally called the "Renaissance," or in a later version of the birth of the modern, the "Scientific Revolution," or today's rendition called the "New World Order" actually have been unique, transformative theaters of origin. But they have been

narrativized and canonized as such cradles of modern humanity, especially technoscientific humanity with its secular salvation and damnation histories. Certainly, in this book, if only by opposition, I am complicit in the narrativization and figuration of the Scientific Revolution and the New World Order. *Modest_Witness@Second_Millennium* meditates on world-making machines that are located at two ends of the story of modernity. Perspective techniques and the vacuum pump, at one end, and the computer and the DNA sequencing machine, on the other end, are the artifacts with which we convince ourselves our histories are true.

Metonymic for the entire array of Renaissance visual techniques, Albrecht Dürer's *Draughtsman Drawing a Nude* (1538) conventionally dramatizes the story of a revolutionary apparatus for turning disorderly bodies into disciplined art and science. [Figure 5.4. *Draughtsman Drawing a Nude*] In the drawing, an old man uses a line-of-sight device and a screen-grid to transfer point for point the features of a voluptuous, reclining female nude onto a paper grid marked off into squares. The upright screen-grid separates the prone woman on the table, whose hand is poised over her genitals, from the erectly seated draughtsman, whose hand guides his stylus on the paper. Dürer's engraving attests to the power of the technology of perspective to discipline vision to produce a new kind of knowledge of form. As art historian Lynda Nead argued, "Visual perception is placed on the side of art and in opposition to the information yielded through tactile perception.... Through visual perception we may achieve the illusion of a coherent and unified self" (1992:28). Here, as with Dürer's drawing, the disciplining screen between art and pornography is paradigmatically erected.

The gendering of this kind of vision is, of course, not subtle. Indeed, feminists argue that this visual technology was part of the apparatus for the *production*

Figure 5.2 The Creation of Adam. Sistine Chapel ceiling. 1511–12.

of modern gender, with its proliferating series of sexually charged oppositions condensed into the tension at the interface between touch and vision. Nead writes, "Woman offers herself to the controlling discipline of illusionistic art. With her bent legs closest to the screen, [Dürer's] image recalls not simply the life class but also the gynecological examination. Art and medicine are both foregrounded here, the two discourses in which the female body is most subjected to scrutiny and assessed according to historically specific norms" (1992:11). Obviously, it is only after the institutions of the life class and the gynecological exam emerged that Dürer's print could be retrospectively read to recall them.[11] As part of reforming her own self-making technology, Nead, the feminist art his-

Although history has long forgotten them, Lambini & Sons are generally credited with the Sistine Chapel floor.

Figure 5.3 "The Sistine Chapel Floor" © Gary Larson.

torian, is telling a story about the birth of the figure of Woman. As for me, the feminist analyst of technoscience attuned to artistic and biomedical visual delights, I see Dürer's majestic print and Bell Telephone's television advertising through the grid of Kelly's virtual speculum. In the life class and gynecological exam that is technoscience, critique caresses comedy. I laugh: therefore, I am ... implicated. I laugh: therefore, I am responsible and accountable. That is the best I can do for moral foundations at the tectonic fault line joining the sacred, the scientific, and the comic. And everyone knows that end-of-the-millennium Californians build their houses, and their theories, on fault lines.

In Renaissance visual technology, form and narrative implode, and both seem merely to reveal what was already there, waiting for unveiling or discovery. This epistemology underlies the European-indebted sense of what counts as reality in the culture, believed by many of its practitioners to transcend all culture, called modern science. Reality, as Westerners have known it in story and image for several hundred years, is an *effect* but cannot be recognized as such without great moral and epistemological angst. The conjoined Western modern sense of the "real" and the "natural" was achieved by a set of fundamental innovations in visual technology beginning in the Renaissance.[12]

Twentieth-century scientists call on this earlier visual technology for insisting on a specific kind of reality, which readily makes today's observers forget the conditions, apparatuses, and histories of its production. Especially in computer and information sciences and in biotechnology and biomedicine, representations of late-twentieth-century technoscience make liberal use of iconic exemplars of early modern European art/humanism/technology. Current images of technoscience quote, point to, and otherwise evoke a small, conventional, potent stock of Renaissance visual analogs, which provide a legitimate lineage and origin story for technical revolutions at the end of the Second Christian Millennium. Today's Renaissance *Sharper Image Catalogue*[13] includes the anato-

Figure 5.4 Albrecht Dürer. Draughtsman Drawing a Nude. 1538.

mized human figures in *De humanis corporis fabrica* of Andreas Vesalius, published in Basel in 1543; Leonardo da Vinci's drawing of the human figure illustrating proportions, or the *Vitruvian Man*, (ca. 1485–1490); Dürer's series of plates on perspective techniques; the maps of the cartographers of the "Age of Discovery"; and, of course, Michelangelo's *Creation of Adam*. Invoking this ready stock, a venture capitalist from Kleiner Perkins Caufield & Byers mutated the analogies to make a related historical observation, noting that biotech has been "for human biology what the Italian Renaissance was for art" (Hamilton 1994:85). In technoscientific culture, at the risk of mild overstatement I think one can hardly extend an index finger (or finger substitute) toward another hand (or hand substitute) without evoking the First Author's (or First Author Substitute's) gesture.

In Michelangelo's version of authorship, Adam lies on the earth, and, conveyed by angels, God moves toward him from the heavens. An elderly, patriarchal God the Father reaches his right index finger to touch the languidly extended left index finger of an almost liquid, nude, young-man Adam. A conventional art history text concludes, "Adam, lying like a youthful river god, awakens into life" (Rubenstein et al. 1967:99; see also Jansen and Jansen 1963:359-60). Adam is a kind of watery, earth-borne fetus of humanity, sparked into life on a new land by the heavenly Father. Michelangelo's God, however, is also carrying another, truly unborn human being. Still in the ethereal regions above the earth, Eve is held in the shelter of God's left arm, and at the origin of mankind she and Adam are looking toward each other. It is not entirely clear whom Adam sees, God or Woman—exactly the problem addressed by the screen barrier between art and pornography. Maybe in innocence before the Fall and at the moment of the renaissance of modern vision, a yearning Adam can still see both at once. Touch and vision are not yet split. Adam's eye caresses both his Author and his unborn bride.

Anne Kelly's drawing suggests other screens as well, such as that between art and science, on the one hand, and caricature and politics, on the other. Like the transparent film between art and pornography, the interface between the medico-scientific image and the political cartoon unstably both joins and separates modest witnesses and contaminated spectators. In both potent zones of transformation, the reclining female nude seems suggestively common. Dürer's woman in *Draughtsman Drawing a Nude*, the *Venus d'Urbino* by Titian (1487?–1576), the *Rokeby Venus* by Diego Velázquez (1599–1660), *Venus at Her Toilet* by Peter Paul Rubens (1577–1640), and Edouard Manet's *Olympia* (1863) are all ancestors for Kelly's first woman. [Figure 5.5. *Rokeby Venus*.] Kelly's cartoon figure depends on the conventions in modern Western painting for drawing the recumbent nude female.[14]

Lynn Randolph's painting *Venus*, part of her *Ilusas* or "deluded women" series, is a more formal feminist intervention into the conventions of the female nude and her associated secretions and tools [Figure 5.6. *Venus*]. Scrutinizing the standard line between pornography and art, Randolph writes, "This contemporary Venus is not a Goddess in the classical sense of a contained figure. She is an unruly woman, actively making a spectacle of herself. Queering Botticelli, leaking, projecting, shooting, secreting milk, transgressing the boundaries of her body. Hundreds of years have passed and we are still engaged in a struggle for the interpretive power over our bodies in a society where they are marked as a battleground by the church and the state in legal and medical skirmishes" (1993).

Kelly, however, is drawing a female Adam, not a Venus. The story is different, and so is the optical technology. Kelly's woman looks not into the mirror that fascinates Rubens's and Velázquez's nudes but into a screen that is in the heavenly position of Michelangelo's God. The "venereal" women with mirrors in the history of Western painting have given way in Kelly's drawing to the "authorial" woman with keyboard and computer terminal. Kelly's woman is not in a story of reflections and representations. Whatever she sees, it is not her reflection. The computer screen is not a mirror; the fetus is not her double or her copy. First Woman in *Virtual Speculum* looks not into the normal reality established by Renaissance perspective but into the virtual reality given by a time

Figure 5.5 Diego Rodriquez de Silva y Velázquez. The Toliet of Venus ("Rokeby Venus") 1649.

called postmodernity. Both realities are technical effects of particular apparatuses of visual culture. Both realities are simultaneously material, embodied, and imaginary. Both realities can only be inhabited by subjects who learn how to see and touch with the right conventions. It's all a question of interactive visual

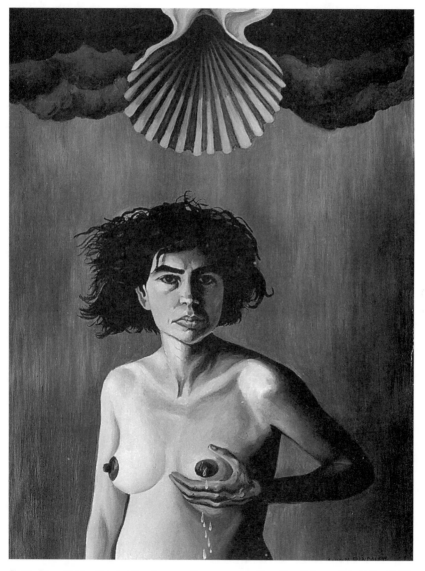

Figure 5.6 Lynn Randolph. Venus, oil on masonite. 14 ¹/₂'' x 10 ¹/₂''. 1992. Photograph by Rick Gardner.

technology. Reach out and touch someone; this is the long-distance call.

Not under the arm of God but in computer-generated visual space, the fetus meets First Woman's gaze. Kelly's unborn fetus, not the Adamlike woman, is in the position of Michelangelo's still uncreated Eve. From the nonperspective of virtual space, the First Woman and the fetus confront each other as Adam and Eve did in Michelangelo's version of human creation. In that reading, the computer screen is the embracing arm of God. Had God's gender value been transmuted as Adam's has been? Is the computer womb now female, or is gender one of the many things at stake? Kelly's cartoon allows at least two readings of the fetus: It is either in the position of God or in that of the not-yet-created Eve. If the fetus is Eve, the computer itself, with keyboard, is the encompassing deity reaching out to the female Adam's extended but limp hand. That reading makes Kelly's Adam the effect of the computer, the effect of the "creative" technologies of cyberspace. On the other hand, the female Adam has her hand on the keypad; she seems to be in the position of author. Then the fetus is her file, which she is writing; editing; or, as one viewer suggested, deleting. Certainly, the politics of abortion are implicit in this cartoon. Maybe she is reaching for the "escape" key, or perhaps merely the "control" key.[15]

Like traditional masculine figures in the reproductive imagery of technoscience, who have brain children all the time,[16] Kelly's First Woman seems to have a pregnancy associated with the organs of cognition and writing. Her pregnancy is literally extrauterine. Or perhaps Kelly's Adam is not pregnant at all; she may be viewing a fetus with no further connection to her once the file is closed. Literally, the fetus is somehow "in" the computer. This fetus is a kind of data structure whose likely fate seems more connected to downloading than birth or abortion. Just as the computer as womb-brain signifies the superior creativity of artificial intelligence, the on-screen fetus is an artificial life form. As such, *Virtual Speculum*'s fetus is *not* disembodied. Rather, the specific form of embodiment inside the apparatuses of technoscience is the material conundrum presented by the cartoon. The computer is metonymic for technoscience, an inescapable materialization of the world. Life itself, a kind of technoscientific deity, may be what is virtually pregnant. These ontologically confusing *bodies*, and the practices that produce specific embodiment, are what we have to address, not the false problem of *dis*embodiment.[16] Whose and which bodies—human and nonhuman, silicon based and carbon based—are at stake, and how, in our technoscientific dramas of origin?

The proliferating readings of Kelly's cartoon make one conclusion inescapable: Reversals and substitutions undo the original, opening the story up in unexpected ways. Themselves forms of repetition, reversals and substitutions

make the condition of all repetition obvious. The great stories of mimesis are undone. Caricature breaks the unspoken agreements that stabilized the original. Caricatures break the frame of salvation history. Perhaps that point gives the key for reading the multiple out-of-frame elements of Kelly's cartoon. The pregnancy is ectopic, to say the least; the fetal umbilical cord and barely visible placenta go off screen on the display terminal, and the electrical cords wander up and off screen from the whole cartoon with no point of attachment in view. The computer terminal, itself a work station, seems to be the metafetus in the picture. Further, this metafetus is an extrauterine abortus, with ripped-out umbilical cords like those in Lennart Nilsson's emblematic photographs of the beginnings of life itself. There is an odd kind of obstetrical art and technology at work here. It is not just Dürer's visual technology that makes a feminist "recall" the gynecological exam and the life class, those troubling and productive scenes of medical science and of art. In Kelly's meditation, the examination of both art and life is distinctly eccentric.

Fetal Work Stations and Feminist Technoscience Studies

If Kelly's fetus cannot be the woman's reflection, the unborn being might be her, or someone's, project. More likely, the fetus in cyberspace signifies an entity that is constituted by many variously related communities of practice. This fetus is certainly an object of attention and a locus of work, and Kelly's First Woman is at her work station.[18] Feminist scholars have also been at a "fetal work station." Like data processors at their video terminals in the information economy, feminists' positions at their analytical keyboards have not always been a matter of choice. Reproduction has been at the center of scientific, technological, political, personal, religious, gender, familial, class, race, and national webs of contestation for at least the past twenty-five years. Like it or not, as if we were children dealing with adults' hidden secrets, feminists could not avoid relentlessly asking where babies come from. Our answers have repeatedly challenged the reduction of that original and originating question to literalized and universalized women's body parts. It turns out that addressing the question of where babies come from puts us at the center of the action in the New World Order. With roots in local and international women's health movements as well as in various scholarly communities, since the early 1970s feminists have developed a rich toolkit for technoscience studies through their attention to the social-technical webs that constitute reproductive practice.[19] Idiosyncratically, I will inspect a small, recent inventory from this toolbox in order to pursue my inquiry into the optical properties of the virtual speculum.

In their powerful paper on the many constituencies who construct the French abortifacient called RU486, sociologist Adele Clarke and her former student Teresa Montini developed social worlds and arena analysis for feminist science studies (Clark and Montini: 1993).[20] Clarke and Montini are clear that their own analysis turns the volume up or down on some actors more than others; their own representations are part of the struggle for what will count as reproductive freedom, and for whom. Attention to this kind of point characterizes feminist science studies in general, whether generated from the academy or from policy-forming and community-action sites.

Using these tools, Monica Casper (1995b) studies human fetal surgery historically and ethnographically. Casper is developing the notions of the "technofetus" and the "fetus as work object." Casper's approach shows the fetus to be the site and result of multiple actors' work practices, including the mother's. Because Casper is necessarily a member of interdigitating communities of scholarly and political practice, her own positioning is neither invisible nor unaccountable. The many communities of practice that are held together around the technofetus are by no means necessarily in harmony. Their work tools—rhetorical and material—can make the fetus into very different kinds of entities. However, neither "multiplicity" nor "contestation" for their own sake are the point in feminist science studies. Joining analysts to subjects and objects of analysis, questions of power, resources, skills, suffering, hopes, meanings, and lives are always at stake.

In a similar spirit, Charis Cussins, trained in a science studies program, traces the continual "ontological choreography" that constructs subjects, objects, and agents at an infertility clinic (Cussins 1994). Subjects and objects are made and unmade in many ways in the extended processes of infertility treatment. Cussins shows that the different stakes, temporalities, trajectories, and connections and disconnections to women's and others' bodies and part-bodies—as humans and nonhumans are enrolled together in the practices of technoscience—require ethnographic, sustained inquiry.

Anthropologist Rayna Rapp's multiyear ethnographic study of women in New York City from many social classes, ethnicities, language communities, and racially marked groups also vividly describes the plethora of material-semiotic worlds in which fetuses and pregnant women have their being (Rapp 1994 and forthcoming). Women who accept and who refuse the procedures of fetal genetic diagnosis, research geneticists, genetic counselors, family members, support groups for people with genetically disabled children—all these people, variously intertwined with machines, babies, fetuses, clinical materials, and each other, make up Rapp's research community. The consequences of all the actors' location in these dynamic, differentiated worlds are crucial to her account, and

her own profound mutations in the course of doing the work grow from and feed back into the research and writing.

In the linked interdisciplinary worlds of feminist accounts of techno-science, Valerie Hartouni, located professionally in a communications depart-ment, takes up the many contending discourses of maternal nature in contemporary reproductive cultures in the United States. In a subtle and incisive series of papers, Hartouni examines first how class, gender, and genetic parent-hood interdigitate in the Baby M surrogate mother legal arguments; then how the judicial injunction not to speak of race in the case of the African American gestational surrogate Anna Johnson, who carried a child for a mixed-race (Filipina-Anglo) couple, was nonetheless part of the saturation of the case with racial and class markings; and finally how the performance video *S'Aline's Abortion*, despite explicit prochoice intentions, nonetheless was positioned by its visual rhetoric inside antichoice narratives for many audiences (Hartouni 1991; 1992; 1994; and forthcoming).[21] Hartouni's work is part of the broad feminist inquiry into how genetic relationship displaces other discourses of connection to a child in legal, biotechnical, familial, and entertainment worlds. Her writing contributes to the project of crafting the feminist visual literacy needed for working effectively inside a reproductive technoscience politics saturated with visual communications practices.

Reproductive politics are at the heart of questions about citizenship, liberty, family, and nation. Feminist questions are not a "special preserve" but a "general" discourse critical for science studies as such. Inaugural acts of chief executive offi-cers in mid-1990s U.S. politics illustrate an aspect of this claim. After taking the oath of office as president of the United States in January 1993, Bill Clinton issued his first executive orders, which established his presidency symbolically and mate-rially. His first acts did not concern war or other conventional domains of national interest and manly action. His first acts had to do with embryos and fetuses embedded in technoscientific contestations. Through embryos and fetuses, those orders had to do with entire forms of life—public, embodied, and personal—for the citizens of the state. Clinton began the process of lifting restrictions on pro-viding information about abortion in federally funded clinics, permitting medical experimentation on aborted fetal tissue, and allowing the importation of the con-troversial abortifacient and potential cancer treatment RU486.

Similarly, but with opposite political intent, the first official act of Pete Wilson after he was reelected governor of California in 1994 was to order the closing of a state program that provided prenatal care to pregnant "undocu-mented" immigrant women. Wilson had staked his campaign on Proposition 187, which denied so-called illegal immigrants virtually all social services, espe-

cially public education and nonemergency medical care. Despite the denials of its backers, Proposition 187 was widely understood to have fundamental racial-ethnic, class, and national targets, especially working-class Latinos of color coming across the Mexican-U.S. border. The measure passed by a two-to-one margin. That is, Proposition 187 was overwhelmingly popular with the older, Republican, white, and economically affluent electorate who voted in the 1994 election—many of whom, including a candidate for U.S. Senate who supported Proposition 187, had recently hired "illegal" women of color to care for their white children while seeking to withhold social services from the children of these same employees. To withhold reproductive health care from "undocumented" women of color, whose children would be born U.S. citizens if their pregnancies came to term in California, was the first concern of the reelected executive. Fetal protection (and the health of women) suddenly looked like a bad idea, and fetal endangerment (and the endangerment of "illegal" women of color) was the direct implication of the governor's inaugural act. Biomedicine—where postnatal people, machines, fetuses, health beliefs, diagnostic procedures, and bodily fluids are enrolled together in potent configurations—was the arena of conflict. Biomedicine is where freedom, justice, and citizenship were at stake.

Finally, another of Clinton's first public acts as commander in chief threatened to queer the sacred site of the citizen-warrior by changing the U.S. armed forces' policy of excluding acknowledged gay men and lesbians from the military. The citizen-soldier's "manliness" has long been at the center of the political theory of the state and citizenship. However inadequately, color and gender were addressed in the U.S. military before the category of queer. The tragicomic panic that ensued in Congress and among the Joint Chiefs of Staff thwarted Clinton's intent to deal with the matter by executive order. My point is that discursive, embodied entities such as the fetus, the pregnant immigrant, and the homosexual are not the subjects of "social" issues, in contrast to "political" matters of state and public policy. Like the embryo or fetus and the "undocumented" pregnant woman, the queer is at the heart of contests to reconfigure precisely what public space is and who inhabits it. Technoscience is intrinsic to all of these struggles.

The work sketched here shows that to study technoscience requires an immersion in worldly material-semiotic practices, where the analysts, as well as the humans and nonhumans studied, are all at risk—morally, politically, technically, and epistemologically. Science studies that do not take on that kind of situated knowledge practice stand a good chance of floating off screen into an empyrean and academic never-never land. "Ethnography," in this extended sense, is not so much a specific procedure in anthropology as it is a method of being at risk in the face of the practices and discourses into which one inquires. To be at

risk is not the same thing as identifying with the subjects of study; quite the contrary. And self-identity is as much at risk as the temptation to identification. One is at risk in the face of serious nonidentity that challenges previous stabilities, convictions, or ways of being of many kinds. An "ethnographic attitude" can be adopted within any kind of inquiry, including textual analysis. Not limited to a specific discipline, an ethnographic attitude is a mode of practical and theoretical attention, a way of remaining mindful and accountable. Such a method is not about "taking sides" in a predetermined way. But it is about risks, purposes, and hopes—one's own and others'—embedded in knowledge projects.[22]

Ethnography is not only a mode of attention, however. Textual analysis must be articulated with many kinds of sustained scholarly interaction among living people in living situations, historical and contemporary, documentary and *in vivo*. These different studies need each other, and they are all theory-building projects. No one person does all the kinds of work; feminist science studies is a collective undertaking that cultivates a practice of learning to be at risk in all the sorts of work necessary to an account of technoscience and medicine.

Under these conditions, looking for a feminist doctrine on reproductive technology, in particular, or on technoscience, in general, would be ludicrous. But understanding feminist technoscience scholarship as a contentious search for what accountability to freedom projects for women might mean, and how such meanings are crafted and sustained in a polyglot world of men and women, is not ludicrous. Preset certainties, feminist and otherwise, about what is happening in theaters of reproduction, or any theater of technoscience, stand an excellent chance of being flagrantly wrong. But feminist questions shape vision-generating technologies for science studies. Freedom and justice questions are intrinsic to the inquiry about the joinings of humans and nonhumans. Feminist technoscience inquiry is a speculum, a surgical instrument, a tool for widening all kinds of orifices to improve observation and intervention in the interest of projects that are simultaneously about freedom, justice, and knowledge. In these terms, feminist inquiry is no more innocent, no more free of the inevitable wounding that all questioning brings, than any other knowledge project.

It does not matter much to the figure of the still gestating, feminist, antiracist, mutated modest witness whether freedom, justice, and knowledge are branded as modernist or not; that is not our issue. We have never been modern (Latour 1993; Haraway 1994b). Rather, freedom, justice, and knowledge are—in bell hooks's terms—about "yearning," not about putative Enlightenment foundations. Keep your eyes on the prize. Keep our eyes on the prize. For hooks, yearning is an affective and political sensibility allowing cross-category ties that "would promote the recognition of common commitments and serve as a base

for solidarity and coalition" (hooks 1990: 27).[23] Yearning must also be seen as a cognitive sensibility. Without doubt, such yearning is rooted in a reconfigured unconscious, in mutated desire, in the practice of love,[24] in the ecstatic hope for the corporeal and imaginary materialization of the antiracist female subject of feminism, and all other possible subjects of feminism. Finally, freedom, justice, and knowledge are not necessarily nice and definitely not easy. Neither vision nor touch is painless, on or off screen.

The Right Speculum for the Job[25]

An inquiry into instruments of visualization, Kelly's cartoon can carry us another step toward understanding feminist science studies. *Virtual Speculum* is replete with signifiers of *choice*, a term that has been encrusted by colonies of semiotic barnacles in the reproductive politics of the last quarter-century. What counts as choice, for whom, and at what cost? What is the relation of "choice" to "life," and especially to "life itself"?

Kelly's cartoon is not denunciatory. I do not see in it any stereotyped position on new reproductive technologies or pious certainty about supposed alienation and disembodiment. Nor is Kelly's cartoon celebratory. It does not reflect credit on the original; it does not announce a new scientific age in the image of an original Creation. The cartoon depends on signifiers of information and communications technologies. *Information* is a technical term for signal-to-noise discrimination; information is a statistical affair for dealing with differences. Information is not embedded in a metaphysics of reflection and representation. The pixel grid of the cartoon's screen will not yield a point-for-point emplotment of an original body, disciplined through an ontology and epistemology of mimesis, reflection, and representation. Kelly is not Dürer.

Instead, *Virtual Speculum* is diffractive and interrogatory: It asks, "Is this what feminists mean by choice, agency, life, and creativity? What is at stake here, and for whom? Who and what are human and nonhuman centers of action? Whose story is this? Who cares?" The view screen records interfering and shifted—diffracted—patterns of signifiers and bodies. What displacements in reproductive positioning matter to whom, and why? What are the conditions of effective reproductive freedom? Why are public and personal narratives of self-creation linked to those of pregnancy? Whose stories are these? Who is in the cartoon, who is missing, and so what? What does it mean to have the public fetus on screen? Whose fetuses merit such extraordinary attention? What does it mean to embed a joke about self-creation and pregnancy inside Western and "white" conventions for painting the female nude? Kelly's cartoon is embedded inside signifiers of the Creation, Renaissance, Scientific Revolution, Information Age,

and New World Order. How does salvation history get replicated or displaced inside technoscience? What are the consequences of the overwhelmingly Christian signifiers of technoscience. If Michel Foucault wrote about the care of the self and the development of disciplinary knowledge in two different cultural configurations within Western history (classical Greek and modern European), Kelly is sketching an inquiry into the apotheosis of the fetus and reproductive technoscience as a diagnostic sign of the end of the Second Christian Millennium. How is care of the fetus today analogous to care of the self in classical antiquity—an elite set of practices for producing certain kinds of subjects?

What is the right speculum for the job of opening up observation into the orifices of the technoscientific body politic to address these kinds of questions about knowledge projects? I want to approach that question by going back to the eruption of the gynecological speculum as a symbol in U.S. feminist politics in the early 1970s. Many feminists among my cohorts—largely young, white, middle-class women—"seized the masters' tools" in the context of the Women's Liberation Movement and its activist women's health movement.[26] Armed with a gynecological speculum, a mirror, a flashlight, and—most of all—each other in a consciousness-raising group, women ritually opened their bodies to their own literal view. The speculum had become the symbol of the displacement of the female midwife by the specialist male physician and gynecologist. The mirror was the symbol forced on women as a signifier of our own bodies as spectacle-for-another in the guise of our own supposed narcissism. Vision itself seemed to be the empowering act of conquerors.

More than a little amnesiac about how colonial travel narratives work, we peered inside our vaginas toward the distant cervix and said something like, "Land ho! We have discovered ourselves and claim the new territory for women." In the context of the history of Western sexual politics—that is, in the context of the whole orthodox history of Western philosophy and technology—visually self-possessed sexual and generative organs made potent tropes for the reclaimed feminist self. We thought we had our eyes on the prize. I am caricaturing, of course, but with a purpose. "Our Bodies, Ourselves" was both a popular slogan and the title of a landmark publication in women's health movements.[27]

The repossessed speculum, sign of the Women's Liberation Movement's attention to material instruments in science and technology, was understood to be a self-defining technology. Those collective sessions with the speculum and mirror were not only symbols, however. They were self-help and self-experimentation practices in a period in which abortion was still illegal and unsafe. The self-help groups developed techniques of menstrual extraction, that is, early abortion, that could be practiced by women alone or with each other outside

professional medical control. A little flexible tubing joined the mirror and the speculum in more than a few of those sessions. Meanwhile, biomedical clinicians were introducing the sonogram and endoscopic fetal visualization while Lennart Nilsson's photographs spread around the medicalized globe. We had to wonder early if we had seized the right tools.

Still, the sense of empowerment experienced by the women in early-1970s self-help groups was bracing. The spirit was captured in a cartoon in the July 1973 issue of *Sister, the Newspaper of the Los Angeles Women's Center* [Figure 5.7. Wonder Woman and the Doctors]. Wonder Woman—the Amazonian princess from Paradise Isle, complete with her steel bracelets that could deter bullets;

From Sister, the Newspaper of the Los Angeles Women's Center (July 1973)

Figure 5.7 Wonder Woman and the Doctors.

stiletto high heels; low-cut, eagle-crested bodice; star-spangled blue minishorts; and magic lasso for capturing evildoers and transportation needs—seizes the radiant speculum from the white-coat-clad, stethoscope-wearing, but cowering white doctor and announces, "With my speculum, I am strong! I can fight!"

Wonder Woman entered the world in 1941 in Charles Moulton's popular cartoon strips.[28] After falling into a sad state by the end of the 1960s, she was

Figure 5.8 MS. magazine cover, Vol. 1, No. 1, July 1972. Reprinted with Permission.

resurrected in several venues in the early 1970s. Wonder Woman's first female comic-book editor, Dorothy Woolfolk, brought her back to the mass market in 1973. *Ms.* magazine put Wonder Woman on the cover of its first issue in July 1972 under the slogan "Wonder Woman for President" [Figure 5.8. Wonder Woman cover for *Ms.*]. The Vietnam War was raging on one side of the cover, and a "Peace and Justice in '72" billboard adorned the storefronts on a U.S. street on the other side. A gigantic Wonder Woman was grabbing a U.S. fighter jet out of the sky with one hand and carrying an enlightened city in her magic lasso in the other hand. The city might be a feminist prototype for SimCity2000™.[29] Wonder Woman's lasso outlined a glowing urban tetrahedron that would have made Buckminster Fuller proud.

In their groundbreaking 1973 pamphlet on medicine and politics, feminist academic and activist historians Barbara Ehrenreich and Dierdre English reprinted the *Sister* Wonder Woman figure seizing the speculum. The context was the chapter on the future, in which the authors emphasized that "self help is not an alternative to confronting the medical system with the demands for reform of existing institutions. Self help, or more generally, self-knowledge, is critical to that confrontation. Health is an issue which has the potential to cut across class and race lines. . . . The growth of feminist consciousness gives us the possibility, for the first time, of a truly egalitarian, mass women's health movement" (1973: 84–85).[30] Ehrenreich and English emphasized that not all women had the same histories or needs in the medical system. "For black women, medical racism often overshadows medical sexism. For poor women of all ethnic groups, the problem of how to get services of any kind often overshadows all qualitative concerns. . . . A movement that recognized our biological similarity but denies the diversity of our priorities cannot be a women's health movement, it can only be *some women's* health movement" (1973: 86; italics in original).

The speculum was not a reductionist symbolic and material tool that limited the feminist health movement to the politics of "choice" defined by demands for legal, safe abortion and attention to the new reproductive technologies. Nor was the speculum definitive of an exclusivist, middle-class, white movement. The women's health movement was actively built, and often pioneered, by women of color and their specific organizations as well as by mixed and largely white groups that cut across class lines.[31] That legacy is too often forgotten in the terrible history of racism, class-blindness, generational arrogance, and fragmentation in American feminism as well as in other sectors of U.S. progressive politics. However, the fullest meanings of reproductive freedom critical to feminist technoscience politics cannot easily be signified by the gynecological speculum or by the virtual speculum of the computer terminal, no matter how important it

remains to control, inhabit, and shape those tools, both semiotically and materially. The networks of millionaires and billionaires from Paul Simon's song at the beginning of this chapter still determine the nature of the U.S. health system, including reproductive health, for everybody. The structure and consequences of that complex determination are what we must learn to see if "choice" is to have a robust meaning. The last verse of "The Boy in the Bubble" reminds us that the relentless bursts of "information"—in transnational urban and rural jungles—are a long-distance call we cannot ignore. And Bell Telephone is not the only carrier.

The Statistics of Freedom Projects

A speculum does not have to be a literal physical tool for prying open tight orifices; it can be any instrument for rendering a part accessible to observation. So I will turn to another kind of speculum—statistical analysis coupled with freedom- and justice-oriented policy formation—to find a sharper focus for describing what feminists must mean by reproductive freedom, in particular, and technoscientific liberty, in general. In this chapter, in relation to the goals of feminist technoscience studies, I have adopted the civil rights rallying cry, "Keep your eyes on the prize!" I mean my appropriation of this phrase to emphasize that conducting an analysis of reproductive freedom from the point of view of *marked* groups—groups that do not fit the white, or middle-class, or other "unmarked" standard—is the only way to produce anything like a general statement that can bind us together as a people. Working uncritically from the viewpoint of the "standard" groups is the best way to come up with a particularly parochial and limited analysis of technoscientific knowledge or policy, which then masquerades as a general account that stands a good chance of reinforcing unequal privilege. However, there is rarely only one kind of standard and one kind of relative marginality operating at the same time. Groups that do not fit one kind of standard can be the unmarked, standard, or dominant group in another respect. Also, reproductive freedom is only one piece of what feminist technoscientific liberty must include, for women and men. Feminist technoscience studies are about much more than reproductive and health matters. Feminist technoscience studies are about technoscience *in general*. But, fundamentally, there is no way to make a *general* argument outside the never-finished work of articulating the partial worlds of *situated* knowledges. Feminism is not defined by the baby-making capacity of women's bodies; but working from that capacity, in all of its power-differentiated and culturally polyglot forms, is *one* critical link in the articulations necessary for forging freedom and knowledge projects inside technoscience.

Associate Counsel and Director of the Black Women's Employment Program

of the NAACP Legal Defense and Educational Fund (LDF) Charlotte Rutherford (1992) provides the needed perspective. A civil rights lawyer, feminist, African American woman, and mother, Rutherford articulates what reproductive freedom must mean and shows how both women's groups and civil rights organizations would have to change their priorities in order to take such freedom into account. Her argument is the fruit of intensive meetings with many African American women's groups and internal debate in the LDF in 1989-1990 on Black women's reproductive health and the U.S. Supreme Court rulings on abortion restrictions. A group of nationally prominent African American women active in public policy issues "maintained that reproductive freedoms are civil rights issues for African American women" (Rutherford 1992:257). From that perspective, I maintain, reproductive freedom *in general* has a much sharper resolution.

Included in the LDF formulation of reproductive freedoms for poor women were, at a minimum, "(1) access to reproductive health care; (2) access to early diagnosis and proper treatment for AIDS, sexually transmitted diseases, and various cancers; (3) access to prenatal care, including drug treatment programs for pregnant and parenting drug abusers; (4) access to appropriate contraceptives; (5) access to infertility services; (6) freedom from coerced or ill-informed consent to sterilization; (7) economic security, which could prevent possible exploitation of the poor with surrogacy contracts; (8) freedom from toxics in the workplace; (9) healthy nutrition and living space; and (10) the right to safe, legal, and affordable abortion services" (Rutherford 1992:257-58). It seems to me that all citizens would be better served by such a policy than from an approach to reproductive choice or rights that begins and ends in the well-insured, sonographically monitored, Bell Telephone system-nurtured uterus with its public fetus. These are the pulsating, relentless bursts of information in Paul Simon's song. These are "The Boy in the Bubble"'s long-distance message.

Not all African American women are poor, and not all poor women are African American, to say the least. And all the categories are discursively constituted and noninnocently deployed, both by those who inhabit them (by choice, coercion, inheritance, or chance) and those who do not (by choice, coercion, inheritance, or chance). I believe that *learning* to think about and yearn toward reproductive freedom from the *analytical and imaginative standpoint* of "African American women in poverty"—a ferociously lived discursive category to which I do not have "personal" access—illuminates the general conditions of such freedom. A standpoint is not an empiricist appeal to or by "the oppressed" but a cognitive, psychological, and political tool for more adequate knowledge judged by the nonessentialist, historically contingent, situated standards of strong objectivity. Such a standpoint is the always fraught but necessary fruit of the *practice* of

oppositional and differential consciousness. A feminist standpoint is a practical technology rooted in yearning, not an abstract philosophical foundation.[32]

Therefore, feminist knowledge is rooted in imaginative connection and hard-won, practical coalition—which is not the same thing as identity but does demand self-critical situatedness and historical seriousness. Situatedness does not mean parochialism or localism; but it does mean specificity and consequential, if variously mobile, embodiment. Connection and coalition are bound to sometimes painful structures of accountability to each other and to the worldly hope for freedom and justice.[33] If they are not so bound, connection and coalition disintegrate in orgies of moralism. In the kind of feminist standpoint remembered and put back to work in this chapter, much important feminist knowledge must be technically "impersonal." Statistics have an important but fraught history in the crafting of authoritative, impersonal knowledge in democratic societies. The history of statistics is directly related to the ideals of objectivity and democracy.

In Theodore Porter's terms (1994; 1995), statistics is a basic technology for crafting objectivity and stabilizing facts. Objectivity is less about realism than it is about intersubjectivity. The impersonality of statistics is one aspect of the complex intersubjectivity of objectivity; that is, of the public quality of techno-scientific knowledge. Feminists have high stakes in the speculum of statistical knowledge for opening up otherwise invisible, singular experience to reconfigure public, widely lived reality. Credible statistical representation is one aspect of building connection and coalition that has nothing to do with moralistic "standing in the place of the oppressed" by some act of imperialistic fantasy or with other caricatures of feminist intersubjectivity and feminist standpoint. Demanding the competent staffing and funding of the bureaus that produce reliable statistics, producing statistical representations in our own institutions, and contesting for the interpretation of statistics are indispensable to feminist technoscientific politics. Providing powerful statistical data is essential to effective public representations of what feminist and other progressive freedom and justice projects mean.[34] Recording, structuring, processing, and articulating such data should raise at least as interesting scientific problems as any that have merited a Nobel Prize in economics so far.

Porter argued that "it is precisely the communicability of numbers and of these rules [for manipulating numbers] that constitutes their claim to objectivity. . . . The crucial insight there is to see objectivity as a way of forming ties across wide distances" (1994:48). Porter believed that this kind of objectivity inheres in specialist communities, which rely on expertise rather than on community and which substitute quantitative representations for trust and face-to-face interactions. He sees such modes of objectivity as ill adapted to express

moral and ethical arguments (49). However, I believe that the history of struggle to recraft and stabilize public realities as part of learning to put together general policies from the analytical, imaginative, and embodied standpoint of those who inhabit too many zones of unfreedom and yearn toward a more just world shows "impersonal," quantitative knowledge to be a vital dimension of moral, political, and personal reflection and action.

Crafting a politics that refuses the constrictions of both the abortion and the new reproductive technology debates, with their inadequate discourse of choice, Charlotte Rutherford explores the requirements for reproductive freedom by means of statistical illustrations of the differential conditions that are experienced by women differently marked by race and class in the United States (Rutherford 1992). For example, in 1990, "29.3% of all African American families had incomes below the poverty level, compared to 8.1% of white families and 10.7% of families of all races" (1992:257n8). In 1985, because of the confluence of medically uninsured women's situations and the fact that 80 percent of private insurance policies did not include office visits or services for preventive, non-surgical reproductive health care, "at least 76% of all women of reproductive age must pay themselves for preventive, non-surgical health care" (258n11). "The maternal mortality rate (the number of deaths of mothers per 100,000 live births) for all African American women in 1986 was 19.3 compared to 4.7 for white mothers" (259n12). "In 1986, African American women were 3.8 times more likely than white women to die from pregnancy-related causes" (260). "Blacks were more than twice as likely as whites to have late (third trimester) or no prenatal care, . . . and the frequency of late or no care among American Indians was at least as high as that for Blacks" (260n15).

"In 1991, almost five million working mothers maintained their families alone and 22.3% of them lived in poverty. . . . In 1988, of all poor African American families, 75.6% were maintained by African American women alone, compared to 44% of poor white families and 47.8% of poor Hispanic families" (264n32). "In 1987, only 18% of the pregnancies to women under age 20 resulted in births that were intended, while 40% resulted in births that were not intended, and 42% ended in abortion" (265n38). "Among households headed by individuals between 15 and 24 years of age, the poverty rate is staggering: 65.3% for young African American families and 28.5% for young white families" (266n45). "The risk of infertility is one and a half times greater for African Americans [23% of couples] than for whites [15% of couples]" (267). "Whites and those with higher incomes are more likely to pursue infertility treatment than are African Americans and the poor" (268). "About 75% of low-income women in need of infertility services have not received any services. . . . Among

all higher income women, 47% [in need of them] have received no services" (268n56). Among physicians who provide infertility services in the United States, only 21 percent accept Medicaid patients for such care (268n61). "By 1982, only fifteen percent of white women were sterilized, compared to twenty-four percent of African American women, thirty-five percent of Puerto Rican women, and forty-two percent of Native American women. Among Hispanic women living in the Northeast, sterilization rates as high as sixty-five percent have been reported" (273-74). Even in the 1990s, the federal government will pay for sterilization for poor women but not for abortions. The worst sterilization abuses of the recent past have been reduced by consent forms and procedures put in place since the 1970s, but the conditions leading poor women to "choose" sterilization more often because other options are worse are not acceptable. Meanwhile, "in 1985 eighty-two percent of all counties in the United States—home to almost one-third of the women of reproductive age—had no abortion provider" (280). To say the least, the situation has not improved in the 1990s. Restrictions on poor women's access to abortion mean later abortions. "In 1982, after the ban on federal funding was implemented, 50% of Medicaid-eligible patients had their abortions after nine weeks of pregnancy, compared with only 37% of non-Medicaid-eligible women" (280n128).

Rutherford also shows that toxins and other hazards in neighborhoods and workplaces differentially damage poor people and people of color because they get more intensive and long-term exposures. To be a houseworker or janitor, hospital worker, farm worker, dry-cleaning or laundry employee, chicken processor, tobacco worker, or fabric-mill worker is to experience a lifetime of toxic exposure that can damage reproductive cells and fetuses, not to mention adult bodily tissues. Pesticides, heat, noise, dust, mechanical hazards, poor nutrition, inadequate medical care, and high levels of stress lower life expectancies of adults, children, and fetuses. Those predominantly female occupations held disproportionately by women of color are especially dangerous to fetal and maternal health. The only thing that might be even more damaging to freedom and health is unemployment. Is anyone really surprised? "Who cares?" is the fundamental question for technoscientific liberty and science studies. Toxics are a civil rights issue, a reproductive freedom concern, and a feminist technoscience matter; that is, toxics are a general issue for technoscientific knowledge and freedom projects.[35]

The age of designer fetuses on screen is also the age of sharp disparities in reproductive health, and therefore of sharp disparities in technoscientific liberty. In the 1990s, fetuses are objects of public obsession. It is almost impossible to get through the day near the end of the Second Christian Millennium in the United

States without being in communication with the public fetus. In these days of miracle and hype, the public fetus may be the way we look to distant galaxies. The fetus hurtling through space at the end of the movie *2001* is not a feminist image; neither is the long-distance touch of Bell Telephone. In alliance with the women meeting with Charlotte Rutherford at the Legal Defense and Educational Fund, both Kelly's First Woman with her finger on the divine keyboard and *Sister's* Wonder Woman seizing the gynecological speculum must work to make the general community of women publicly visible as movers and shakers in technoscience. That much, at least, is owed to the people who taught us all to keep our eyes on the prize. "With my speculum, I *am* strong! I *can* fight!" There is still a chance, barely, to build a truly comprehensive feminist technoscience politics.

The Invisible Fetus

> There are many lives and even more deaths to keep track of, numbering the bones of a people whom the state hardly thinks worth counting at all.
>
> —Nancy Scheper-Hughes, *Death Without Weeping*

It seems fitting to close this meditation on the virtual speculum with an image that is not there—with the *missing* representations of fetuses and babies that must trouble anyone yearning for reproductive freedom. In a world replete with images and representations, whom can we not see or grasp, and what are the consequences of such selective blindness? From the point of view of a barely imaginable, desperately needed, transnational, intercultural, and resolutely situated feminism—a feminism circulating in networks at least as disseminated, differentiated, and resilient as those of flexible capitalism's New World Order, Inc.—questions about optics are inescapable. How is visibility possible? For whom, by whom, and of whom? What remains invisible, to whom, and why? For those peoples who are excluded from the visualizing apparatuses of the disciplinary regimes of modern power-knowledge networks, the *averted gaze* can be as deadly as the all-seeing panopticon that surveys the subjects of the biopolitical state. Moreover, counting and visualizing are also essential to freedom projects. Not counting and not looking, for example in health and well-being, can kill the New World Order as surely as the avid seminal gaze of state curiosity, for example in the fixing of the criminal or the addict. Similarly, the assumed naturalness of ways of living and dying can be as intolerable as the monomaniacal construction and production of all the world as technical artifact. By now we should all know that both naturalization and technicization are equally necessary to the regimes of flexible accumulation.

Because my last image springs from a missing gaze, I have no picture to print, no reprinting permission to seek. In the demographers' language, this nonimage is of human "reproductive wastage," that is, of the dead babies and fetuses, the *missing* offspring, who populate the earth's off-screen worlds in unimaginable numbers in the late twentieth century. These are fully "modern" or "postmodern" fetuses and babies, brought into invisible existence within the same New World Order that ordains bright lights, genetic gymnastics, and cybernetic wonders for the public fetuses of the better-off citizens of planet Earth at the end of the Second Christian Millennium. These missing fetuses and babies are not residues of some sad traditional past that can be scrubbed clean by the new brooms of modernity and its sequelae in postmodernity's regimes of flexible accumulation. Quite the contrary: The missing images, and what they represent, are precisely contemporary with and embedded in the same networks as the all-too-visible on-screen fetal data structures. If Anne Kelly's on-line fetus is postmodern, so is the uncounted fetus I am seeking in this essay. And vice versa, if "we" have never been modern, neither have "they."[36] Temporality takes many shapes in the wormholes of technoscience, but the least believable figures are the divisions of the world and its inhabitants into modern and premodern, progressive and traditional, and similar conventions. The solid geometry of historical time is much more troubling than that.

Of course, images of hungry babies and children, if not fetuses, periodically fill our television screens. The *mode* of presence and absence changes for differently positioned citizens in technoscientific public reproductive visual culture more than absolute presence or absence. The visual icons of hungry infants do not perform the same semiotic work as the icons of the highly cultivated on-screen fetuses favored by Bell Telephone. Here, I want to explore one form of off-screen, out-of-frame positioning for the children of contemporary, expanding, marginalized populations.

Nancy Scheper-Hughes is responsible for my missing visual text as I follow her through her search in the municipal records offices and *favelas*, or slums, of a town in a sugar-plantation region of the Brazilian Nordeste over the past twenty-five years. Besides drastically reducing the complexity of accounts in her book, my sketch adds analogies, renarrativizes, and uses parts of her story in ways she did not. But we are enmeshed together in webs spun by yearning and analysis.

Developing John Berger's image, Scheper-Hughes, an anthropologist, saw herself as a "clerk or keeper of the records"—listening, watching, and recording those events and entities that the powerful do not want to know about (Scheper-Hughes 1992:29).[37] For Scheper-Hughes, recording was a work of recognition and an act of solidarity. She attempted to count, to make statistically

visible, the reproductive history, and especially the dead babies, of the poorest women in the Brazilian town. Moreover, she linked the existence and numbers of those dead babies to precisely the same global/local developments that led their richer sisters, living in the neighborhoods in which many of the impoverished *favela* women worked as domestics, to seek the latest in prenatal care and reproductive medicine. Undercounted and on screen: Those were the two states of being under examination.[38]

Caught in a nightmare, I am forced to remember another context in which offspring are counted in the regimes of technoscience. An equation in theoretical population biology has two variable quantities, r and K, which can be linked to different reproductive "strategies" adopted by species in the context of the theory of natural selection. "K-selected species" are said to "invest" tremendous resources in each individual offspring and to have rather few offspring over their lives. Each offspring, then, is a valued "reproductive investment," in the ordinary but nonetheless stupefying language of investment-portfolio management in which Darwin's theory has been developed in this century. On the other hand, "r-selected species" are said to adopt the strategy of spewing as many offspring into the world as possible, with little physiological or biosocial investment in any individual, in the hope that some offspring will survive to reproduce. For biologists, all human beings, with their large and expensive fetuses and infants who take many years to mature to reproductive age, are paradigmatic K-selected organisms. Dandelions or cockroaches, with their abundant offspring, none of whom get many nutritious goodies packed into their embryos or much parental attention during development, are typical r-selected creatures. Low infant mortality is the norm for K-strategists; high infant mortality is the normal state of affairs for r-strategists. As the sociobiological authors Martin Daly and Margo Wilson put it, the contrast is between "profligacy or careful nurture" (1978:124).[39] Careful parents with solid family values versus vermin and weeds: That seems to be the gist of the story in this reading of an equation. I translate this lesson in evolutionary theory into human reproductive politics in the New World Order: intensely cultivated fetuses, located at the center of national culture and portrayed as individuals from fertilization on, versus throwaway fetuses and dead babies, located "down there" and known only as "angels."

In the U.S. imperialist imaginary, societies "down there" relative to the United States, in the warm and sordid regions of the planet, seem to have lots of human beings who act like r-strategists. The colder, more cerebral, less genital climes to the north—if one discounts immigrants of color and other nonprogressive types common in racist imagery—are replete with good K-strategists.[40] The supposedly natural craving for a healthy child genetically related to the par-

ents, which is said to drive reproductive heroics in contemporary wealthy nations or parts of town, seems almost to be a bad joke about K-selection. The fetus—and the child tied into lucrative markets of all kinds—becomes so important that media conglomerates and biomedical industries, who have much more money than mothers and fathers, seem to be the major reproductive investors. Meanwhile, literally many hundreds of millions of children experience serious deprivation, including 15 million hungry children in the United States in the mid-1990s.[41] The stereotypical rich people's lament that the poor have too many children seems to be an even worse joke about r-selection.[42] There is too much hunger, and hunger of too many types, independently of whether there are too many children of the rich or of the poor.

I strongly believe that there are too many people on earth, not just millions but billions too many for long-term survival of ourselves and incomprehensible numbers of other species. That belief in no way softens questions of justice and freedom about who survives and reproduces and how. The individual human beings matter; the communities matter. Counting matters. Further, reducing population growth rates and absolute numbers in every class, race, ethnicity, and other category on Earth will not necessarily reduce habitat destruction, urban or rural poverty, pollution, hunger, crime, agricultural land devastation, over-crowding, unemployment, or most other evils. Population levels are not causes in such a simple sense. The story of inter-relationship is much more complex, and it is hotly contested. I am convinced that the success of comprehensive freedom and justice projects would do a much better job of alleviating suffering and reducing resource and habitat devastation than population limitation policies in the absence of such commitments. Those statements are also beliefs, ones deeply enmeshed in the fraught worlds of technoscience.

On the one hand, it seems that demographers and population specialists of every stripe do nothing but count human beings. United Nations reports, World Bank studies, national censuses, and innumerable reference works are full of data about population and reproduction for every spot on Earth. On the other hand, a clerk of the records—working out of the traditions of Catholic liberation theology, socialist feminism, medical anthropology, and risk-taking ethnography— was still needed to count missing children in the biopolitical age. In a time of crushing overpopulation, the perverse fact is that there are *too few* living babies among the poorest residents on earth, too few in a sense that matters to thinking about technoscience studies and reproductive freedom. These missing and dead babies are, of course, intrinsic to the ongoing production of overpopulation. The surplus death of the children of the poor is closer to a cause of overpopulation than one is likely to find by many other routes of analysis. The 1994 United

Nations meetings on population and development in Cairo prominently advanced this proposition. Getting a grip on the motor of this surplus death is a problem of world-historical proportions. Wherever else this problem leads, it should take us to the center of feminist technoscience studies.

To pursue these claims, let us turn back to Nancy Scheper-Hughes's story. A U.S. white citizen, she first went to the *favelas* of the Nordeste of Brazil in 1964 as an idealistic twenty-year-old public health and community development worker. In those years, she came to know many women of a particular community, and she got involved in community action programs for child care and child health. Between 1982 and 1989, after an absence of fifteen years, Scheper-Hughes returned four times to the same community, this time as an anthropologist, an identity she had earlier disdained. The turbulent political and economic contexts of Brazil throughout those years were never far from the surface. In oral interviews and less formal interactions, Scheper-Hughes listened to the women living in this particular shantytown as they recounted reproductive histories and their meanings. She also haunted the records offices of the municipality and of hospitals, forcing recalcitrant institutions and bureaucrats to disgorge data on births and child deaths. Trying to get a grip on how many of which classes died in a year, she talked with the municipal carpenter, whose main job seemed to be making coffins for the children of the poor. His requisitions for the materials needed to make the boxes for dead "angels" gave her more numbers for her growing numerical testimony.

Scheper-Hughes's figures covered several years and allowed some sense of the trajectory of infant and child death and of the reproductive histories of women of different generations. Besides combing local, regional, and national data sources, Scheper-Hughes talked to pharmacists, grocers, priests, and anybody else who could cast some light on her questions about birth, life, and death among the very young and very poor. She talked to the better-off citizens and prowled through data on them, getting a grip on their different reproductive experiences. Across the period of her study, laws and practices governing registration of births and deaths changed substantially. There is no illusion of comprehensive data in Scheper-Hughes's accounting, but there is nonetheless an arresting ethnographic picture of infant birth and death in the flexible matrices of the New World Order.

There is nothing particularly modern about high rates of birth and infant and child mortality for our species. The opposite is supposed to be the case. The orthodox story of modernity has it that a demographic transition occurs more or less reliably with modern economic development, such that both death rates and birth rates decline, albeit rarely if ever in a neatly coordinated fashion. "Rates"

themselves are a particularly modern sort of discursive object; knowledge about progress is inconceivable, literally, without knowledge of rates of change. Death rates go down first, followed at variously unfortunate intervals by birth rates. But whatever the fits and starts of different rates for births and deaths, modernity brings in its wake a greatly lowered rate of infant and child death as a fundamental part of the demographic transition to stable populations and low birth rates.

The people among whom Nancy Scheper-Hughes studied, however, experienced quite another sort of demographic transition. Scheper-Hughes called the pattern the "modernization of child mortality" and the "routinization of infant death" (1992:268–339). Scheper-Hughes emphasized the moral, social, and emotional relations of mothers and whole communities to the extreme levels of infant death among them.[43] Riveted by the form of modernity and postmodernity she describes, I highlight here only a limited part of her story. Over the period of the study, death rates for children over a year old did decline among the very poor as well as among the better off. Childhood infectious disease, the traditional "nonmodern" killer of the young, was reduced by immunization.[44] But death rates among children less than a year old went up, and the killer—drastic undernourishment, resulting in diarrhea and death from acute dehydration—was highly modern. The modernization of child mortality meant "the standardization of child death within the first twelve months of life and its containment to the poorest and marginalized social classes" (1992:296). In the town Scheper-Hughes studied, by 1989 96 percent of all child deaths occurred in the first year of life.

In one sense, the cause of the increase in infant mortality seems obvious and easily remediable—loss of the practice of breastfeeding. Restore the practice of breastfeeding, which has continued to decrease in each generation in the "developing world" since about 1960, and the very poor will not see their infants die in such vast numbers. Promote breastfeeding, get the artificial infant formula-makers to cooperate, teach rehydration therapy, and watch death rates come down. Get poor women to "choose" breastfeeding as their grandmothers once did. These are neither new observations nor obscure solutions, and many people work hard to put them into action.

But Scheper-Hughes argues that the modernization of infant death through starvation and dehydration is *intrinsic* to the form of development practiced in the third world under the terms set by unleashed national and transnational market forces and structural adjustment policies enforced by world sources of capital. The drastically marginalized populations that teem all over the earth, including in U.S. cities, are the direct result of up-to-the-minute (post)modernization policies over the past thirty years, and especially the past

fifteen years. In the current, acute, global forms of dependent capitalism, "marginalized" means anything but "rare." For Brazil, Scheper-Hughes narrates the complex patterns of the "economic miracle," World Bank versions of economic development in the 1980s, practices of structural adjustment, inflation, and the resulting falling real wage of the poorest classes. In the years following the military junta in Brazil in 1964, total national wealth increased in the context of the systematic relocation of wealth from the bottom 40 percent of the population to the top 10 percent. Progressively, in the context of mass dislocations and migrations, semisubsistence peasants have become urban, temporary, day-wage workers in large numbers. Food has become a commodity everywhere and for everyone—including the newborn.

These are the critical determinants of reproductive freedom and unfreedom in the New World Order, with its up-to-the-minute, technoscientifically mediated systems of flexible accumulation. Labor patterns, land use, capital accumulation, and current kinds of class reformation might have more to do with the flow of breast milk than whether or not Nestlé has adopted policies of corporate responsibility in its third world infant-formula markets. Artificial milk is a reproductive technology, without doubt, as is the human body itself in all its historical/natural/technical complexity. But agribusiness seed technologies, which come with packages of labor and resource use, or marketing systems for national and international customers are at least as much reproductive technologies as are sonograph machines, cesarean surgical operations, or *in vitro* fertilization techniques. Those seeds and those marketing patterns are central technoscientific actors, in which humans and nonhumans of many kinds are mutually enrolled in producing ways of life and death. It is high time that studies of reproductive technologies stop assuming that their central artifacts of interest are to be found only in the biomedical clinic. In several senses, computers in financial centers in Geneva, New York, or Brasília are reproductive technologies that have their bite in the breasts of marginalized women and the guts of their babies. It shows in the coffin-maker's invoices; the shelves of local grocery stores, where "choice" is best studied; and, as we shall see, in (post)modern customs for establishing paternity among the poor.

Why do poor women stop breastfeeding in the New World Order? How does technoscientifically mediated capital flow affect paternity-recognition rituals? Why can't "rational choice" prevail in the *favelas* of the Nordeste, and perhaps also on the flatlands of the East Bay near San Francisco in California? Scheper-Hughes tells an arresting story about the corporeal economy of breast milk, diarrhea, and family formation inside Brazil's economic miracle. With all its local themes and variations, the story travels globally all too well. It encapsu-

lates one of the plot structures of postmodern narration—one left out of semi-otics textbooks and psychoanalytical theory—in which gender, race, class, and nation get up-to-the-minute remakes.

Loosely following Scheper-Hughes's map, let us explore the parameters of breastfeeding. In the 1960s the U.S.-sponsored Food for Peace program introduced large amounts of industrially produced powdered milk into the third world. A food inscribed with a better technoscientific pedigree and radiating more enlightened purposes would be hard to find. International aid-promoted, packaged baby milk programs ended in the 1970s, but corporations like Nestlé moved in to develop the infant-formula market. Much of this market depends on very small purchases at any one time, not unlike the soft-drink industry among the impoverished. Marketing infant formula to the poor is like marketing drugs—small, cheap packages are essential to hooking the customers and developing the mass market. Active organizing emerged against the aggressive, medically inflected marketing of artificial formula to women who could neither afford the product over the long haul nor count on conditions to prepare it hygienically. After a lot of denial and resistance, in response to an international boycott started in 1978, Nestlé finally adopted codes for ethical practice and modified its marketing and advertising patterns. But breastfeeding continued to decline, and infant death continued to be modernized. "Ethics" turns out to have precious little to do with "choice" in vast areas of technoscience, including the yearning for reproductive freedom.

Four factors converge in this story. First, Scheper-Hughes found that the *culture* of breastfeeding unraveled over a brief period—including both the ability of older women to teach younger women and poor women's belief in the goodness of what comes from their own bodies, compared to what comes from "modern" objects such as cans or hypodermic needles.[45] To emphasize that breastfeeding is practice and culture, just as technoscience is practice and culture, is to stress that the body is simultaneously a historical, natural, technical, discursive, and material entity. Breast milk is not nature to the culture of Nestlé's formula. Both fluids are natural-technical objects, embedded in matrices of practical culture and cultural practice. Women can lose, regain, or improve the natural-technical knowledge necessary to breastfeeding, just as young elephants can lose the ability to find water in long droughts when most of the older, knowledgeable animals are killed by poaching or by inexpert culling of herds. That comparison is not a naturalization of women but an insistence on the shared natural-technical matter of living as intelligent mortal creatures on this planet. Within the kind of feminist technoscience studies that makes sense to me, breastfeeding practices, elephant cultural transmission, and laboratory and

factory knowledge and commodity production are ontologically and epistemo-logically similar. Historical ways of life and death are at stake in each of the natural-technical categories. The differences lie in the all-important specificities.

Second, and related to loss of knowledge about how or whether to breast-feed, poor women cannot breastfeed babies in the context of the jobs that they can get after the transition from semisubsistence peasant to urban casual day laborer, including current forms of domestic service. The issue goes way beyond the Brazilian *favela* that Scheper-Hughes studied. Just as right-wing California politicians can and do agitate for withholding medical and educational benefits from the children of the migrant women who take care of these same politician-employers' offspring, modern female employers of other women can and do dis-courage practices that the wealthy reserve for themselves in the interest of health and family. Breast-milk storage equipment notwithstanding, babies have to be with mothers in order to breastfeed consistently. On-the-job breastfeeding facilities, as well as other aspects of affordable and comprehensive child care, remain pie-in-the-sky labor demands in most places of employment in the United States. Discursively, such facilities are costly benefits, not natural rights. It is no wonder that poor women in and out of the "third world" have much less chance to "choose" breastfeeding, even if they continue, in spite of everything, to trust their own—disproportionately poisoned—bodies to give better nutri-tion than modern commodities can.[46]

Third, the shelves in the groceries that served the shantytown citizens were replete with every sort of scientifically formulated milk for infants. Literate or not, the mothers were well versed in all the varieties and their relative merits for babies of different ages and conditions. "The array of 'choices' was quite daunt-ing, and the display of infant-formula powdered milk tins and boxes took up a full aisle of the local supermarket, more than for any other food product" (Scheper-Hughes 1992:319). Like the mandatory health warning on cigarette packages in the United States, packages that disproportionately fill the poorest areas of cities, all the infant-milk containers carried required warnings about proper use of the product, consulting a physician, and refrigeration. Consumer protection is such an illuminating practice in transnational capital's progressive regulatory regimes.

Fourth and last, let us turn to a scenario of family formation, to the kind of scene beloved in psychoanalytic contributions to feminist theory. I am particularly interested here in the material/semiotic rituals that create fathers and in the prac-tices that relocate baby's milk from the breasts disdained by responsible, loving women to the packages—replete with corporate and state warnings—car-ried into the home by responsible, loving men. I am interested in the metonymy

that marks the implantation of the name of the father in the *favela* and in what such substitutions do to the formation of the "unconscious" in feminist technoscience studies. I believe this kind of unconscious underlies practices of yearning, oppositional consciousness, and situated knowledges. The primal scene in the *favela* is established and signified by a gift of milk. Father's milk, not semen, is his means of confirming paternity and establishing the legitimacy of his child.

Scheper-Hughes writes that in the conditions of shantytown life, marriage becomes much more informal, consensual, and, in my ironic terms, postmodern. "Shantytown households and families are 'made up' through a creative form of bricolage in which we can think of a mother and her children as the stable core and husbands and fathers as detachable, circulating units. . . . A husband is a man who provides food for his woman and her children, regardless of whether he is living with them." The symbolic transaction by which a father "claims" his child and his woman is to bring the infant's first weeks' supply of Nestogeno, an especially valued Nestlé product in a lovely purple can. A woman who breastfeeds is thought of as an abandoned woman, or a woman otherwise unprovided for or sexually disdained by a man. Ideally, the equation is, "Papa: baby's 'milk'" (Scheper-Hughes 1992:323-25). Through that particular and historical milk, meanings of paternity circulate. In this specific narration of metonymy and substitution, a powerful version of feminist desire is born. The desire is not for a supposed natural mother over and against a violating father but for a new world order in which women, men, and children can be linked in signifying chains that articulate the situated semiotic and material terms of reproductive freedom.

• • •

The missing babies of the *favela* are carried away in diarrhea, a "sea of froth and brine. . . . 'They die,' said one woman going straight to the heart of the matter, 'because their bodies turn to water'" (Scheper-Hughes 1992:303). Through the signifying flow of commodified milk—which links children and fathers, husbands and wives, first and third worlds, centers and margins, capital and bodies, milk and excrement, anthropologist and clerk of the records—we are recirculated back into the turbulent, heterogeneous rivers of information that constitute the embryo, fetus, and baby as a modern sacrum—or cyborg kinship entity—on the globalized planet Earth. The diarrhea of angels mixes with the amniotic fluid of on-screen fetuses. We are accountable for this material and semiotic anastomosis in the body politic and the clinical body of the "postmodern" human family. The longing to understand and change the fluid dynamics inherent in this kind of anastomosis is what I mean by yearning in feminist technoscience studies.

The signifying chains that make up these kinds of linkages are not, in any simple sense, about cause and effect. The multidimensional splices that bind together the New World Order, Inc., cannot be described in linear equations. But these higher-order linkages matter; they are not decorative flourishes. One task of feminist technoscience studies is to construct the analytical languages—to design the speculums—for representing and intervening in our spliced, cyborg worlds. In the Bell Telephone ad, paternity was channeled from the phone through the mother-to-be's touching the sonographic image of the fetus on the video monitor. In the *favela* of the Nordeste, paternity was channeled through the gift of scientifically formulated, commodified infant milk. The signifiers of choice for Bell Telephone and for Nestlé parody feminist reproductive freedom and knowledge projects and the dispersed, disseminated, differentiated, "transnational" yearning that sustains them. In Kelly's cartoon, reproductive choice was interrogated in First Woman's authorial touch on the computer keyboard. In Charlotte Rutherford's arguments about reproductive freedom for African American women, the statistics of inequality bore eloquent testimony to the reproduction of unfreedom. All of these accounts are aspects of the inquiry into reproductive technology in the New World Order. As Wonder Woman put it in 1973, "With my speculum, I *am* strong! I *can* fight!" The right speculum for the job makes visible the data structures that are our bodies.

• • •

It was a dry wind
And it swept across the desert
And it curled into the circle of birth
And the dead sand
Falling on the children
The mothers and the fathers
And the automatic earth
• • •
And don't cry, baby, don't cry.

— ©Paul Simon/Paul Simon Music (BMI)

6

RACE

Universal Donors in a Vampire Culture: It's All in the Family. Biological Kinship Categories in the Twentieth-Century United States

> If the human face is "the masterpiece of God" it is here then in a
> thousand fateful registrations.
> —Carl Sandburg, Prologue to Edward Steichen, *The Family of Man*

Race is a fracturing trauma in the body politic of the nation—and in the mortal bodies of its people. Race kills, liberally and unequally; and race privileges, unspeakably and abundantly. Like nature, race has much to answer for; and the tab is still running for both categories. Race, like nature, is at the heart of stories about the origins and purposes of the nation. Race, at once an uncanny unreality and an inescapable presence, frightens me; and I am not alone in this paralyzing historical pathology of body and soul. Like nature, race is the kind of category about which no one is neutral, no one unscathed, no one sure of their ground, if there is a ground. Race is a peculiar kind of object of knowledge and practice. The meanings of the word are unstable and protean; the status of the word's referent has wobbled—and still wobbles—from being considered real and rooted in the natural, physical body to being considered illusory and utterly socially constructed. In the United States, race immediately evokes the grammars of purity and mixing, compounding and differentiating, segregating and bonding, lynching and marrying. Race, like nature and sex, is replete with all the rituals of guilt and innocence in the stories of nation, family, and species. Race, like nature, is about roots, pollution, and origins. An inherently dubious notion, race, like sex, is about the purity of lineage; the legitimacy of passage; and the drama of inheritance of bodies, property, and stories. I believe that, like nature, race haunts us

213

who call ourselves Americans. All of our rational denials only deepen the suppurating puncture wound of a racialized history, past and present.

Inheriting the whirlwind it sowed as founding seeds in slavery, dispossession, and genocide as well as in immigration, democracy, and liberty, the republic of the United States is a society consumed by ideas of racial purity and racial denial. Therefore, the United States is also replete with fascination with racial mixing and racial difference. Fascination with mixing and unity is a symptom of preoccupation with purity and decomposition. And like any expanding capitalist society that must continually destroy what it builds and feed off every being it perceives as natural—if its strategies of accumulation of wealth are to continue to push the envelope of catastrophe—the United States is consumed with images of decadence, obsolescence, and corruption of kind. No wonder its natural parks and its stories of gardens and wilderness have been more therapeu-tically crucial to nursing national innocence than any of its other civic sacraments.

As a middle-class, professional, white woman in the United States who is riveted by fascination with the fungal web of nature, nation, sex, race, and blood in U.S. history, I write behind a disavowal, an incantation, an alibi, a tic or symptom. Behind a list of personal qualifying adjectives—white, Christian, apostate, professional, childless, middle-class, middle-aged, biologist, cultural theorist, historian, U.S. citizen, late-twentieth-century, female—I write about the universal, that is, about "the human." The human is the category that makes a luminous promise to transcend the rending trauma of the particular, especially that particular nonthing and haint called race. Like all symptoms, my neurotic listing makes a false promise to protect me from category confusion, from the irrational fear that drives the tic, from corruption.

Lurching beyond the symptom in the first paragraphs, however, I acknowledge that a specific figure animates this essay. The figure is the vampire: the one who pollutes lineages on the wedding night; the one who effects category transformations by illegitimate passages of substance; the one who drinks and infuses blood in a paradigmatic act of infecting whatever poses as pure; the one that eschews sun worship and does its work at night; the one who is undead, unnatural, and perversely incorruptible. In this essay, I am instructed by the vampire, and my questions are about the vectors of infection that trouble racial categories in twentieth-century bioscientific constructions of universal humanity. For better and for worse, vampires are vectors of category transformation in a racialized, historical, national unconscious. A figure that both promises and threatens racial and sexual mixing, the vampire feeds off the normalized human, and the monster finds such contaminated food to be nutritious. The vampire also insists on the nightmare of racial violence behind the fantasy of purity in the rituals of kinship.[1]

It is impossible to have a settled judgment about vampires. Defined by their categorical ambiguity and troubling mobility, vampires do not rest easy (or easily) in the boxes labeled good and bad. Always transported and shifting, the vampire's native soil is more nutritious, and more *unheimlich*, than that. Deeply shaped by murderous ideologies since their modern popularization in European accounts in the late eighteenth century—especially racism, sexism, and homophobia— stories of the undead also exceed and invert each of those systems of discrimination to show the violence infesting supposedly wholesome life and nature and the revivifying promise of what is supposed to be decadent and against nature.

Just when one feels secure in condemning the toothy monster's violations of the integrity of the body and the community, history forces one to remember that the vampire is the figure of the Jew accused of the blood crime of polluting the wellsprings of European germ plasm and bringing both bodily plague and national decay, or that it is the figure of the diseased prostitute, or the gender pervert, or the aliens and the travelers of all sorts who cast doubt on the certainties of the self-identical and well-rooted ones who have natural rights and stable homes. The vampires are the immigrants, the dislocated ones, accused of sucking the blood of the rightful possessors of the land and of raping the virgin who must embody the purity of race and culture. So, in an orgy of solidarity with all the oppressed, one identifies firmly with the outlaws who have been the vampires in the perfervid imaginations of the upstanding members of the whole, natural, truly human, organic communities. But then one is forced to remember that the vampire is also the marauding figure of unnaturally breeding capital, which penetrates every whole being and sucks it dry in the lusty production and vastly unequal accumulation of wealth. Yet the conjunction of Jew, capitalist, queer, and alien is freighted with too much literal genocide to allow even the jeremiad against transnational capital to carry the old-time conviction of moral certainty and historical truth. The vampire is the cosmopolitan, the one who speaks too many languages and cannot remember the native tongue, and the scientist who forces open the parochial dogmas of those who are sure they know what nature is. In short, once touched by the figure of this monster, one is forced to inhabit the swirling semantic field of vampire stories.[2] In those zones, uninvited associations and dissociations are sure to undo one's sense of the self same, which is always neatly prelabeled to forestall moral, epistemological, and political scrutiny.

So, I need the undead and noninnocent figure of the vampire to enter the fraught constructions of human unity and racial difference in the twentieth-century United States. Painted in interaction with an earlier version of this chapter, Lynn Randolph's 1995 painting *Transfusions* sets my visual text for proceeding [Figure 6.1. *Transfusions*.]. A blue-clad dancer's body lies prone on a stark white

operating table, her neck penetrated by a vampire bat whose wing vessels pulse with her red blood. A transfusion bag on a medical stand ties into the circulation of the woman and the bat, which is linked in swirling time-lapse photographic repetitions to the teleoperator chamber in the top right hand quadrant of the painting. Inside the chamber and operating its controls is the rat-toothed figure of Count Graf Orlock from *Nosferatu*, F. W. Murneau's 1922 German Expressionist silent film, which was the first vampire movie.[3] The fingernails on the hands of the mad doctor-vampire are clawed, and the chamber is swathed in the sterilizing light of blues, purples, and ultraviolets. The black field of the painting is transected by the bright white of the slab and punctuated by the reticulations and pools of red blood. The surrealist traffic of informatics and biologics in the circulating fluids of the cables and joysticks of the remote control machine, the dancing bats, and the prone woman infuse the visual field. Remembering the toxic cocktail of organicism, anti-Semitism, anticapitalism, and anti-intellectualism that percolates through vampire stories, I cannot see Randolph's painting as a simple affirmation of the woman and indictment of the techno-vampire. Rather, drawing on her practice of metaphoric realism, Randolph uses the vampire-cyborg mythology to interrogate the undead psychoanalytic, spiritual, and mundane zones where biomedicine, information technology, and the techno-organic stories of kinship

Figure 6.1 Lynn Randolph, Transfusions, oil on canvas, 59" x 48", 1995.

converge. This is the kinship exchange system in which gender, race, and species—animal and machine—are all at stake. Joining the pulsing fluids of blood and data, *Transfusions* guides us through the interrogation of universal donors.

I approach the universal through a particular discourse, the science of biology. Biology's epistemological and technical task has been to produce a historically specific kind of human unity: namely, membership in a single species, the human race, *Homo sapiens*. Biology discursively establishes and performs what will count as human in powerful domains of knowledge and technique. A striking product of early biological discourse, race, like sex and nature, is about the apparatuses for fabricating and distributing life and death in the modern regimes of biopower. Like nature and sex, at least from the nineteenth century race was constituted as an object of knowledge by the life sciences, especially biology, physical anthropology, and medicine. The institutions, research projects, measuring instruments, publication practices, and circuits of money and people that made up the life sciences were the machine tools that crafted "race" as an object of scientific knowledge over the past 20 years. Then, in the middle of the twentieth century, the biological and medical sciences began to disown their deadly achievement and worked like Sisyphus to roll the rock of race out of the upscale hillside neighborhoods being built in post–World War II prosperous times to house the new categories of good natural science. All too predictably, the new universals, like the suburbs and the laboratories, were all too white.

Biology is not the body itself but a discourse on the body. "My biology," a common expression in daily life for members of the U.S. white middle class, is not the juicy mortal flesh itself, but a linguistic sign for a complex structure of belief and practice through which I and many of my fellow citizens organize a great deal of life. Biology is also not a culture-free universal discourse, for all that it has considerable cultural, economic, and technical power to establish what will count as nature throughout the planet Earth. Biology is not everyone's discourse about human, animal, and vegetable flesh, life, and nature; indeed, *flesh*, *life*, and *nature* are no less rooted in specific histories, practices, languages, and peoples than *biology* itself. Biologists are not ventriloquists speaking for the Earth itself and all its inhabitants, reporting on what organic life really is in all its evolved diversity and DNA-soaked order. No natural object-world speaks its metaphor-free and story-free truth through the sober objectivity of culture-free and so universal science. Biology does not reach back into the mists of time, to Aristotle or beyond. It is, rather, a complex web of semiotic-material practices that emerged over the past 200 years or so, beginning in "the West" and traveling globally. Biology emerged in the midst of major inventions and reworkings of categories of nation, family, type, civility, species, sex, humanity, nature, and, race.

That biology—at every layer of the onion—is a discourse with a contingent history does not mean that its accounts are matters of "opinion" or merely "stories." It does mean that the material-semiotic tissues are inextricably intermeshed. Discourses are not just "words"; they are material-semiotic practices through which objects of attention and knowing subjects are both constituted. Now a transnational discourse like the other natural sciences, biology is a knowledge-producing practice that I value; want to participate in and make better; and believe to be culturally, politically, and epistemologically important. It matters to contest for a livable biology, as for a livable nature. Both contestations require that we think long and hard about the permutations of racial discourse in the life sciences in this century. This chapter is a small contribution to that end.

In the United States in the twentieth century, the categories of biology often become universal donors in the circulatory systems of meanings and practices that link the family, state, commerce, nature, entertainment, education, and industry. Apparently culture-free categories are like type O- blood; without a marker indicating their origin, they travel into many kinds of bodies. Transfused into the body politic, these categories shape what millions of people consider common sense in thinking about human nature. In this chapter, I will pay attention to three twentieth-century configurations of bioscientific thinking about the categories of unity and difference that constitute the human species. Claiming to be troubled by clear and distinct categories, I will nonetheless nervously work with a wordy chart, a crude taxonomic device to keep my columns neatly divided and my rows suggestively linked.

Table 6.1 is an effort to chart twentieth-century biological kinship categories that I believe are critical in racial discourse in the U.S. professional middle classes, but the categories have power far beyond those circles. The chart deliberately emphasizes U.S. views of the world linked to elite scientific culture. Like any such taxonomic device, the chart emphasizes *related* discontinuities across its columns, placing into distinct periods what from other points of view could appear on a continuum or, alternatively, seem to be completely unconnected. Contentious homologies, as well as divisions, are suggested by placing objects across from each other within columns. Many other practices besides biology—such as prisons, welfare systems, real estate policy, schools, youth culture, child-raising patterns, and labor markets—are potent constructors of race and kinship. Table 6.1, however, monomaniacally pursues its suspicions from the foundation of its periodization and its associated "key objects of knowledge": race, population, and genome. I have chosen three broad time divisions—1900 to the 1930s, 1940 to somewhere in the 1970s, and about 1975 into the 1990s—because I think national and international, technological, laboratory, clinical,

Universal Donors in a Vampire Culture: Twenieth-Century U.S. Biological Kinship Catagories
Table 6.1

DATES	1900–1930s	1940–1970s	1975-1990s
KEY OBJECT OF KNOWLEDGE	race	population	genome
FAMILY PORTRAIT	gorilla diorama, American Museum of Natural History, 1936	*Fossil Footprint Makers of Laetoli,* painting by Jay Matternes, 1979	SimEve and matrix of morphed progeny, *Time* magazine, 1993
DATA OBJECTS	tree genealogies, taxonomies	gene frequencies	genetic databases
PARADIGMATIC TECHNICAL PRACTICE	craniometry	measure ABO blood marker frequencies	genetic mapping DNA analysis by polymerase chain reaction (PCR) and restriction fragment length polymorphism (RFLP)
EVOLUTIONARY PARADIGM	typological paradigm Spencerian versions of Darwinism William Z. Ripley, *The Races of Europe,* 1899 Franklin H. Giddings, *Social Marking System,* 1910	populationist paradigm neo-Darwinism evolutionary synthesis Theodosius Dobzhansky, *Genetics and the Origin of Species,* 1937	sociobiological neo-Darwinist paradigm unit of selection debates (gene, organism, population) E.O. Wilson, *Sociobiology, The New Synthesis,* 1975

		George Gaylord Simpson, *The Major Features of Evolution*, 1953	Richard Dawkins, *The Selfish Gene*, 1976; *Extended Phenotype*, 1982
		James D. Watson, *Molecular Biology of the Gene*, 1965	
PEDAGOGICAL PRACTICE	Biology is established in high schools nationally.		

Hygiene and eugenics are closely linked.

By 1928, 20,000 U.S. college students are enrolled in 376 courses in eugenics. | UNESCO race statements, authored by evolutionary biologists, appear in 1950 and 1951.

The New Physical Anthropology guides research and teaching.

Biological Sciences Curriculum Study (BSCS) revised curriculum is introduced. The context is scientific competition of the Cold War. | Biodiversity and biotechnology are closely linked in humanist and enviromentalist ideologies, international conventions, and pedagogy.

Advances in Genetic Technology (1989) is a BSCS high school biotechnology text. The context is international corporate high-technology competitiveness.

Corporations fund high school biology laboratories to teach biotechnology. |
| ETHICAL DISCOURSE ON HUMAN HEREDITY | Eugenic marriage counseling and eugenic sterilization are urged. | Medical genetic counseling emerges for a growing list of genetic diseases. | Bioethics becomes a regulatory industry of its own. |
| STATUS OF RACE AS EPISTEMOLOGICAL OBJECT IN SCIENCE AND POPULAR CULTURE | Race is real and fundamental in both areas. | Race is an illusory object constructed by bad science. | Race reemerges in medical discourse on organ transplants and drug testing. |

220

		Race remains prominent in domains of culture, social science, and politics.	Race is a hotly contended issue in cultural, political, and community struggles.
		Nazi genocidal practices are strong in public memory and mute many aspects of racial policies. At the same time, apartheid flourishes in many forms.	Race is a fashion accessory for *United Colours of Benetton* Ethnic cleansing and race based immigration restriction reemerge globally.
RHETORICS OF UNITY AND DIVERSITY	family trees	universal family of man	Human Genome Project (ManTM)
	Model eugenic families compete at state fairs.	Kalahari desert !Kung hunter-gatherers are the model for man.	Human Genome Diversity Project
	H.H. Goddard, *The Kallikak Family*, 1912 C.B. Daveport, *The Trait Book*, 1912	Films: *The Hunters,* 1957; *The Making of Mankind III: The Human Way of Life,* 1982	System dynamics modeling of sub-Saharan pastoralists becomes biosocial paradigm. Amazon forest people (e.g., the Kayapó) are popular paradigms of indigenous cultural and biodiversity discourses and of indigenous transnational commercial and technological savvy.
IDEAL OF PROGRESS	Everything moves in stages from primitive to civilized. Hierarchy is natural at all levels of organization.	The universal sharing way of life is at the origin. System management should produce cooperation.	Multiculturalism and networking are ideologically dominant in sciences, businesses, and liberal political practice.

SYMBOLIC AND TECHNICAL STATUS OF BLOOD	Blood = kinship = race/family/culture.	Gene/blood and culture tie is broken.	Blood is merely the tissue for getting easy DNA samples.
	Blood and gene are one.	Blood is the key fluid studied for gene frequencies.	The genome largely displaces blood symbolically and technically.
	Blood and culture are closely tied.	The gene begins to displace blood/race in discourses of human diversity.	
	ABO markers constructed, 1908.		Synthetic blood and autotransfusions are ideal.
	Landsteiner Nobel Prize in 1930; Rh factors follow. Blood, culture, language, race, nature, and land are tightly linked.	ABO system is elaborated. First heart transplant is in 1967.	Baboon-human heart transplant is in 1990.
DISEASES OF THE "BLOOD"	"Bad blood" covers venereal disease generally (e.g., syphilis)	Hemoglobinopathies (i.e., sickle-cell anemia) are studied.	New diseases are interpreted as communication and information transfer pathologies (e.g., AIDS).
		Research expands on genetics of diverse human hemoglobins.	Fear of infected blood is rampant.
PARADIGMATIC PATHOLOGY	decadence, rotting, infection, tuberculosis	obsolescence, stress, overload	defective gene, errors in the database, immunological breakdown
PROPHYLAXIS	vaccination and public health	system engineering and management	technical enhancement and system redesign
	Infection control is boundary maintenance.		Boundary crossing seems more interesting than boundary maintenance.

222

MEANING OF THE GENE	Gene/blood are linked to race and nature.	Gene = information equation emerges. Notion of life as an information system is consolidated. The gene is the sign of the universal. Genetic and cultural diversity discourses are separated.	Gene = information is infinitely elaborated. Information = communication. Informatics and genomics converge. Genetic and cultural diversity discourses are conflated.
"THE FAMILY"	Focus is on the natural heterosexual reproductive family. Miscegenation is biological pathology. Kinship is perceived to stem from blood.	Focus is on the natural heterosexual reproductive family. Intermarriage is biologically normal.	New Reproductive Technologies (NTRs) dominate scientific, legal, and popular attention. The first "test-tube baby" is born in 1978. The status of heterosexuality and many reproductive practices is unstable. artifactual families morphing
RELATION TO INDUSTRIAL TECHNOLOGIES AND SCIENTIFIC IDEOLOGIES	Organicism and mechanism are believed to be oppositional and distinct. Boundaries between living and nonliving seem secure.	Cybernetics becomes popular discourse in the 1950s and 1960s. Cyborgs are named in 1960 in the context of the space race.	Cyborgs proliferate in business, the military, popular culture, technoscience, and interdisciplinary theory.

Interfaced cybernet-
ic/organic systems in
military and civilian
technologies, e.g.,
numerical–controlled
machine tools are
developed.

Cyborgs become sec-
ond–order cyberspace
beings in the 1980s.

Gaia hypothesis is
named in 1969.

Artificial life research
emerges in the 1980s.

LEGAL AND POLITICAL
DOCUMENTS

Eugenic sterilization
laws are passed by 30
state legislatures in the
United States from
1907–31.

U.S. National Origins
Act of 1924 restricts
immigration by
racial logic.

UNESCO statements
on race, 1950, 1951,
are written from point
of view of population
genetics and modern
evolutionary synthesis.

The Biological
Diversity Convention,
NAFTA, GATT, and
the World Trade
Organization include
provisions on patenting
biological materials.

First world–third
world struggles over
biodiversity intensify.

Biodiversity erosion is
an official emergency.

Indigenous peoples
(e.g., the Guaymi of
Panama) contest
patenting of human
genes and organize to
repatriate their genetic
material from the
American Type
Culture Collection
and other first world
genomic/informatics
databanks.

RESEARCH INSTITU- TIONS FOR HUMAN UNITY AND DIVERSITY	Cold Spring Harbor Eugenics Records Office.	Wenner Gren Foundation's Early Man in Africa research program.	GenBank©
			Human Genome Project
		Multidisciplinary international team research in paleoan- thropology	Human Genome Diversity Project
			HUGO in Europe
PHOTOGRAPHIC DOCUMENTS OF HUMANITY AND EARTH	Eugenic and dysgenic facial portraiture and racial types	*The Family of Man,* Museum of Modern Art, 1955	*The Multicultural Planet,* UNESCO, 1994
			LANDSAT photo- graphic mapping
	Panoramic nature photography, 1920	NASA photos of the Whole Earth, 1969	
DISCOURSE OF RELATION TO OTHER SPECIES	Species are defined by interbreeding block.	Interest is in gene flow among popula- tions within species.	Nature is a genetic engineer that continually exchanges, modifies, and invents new genes across various barriers.
		Separate species are maintained in nature.	
			Viruses are information vectors that link us all.
MODEL OF NATURE	The community (organismic) model frames study of species associations and suc- cessions through time.	The ecosystem (cybernetic) model frames study of radioactive isotopes and energy flows traced through trophic levels.	Simulated and global ecosystems are prominent in research.
			Database and infor- matics development are critical to models of nature.
	The University of Chicago school of ecology is dominant.		
			Geographic informa-

	F. Clements and V. Shelford, *Bio-Ecology*, 1939. W. C. Allee, A. E. Emerson, O. Park, T. Park, K. P. Schmidt, *The Principles of Animal Ecology*, 1949.	Systems dynamics modeling techniques emerge in business and biology. The Odum school of ecology is prominent. Eugene Odum, *Fundamentals of Ecology*, 1959 D.H. Meadows et al., *Limits to Growth*, 1972	tion systems (GIS) reorganize research and policy practice. E.O. Wilson, ed., *Biodiversity*, 1988. The Maxis Corporation builds the Gaia hypothesis and artificial life research into its SimEarth and SimLife games.
PRESERVATIONIST PRACTICE	colonial and national park system Parc Albert in the Belgian Congo	postcolonial park management Serengeti in Tanzania	Global environmental regulation debates are dominated by northern hemisphere powers. Rain Forest Reserves biodiversity banking ecotourism debt for nature swaps
POPULAR IMAGES OF APES	Tarzan is raised by Kala, his ape mother, and fights the powerful rival male ape Terkoz. E. R. Burroughs, *Tarzan of the Apes*, 1914	Jane Goodall goes to Gombe to live in nature with the wild chimpanzees. Jane Goodall, *In the Shadow of Man*, 1971	Koko, the sign language-using gorilla in the Silicon Valley, tries to get pregnant with IVF. F. Patterson and E. Linden, *The Education of Koko*, 1981 Virtual landscape

PARADIGMS OF GAR-DENING AND LAND-SCAPE ARCHITECTURE	United States: Wilhelm Miller, "The Prairie Spirit in Landscape Gardening" on Jens Jensen's designs for the "wild" and "natural" garden	Ecological planning emerges in urban design.	planning emerges.
		New Towns, Houston, Tex., "The Woodlands"	Martha Schwartz's "Splice Garden" is built on the Whitehead Institute roof, Cambridge, Mass.
	Germany: the "natural garden"	Ian McHarg, *Design with Nature*	
ICONS OF GENETIC ACHIEVEMENT	Mendelian genetics, pure types	Hybridized seed and animals	Transgenic plants and animals
	Standardized egg and poultry breeding and marketing	Green Revolution "miracle" seeds	Herbicide-resistant crops
MAJOR INSTITUTIONS FOR PLANTS AND ANIMAL GENETIC RESEARCH	Agricultural research stations and U.S. land-grant universities	Foundation-funded research institutes for breeding high-response varieties	Transnational corpo-rations, foundations, international financial institutions, national science policy, and major universities all participate in interna-tional corporatization of genetics, molecular biology, and biotechnology.
	University basic research (Morgan fruitfly lab at Columbia)	Mexico: Centro Internacional del Mejoramiento del Maïz y Trigo, 1966	
		Philippines: International Rice Research Institute, 1960	Global network of gene banks is consolidated.
		World Bank-launched Consultative Group on International Agricultural Research, 1970	
			Third-world charges

		Major science universities develop genetic research.	intensify that the first world collects diversity, disregarding local expertise or treating it as a natural resource, and produces homogeneity in standardized commodities.
		The National Seed Storage Laboratory, first U.S. national gene bank, is established, Fort Collins, Colo., 1959.	
POPULAR IMAGES INSIDE POLITICAL IDEOLOGY	American Museum of Natural History big-game dioramas	Man the Hunter and the first Civil Rights Movement	Sociobiological reproductive investment strategists in nature
	Teddy Bear Patriarchy (Theodore Roosevelt-style Progressive Era reform through expertise)	United Nations humanism (20th century Bridgewater Treaties)	*United Colours of Benetton* Multiculturalism
ICONS OF NATIONAL AND INTERNATIONAL DISCOURSE	*Birth of a Nation* (D.W. Griffith film, 1915)	*The Family of Man,* 1955, Museum of Modern Art	"Rebirthing of a Nation" is featured in *Time* magazine 1993 special issue on immigration.
		Cold War blocs and multinational organizations reshape official national ideologies.	Context is transnationalism, the New World Order, and multiculturalism as dominant ideologies and practices.
		United Nations: Food and Agriculture Organization, World Health Organization, UNESCO	
		World Bank (Bretton Woods,1944)	
		International Monetary Fund (1945)	Flexible postmodernity

ECONOMIC DISCOURSE	Fordist modernity monopoly capital modern corporation	Fordist modernity in a multinational vein U.S. is hegemonic in the post-WWII economic order. Militarized economy is driven by the Cold War.	New World Order, Inc., is unfettered from Cold War contests. Structural adjustment dominates aid and development policy. transgenic organisms
SIGNS OF SCIENTIFIC POWER AS TRANSGRESSION AND TRANSCENDENCE	airplane telephone	transuranic elements (plutonium, 1940) first nuclear bombs, Little Boy and Fat Man	Flavr Savr tomato, OncoMouseTM
INSTRUCTIONS ON HOW TO ACT AROUND ALIENS	H.G. Wells, *War of the Worlds* 1898, radio dramatization by Orson Welles, 1938	Films: *The Day the Earth Stood Still*, 1951 *2001: A Space Odyssey*, 1968	Films: *Alien*, 1979 *Aliens*, 1986 *Alien³*, 1992 *Alienⁿ*, forthcoming
FEMINIST INSTRUCTIONS ON HOW TO ACT AROUND ALIENS	CharlottePerkins, Gilman, *Herland*, 1915	Ursula LeGuin, *The Left Hand of Darkness*, 1969 Joanna Russ, *The Female Man*, 1975	Octavia Butler, Xenogenesis Trilogy, 1987-1989 Marge Piercy, *He, She and It*, 1991
ANIMATION TECHNOLOGY	Muybridge nineteenth-century stop-action techniques	Walt Disney Studios, *Fantasia* and *Pinocchio*, 1940	Industrial Light and Magic computer-generated graphics, esp. morphing; *Terminator 2*, 1991; *Jurassic Park*, 1993

field, political, economic, and cultural transformations within these temporal patterns have been intrinsic to the processes that reshaped biological discourse about human unity and diversity, producing mutations that merit attention.

Of course, practices, ideas, and institutions spill from one period into the next, but I think "real-world" patterns of power and authority shift within the paradigmatic configurations detailed in the rows within each period. The illusion of progressing from one period to the next with no carryovers and uncanny repetitions might be tempered by imagining setting "periodic boundary conditions" on that table, to change the topology of the flat table so that it wraps around on itself to form a cylinder or even a torus.[4] Also, many other practices, ideas, and institutions fill these time periods but find no place on this chart. A paradigmatic category for some communities of practice is contested by other communities, and from various other points of view, what looks like a paradigm to me could look trivial or just wrong. Learning how to get at a point of view in constructing and using a chart is part of my purpose. Unlike a perspective drawing that geometrically constructs the unique point from which to see into the composition, Table 6.1 invites the reader to evaluate contending locations as an intrinsic aspect of participating in scientific culture on the charged topics of race, sex, and nature. One way to do this is to make the chart into a narrative device, that is, to use it to construct a story. Stories are not "fictions" in the sense of being "made up." Rather, narratives are devices to produce certain kinds of meaning. I try to use stories to tell what I think is the truth—a located, embodied, contingent, and therefore real truth.

My chart does *not* argue that "forces" such as political developments "influenced" biology from the "outside," or vice versa; nor does it imply that life science, or anything else, is the summation of its determinations. Biology is complex cultural practice engaged in by real people, not bundles of determinations just waiting for the analyst's clever discovery. Biology might be politics by other means, but the means are specific to the located practice of the life sciences. These means are usually more about things like genes, graphs, and blood than about legislatures or supposed social interests of scientists.

The relationships that are insistently urged by the proliferation of rows inside each period could seem perversely arbitrary, linking not just apples and oranges but gardens and genes, vampires and Nobel Prize winners, or masterful DNA and frivolous fashion magazines. I think such odd bedfellows are linked, but I often stutter in naming *how* they are tied together. The stutter is an incitement to work out the trouble, not to pass over the complexities of worlds of discourse by hygienic category separation. The luxuriating rows are meant to invite the reader to add or subtract, to alter what is inside the boxes, to explore

geometries of relationship that more restrained meaning-making devices might make look foolish. I do not think the rows within columns are linked by the conventions of cause and effect, but they are not just random free associations either. Yet, I know from my own relationship to this chart, as well as that of colleagues who have commented on its various drafts, that it induces a kind of generative dream state. The chart, like any residue of semiosis, could be read as a symptom. But the reader would have to decide, take a stand on, what the symptom is *of.* That is simultaneously a political, cultural, and scientific question. From a biological point of view, symptoms point to functioning, or malfunctioning, bodies, and processes that might otherwise be invisible.

The best metaphor, and technical device, for representing the kind of relationality implicit in this chart might be hypertext. In hypertext readers are led through, and can construct for themselves and interactively with others, webs of connections held together by heterogeneous sorts of glues. Pathways through the web are not predetermined but show their tendentiousness, their purposes, their strengths, and their peculiarities. Engaging in the epistemological and political game of hypertext commits its users to the search for relationships in a funguslike mangrove or aspen forest where before there seemed to be neat exclusions and genetically distinct, single-trunk trees. I think part of the work of interrogating racial discourse—or any discourse—is learning how to represent both relationality and the "ontological" status of categories provocatively. Failing to produce an actual hypertext for this essay, I hope that the old-fashioned, clumsy, two-dimensional pencil-and-paper chart (done, of course, on a computer generally available to people like me in the so-called first world) might ironically prove able to subvert the monological, conventional oppositions of cause and effect versus randomness. I rely on the reader to act like a savvy hypertext user by making jumps, connections, and multiple pathways through Table 6.1.

I like the idea of using a truly monological object like a chart, and not some timely fractal design, to figure nonlinear, dynamic relationships. If it is successful, the chart undoes charting, as a vampire undoes the family tree and its genealogical method. I also like to use the blunt, in-your-face quality of entries in a chart to provoke questions about the contextual conditions of existence for any category. It keeps the contingency of our meaning-making devices up front even while we, laughing a little nervously, use them to do work we care about. That seems especially important to me when trying to work with molten, explosive categories such as race, sex, or nature, much less all three such bombs together. Finally, there is nothing like the metaphor of hypertext for reinforcing the class, ethnic, and professional bias of the chart. Who, after all, figures the ability to read complex networks of relationality as hypertext?

So a chart like this is a rhetorical instruments, a kind of argument, a technology of persuasion, or, more simply, a device to think with. I want my readers to ask if the chart works and what it works for. As my argument unfolds, I will detail some of the consequences of this taxonomic excursion. Space does not allow me to go systematically through the chart, or even to identify all of its entries. Various readers will bring different kinds of expertise to Table 6.1 and make more or less sense of—and quibble with—different parts of it. I think both that this is inevitable with any text and that it is a good thing, not the mark of deficiency of author or reader. I want the chart to work like an echo chamber or a diffraction grid, producing wave interferences that make many kinds of patterns on the active recording neural tissues of readers. Still, inescapably, from various points of entry, some of the chart will seem self-evident, some obscure, some properly explained. I hope the readers will use the chart to provoke and explore and not be repelled by the unknown regions, the obvious parts, or my errors.

Leaving most categories in the chart to fare for themselves, I will work to control one braided narrative line. The story resonates from images of racialized faces, which are taut membranes stretched across the scaffolding of accounts of conjoined biological and technological evolution. The story moves from the primal ape family, rebirthed by taxidermy in the dioramas of the American Museum of Natural History in New York City in the 1930s; to the universal first family seen in the 1960s to be living its sharing way of life on the African savannah at the dawn of the human species; to the computer-generated, multicultural SimEve in *Time* magazine's "New Face of America" of the 1990s. I will try to show how the mutations of bioscientific categories from race to population to genome code for what can count as human, and therefore as progressive, in the civic and personal bodies of twentieth-century U.S. Americans.

Race

The starting point for my story is the racial discourse in place at the end of the nineteenth century in Europe and the United States. As the historian George Stocking put it, "'blood' was for many a solvent in which all problems were dissolved and processes commingled." "Race" meant the "accumulated cultural differences carried somehow in the blood" (Stocking 1993:6). The emphasis was on "somehow," for blood proved a very expansible and inclusive fluid. Four major discursive streams poured into the cauldron in which racial discourse simmered well into the early decades of the twentieth century, including the ethnological, Lamarckian, polygenist, and evolutionist traditions. For each approach, the essential idea was the linkages of lineage and kinship. No great distinction could be maintained between linguistic, national, familial, and physical

resonances implied by the terms *kinship* and *race*. Blood ties were the proteinaceous threads extruded by the physical and historical passage of substance from one generation to the next, forming the great nested, organic collectives of the human family. In that process, where race was, sex was also. And where race and sex were, worries about hygiene, decadence, health, and organic efficiency occupied the best of minds of the age, or at least the best published.

These same minds were uniformly concerned about the problems of progress and hierarchy. Organic rank and stage of culture from primitive to civilized were at the heart of evolutionary biology, medicine, and anthropology. The existence of progress, efficiency, and hierarchy were not in question scientifically, only their proper representation in natural-social dramas, where race was the narrative colloid or matrix left when blood congealed. The plenum of universal organic evolution, reaching from ape to modern European with all the races and sexes properly arrayed between, was filled with the bodies and measuring instruments proper to the life sciences. Craniometry and the examination of sexual/reproductive materials both focused on the chief organs of mental and generative life, which were the keys to organic social efficiency. Brains were also sexual tissues, and reproductive organs were also mental structures. Furthermore, the face revealed what the brain and the gonad ordained; diagnostic photography showed as much. The evolution of language, the progress of technology, the perfection of the body, and the advance of social forms seemed to be aspects of the same fundamental human science. That science was constitutively physiological and hierarchical, organismic and wholist, progressivist and developmental.

To be sure, in the early twentieth century Franz Boas and social-cultural anthropology broadly were laying the foundations of a different epistemological order for thinking about race. But, encompassing immigration policy, mental-health assessments, military conscription, labor patterns, nature conservation, museum design, school and university curricula, penal practices, field studies of both wild and laboratory animals, literary evaluation, the music industry, religious doctrine, and much more, race—and its venereal infections and ties to sexual hygiene—was real, fundamental, and bloody. If the skeptic of poststructuralist analysis still needs to be convinced by an example of the inextricable weave of historically specific discursive, scientific, and physical reality, race is the place to look. The discursive has never been lived with any greater vitality than in the always undead corpus of race and sex. For many in the first decades of the twentieth century, race mixing was a venereal disease of the social body, producing doomed progeny whose reproductive issue was as tainted as that of lesbians, sodomites, Jews, overeducated women, prostitutes, criminals, masturbators, or

alcoholics. These were the subjects, literal and literary, of the commodious discourse of eugenics, where intraracial hygiene and interracial taxonomy were two faces of the same coin.[5]

Even radicals and liberals, to name them anachronistically, who fought the reproductive narrative and social equations named in the preceding paragraph, accepted race as a meaningful object of scientific knowledge. They had little choice. These writers and activists worked to reshape race into a different picture of collective human health (Stepan and Gilman 1993).[6] Scientific racial discourse—in the sense that did not insist on the separation of the physical and the cultural and spoke in the idiom of organic health, efficiency, and familial solidarity—accommodated writers from great American liberators such as W. E. B. Du Bois and Charlotte Perkins Gilman to middle-of-the-road, Progressive Era, unabashed racists such as Madison Grant.[7] Du Bois is particularly interesting because he most consistently rejected "biologism" in his approach to race and racism, but the broad discourse that assimilated race feeling to family feeling and invited discussion on the childhood and maturity of collective human groups called races was inescapable (Du Bois 1989:8). Although he retracted such language a decade or so later, in 1897 Du Bois wrote that the history of the world is the history of races: "What is race? It is a vast family ... generally of common blood and language, always of common history" (Du Bois 1971:19; see also Appiah 1985; 1990:16n3; Stepan and Gilman 1993:192n7).

George Stocking's thumbnail portrait of the Social Marking System developed by the U.S. sociologist Franklin H. Giddings around 1900 to 1910 collects up the ways that race and nation, passing through kinship of many ontological kinds and degrees of closeness, were held together on a continuum of social-biological differences. "The essential element of the race concept was the idea of kinship. . . . 'Race' and 'nation' were simply the terms applied to different levels of a single pyramid" (Stocking 1993:7–8). Giddings attempted to provide a quantitative notation to distinguish degrees of kinship, arrayed across eight different kinds of relatedness. Types such as the Hamitic, the Semitic, the Celtic, and so on filled the taxonomic slots. The specifics of Gidding's classification are less important here than their illustration of the exuberance of racial taxonomizing in the United States. In these taxonomies, which are, after all, little machines for clarifying and separating categories, the entity that always eluded the classifier was simple: race itself. The pure Type, which animated dreams, sciences, and terrors, kept slipping through, and endlessly multiplying, all the typological taxonomies. The rational classifying activity masked a wrenching and denied history. As racial anxieties ran riot through the sober prose of categorical bioscience, the taxonomies could neither pinpoint nor contain their terrible discursive product.

234

To complete my brief caricature of race as an object of bioscientific knowledge in the period before World War II, I will turn to a family portrait that innocently embodies the essence of my argument. The portrait slips down the developmental chain of being to racialized urban humanity's ultimate other and intimate kin, the gorilla in nature[8] [Figure 6.2. Gorilla Group in the American Museum of Natural History]. Figure 6.2 shows a taxidermic reconstruction of a gorilla group, with a striking silverback male beating his chest, a mother at one side eating calmly, and a toddler. A young blackback male is in the diorama but out of the photograph. The primal ape in the jungle is the doppelgänger and mirror to civilized white manhood in the city. Culture meets nature through the looking glass at the interface of the Age of Mammals and the Age of Man. Preserved in changeless afterlife, this vibrant gorilla family is more undead than it is alive. The members of this (super)natural gorilla family were hunted, assembled, and animated by the art of taxidermy to become the perfect type of their species. Dramatic stories about people, animals, tools, journeys, diseases, and money inhere in each precious corpse, from the chest-beating male called the

Figure 6.2 Gorilla Group in African Hall. Animals by Carl E. Akeley. Background by Willima Leigh. Neg. #314824. Courtesy of the American Museum of Natural History. Photograph by Wurts Brothers.

Giant of Karisimbi to the ape-child speared as it screamed in terror on the steep volcanic mountainside. The blood was drained; face masks taken from the corpses; the skins stripped and preserved, shipped across continents, and stretched over special light mannequins. Lit from within and surrounded by the panoramic views made possible by Hollywood set painting and the new cameras of the 1920s, the perfect natural group—the whole organic family in nature—emerged in a lush Eden crafted out of detailed reconstructions of leaves, insects, and soils. In these ways, the gorilla was reborn out of the accidents of biological life, a first birth, into epiphanic perfection, a second birth, in a diorama in the Akeley African Hall in the American Museum of Natural History in New York City.

Behind the dioramic re-creation of nature lies an elaborate world of practice. The social and technical apparatus of the colonial African scientific safari and the race-, class-, and gender-stratified labor systems of urban museum construction organized hundreds of people over three continents and two decades to make this natural scene possible. To emerge intact, reconstructed nature required all the resources of advanced guns, patented cameras, transoceanic travel, food preservation, railroads, colonial bureaucratic authority, large capital accumulations, philanthropic institutions, and much more. The technological production of a culturally specific nature could hardly be more literal. The intense realism of the diorama was an epistemological, technological, political, and personal-experiential achievement. Natural order was simply there, indisputable, luminous. Kinship was secure in the purity of the achieved vision.

Walt Disney Studios and National Geographic might do better in the decades to come, but they needed the magic of motion pictures. The achievement of the prewar natural history diorama relied more on a sculptural sensibility that was also manifest in the elegant bronzes, placed just outside the African Hall, of "primitive natural man," the East African Nandi lion-hunters. Their perfection was sought by the same scientist-artist, Carl Akeley, who designed the dioramas for the American Museum. Organicism and typology ruled unchallenged in these practices, in which the earth's great racial dramas, constructed in a white, imperial, naturalist, and progressive frame, were displayed as pedagogy, hygiene, and entertainment for an urban public.

After the successful scientific hunt for the perfect specimen, the superior nobility of hunting with the camera was urged in a conservationist doctrine that downplayed further hunting with the gun. To strengthen the conservationist argument, white women and children came on the final hunt for the museum's gorillas to prove that the great violent drama of manhood in confrontation across species could give way to a gentler tale. In part because of the efforts of the

members of this collecting expedition in 1921-1922 and of the officers of the American Museum, the area where the Giant of Karisimbi died became a Belgian national park, the Parc Albert in the Belgian Congo, where nature, including "primitive" people as fauna in the timeless scene, was to be preserved for science, adventure, uplift, and moral restoration as proof against civilization's decadence. No wonder universal nature has been a less than appealing entity for those who were not its creators and its beneficiaries. Undoing this inherited dilemma has never been more urgent if people and other organisms are to survive much longer.

The hunt for the Giant of Karisimbi took place in 1921, the same year that the American Museum of Natural History hosted the Second International Congress of Eugenics. Collected proceedings from the congress were titled "Eugenics in Family, Race, and State." The Committee on Immigration of the Eugenics Congress sent its exhibit on immigration to Washington, D.C., as part of its lobbying for racial quotas. In 1924 the U.S. National Origins Act restricted immigration by a logic that linked race and nation. For officials of the American Museum, nature preservation, germ plasm protection, and display work were all of a piece. Exhibition, conservation, and eugenics were part of a harmonious whole. Race was at the center of that natural configuration, and racial discourse, in all of its proliferating diversity and appalling sameness, reached deep into the family of the nation.

Population

The community of race, nation, nature, language, and culture transmitted by blood and kinship never disappeared from popular racialism in the United States, but this bonding has not been meaningfully sustained by the biological sciences for half a century. Rather than dwell on the scientific and political processes that led to the biosciences' reversal on the reality and importance of race to evolutionary, genetic, physiological, therapeutic, and reproductive explanations in the middle decades of the twentieth century, I will leap to the other side of the divide, to where the Wizard of Oz has changed the set in the theater of nature. The major difference is that an entity called the population is now critical to most of the dramatic action.

A population, a relatively permeable group within a species, differed by one or more genes from other such groups. Changes of gene frequencies within populations were fundamental evolutionary processes, and gene flow between populations structured the traffic that bound the species together. Genes and genotypes were subject to Darwinian natural selection in the context of the functioning phenotypes of whole organisms within populations. Occasionally

still a convenient notion, race was generally a misleading term for a population. The frequency of interesting genes, such as those coding for immunological markers on blood cells or for different oxygen-carrying hemoglobins, might well differ more for individuals within a population than between populations. Or they might not; the question was an empirical one and demanded an explanation that included consideration of random drift, adaptational complexes, and the history of gene exchange. The populations' history of random genetic mutation and gene flow, subjected to natural selection resulting in adaptation, constituted the history of the species. Populations were not types arranged hierarchically but dynamic assemblages that had to function in changing environments. Measurements had to be of structures important to adaptational complexes related to current function. For example, craniometry producing brain-volume values on a putative hierarchical chain of being gave way to measurements of structures critical to dynamic action in life, such as facial regions critical to chewing and subject to physical and functional stresses during the development of the organism. Highly variable and permeable natural populations seemed to be the right kind of scientific object of knowledge, and the racial type seemed to be a residue from a bad nightmare.

The construction of the category of the population occurred over several decades. Leading parts were taken by naturalists studying geographical variation and speciation; geneticists learning that mutations were inherited in discrete Mendelian fashion; population geneticists constructing mathematical models showing how mutation, migration, isolation, and other factors could affect the frequency of genes within populations; and experimentalists demonstrating that natural selection could operate on continuous variations to alter the characteristics of a population. The synthesis of these lines of research—which was effected by the Russian-trained immigrant U.S. geneticist Theodosius Dobzhansky; the English scion of the scientific Huxley clan, Julian Huxley; the polymath German-trained immigrant U.S. systematist Ernst Mayr; and the U.S. paleontologist George Gaylord Simpson, among others, from the late 1930s to the late 1940s—changed the face of dominant evolutionary theory. The result was called the modern synthesis or the neo-Darwinian evolutionary theory.[9] Several of the men who put the modern synthesis together were also popular writers, published by the major university presses, who developed an antiracist, liberal, biological humanism that held sway until the 1970s.[10] This was a scientific humanism that emphasized flexibility, progress, cooperation, and universalism.

This was also precisely the humanism enlisted by M. F. Ashley Montagu, former student of Franz Boas and organizer of the United Nations Educational, Scientific, and Cultural Organization's (UNESCO) statements on race in 1950

and 1951 (UNESCO 1952). Perched on the cusp between the Allied victory over the Axis powers, the ideological contest for defining human nature waged by "socialism" and "capitalism" in the Cold War, and the struggles for third world decolonization that sharpened after World War II, the U.S.-sponsored documents were intended to break the bioscientific tie of race, blood, and culture that had fed the genocidal policies of fascism and still threatened doctrines of human unity in the emerging international scene. Since biologists had to bear so much of the responsibility for having constructed race as a scientific object of knowledge in the first place, it seemed essential to marshal the authority of the architects of the new synthesis to undo the category and relegate it to the slag heap of pseudo-science. It would not have done for the UNESCO statement to have been authored by social scientists. The crafting of the UNESCO race statements provides a unique case study for the discursive reconstitution of a critical epistemological and technical object for policy and research, where science and politics, in the oppositional sense of those two slippery terms, form the tightest possible weave.

The concept of the population was in the foreground as the authors argued that plasticity was the most prominent species trait of *Homo sapiens*. While the strong statement that the range of mental talent is the same in all human groups did not survive controversy over the 1950 version, the negative argument that science provides no evidence of inherited racial inequality of intelligence remained. The contentious 1950 statement that universal brotherhood (sic) is supported by a specieswide, inborn trait of a drive toward cooperation also did not live through the rewriting in 1951. Nonetheless, the latter document— signed by 96 internationally prominent scientific experts before it was released— remained uncompromising on the key ideas of plasticity, educability, the invalidity of the race-and-culture tie, and the importance of populationist evolutionary biology.[11] To cast group differences typologically was to do bad science—with all the penalties in jobs, institutional power, funding, and prestige that flow from such labeling. Needless to say, biological racialism did not disappear overnight, but a palace coup had indeed taken place in the citadel of science.[12]

Walking out of UNESCO House in Paris, the new universal man turned up fossilized in East Africa almost immediately. In honor of this timely geological appearance, the *Harvard Lampoon* dubbed Olduvai Gorge, made famous by the paleo-anthropological investigations of the Leakey family, the "Oh Boy! Oh Boy! Gorge" for its stunning hominid fossils and the associated accounts of the dawn of human history and of the species-defining characteristics of human nature. Deeply indebted to the modern synthesis, the New Physical Anthropology developed from the 1950s to become a major actor in identifying

those adaptational complexes that made "us" human and in installing them in both pedagogical and research practice. Public and intradisciplinary antiracist lectures, new undergraduate and graduate curricula in physical anthropology sustained by the expanding institutional prosperity of the postwar era in the United States, field studies of natural primate populations, and major programs of research on African hominid fossils were all part of the program of the new physical anthropology. Its objects of attention were not typologically constructed taxonomies but systems of action that left their residue in the enduring hard structures in fossil beds or under the skin of still living animals. Adaptational behavior is what these biological anthropologists cared about, whether they were looking at pelvic bones, crania, living monkeys and apes, or modern hunter-gatherers. In the new framework, people who were typical "primitives" to the earlier expeditions of the American Museum of Natural History were fully modern humans, exhibiting clearly the fundamental adaptational complexes that continue to characterize all populations of the species. Indeed, lacking the stresses of too much first world abundance, the former "primitives," like modern hunter-gatherers, became especially revealing "universal" human beings.

The most important adaptational complex for my purposes in this chapter is the species-defining sharing way of life, rooted in hunting and the heterosexual nuclear family. Man the Hunter, not the urban brother of the Giant of Karisimbi or the Nandi lion spearmen, embodied the ties of technology, language, and kinship in the postwar universal human family. Parent to technology and semiology—to the natural sciences and the human sciences—in the same adaptational behavior, Man the Hunter crafted the first beautiful and functional objects and spoke the first critical words. Hunting in this account was not about competition and aggression but about a new subsistence strategy possible for striding, bipedal protohumans with epic hand-eye coordination. Acquiring big brains and painful births in the process, these beings developed cooperation, language, technology, and a lust for travel, all in the context of sharing the spoils with mates, children, and each other. Males were certainly the active motor of human evolution in the hunting hypothesis of the 1950s and 1960s, but the logic was not too much strained in the 1970s by foregrounding Woman the Gatherer and a few useful family reforms, such as female orgasms and mate choice favoring males who made themselves useful with the kids.[13] Still, baby slings, carrying bags for roots and nuts, daily adult gossip, and talking to children could hardly compete for originary drama with elegant projectiles, adventurous travel, political oratory, and male bonding in the face of danger.[14]

Two powerful photographic documents of the universal human family conclude my meditation on the hopeful, but fatally flawed, biological humanism

of the midtwentieth century: the late-1970s painting called *Fossil Footprint Makers of Laetoli* by the anatomical illustrator Jay Matternes, and the New York Museum of Modern Art's publication from its 1955 epic photographic exhibit called *The Family of Man*. Both documents stage the relations of nature and culture mediated by the heterosexual, reproductive, nuclear family as the figure of human unity and diversity. Both renderings of the human story are starkly under the visible sign of the threat of nuclear destruction, and both suggest a saga of unity, danger, and resilience that permeated accounts of science, progress, and technology in the post–World War II era.

Accompanying an international museum exhibit of hominid fossils in the 1980s, Matternes's painting shows the hominid First Family walking across the African savanna under the cloud of an erupting volcano, the sign of destruction by fire.[15] These transitional figures between apes and modern humans recall the gorilla family in the American Museum of Natural History. But for earthlings in the last chilling years of the Cold War, the thick cloud of dust spewing into the sky to obscure the sun in Matternes's reconstruction could not help but evoke the looming threat of nuclear winter. Expulsion from Eden had particular narrative resonances in nuclear culture. In the era of nuclear superpowers facing off in fraternal rivalry, threats came in centralized apocalyptic packages. In the New World Order of the post–Cold War era, nuclear threats, like all else, have a more dispersed and networked structure of opportunity and danger—for example, criminal smuggling of plutonium from the former Soviet Union and the apocalypse-lite of plutonium poisoning of urban water supplies or dirty minibombs backing up political disputes. Matternes's painting is a reconstruction of the life events that might have been responsible for the 3.7-million-year-old footprints found in the volcanic ash at Laetoli, near the Olduvai Gorge, by Mary Leakey and others in the late 1970s. The space-faring descendants of the First Family put their footprints in moon dust in 1969 in Neil Armstrong's "one small step for mankind," just as the *Australopithecus afarensis* trekkers, at the dawn of hominization, made their way through the volcanic dust of the human travel narrative.

The great myths of birth and death, beginnings and endings, are everywhere in this painting. The reconstructed hominids are members of a highly publicized ancestor-candidate species that has been at the center of scientific debates about what counts as human. Perhaps the best-known fossil in this media and scientific fray has been the 3.5-million-year-old skeleton of a diminutive female named Lucy by her Adamic founders, after the Beatles' "Lucy in the Sky with Diamonds." The African plain in the painting, scene of the passage of Lucy's relatives, is both rich with the signs of abundant animal life and thickly encrusted with the smothering ash that must drive all the animals,

including these early hominids, in search of food. The three family members vividly dramatize the central adaptive complexes that made "us" human. The elements for the universal sharing way of life are unmistakable. The male strides ahead, carrying a serviceable tool, although not quite the future's elegant projectiles that were critical to the hunting hypothesis as well as to Stanley Kubrick's *2001: A Space Odyssey*. *A. afarensis* would have to wait for somewhat larger heads before they improved their aesthetic sense. The antiracist universals of the evolutionary drama scripted according to the humanist doctrines of the modern synthesis left in place the durable essentials of the sexual division of labor, male-headed heterosexual families, and child-laden females—here pictures *without* the baby-carrying sling that many anthropologists argue was likely to have been among the first human tools. In Matternes's Adamic imagination, the child-carrying female follows behind, looking to the side, while the male leads, looking into the future. The germ of human sociality was the couple and their offspring, not a mixed foraging group, a group of related females with their kids, two males with one carrying a kid, or any other of the many possibilities for those first small steps for mankind left in the dust at Laetoli.[16]

If it is the numbing and hegemonic sameness of the universal way of life that I resist in the new physical anthropology, including many of its feminist versions, and in Matternes's painting, then perhaps an earlier document, the popular coffee-table book of Edward Steichen's photographic exhibit called *The Family of Man*, can settle my dyspeptic attack of political correctness. If I detect the unself-conscious ethnocentricity of those who crafted the natural-technical object of knowledge called the First Family and the universal hominizing way of life, perhaps the global scope of the 1955 document will allow a more capacious field for imagining human unity and difference. Yet, once I have learned to see the Sacred Image of the Same and the Edenic travelogue of so much Western historical narrative, I have a hard time letting go of this perhaps monomaniacal critical vision, which might be worse than the objects it complains about. My own perverse skill at reading the sameness of my own inherited cultural stories into everything is one of the symptoms that drives this chapter. Still, I believe that this capacity of reproducing the Same, in culpable innocence of its historical, power-charged specificity, characterizes not just me but people formed like me, who are liberal, scientific, and progressive—just like those officials of the American Museum of Natural History who sent their eugenic immigration exhibit to Washington in 1921. I am worried that too little has changed in hegemonic bioscientific discourse on nature, race, unity, and difference, even in the face of seeming major change. So let me pursue my suspicion that the Sacred Image of the Same is not just my problem but is also one of the tics that repro-

duces sexually charged racist imaginations even in the practices most consciously dedicated to antiracism.

In this mood, I am not surprised that Steichen's 1955 photo album does not settle my dyspepsia. My queasiness is not just with the title and its conventional familial trope for binding together humanity, with all the resonances that metaphor evokes of kinship, lineage, and blood ties. There is much to love in *The Family of Man*, including its vivid photos of working, playing, and fighting. Old age, infirmity, and poverty are no barriers to liveliness here. Even the staging of everybody and everything into one grandly decontextualized narrative, which culminates in the United Nations and the hopes for peace in nuclear times after the ravages of depression, fascism, and war, can almost be forgiven. After all, *The Family of Man* is a lot less sanitized than most 1990s versions of multiculturalism. Despite decades of critical visual theory, I am susceptible, even now, to the images of this book. That helps, because it is a rule for me not to turn a dissolving eye onto straw problems, not to "deconstruct" that to which I am not also emotionally, epistemologically, and politically vulnerable.

The Family of Man is ruled throughout its organic tissues by a version of unity that repeats the cyclopean story that collects up the people into the reproductive heterosexual nuclear family, the potent germ plasm for the Sacred Image of the Same. The opening photos show culturally varied young men and women in courtship; then marriage; then all sorts of women in pregnancy and labor; then birth (mediated by a male scientific-medical doctor), nursing, babyhood, and parenting by both genders. The photo album then opens out into culturally and nationally varied scenes of work on the land and in factories. Food, music, education, religion, technology, tragedy and mercy, aging and death, anger and joy, hunger and suffering all find their place. The icons of nuclear war and of other wars, as well as images of racism and fascism, cast a deep shadow. The pall is lifted by the images of democracy (voting) and internationalism (the United Nations), which locate hope for this family story solidly in the signifiers of the "free world." The last pages of the exhibit are full of multihued children, seeds of the future. The last photo (before the unfortunate ocean wave on the inside back cover) is of a little boy and little girl moving away from the viewer, walking hand in hand in a sylvan nature toward the sunny light of a possible future. This book about human universals is vehemently antiracist and simultaneously deeply enmeshed in an ethnospecific, teleological story that continues to make the human collective bleed, or at least to hunger for other stories of what it means to be members of a species and a community. What's not collected in a reproductive family story does not finally count as human. For all the photo narrative's emphasis on difference, this is the grammar of indifference, of the multiplication of sameness.

The desire for a child, for a future, in that potent image permeating *The Family of Man* is at least as fierce as the yearning sustaining the New Reproductive Technologies of the 1980s and 1990s. The genetic imagination never dimmed under the sign of the population. Genetic desire would be no less when the genome became the signifier of human collectivity.

Genome

If universal humanity was plastic under the sign of the population at midcentury, then human nature is best described as virtual in present, end-of-the-millennium regimes of biological knowledge and power. Specifically, human nature is embodied, literally, in an odd thing called a genetic database, held in a few international locations such as the three large public databases for genetic map and sequence data: the U.S. GenBank©, the European Molecular Biological Laboratory, and the DNA Data Bank of Japan. The Genome Data Base at Johns Hopkins University is a massive central repository of all gene-mapping information. In the world of gene sequencing, intellectual property rights vie with human rights for the attention of lawyers and scientists alike. Criminal as well as corporate lawyers have a stake in the material and metaphoric representation of the genome. Funding and policy strongly support rapid public access to genome databases in the interests of research and development. For example, in 1993 the French researcher Daniel Cohen, of the Centre d'Etude du Polymorphisme Humaine in Paris, made his first complete draft map of the human genome available through the Internet. GenInfo, developed by the U.S. National Center for Biotechnology Information of the National Library of Medicine, is a kind of metadatabase containing both protein and nucleic acid sequence data "to which other databases can add, refer, annotate, interpret, and extrapolate" (Corteau 1991:202).[17] In part because of the tremendous physical computing power and human expertise that resulted from nuclear weapons research, informatics development in the U.S. Human Genome Project began under the auspices of GenBank© at the U.S. National Laboratories at Los Alamos, New Mexico. It was there also that the expertise and machines existed that built the matrix for the flourishing of artificial life research at the nearby Santa Fe Institute.

A database is an information structure. Computer programs are the habitats of information structures, and an organism's genome is a kind of nature park among databases. Just as racial hygiene and eugenics were committed to science and progress, and populationist doctrines of human universals were unambiguously on the side of development and the future, the genome is allied with all that is up-to-the-minute. Yet, something peculiar happened to the stable, family-loving, Mendelian gene when it passed into a database, where it has more in

common with LANDSAT photographs, Geographical Information Systems, international seed banks, and the World Bank than with T. H. Morgan's fruitflies at Columbia University in the 1910s or UNESCO's populations in the 1950s. Banking and mapping seem to be the name of the genetic game at an accelerating pace since the 1970s, in the corporatization of biology to make it fit for the New World Order, Inc.[18] If the modern synthesis, ideologically speaking, tended to make everyone his brother's keeper, then, in its versions of kin selection and inclusive fitness-maximization strategies, the sociobiological synthesis runs to making everyone his or her sibling's banker.[19]

Biotechnology in the service of corporate profit is a revolutionary force for remaking the inhabitants of planet Earth, from viruses and bacteria right up the now repudiated chain of being to *Homo sapiens* and beyond. Biological research globally is progressively practiced under the direct auspices of corporations, from the multinational pharmaceutical and agribusiness giants to venture-capital companies that fascinate the writers for the business sections of daily newspapers. Molecular biology and molecular genetics have become nearly synonymous with biotechnology as engineering and redesign disciplines. Beings like Man the Hunter and Woman the Gatherer reappear for their roles on the stage of nature enterprised up as Man™ and Woman™—copyrighted; registered for commerce; and, above all, highly flexible.[20] In a world where the artifactual and the natural have imploded, nature itself, both ideologically and materially, has been patently reconstructed. Structural adjustment demands no less of bacteria and trees as well as of people, businesses, and nations.

The genome is the totality of genetic "information" in an organism, or, more commonly, the totality of genetic information in all the chromosomes in the nucleus of a cell. Conventionally, the genome refers only to the nucleic acid that "codes" for something and not to the dynamic, multipart structures and processes that constitute functional, reproducing cells and organisms. Thus, not even the proteins critical to nuclear chromosomal organization or DNA structures such as mitochondrial chromosomes outside the nucleus are part of the genome, much less the whole living cell. Embodied information with a complex time structure is reduced to a linear code in an archive outside time. This reduction gives rise to the curious, ubiquitous, mixed metaphor of "mapping the code," applied to projects to represent all the information in the genome. DNA in this view is a master molecule, the code of codes, the foundation of unity and diversity. Much of the history of genetics since the 1950s is the history of the consolidation and elaboration of the equation of "gene = information" in the context of master-molecule metaphors. I consider this representational practice for thinking about genetics to constitute a kind of artificial life research

itself, where the paradigmatic habitat for life—the program—bears no necessary relationship to messy, thick organisms.

The convergence of genomics and informatics, in technique and personnel as well as in basic theory and shared tropes, is immensely consequential for bio-scientific constructions of human nature. The technical ability to manipulate genetic information, in particular to pass it from one kind of organism to another in a regulated manner in the lab, or to synthesize and insert new genes, has grown exponentially since the first successful genetic engineering experiments of the early 1970s. In principle, there is no naturally occurring genome that cannot be experimentally redesigned. This is a very different matter compared to the genetic traffic among populations of a species studied within the midcentury evolutionary synthesis, much less compared to the genetic, natural racial types that inhabited the biological world earlier in the century. Genetic engineering is not eugenics, just as the genome does not give the same kind of account of a species as does organic racial discourse.[21]

From the point of view of the 1990s, the genome is an information structure that can exist in various physical media. The medium might be the DNA sequences organized into natural chromosomes in the whole organism. Or the medium might be various built physical structures, such as yeast artificial chromosomes (YACs) or bacterial plasmids, designed to hold and transfer cloned genes or other interesting stretches of nucleic acid. The entire genome of an organism might be held in a "library" of such artifactual biochemical information structures. The medium of the database might also be the computer programs that manage the structure, error checking, storage, retrieval, and distribution of genetic information for the various international genome projects that are under way for *Homo sapiens* and for other model species critical to genetic, developmental, and immunological research. Those species include mice, dogs, bacteria, yeast, nematodes, rice, and a few more creatures indispensable for international technoscientific research.

The U.S. Human Genome Project officially began in 1988 under the management of the Department of Energy and the National Institutes of Health. As a whole, the global Human Genome Project is a multinational, long-term, competitive and cooperative, multibillion-dollar (yen, franc, mark, etc.) effort to represent exhaustively—in genetic, physical, and DNA sequence maps—the totality of information in the species genome.[22] The data are all entered into computerized databases, from which information is made available around the world on terms still very much being worked out. Computerized database design is at the leading edge of genomics research. Design decisions about these huge databases shape what can be easily compared to what else, and so deter-

mine the kinds of uses that can be made of the original data. Such decisions structure the kinds of ideas of the species that can be sustained. National science bodies, tax- and foundation-supported universities, international organizations, private corporations, communities, indigenous peoples, and many configurations of political and scientific activists all play a part in the saga.

Questions about agency—who is an actor—abound in the world of the genome, as in the worlds of technoscience in general. For example, in the discourse of genome informatics, data are exchanged among "agents" and sent to "users" of databases. These entities could as easily be computers or programs as people (Erickson 1992).[23] It does not solve the trouble to say that people are the end users. That turns out to be a contingent, technical, design decision—or a way or representing ongoing flows of information—more than an ontological necessity. People are in the information loop, but their status is a bit iffy in the artificial life world. Compared to the biological humanism of the modern synthesis, technohumanism has had to make a few timely ideological adjustments. Genomics is neither taxidermy nor the reconstruction practices of the new physical anthropology, and the emerging techniques of animation occupy the minds of more than the *Jurassic Park* special-effects programmers at Industrial Light and Magic.

Issues of *agency* permeate practices of *representation* in many senses of both terms: Who, exactly, in the human genome project represents whom? A prior question has to be a little different, however. Who, or what, is the human that is to be exhaustively represented? Molecular geneticists are consumed with interest in the variability of DNA sequences. Their databases are built to house information about both stable and variable regions of genes or proteins. Indeed, for actors from drug designers to forensic criminologists, the uniqueness of each *individual's* genome is part of the technical allure of the human genome projects' spinoffs. More fundamentally, however, the genome projects produce entities of a different ontological kind than flesh-and-blood organisms, "natural races," or any other sort of "normal" organic being. At the risk of repeating myself, the human genome projects produce ontologically specific things called databases as objects of knowledge and practice. The human to be represented, then, has a particular kind of totality, or species being, as well as a specific kind of individuality. At whatever level of individuality or collectivity, from a single gene region extracted from one sample through the whole species genome, this human is itself an information structure whose program might be written in nucleic acids or in the artificial intelligence programming language called Lisp®.

Therefore, variability has its own syntax in genome discourse as well. There is no illusion in the 1990s about single "wild-type" genes and various mutant deviants.[24] That was the terminology of Mendelian genetics of the early twen-

RACE

tieth century, when the languages of the normal and the deviant were much more sanitary. Racial hygiene and its typological syntax are not supported by genome discourse, or by artificial life discourses in general. Genetic investment strategies, in the sense of both evolutionary theory and business practice, *are* supported. The populationist thinking of the modern synthesis blasted an entire toolkit of resources for believing in norms and types. Flexibility, with its specific grammars of human unity and diversity, is the name of the game at the end of this millennium. However, for all of their commitment to variability, most molecular geneticists are not trained in evolutionary population biology, or even in population genetics. This disciplinary fact has given rise to a most interesting project and ensuing controversy for the purposes of this chapter. Let us pick up questions of agency and representation, as well as unity and difference, though the Human Genome Diversity Project (HGDP).

If the human genome databases are exhaustively to represent the species—and to provide information to users who demand that kind of knowledge, in dreams of totality as well as in practical projects—the repositories must contain physical and electronic data about the specific molecular constitution and frequency of genes on a truly global scale. Population geneticists were critical both of molecular biologists' sampling protocols for human genetic material and of their woeful statistical grasp of the structure, distribution, history, and variability of human populations. The population geneticists were also worried that many human populations around the world were becoming extinct—either literally or through interbreeding and swamping of their diversity in larger adjoining populations—with the consequent loss of genetic information forever impoverishing the databases of the species. What it means to be human would have irredeemable informational gaps. There would be a biodiversity information loss in the lifeworld of the genome. Like the vanishing of a rainforest fungus or fern before pharmaceutical companies could survey the species for promising drugs, the vanishing of human gene pools is a blow to technoscience. Prompt and thorough genetic collection and banking procedures as well as preservation of the source of variation, if possible, are the solution.

I am being a bit mordant in my reading of purposes in this account, for the organizers of the Human Genome Diversity Project were largely liberal biological humanists of the old stamp. Also, I remain sympathetic to the desire to produce a human species database that draws from as large a concept of humanity as possible. I want there to be a way to reconfigure this desire and its attendant humanism. However, it was precisely the doctrines of difference, representation, and agency of "universal" humanism that got the project and its well-meaning organizers into well-deserved trouble.[25]

Beginning about 1991, the organizers of the Human Genome Diversity Project proposed to amend the evolutionary population thinking, or lack of thinking, of the mainline Human Genome Project by collecting hair-root, white blood-cell, and cheek-tissue samples, to be held in the American Type Culture Collection, from over 700 groups of indigenous peoples on six continents. Over five years, the cost would be about $23-35 million (compared to more than $3 billion for the Human Genome Project as a whole). Unfortunately, unself-conscious, modernist perspectives distorted the definition of the categories of people from whom samples were to be sought, leading to a vision of dynamic human groups as timeless "isolates of historic interest." Also, other potentially genetically distinct ethnic communities did not appear on the sampling list.

The planning of the project did not involve members of the communities to be studied in any formative way in the science. The people to be sampled might give or withhold permission, to be more or less carefully sought and thoroughly explained, but they were not regarded as partners in knowledge production who might have ends and meanings of their own in such an undertaking. Their versions of the human story, complexly articulated with the genetic science of the visitors, did not shape the research agenda. Permission is not the same thing as collaboration, and the latter could lead to fundamental changes in who and what would count as science and as scientists. All the trappings of universal science notwithstanding, amending a database is a pretty culturally specific thing to want to do. Just why should other people, much less folks called "isolates of historic interest," help out with that project? That is not a rhetorical question, and there can be very strong answers coming from counterintuitive as well as obvious viewpoints for any actor. The question is a fundamental one about the rhetoric of persuasion and the practical processes through which people—including scientists and everybody else—get reconstituted as subjects and objects in encounters. How should the many discourses in play within and between people like the Guaymi of Panama and the Population Geneticists of California be articulated with each other in a power-sensitive way? This is an ethical question, but it is much more than that. It is a question about what may count as modern knowledge and who will count as producers of that knowledge.[26]

Not surprisingly, it turned out that indigenous people were more interested in representing themselves than in being represented in the human story. The encounter was most certainly not between "traditional" and "modern" peoples but between contemporaneous people (and peoples) with richly interlocking and diverging discourses, each with its own agendas and histories. Functioning as boundary objects, "genes" and "genomes" circulated among many of the lan-

guages in play.[27] Members of communities to be sampled, as well as other spokespeople, had several concerns. Some were adamant that genes or other products derived from indigenous material not be patented and used for commercial profit. Others were worried that the genetic information about tribal and marginalized peoples could be misused in genocidal ways by national governments. Some argued that medical and social priorities of the communities could be addressed by the money that would go to funding the genetic sampling, and the HGDP did not give benefits back to the people. Some were quite willing to have indigenous genetic material contribute to a medically useful world knowledge fund, but only under United Nations or similar auspices that would prevent exploitation and profit-making. Ethics committee members of the HGDP tried to assure skeptics that the project had no commercial interests and that the HGDP would try to make sure that any commercial benefits that did result from the sampled material flowed back to the communities. But overall, the general issue was the question of the agency of people who did not consider themselves a biodiversity resource. Diversity was about both their *object* status and their *subject* status.

In May 1993, at a nongovernmental conference meeting parallel to the UN Human Rights Conference in Vienna, the Rural Advancement Foundation International (RAFI) and indigenous peoples urged the HGDP to "halt current collection efforts, convene a meeting with Indigenous peoples to address ethical and scientific issues, incorporate Indigenous organizations in every aspect of the HGDP and grant them veto power, and place the HGDP under direct United Nations control, with decision making delegated to a management committee dominated by Indigenous people" (RAFI 1993:13). Leaders of the HGDP tried to address the objections, but by fall of 1993 they had not set up mechanisms acceptable to the critics to include indigenous peoples in project organizing. The World Council of Indigenous Peoples monitored the project skeptically. It is important to me to note, however, that the HGDP was a minority effort in the Human Genome Project (HGP) and not at the center of the prestigious action. To get the research done at all in the face of the nonpopulationist molecular genetic orthodoxy that guided ordinary practice in the HGP would have been no small trick. It has proved easier to slow down or stop the HGDP, a kind of oppositional effort, than to question the powerful HGP itself. That makes the trouble with "difference" built into this potentially positive scientific project all the more disturbing—and important.

Inescapably, independently of the HGDP but fatally glued onto it, the all-too-predictable scandal happened. Like all pathologies, the scandal revealed the structure of what passes for normal in bioscientific regimes of knowledge and

power. The Guaymi people carry a unique virus and its antibodies that might be important in leukemia research. Blood taken in 1990 from a 26-year-old Guaymi woman with leukemia, with her "informed oral consent," in the language of the U.S. Center for Disease Control in Atlanta, was used to produce an "immortalized" cell line deposited at the American Type Culture Collection. The U.S. Secretary of Commerce proceeded to file a patent claim on the cell line. Pat Moony of the Rural Advancement Foundation International found out about the claim in August 1993 and informed Isidoro Acosta, the president of the Guaymi General Congress. Considering the patent claim to be straightforward biopiracy, Acosta and another Guaymi representative went to Geneva to raise the issue with the Biological Diversity Convention, which had been adopted at the 1993 Earth Summit in Brazil.[28] That convention had been intended to deal with plant and animal material, but the Guaymi made strategic use of its language to address technoscientifically defined human biodiversity. The Guaymi also went to the GATT secretariat to argue against the patentability of material of human origin in the intellectual property provisions of the new GATT treaty then being drafted.

In late 1993, the U.S. Secretary of Commerce withdrew the patent application, although by early 1994 the cell culture had not been returned, as demanded, to the Guaymi. The property and sovereignty battles are far from being resolved; they are at the heart of bioscientific regimes of knowledge and power worldwide. Scientific and commercial stakes are high. The stakes are also the ongoing configuration of subjects and objects, of agency and representation, inside of and by means of these disputes about biopower. The stakes are about what will count as human unity and diversity. The human family is at stake in its databases. I am instructed by the encounter of discourses, where genes are the circulating boundary objects. The Guaymi and the U.S. actors engaged each other in biogenetic terms, and they struggled for shaping those terms in the process. Perhaps the Guaymi did not initiate biotechnological and genetic engineering discourses, including their business and legal branches, but the indigenous Panamanians are far from passive objects in these material and linguistic fields. They are actors who are reconfiguring these powerful discourses, along with others they bring to the encounter. In the process, the Guaymi are changing themselves, the international scientists, and other policy elites.

The organizers of the HGDP continued to try to reorganize the research plan to satisfy both funding agencies and people to be sampled, and in late 1994 the project's International Executive Committee released a document that aimed to establish trust with indigenous peoples' organizations (Kahn 1994). The revised plan promised local control over the survey and protection of the

research subjects' patent rights as well as an independent committee established by UNESCO to advise project organizers on ongoing ethical and other controversial matters. A key provision is that in order to develop scientific priorities and ethical guidelines based on local conditions and cultures, the research be done as much as possible in the countries or regions where the sampled populations live. But localism will not solve key problems. International biodiversity property issues will not go away, and the cosmopolitan nature, as well as local cultural dimensions, of science provide both the attraction and the danger in the HGDP. Issues of cultural meaning, as well as technical and financial matters, are at stake in the global–local dialectic of technoscience, and people categorized as "indigenous" might well be more cosmopolitan than those labeled "Westerners" in key respects. Global/local does not translate as western/elsewhere or modern/traditional.[29] The biotechnology involved in the HGDP is of interest to prospective host countries, and several groups have also expressed interest in possible medical benefits as well as in participating in a project that contributes to defining humanity transnationally.

Europeans were among the first indigenous peoples to proceed with HGDP research. In 1994, the European Union provided $1.2 million to set up 25 labs from Barcelona to Budapest to study questions about European genetic diversity and paleoanthropological history. Of course, the "races" of Europe were also central to the scientific constructions of human unity and diversity in the nineteenth century, and people elsewhere in the world have not always been so convinced this is the way to think about the matter. But regional committees to pursue the HGDP have been set up in North America, South and Central America, and Africa as well as Europe, while India, China, and Japan had declined by late 1994 (Kahn 1994:722). Organized Native Americans in the United States predictably have been divided. The Euchees and Apaches of Oklahoma decided to participate in the HGDP, in part because of their interest in research on the genetics of diabetes, a major health problem of Native Americans. At the same time, in the summer of 1994 a broad coalition of consumer, indigenous, environmental and nongovernmental organizations working on development issued a statement calling on all participants "to work with parallel movements led by indigenous nations to eliminate federal funding to the Human Genome Diversity Project" (Bereano 1994). The major reason was the potential for commercialization, especially in the form of patents on human genes and proteins, without benefit to the sampled populations whose body parts would become museum specimens in an updated form. The Europeans have also shown considerable resistance to the patent fever that grips biotechnology in North America, and the European Parliament legislated that publicly

funded research should not give rise to privately held patents (Bereano 1995).

A troubling leitmotiv in the Guaymi cell-line dispute returns us to the narratives, images, and myths with which I want to conclude this meditation on the human family. In the midst of the polemics, Pat Mooney of the RAFI was quoted as saying, "When a foreign government comes into a country, takes blood without explaining the real implications to local people, and then tries to patent and profit from the cell line, that's wrong. Life should not be subject to patent monopolies" (RAFI 1994:7). The patent monopoly part is true enough, but penetration by a foreign power to take blood evokes much more than intellectual property issues. Indeed, some of the indigenous organizations critical of the HGDP called it the "vampire project" (Kahn 1994:721). I cannot help but hear Mooney's quote in the context of periodically surfacing stories in Latin America about white North Americans stealing body parts, sucking blood, and kidnapping children to be organ donors. The factual accuracy of the accounts is not the point, even though the dubious standards of evidence to which commentators have been held when the stories appear in U.S. news articles and radio talk shows appall me. What matters in this chapter is the stories themselves, that is, the ready association of technoscience with realms of the undead, tales of vampires, and transgressive traffic in the bloody tissues of life. Sampling blood is never an innocent symbolic act. The red fluid is too potent, and blood debts are too current. Stories lie in wait even for the most carefully literal-minded. Blood's translations into the sticky threads of DNA, even in the aseptic databases of cyberspace, have inherited the precious fluid's double-edged power. The genome lives in the realm of the undead in myriad ways that cannot be contained by rational intentions, explicit explanations, and literal behavior. The stories get at structures of power and fantasy that must be faced in all their displaced, uncanny truth.

Table 6.2, "Night Births and Vampire Progeny," is a rough guide through a tiny region of the mine-strewn territory. My chart is indebted to three mainline publications within technoscientific professional and popular culture. Pursuing the symptomatic logic of this chapter, my technique is resolute over-reading. I know no better strategy to deal with the vermin-infested normality of rational discourse. Just state the obvious. Say what should not have to be said.

Running several times in *Science* magazine in 1989–1990, Du Pont's wonderful advertisement for OncoMouse™, the first patented animal in the world, provides my first text [Figure 6.3. Stalking Cancer].[30] OncoMouse™ contains a cancer-causing bit of DNA, called an oncogene, derived from the genome of another creature and implanted by means of genetic engineering techniques. A model for breast cancer research, the redesigned rodent is like a machine tool in

RACE

IMAGE	OncoMouse™	Gorilla-suited bride	SimEve
SOURCE	*Science* magazine	*American Medical News*	*Time* magazine
KIN CATEGORY	species	family	race
REPRODUCTIVE PRACTICE	genetic engineering	professional investment	cybergenesis by morphing
NARRATIVES AND MYTHS	night births in the laboratory scientific enlightenment Plato's allegory of the cave heroic quest	Bad investments yield polluted offspring. Reverse alchemy turns gold into base metal. racialized heterosexuality vampire-toothed bride	masculine parthenogenesis mind children Orestian Trilogy Pygmalion and Galatea
SLOGAN	"where better things for better living come to life"	"If you've made an unholy alliance. . . "	"love that will forever remain unrequited."

the workshops for the production of knowledge. OncoMouse™ is a transgenic animal whose scene of evolution is the laboratory. Inhabiting the nature of no nature, OncoMouse™'s natural habitat is the fully artifactual space of technoscience. Symbolically and materially, OncoMouse™ is where the categories of nature and culture implode for members of technoscientific cultures. For that very reason, the mouse has been at the center of controversy since its production. Defined by a spliced genome, identified with a spliced name, patented, and trademarked, OncoMouse™ is paradigmatic of nature enterprised up. What interests me here, however, are the stories that are crusted like barnacles onto the striking advertising image.

Du Pont's white mouse is in the midst of a heroic travel or quest narrative and part of a noble hunt in which the cancer enemy is stalked. Epistemophilia, the lusty search for knowledge of origins, is everywhere. The mouse climbs out of a womblike, geometric cave toward the light of knowledge, evoking the narrative elements of the Western Enlightenment and of Plato's allegory of the cave. OncoMouse™ is "available to researchers only from Du Pont, where better things for better living come to life." Like it or not, we are catapulted into the narrative fields that contain Frankenstein and his monster and all the other alluring scenes of night births in the mythological culture of science. The laboratory repeatedly figures as an uncanny place, where entities that do not fit, do not belong, cannot be normal—that transgress previously important categories—come into being. I am drawn to the laboratory for this essential narrative of epistemological and material power. How could feminists and antiracists in this culture do without the power of the laboratory to make the normal dubious? Raking ambivalence and strong visitations from a culturally specific unconscious, however, are the price of this alliance with the creatures of technoscience. Reproduction is afoot here, with all of its power to reconfigure kinship. In the proliferating zones of the undead, the kin categories of species are undone and redone, all too often by force. Consciously or unconsciously, whoever designed this ad knew all the right stories. Enlightenment has never been more pregnant with consequences—semiological, financial, and technological—for the human family.

Family imagery is much more explicit and far more ominous in my next text, an ad for Prepaid Medical Management, Inc. (PreMed), which was published in American Medical News on August 7, 1987 [Figure 6.4. If you've made an unholy HMO alliance, perhaps we can help]. PreMed tells physicians that it can help get them out of unprofitable contracts with health maintenance organizations (HMOs) that had promised a financially sound patient base and quality care but instead delivered profits for distant shareholders and high administrative

fees for doctors. PreMed claims to have aided physicians in establishing locally controlled and fiscally sound HMOs in which doctors could determine whom

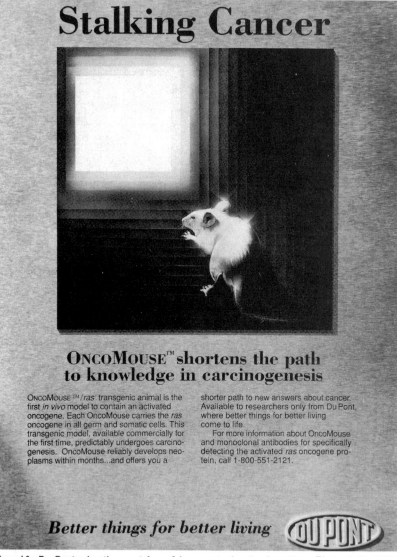

Stalking Cancer

ONCOMOUSE™ shortens the path to knowledge in carcinogenesis

OncoMouse™/*ras* transgenic animal is the first *in vivo* model to contain an activated oncogene. Each OncoMouse carries the *ras* oncogene in all germ and somatic cells. This transgenic model, available commercially for the first time, predictably undergoes carcinogenesis. OncoMouse reliably develops neoplasms within months...and offers you a

shorter path to new answers about cancer. Available to researchers only from Du Pont, where better things for better living come to life.

For more information about OncoMouse and monoclonal antibodies for specifically detecting the activated *ras* oncogene protein, call 1-800-551-2121.

Better things for better living DUPONT

Figure 6.3 Du Pont advertisement from Science magazine for OncoMouse™. April 27. 1990. Courtesy of Du Pont NEN products. on May 19, 1995 Du Pont announced its intent to divest its medical products businesses. The former Du Pont NEN products business will become NEN life science products.

they treated and how they practiced medicine. There is little question that these are pressing concerns in the context of a medicine-for-profit system, in which many patients are uninsured, underinsured, or covered by public plans that pay

If You've Made An Unholy HMO Alliance, Perhaps We Can Help.

All across the country, physicians who once had visions of a beautiful marriage to an HMO have discovered that the honeymoon is over.

Instead of quality care and a fiscally sound patient-base, they end up accepting reduced fees and increased risks. Plus a lot of new rules that make it more like administrating than practicing medicine.

And while you're doing a lot of the administration, the HMO is charging administrative fees in the neighborhood of 17% to 20%. Small wonder, these HMOs continue to reward

distant shareholders with record returns while participating physicians get nothing but grief.

Most doctors have felt there's little or no hope—that "we're trapped," with no way out. But that's not true. There are alternatives. And we're in the business of providing them.

At Prepaid Medical Management Inc., we help physicians develop their own HMOs, negotiate with hostile HMOs or leave contractual situations that have turned sour. And we've been doing it for seven years. In the process, we've helped a number of physician groups profitably leave contracts with national HMOs and establish locally controlled plans with solid fiscal track records.

If you'd like to discuss the alternatives available to your group or IPA, give PreMed President Ed Petrus a call. It's not too late to do something about an unholy alliance.

PREMED®

8400 Normandale Lake Blvd.
Suite 1180
Minneapolis, MN 55437
1-800/833-7612

Figure 6.4 Courtesy of Premed. Advertisement from American Medical News, August 7, 1987.

much less for services than private insurers. Although not referring directly to the larger context, the ad appeared in the midst of an epidemic of national publicity about high Medicare and Medicaid patient loads in urban HMOs, African American crack-addicted and AIDS-infected mothers and babies in inner cities, and astronomical malpractice insurance costs, particularly for urban obstetricians.

The PreMed verbal text makes no reference to race, gender, or class, but I think these codes structure the ad. "Accepting reduced fees and increased risks" is a code for accepting too many poor patients who do not have private insurance. The code, if not a more complicated reality, biases readers to see those high-risk, poor patients as overwhelmingly people of color, especially African American. The visual scene of a wedding and the verbal text about an unholy alliance propel the reader to see the patient as female and black and the doctor as male and white. An unholy alliance is "miscegenation," the bloodsucking monster at the heart of racist and misogynistic terror.[31]

Finally, it is the double disguise, the twice-done veiling of the bride that makes the ad so flagrantly about what it literally covers up with a joke: the class-structured, racialized, sexual politics of U.S. reproductive health and the further withdrawal of medical services from already underserved populations. A white-medical-coat-clad, stethoscope-wearing, prosperous-looking white man with just the right amount of graying hair is putting a gold wedding band on the ring finger of a black gorilla-suited bride in a white wedding gown and veil. The bride is doubly not there. Present are only two disguises: the wedding dress and gorilla suit. The implied infected or addicted pregnant Black woman who is always, in the code, on welfare, is denied in advance.[32] The surface of the ad insists that it is I, not PreMed, who is both making the connection of the gorilla-suited bride with African American women and putting the wedding scene into the context of reproductive health care. Can't I take a joke? But my power to be amused is vitiated by the searing memory of just where African American women fit historically into systems of marriage and kinship in white heterosexual patriarchy in the United States. *Miscegenation* is still a national racist synonym for infection, counterfeit issue unfit to carry the name of the father, and a spoiled future. The bitter history of the scientific and medical animalization of people of African descent, especially in the narratives of the great chain of being that associated apes and Black people, further accounts for my poor sense of humor. The gorilla suit cannot be an innocent joke here, and good intentions are no excuse. The lying disguises cannot hide what they deny.

But this bride is less a living—or a reconstructed—gorilla than an undead monster. She is not a creature in an Akeley diorama, whose natural types always glowed with health. The gorilla-suited bride is the type of no type. Her lips are

parted just enough to show the gleam of a bright white tooth. The bride is a vampire, equipped with the tool for sucking the blood of the husband and polluting his lineage. The shining tooth echoes the brilliant gold of the wedding ring. The wedding night bodes ill. The conventional trope of the scientist-husband of nature generating the legitimate, sacred fruit of true knowledge in the womb of the wife's body is engaged here with chilling modifications. A metaphor for the magical power of science, alchemy is about the generative sexual practices of the craft, which are a kind of marriage that yields gold from base metal. Alchemy is about holy alliances, true marriages with gleaming children. In the PreMed advertisement, the narrative is reversed, and an "unholy alliance" threatens to mutate the promised gold of a medical-career investment into the base metal of a nonproductive practice. "If you've made an unholy alliance, perhaps we can help." Call upon PreMed and enjoy the fruit of a productive union. Be flexible; make the required structural adjustments to stimulate the production of wealth—and its flow upward to the deserving professional classes. Leave that unnatural and unprofitable alliance with infected bodies. A healthy family life demands no less.

The PreMed ad almost seems out of its time. It shouldn't still be possible to publish such an image in a scientific medical magazine. But it is possible. The fierce resurgence of explicit racist, sexist, and class-biased discourse of many kinds all over the world, and exuberantly in the United States, give all too much permission for this merely implicit and latent joke.

My third text, by contrast, wants to be firmly on the side of the antiracist angels. All the signs of liberal multiculturalism pervade *Time* magazine's cover image for its special fall 1993 issue on immigration [Figure 6.5. The New Face of America]. These angels, however, turn out to exist in cyberspace. The *Time* cover is a morphed portrait of a being I call SimEve. In the background is a matrix of her mixed cybergenetic kin, all resulting from different "racial" crosses effected by a computer program. "Take a good look at this woman. She was created by a computer from a mix of several races. What you see is a remarkable preview of . . . The New Face of America." Indeed. We are abruptly returned to the ontology of databases and the marriage of genomics and informatics in the artificial life worlds that reconstitute what it means to be human. Here, the category so ethereally and technically reconfigured is race. In an odd computerized updating of the typological categories of the nineteenth and early twentieth centuries, the programmer who gave birth to SimEve and her many siblings generated the ideal racial synthesis, whose only possible existence is in the matrices of cyberspace. Genetic engineering is not yet up to the task, so it falls to the computer sciences alone for now. Full of new information, the First Family reconstructed by Jay

RACE

Matternes has had a transgenic change of form, to reemerge from *Time*'s computer womb as morphed ideal citizens, fit for the "Rebirthing of America." If the biotechnological genetics laboratory was the natural habitat and evolutionary scene fusing nature and culture for OncoMouse™'s version of the origin of life,

Figure 6.5 Time magazine's morphed simeve. Backed by the racial-ethnic, computer generated matrix for Time's "Rebirthing America" special issue, Fall 1993. Photograph by Ted Thai. Reprinted with permission.

SimEve's primal story takes place in the first morphing program for the personal computer, called Morph 2.0, produced by Gryphon Software Corporation.[33]

This technology has proved irresistible in the United States for 1990s mass cultural racialized kinship discourse on human unity and diversity. Never has there been a better toy for playing out sexualized racial fantasies, anxieties, and dreams. The reverie begins in cross-specific morphing, with the compelling computer-generated composite of human and chimpanzee faces on the cover of the 1992 *Cambridge Encyclopedia of Human Evolution*.[34] Like all portraits, this photograph records and shapes social identity. Soberly looking straight at the reader, the mature face is intelligent and beautiful. Like Carl Akeley's taxidermic reconstructions, this morphed face feeds a deep fantasy of touch across the ethnospecific categories of nature and culture. Unframed by any such specificity, the face seems to bring word about an original transformation in universal natural history.

On the contemporary human register, Gillette's shaving ads on television show the transformation of men's faces into each other across a racial spectrum, producing a utopic multiethnic male bonding. In the September 1994 Great American Fashion issue of the feminism-lite magazine *Mirabella*, the prominent photographer Hiro produced the computer-generated cover image from many photos of exquisitely beautiful multiracial, multiethnic women. Asked by the editors to give them a photo to represent "the diversity of America," Hiro did a simulated (and very light-skinned) woman.[35] A tiny microchip floats through space next to her gorgeous face. I read the chip as a sign of insemination, of the seminal creative power of Hiro, a modern Pygmalion/Henry Higgins creating his Galatea/Eliza Doolittle.[36] But the seminal power is not just Hiro's; it is the generative power of technology. Pygmalion himself has been morphed; he has become a computer program. Internationally, Benetton's ads, including its morphed racial transforms and its magazine *The United Colours of Benetton*, are the most famous. As Celia Lury put it, eschewing the distinction between cloth and skin, Benetton deals with the color of skin as a fashion palette (Lury 1994). Benetton produces a stunningly beautiful, young, stylish panhumanity composed by mix-and-match techniques. Diversity, like DNA, is the code of codes. Race, in Sarah Franklin's words, becomes a fashion accessory (Franklin 1994).

Pop star Michael Jackson brings this last point to its highest perfection. Spanning the range of chosen and imposed bodily "technologies" from cosmetic surgery, genetic skin disease, erotic performance in "private" and "public" life, clothing, costume, music videos—and mortal aging in spite of it all—Jackson's morphing practices have reshaped him by race, sexuality, gender, species, and generation. In the music video "Black and White," Jackson racially morphed himself by computer. In "real life," while a skin disease blanched his

skin, he altered his facial features through cosmetic surgery, which produced race, generation, and gender effects. His childlike persona and his alleged transgressive relations with young boys morphed him into a permanent, if not altogether popular or safe, Peter Pan figure. His performance in Walt Disney's Epcot Center in the 3-D, 15-minute science-fiction production of *Captain E/O* caps the picture. As Ramona Fernandez put it, Jackson "tropes his body constantly. . . . In [*Captain E/O*] Jackson is both Mickey and a postmodern Peter Pan accompanied by bodies created by Lucas. . . . His transmuting body enacts and re-enacts the multiple problematics of race, generation, and gender" (1995b:245). Analyzing Jackson's transmogrifications of himself and others through computer video technology into Cleopatra, ghoul, panther, machine, and superhero, Fernandez locates Jackson's socially significant shape-shifting within the traditions of African American tricksterism. The difference between human and machine, as well as the differences among species, are all fair game for Jackson's antiorigin narratives. As biologist Scott Gilbert writes, "If one wanted to find the intermediate morph of race, gender, and class, Michael Jackson may well be it. This makes him a science fiction 'representative' of humanity: and this is exactly how he depicts himself in *Captain E/O*."[37] This is humanity according to Epcot, where a potent trickster slipped into the monument to a clean and healthy America.[38]

Beginning unambiguously as an African American boy with striking talent, Jackson became neither black nor white, male nor female, man nor woman, old nor young, human nor animal, historical person nor mythological figure, homosexual nor heterosexual. These shape changes were effected through his art, the medical and computer technology of his culture, and the quirks of his body. Surely not even his brief marriage, least of all to Elvis Presley's daughter, could save him from the oxymoronically ineradicable stigmata of morphing. Science and fiction implode with special force in Jackson's iconic body, which is a national treasure of the first order. Jackson, however, is a much less safe representative for rebirthing the nation than the smoothly homogenized SimEve of *Time* magazine.

Not limited to specialists working for transnational corporations, weekly news magazines, official encyclopedias, or world-class entertainers, morphing is a participant reproductive sport too. In Las Vegas, in the Luxor, at the entrance to the gambling casino's reconstructed tomb of the eighteenth-dynasty Egyptian king Tutankhamen, there is a morphing machine that looks like the ordinary photomats in which one can get a quick snapshot. For five dollars a picture, one can enter the box, select the "gene machine" option, indicate whether one will be reproducing with a live partner or with a video model (human or animal),

and then make further choices to determine the race and sex of the resulting child. The morphing machine is not choosy about the biological sex of the parent material. The racial menu for the child is African American, Hispanic, Asian, and Caucasian. Only if one chooses Caucasian are there any further choices, not an unfamiliar belief, but the choices are limited to hair and eye color. Then the machine photographs the parents-to-be, digitally combines them, and shoots out a child of the desired specifications. The child comes out at various ages, from toddler to adolescent. The gene machine is just another way of playing the combinations in Las Vegas at the end of the millennium.[39]

All this is surely not the naturalized typologies of Teddy Bear Patriarchy's early-twentieth-century racial discourse. Nor, in these popular cultural examples, including *Time*'s SimEve, are we subjected to PreMed's version of racial-sexual crossing. So why do I feel so uncomfortable? Shouldn't I be happy that the patently constructed nature of racial and gender categories is so obvious? In the face of resurgent racial hatred all around, what's wrong with a little obvious ideology for butterbrickle multiculturalism? Do we always have to order rocky road? Am I just having a dyspeptic attack of political correctness inevitably brought on by indulging in the pleasures of high-technology commodification within multinational capitalism? Why shouldn't the United Nations' *Family of Man* be morphed into the New World Order's *United Colours of Benetton*? Certainly the photography has advanced, and the human family seems naturally to be the story of the progress of technology.

To address the discomfort, let us look more closely at the *Time* special issue on immigration. In the note from the managing editor on page 2, we learn that *Time* imaging specialist Kin Wah Lam created the matrix of progeny in Figure 6.5 out of photographs of seven male and seven female models, each assigned to a racial-ethnic category. The top (female) and side (male) photos were electronically "mated" to produce the cybergenetic offspring. Each figure is a pleasant-faced but undramatic nude bust, a "natural" man or woman, enhanced modestly by the understated makeup and minimal hairstyling. All the figures are young adults, and all the unions are chastely heterosexual, although presumably the computer could do a bit better than the technology of eggs and sperm on that score. In their defense, the editors' purpose was "to dramatize the impact of multiethnic marriage, which has increased dramatically in the U.S. during the latest wave of immigration." Still, the trope of reproductive heterosexual marriage is as firmly ensconced here as in the worlds of *The Fossil Footprint Makers of Laetoli* or *The Family of Man*. The mixing of immigration could be dramatized by many other practices. The sense of utter homogeneity that emanates from *Time*'s matrix of diversity is numbing. The blacks are not very black; the blonds are not

very blond; the range of skin color would require the best chromatography to distinguish one promising golden hue from another. These figures of the new humanity look like I imagine a catalog of replicants for sale off-world in *Blade Runner* might look—young, beautiful, talented, diverse, and programmed to fulfill the buyer's wishes and then self-destruct. Unlike the terrible white-supremacist scenes of *Birth of a Nation* in 1915, nothing about race and ethnicity in *Time's* "Rebirthing of a Nation" speaks about racial domination, guilt, and hatred. Nothing here is scary, so why am I trembling?

As Claudia Castañeda put it in her argument about "morphing the global U.S. family," "the racism here does not consist in the establishment of a hierarchy for domination based on biologized or even culturized racial difference. Its violence consists in the evacuation of histories of domination and resistance (and of all those events and ways of living that cannot be captured in those two terms) *through* technological (but still decidedly heterosexual) reproduction" (Castañeda 1994).[40] The denials and evasions in this liberal, antiracist, technophilic exercise are at least as thick as they are in the PreMed ad. All the bloody history caught by the ugly word *miscegenation* is missing in the sanitized term *morphing*. Multiculturalism and racial mixing in *Time* magazine are less achievements against the odds of so much pain than a recipe for being innocently raptured out of mundane into redeemed time. It is the resolute absence of history, of the fleshy body that bleeds, that scares me. It is the reconfirmation of the Sacred Image of the Same, once again under the sign of difference, that threatens national rebirth. I want something much messier, more dangerous, thicker, and more satisfying from the hope for multiculturalism. To get that kind of national reproductive health delivery is going to take addressing past and present sexualized racial power, privilege, exclusion, and exploitation. I suspect the nation will have to swallow the castor oil of sober accountability about such racialized sex before morphing looks like much fun to most of its citizens.[41]

Alongside a photo of the imaging specialist, labeled with a classically orientalist caption, "Lam creates a mysterious image," *Time's* managing editor tells us still more about the cybergenesis of the woman on the cover: "A combination of the racial and ethnic features of the women used to produce the chart, she is: 15% Anglo-Saxon, 17.5% Middle Eastern, 17.5% African, 7.5% Asian, 35% Southern European and 7.5% Hispanic. Little did we know what we had wrought. As onlookers watched the image of our new Eve begin to appear on the computer screen, several staff members fell in love. Said one: 'It really breaks my heart that she doesn't exist.' We sympathize with our own lovelorn colleagues, but even technology has its limits. This is a love that must forever remain unrequited."

Themes running throughout the essay implode in this unlikely black hole.

Early-century racialized ethnic categories reappear as entries in an electronic database for a truly odd statistical population analysis. A virtual woman is the result, fathered like Galatea, Pygmalion's creature, with which he fell in love. The curious erotics of single-parent, masculine, technophilic reproduction cannot be missed. SimEve is like Zeus's Athena, child only of the seminal mind—of man and of a computer program. The law of the nation, like that laid down by Athena for Athens in the Orestian trilogy, will be the Law of the Father. The Furies in cyberspace will not be pleased. In the narrative of romantic love, SimEve forever excites a desire that cannot be fulfilled. This is precisely the myth infusing dreams of technological transcendence of the body. In these odd, but conventional, technoscientific erotics, the actual limits of technology only spur the desire to love that which cannot and does not exist. SimEve is the new universal human, mother of the new race, figure of the nation; and she is a computer-generated composite, like the human genome itself. She is the second- and third-order offspring of the ramifying code of codes. She ensures the difference of no difference in the human family.

PostScript™

Throughout this chapter, racial discourse has persistently pivoted on sexual hygiene, and the therapeutic scene has been the theater of nature in the city of science. I am sick to death of bonding through kinship and "the family," and I long for models of solidarity and human unity and difference rooted in friendship, work, partially shared purposes, intractable collective pain, inescapable mortality, and persistent hope. It is time to theorize an "unfamiliar" unconscious, a different primal scene, where everything does not stem from the dramas of identity and reproduction. Ties through blood—including blood recast in the coin of genes and information—have been bloody enough already. I believe that there will be no racial or sexual peace, no livable nature, until we learn to produce humanity through something more and less than kinship. I think I am on the side of the vampires, or at least some of them. But, then, since when does one get to choose which vampire will trouble one's dreams?

FACTS, WITNESSES, AND CONSEQUENCES

I have tried to persuade my readers that several apparently counterintuitive claims should have the status of matters of fact—that is, crucial points of contingent stability for possible sociotechnical orders, attested by collective, networked, situated practices of witnessing. Witnessing is seeing; attesting; standing publicly accountable for, and psychically vulnerable to, one's visions and representations. Witnessing is a collective, limited practice that depends on the constructed and never finished credibility of those who do it, all of whom are mortal, fallible, and fraught with the consequences of unconscious and disowned desires and fears. A child of Robert Boyle's Royal Society of the English Restoration and of the experimental way of life, I remain attached to the figure of the modest witness. I still inhabit the stories of scientific revolution as earthshaking mutations in the apparatuses of production of what may count as knowledge. A child of antiracist, feminist, multicultural, and radical science movements, I want a mutated modest witness to live in worlds of technoscience, to yearn for knowledge, freedom, and justice in the world of consequential facts. I have tried to queer the self-evidence of witnessing, of experience, of the conventionally upheld and invested perceptions of clear distinctions between subject and object, especially the self-evidence of the distinction between living and dead, machine and organisms, human and nonhuman, self and other as well as of the distinction between feminist and mainstream, progressive and oppressive, local and global.

Queering all or any of these distinctions depends, paradigmatically, on undoing the founding border trace of modern science—that between the technical and the political. The point is to make situated knowledges possible in order to be able to make consequential claims about the world and on each other. Such claims are rooted in a finally amodern, reinvented desire for justice and democratically crafted and lived well-being. It is important to remember that these were also, often, the dreams of the players in the first Scientific

Revolution, that first time machine of modernity, as they sought to avert the terrors of civil war, absolutist religion, and arbitrary monarchs. Perhaps ironically, meeting the criterion of heightened, strong objectivity, rather than wallowing in the soft and flaccid swamps of ordinary technoscientific objectivity, depends on undoing the tricks of modernity's Wizard of Oz's masterpiece, called the air-pump. The air-pump is the synecdochic and originary figure in my story for the whole apparatus of production of what may count as reliable knowledge in technoscience.

I want to call the problematic but compelling world of antiracist feminist multicultural studies of technoscience "cat's cradle." Making string figures on fingers is cat's cradle (Westerveld 1979). Relying on relays from many hands and fingers, I try to make suggestive figures with the varying threads of science studies, antiracist feminist theory, and cultural studies. Cat's cradle is a game for nominalists like me who cannot *not* desire what we cannot possibly have. As soon as possession enters the game, the string figures freeze into a lying pattern. Cat's cradle is about patterns and knots; the game takes great skill and can result in some serious surprises. One person can build up a large repertoire of string figures on a single pair of hands, but the cat's cradle figures can be passed back and forth on the hands of several players, who add new moves in the building of complex patterns. Cat's cradle invites a sense of collective work, of one person not being able to make all the patterns alone. One does not "win" at cat's cradle; the goal is more interesting and more open-ended than that. It is not always possible to repeat interesting patterns, and figuring out what happened to result in intriguing patterns is an embodied analytical skill. The game is played around the world and can have considerable cultural significance. Cat's cradle is both local and global, distributed and knotted together (Haraway 1994a).

The mutated modest witness who plays cat's cradle games—rather than joining the strategic, agonistic contest of matching feats of strength and amassing allies, measured by strength and numbers, reputed to constitute ordinary science in action—cannot afford self-invisibility. And reflexivity is not enough to produce self-visibility. Strong objectivity and agential realism demand a practice of diffraction, not just reflection. Diffraction is the production of difference patterns in the world, not just of the same reflected—displaced—elsewhere. The modest witness in the cat's cradle game cannot breathe any longer in the culture of no culture.

Let me summarize a few of the terms circulating in the net of the virtual community of feminist science studies, where retooled modest witnesses surf: strong objectivity (Harding 1992); agential realism (Barad 1995a and 1995b); modest interventions (Heath forthcoming); boundary objects, borderlands,

communities of practice, articulation work, misplaced concretism, and feminist method (Star 1994); cyborgs and situated knowledges (Haraway 1991); border crossings and narrative strategies (Traweek 1992); science as social knowledge (Longino 1990). If any one thing pervades this heterogenous list, it is a commitment to avoiding what Whitehead called "the fallacy of misplaced concreteness" (1948:52), where simple location and a metaphysics of substantives with primary and secondary qualities—those fruitful but extreme abstractions that were critical to seventeenth-century innovations later narrated as the Scientific Revolution—get mistaken as reality. Attention to the agencies and knowledges crafted from the vantage point of nonstandard positions (positions that don't fit but within which one must live), including the heterogeneous locations of women, and questions about for whom and for what the semiotic-material apparatuses of scientific knowledge production get built and sustained are at the heart of feminist science studies. Interrogating critical silences, excavating the reasons questions cannot make headway and seem ridiculous, getting at the denied and disavowed in the heart of what seems neutral and rational: These notions are all fundamental to feminist approaches to technoscience (Keller 1992a:7392). I think what binds the lumpy community of modest witnesses called feminist science studies together is what bell hooks (1990) called "yearning." Yearning in technoscience is for knowledge projects as freedom projects— in a polyglot, relentlessly troping, but practical and material way—coupled with a searing sense that all is not well with women, as well as billions of nonwomen, who remain incommensurable in the warped coordinate systems of the New World Order, Inc.

Committed to cyborg articulations, I have tried to undermine the notion of *self*-evidence entirely by insisting, along with most other critical intellectuals and practitioners of science studies, that the shapes the world takes are conventional and revisable, if also eminently solid and full of consequences for unequally distributed chances of life and death. Valid witness depends not only on modesty but also on nurturing and acknowledging alliances with a lively array of others, who are like and unlike, human and not, inside and outside what have been the defended boundaries of hegemonic selves and powerful places. I am thinking, centrally, of selves such as scientists and places such as laboratories. By the end of the Second Millennium, it is past time to queer them permanently, to revise them generically, to color them back into visibility. The empty spaces of both the "culture of no culture" of self-invisible technoscientists and the "nature of no nature" of the chimerical entities emerging from the world-constructed-as-laboratory must be remapped and reinhabited by new practices of witnessing. With the evident implosion of nature and culture for those who

held the distinction sacred, the task of staking out common space is inescapable. What will count as modesty now is a good part of what is at issue. Whose agencies will revised forms of "modest witness" enhance, and whose will it displace? The kind of modest witness that attests the natural kinship of the fully artifactual FemaleMan© and OncoMouse™ is the kind that insists on an actor-network theory that traces the stakes, alliances, and action of a much-enhanced array of constituents and producers of what may count as fact. It is a kind of modest witness that insists on its situatedness, where location is itself always a complex construction as well as inheritance, and that casts its lot with the projects and needs of those who could not or would not inhabit the subject positions of the self-invisible and the discursive sites, the "laboratories," of the credible, civil man of science. *Modest_Witness@Second_Millennium* needs a new experimental way of life to fulfill the millennarian hope that life will survive on this planet.

Entities such as the fetus, chip, gene, bomb, brain, race, ecosystem, seed, and database are partly like Robert Boyle's air-pump: They are material technologies through which many must pass and in which many visible and invisible actors and agencies cohere. The air-pump was a device for establishing matters of fact, an instrument in a new way of life, called "experimental," based on the laboratory as a theater of persuasion. The air-pump was part of the armament enforcing the partition of the world into subjects and objects. Thus, my hypertext nodes and links or totipotent stem cells are also very unlike the air-pump because they are all part of a material technology for tearing down the Berlin Wall between the world of objects and the world of subjects, and the world of the political and the technical. They all attest, witness, to the implosion of nature and culture in the embodied entities of the world and their explosion into contestations for possible, maybe even livable, worlds in globalized technoscience.

To play with the hypertext made up of entities such as the gene, fetus, race, seed, and database, one must enter the Net from many sites. One must risk following the links among stem cells through indeterminate numbers of dimensions, perceiving and allying with agencies and actors too often excluded by scholars of technoscience. One must understand that the reality effect of "virtual reality" is no less and no more "real" than that made available—and enforced—by the material, literary, and social conventions of the first scientific revolutions and renaissances that make up the stories about European-derived apparatuses for the production of matters of fact and states of self-evidence. If the endeavors of antiracist feminist studies, cultural studies, and science studies are really to lose their status as preformed and mutually repellent categories, joined, if at all, by an exhausting series of coordinating conjunctions and defensive addenda and apologies, then entering the Net is going to require a radically reformed prac-

tice for finding our addresses and sending our messages into the ether. A livable worldwide web should be the mutated modest witness's game of cat's cradle, where the end of the millennium becomes a trope for swerving away from the brands that mark us all in the too persuasive stories of the New World Order, Inc. This is the cat's cradle game that the FemaleMan© and OncoMouse™ need to learn to play.

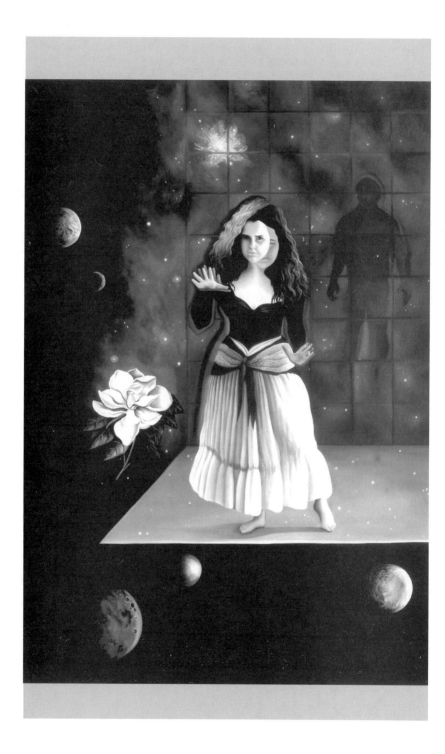

A Diffraction. Lynn Randolph, oil on canvas, 58" x 46", 1992.

Diffraction patterns record the history of interaction, interference, reinforce-
ment, difference. Diffraction is about heterogeneous history, not about origi-
nals. Unlike reflections, diffractions do not displace the same elsewhere, in
more or less distorted form, thereby giving rise to industries of metaphysics.
Rather, diffraction can be a metaphor for another kind of critical conscious-
ness at the end of this rather painful Christian millennium, one committed to
making a difference and not to repeating the Sacred Image of Same.
Diffraction is askew of Christian narrative and Platonist optics, in their sacred
secular technoscientific story cycles as well as their more orthodox manifes-
tations. Diffraction is a narrative, graphic, psychological, spiritual, and politi-
cal technology for making consequential meanings.

About this painting for the Ilusas series, Randolph writes:

> The screened memory of a powerful male figure in every
> woman's life marks a place where change occurs. The shifts that
> occur with age and psychic transformations, the multiple selves
> incorporated in one body, are embodied in the central figure with
> its two heads, extra fingers, and metaphysical space in between.
> Diffraction occurs at a place at the edge of the future, before the
> abyss of the unknown. The structural pattern of the matter in a
> galaxy may be repeated in a magnolia blossom, a vision perhaps
> peculiar to painters from Texas. I'm trying to create bodies that
> matter. Perhaps by placing women's reality into a SF world, a
> place composed of interference patterns, contemporary women
> might emerge as something other than the sacred image of the
> same, something inappropriate, deluded, unfitting, and magical—
> something that might make a difference. I believe that we need to
> be the active about this, not removed; . . . real (not natural) and
> soiled by the messiness of life. (1993:9)

NOTES

Part I.Syntactics: The Grammar of Feminism and Technoscience

1 To stress the Church's control of the power to enforce such names, I use the accusatory terms of the Inquisition for dissenters, Muslims, and Jews. Nili included the "infidels" in her category of heretics, but her Palestinian sisters would remind her that it is worthwhile to be more explicit when identifying the peoples of the book and their oppositional literacies.

2 Fernandez (1991 and 1995a) discusses the mixed cultural literacies necessary to navigating the material-semiotic webs of the contemporary United States. She inhabits a series of trickster figures to trouble conventional passages through literatures; museums; encyclopedias; dictionaries; theme parks; and multicultural canon, literacy, and pedagogy wars. Sandoval (1991 and forthcoming) theorizes oppositional and differential consciousness, rooted in the reading and writing practices of U.S. Third World women of color but able to be learned broadly. That kind of nonreductive, noninnocent, achieved political-semiotic sensibility—indebted to and articulated with those who learned to see and operate in the world in critical new ways—is central to feminist standpoint theories, including those in science studies.

3 ARPA is the acronym for (Defense) Advanced Research Projects Administration, later amended to DARPA.

4 The marvelous blend of hype, sober analysis, and policy development joining the rebirth of the nation to the new world information order is everywhere; for example, see the National Information Infrastructure: Agenda for Action (Information Infrastructure Task Force 1993). For the more suspicious, MicroAssociates, Box 5369, Arlington, VA 22205, keeps a power structure research database on disks. No Modest_Witness@Second_Millennium should be without those disks.

5 Marilyn Strathern inquires into the ways culture is "enterprised-up" in the enhancements of advertising, in particular, but also in the "enterprise culture" of the New World Order descended from Thatcher, Reagan, Bush, and their potent kin, more generally. "Marketed products are quality-enhanced." She sees such enhancement as peculiar to a world where "the natural, innate

property and the artificial, cultural enhancement become one.... This is not a new essentialism but a collapse of the difference between the essential and the superadded" (Strathern 1992:38–39). My interest in the zones of implosion of nature and culture is kin to Strathern's.

6 I am in conversation with Braidotti (1994) in this discussion.

7 Or, as Claudia Castañeda (in progress) put it, the child is the chronotope that organizes developmental time.

8 I owe "life itself" to Sarah Franklin (1993b).

9 The Maxis computer game *SimEarth* is one practical training exercise for learning to inhabit the systematically globalized "whole earth." Seldom has subject constitution been so literal, visible, and explicit. The game's promotional material on the box urges *SimEarth* players to "take charge of an entire planet from its birth to its death—10 billion years later. Guide life from its inception as single-celled microbes to a civilization that can reach for the stars." Players can "promote life, create and destroy continents, terraform hostile worlds." Finally, players are urged to "guide your intelligent species through trials of war, pollution, famine, disease, global warming, and the greenhouse effect." Nothing in *SimEarth* is abstract; the subjects and objects are materialized in located, particular practices. It is as if the chapter "Centers of Calculation" in Bruno Latour's (1987) *Science in Action* had been outlined by the software writers at Maxis: "View the entire world as either a flat projection or a spinning globe.... Close up views, for inspecting and modifying planets, display climate, life, and data layers."

10 Meanwhile, the Wells Fargo Bank is the biggest institutional shareholder of General Electric, which owns NBC. Notions of totalization come so naturally. Mixed and differential literacies for interpreting "global culture," and recognizing worlds outside the Net, must be deliberately cultivated.

Part II. Semantics:
Modest_Witness@Second_Millennium.FemaleMan©_Meets_OncoMouse™

1 *General Hospital* and *Dallas* were popular soap operas in the 1980s and 1990s.

2 Inspired by Benjamin's *flâneur*, Ramona Fernandez (1991:1995a) explored the materialized narrative technology of Disney World by traveling through its sites in the persona of a family of figures—the *curandera*, cyborg, mestiza, and *pachuco*, who together forged a potent trickster literacy that helped me write my book.

Chapter 1. Modest_Witness@Second_Millennium
Modest Witness

1 Commerce is a variant of conversation, communication, intercourse, passage. As any good economist will tell you, commerce is a procreative act.

2 Traweek was studying the legitimate sons of Robert Boyle; her physicists' detector

devices are the mechanical descendants of his air-pump as well. Humans and nonhumans have progeny in the odd all-masculine reproductive practices of technoscience. "I have presented an account of how high energy physicists construct their world and represent it to themselves as free of their own agency, a description, as thick as I could make it, of an extreme culture of objectivity: a culture of no culture, which longs passionately for a world without loose ends, without temperament, gender, nationalism, or other sources of disorder—for a world outside human space and time" (Traweek 1988:162).

3 Of course, what counts as a warrant for disinterestedness, or lack of bias, changes historically. Shapin (1994:409–17) stresses the difference between the face-to-face, gentlemanly standards for assessing truth telling in seventeenth-century England and the anonymous, institutionally and professionally warranted practices of science in the twentieth century. Inside concrete laboratories, however, Shapin suggests that members of the community based on face-to-face interactions continue to assess credibility in ways Robert Boyle would have understood. Part of the problem scientists face today is legitimation of their criteria in the eyes of "outsiders." One of my goals in this book is to trouble what counts as insiders and outsiders in setting standards of credibility and objectivity. "Disinterested" cannot be allowed to mean "dislocated"; i.e., unaccountable for, or unconscious of, complex layers of one's personal collective historical situatedness in the apparatuses for the production of knowledge. Nor can "politically committed" be allowed to mean "biased." It is a delicate distinction, but one fundamental to hopes for democratic and credible science. Etzkowitz and Webster (1995) discuss how the "norms of science," and so of what counts as objective, have changed during the twentieth century in the United States. For example, in molecular biology university-based investigators formerly doing tax- and foundation-supported "pure science," which semiotically warranted their credibility and disinterestedness, as the grants economy eroded became much more closely tied to corporations, where intellectual property and science implode. Perhaps some of the anxiety about objectivity in the "science wars"—in which science studies scholars, feminist theorists, and the like are seen as threatening broad-based belief in scientific credibility and objectivity through their irresponsible "perspectivalism" and "relativism"—should really be traced to transformed standards of disinterestedness among scientists themselves. See especially the attacks by Gross and Levitt (1994).

4 Shapin (1994) writes almost exclusively about the social technology for warranting credibility. He analyzes the transfer of the code of gentlemanly honor, based on the *independence* of the gentleman, that man of means who owes no one anything but the truth, from established social regions to a new set of practices—experimental science. The most original contribution of Shapin and Schaffer (1985) is their analysis of the weave of all three technologies, and especially of the heart of the experimental life form—the sociotechnical apparatus that built and sustained the air-pump, which I take to be

metonymic for the technoscientific instrument in general.

5 Potter forthcoming. In writing this chapter, I worked from an earlier manuscript version of Potter's paper in which she discussed the *hic mulier/haec vir* controversy from the 1570s through 1620 in the context of gender anxieties evident in English Renaissance writers, and extending to Boyle and other post-Restoration authors. Potter relied on Woodbridge 1984.

6 On that topic, see Schiebinger 1989 and Laqueur 1990. "Biological" sexual difference is my own anachronistic adjective in this sentence.

7 See Merchant and Easlea 1980.

8 See the series of essays and counteressays that begins with Collins and Yearley's (1992:301–26) "Epistemological Chicken." Bruno Latour, Steve Woolgar, and Michel Callon were the other combatants, some better humored than others. The stakes were what got to count as the really real.

9 Hendricks 1996 and 1994. *A Midsummer Night's Dream* was composed about 1600.

10 Exploring how "race" was constructed in early modern England, Boose (1994) cautions against hearing twentieth-century meanings of color in sixteenth- and seventeenth-century writing. Boose argues that the almost unrepresentable narrative of love and sexual union between a dark African woman and an English man, tied to European patriarchal questions about lineage and the fidelity of transmission of the image of the father, was an important node in the production of modern race discourse. Inflected also by discourse on Jews and on the Irish, English constitutions of race were changing across the seventeenth century, not unlinked to the fact that by midcentury, "England would be competing with the Dutch for the dubious distinction of being the world's largest slave trader" (1994:40). These issues are vastly understudied in accounting for the shapes taken by early modern science.

11 The ambiguities and tensions between the two chief aristocratic and gentlemanly qualities, civility and heroic virtue, should be examined in the context of the experimental way of life in this period. Shapin (1994) assembles compelling evidence about the nature and importance of civility for establishing truth-telling.

12 Because the published page numbers will differ, I omit page references to both Potter's manuscript and forthcoming paper.

13 Schiebinger 1989:25–26; Noble 1992:230–31; Potter forthcoming.

14 See Rose 1994:115–35 for the story of women in England's Royal Society.

15 "From this perspective the proper subject of gender and science thus becomes the analysis of the web of forces that supports the historic conjunction of science and masculinity, and the equally historic disjunction between science and femininity. It is, in a word, the conjoint making of 'men,' 'women,' and 'science'" (Keller 1990:74). If "gender" here means "kind," and thus includes *constitutively* the complex lineages of racial, sexual, class, and national formations in the production of differentiated men, women, and science, I could not agree more.

16 Recall the trope of the eye of God in Linnaeus's vision of the second Adam as the authorized namer of the new plants and animals revealed by eighteenth-cen-

tury explorations. Nature can be seen and warranted; it is not the witness to itself. This narrative epistemological point is part of the apparatus for the repeated placing of "white" women and people of "color" in nature. Only as objects can they enter science; their only subjectivity in science is called bias and special interest unless they become honorary honorable men. This is an ethnospecific story of representation, requiring surrogacy and ventriloquism as part of its technology. The self-acting agent who is the modest witness is also "agent" in another sense—as the delegate for the thing represented, as its spokesperson and representative. Agency, optics, and recording technologies are old bedfellows.

17 Merchant 1980; Easlea 1980; Keller 1985; Jordanova 1989; Noble 1992; Schiebinger 1989.

18 The veil is the chief epistemological element in Orientalist systems of representation, including much of technoscience. The point of the veil is to promise that something is behind it. The veil guarantees the worth of the quest more than what is found. The metaphoric system of discovery that is so crucial to the discourse about science depends on there being things hidden to be discovered. How can one have breakthroughs if there is no resistance, no trial of the hero's resolve and virtue? The explorer is a hero, another aspect of epistemological manly valor in technoscience narratives. See Yeganogolou 1993. Feminist narratologists have spent a lot of time on these issues. Science studies scholars should spend a little more time with feminist and postcolonial narratology and film theory.

19 Remember that the author is a fiction, a position, and an ascribed function. And writing is dynamic; positions change. There are other Latours, in and out of print, who offer a much richer tropic tool kit than that in *Science in Action*. In particular, in writing and speaking in the mid-1990s, Latour, as well as Woolgar and several other scholars, evidence serious, nondefensive interest in feminist science studies, including the criticism of their own rhetorical and research strategies in the 1980s. I focus on *Science in Action* in this chapter because that book was taken up so widely in science studies. But see Woolgar 1994; CRICT 1995; Latour 1996.

Chapter 2. FemaleMan©_Meets_OncoMouse™
Mice into Wormholes: A Technoscience Fugue in Two Parts

1 Bruno Latour (1987, chapter 4) is responsible for the common adoption of the word *technoscience* in science studies. Latour argued that the "inside" of that powerful and world-changing site called the laboratory constitutes itself by extending its reach "outside" through the mobilization and reconfiguration of resources of all kinds. He stressed that academic scientists were a very small part of the "armies of people who do science" (173). In *Science in Action*, the warlike, combative nature of technoscience seemed to be more than metaphorical for Latour; he concentrated on enrolling, enlisting, mobilizing,

and aligning from the point of view of the powerful center. Latour mobilized "technoscience" to attack the distinction between what counts as "science" and as "society.""I will use the word 'technoscience' from now on to describe all the elements tied to the scientific contents no matter how dirty, unexpected or foreign they seem" (1974). "The question for us who shadow scientists is not to *decide* which one of these links is 'social' and which one is 'scientific' ... [;] we should be as undecided as the various actors we follow as to what technoscience is made of" (176). Shaped by feminist and left science studies, my own usage works both with and against Latour's. In Susan Leigh Star's terms, I believe it less epistemologically, politically, and emotionally powerful to see that there are startling hybrids of the human and nonhuman in technoscience—although I admit to no small amount of fascination—than to ask for whom and how these hybrids work (Star 1991; Suchman 1994; Harding 1992; Haraway 1988; 1994b; Winner 1986). Paul Rabinow roots the meaning of technoscience in Heidegger's formulation (conference discussion, School of American Research, Santa Fe, October 1993). For Heidegger (1977), technicity, which is paradigmatic of violation and deadliness, designated the turning of all the world into resource, into fund. Technoscience, in that sense, empties—resources—everything. I do not want to lose those tones entirely, but I want to complicate them and put them into contradiction with the lively, unfixed, and unfixing practices of technoscience. Because I think that the surprises just might be good ones and that the established disorder without the hope of surprises can take away our ability to stay epistemologically, emotionally, and politically alive, I am more interested in the unexpected than in the always deadly predictable. I believe this attitude also characterizes Latour's writing in spite of its sometimes monomaniacal focus on mobilization.

2 Human mental patients were also part of psychiatric research on neural-chemical implants and telemetric monitoring at Rockland in the 1960s, a fact I learned when I was researching the crafting of nonhuman primates as model systems for human ills in the United States (Haraway 1989:109). Kline was associated with the Psychiatric Research Foundation in New York, an organization established to promote controversial investigations into psycho-pharmacology. Nancy Campbell's (1995) dissertation on the history of U.S. drug and addiction discourses details the dovetailing of such research in the 1950s and 1960s with Cold War agendas, including Central Intelligence Agency (CIA)-sponsored research on behavior control. The liberal philanthropic foundations, especially the Macy Foundation, which was so important to the configuration of cybernetics as an interdisciplinary field in the late 1940s and early 1950s, were liberally involved. Geoffrey Bowker (1993) analyzes the myriad routes through which technical and popular culture was shooting up with all things cybernetic in the 1950s and '60s in the United States. Marge Piercy used research at Rockland State Hospital as background for the brain-implant experiments practiced on psychiatric patients in her feminist science fiction story *Woman on the Edge of Time* (1976). Influenced by Piercy, I used the

cyborg as a blasphemous antiracist feminist figure useful for science studies analyses and feminist theory alike (Haraway 1985). Piercy developed her thinking about the cyborg as lover, friend, object, subject, weapon, and golem in *He, She, and It* (1991). Her cyborgs and mine exceeded their origins, defied their founding identities as weapons and self-acting control devices, and so troubled U.S. cultural commitments to what counts as agency and self-determination for people, much less machines. For an analytical catalog of real-life military cyborgs, see Chris Gray 1991. Gray first called my attention to the Clynes and Kline paper. On machines and subjectivity in closed cyborg worlds, see Paul Edwards 1996. For a more open view of a many-sided cybernetic world, see Ronald Eglash's (1992) analysis of U.S. popular and technical workings since the 1960s of self-organizing systems, fractals, recursive information patterns, analogue representation, and nonlinear dynamic systems.

3 Odo, the shape-shifter security chief on the Federation space station, *Deep Space Nine*, in one episode even morphed himself into the shape of a rat, all the better to get perspective on the dubious traffic at the entrance to a wormhole. *Deep Space Nine* is ideal for the reduced expectations of technophilic U.S.ers in the 1990s; I certainly cannot recall any rats on the starships *Enterprise* in the earlier generations of the *Star Trek* myth. Inevitably, Odo is also the name for a breast cancer candidate gene in a major molecular biology research laboratory (Deborah Heath, personal communication).

4 In 1993, 59 percent of the total federal research and development budget still went directly for defense, including nuclear weapons, down from 67 percent in the peak year of 1987 (NSB 1993:xviii).

5 The superscript 239 designates the atomic weight of fissionable, that is, explosive, plutonium, Pu^{239}. Fissionable uranium has an atomic weight of 235; 99 percent of naturally occurring elemental uranium has an atomic weight of 238. Breeder reactors use small amounts of U235 to produce Pu^{239} from the abundant U^{238} in the reactor mix.

6 Because of the decay of radioactive uranium in ore deposits, extremely small amounts of plutonium and neptunium are formed spontaneously outside the laboratory, a process that was described after the deliberate human production of plutonium. In a sense, the natural process mimed the artifactual one, a reversal we will meet again with transgenic organisms.

7 For these figures, I draw from Kuletz's (1996) analytically compelling and moving account of the nuclear landscape in the U.S. Southwest. Kuletz draws overlapping maps of "science cities in the desert," nuclear waste areas, testing areas ("outdoor laboratories"), uranium mining sites, military installations, and contemporary Native American lands and homes. She also layers complex tissues of testimony and perspectives from indigenous peoples, scientists, and others who inhabit the nuclear landscape. Inhabited by the densest concentrations and diversity of living indigenous peoples in the United States, this landscape is both intensely local and intricately global. The human family is bound tightly by these realities in a forced union of epic proportions.

8 Other measures of technoscientific hegemony of the developed countries come

from considering current journal holdings in libraries; the proportion of world research funded by the industrial countries (95 percent in 1990); percent of articles authored by third world scientists in those journals that are used to construct the key databases; and numbers of third world institutions that can provide their researchers with the Internet access and CD-ROM drives that are so crucial to current methods of scientific communication. In a recent survey of 31 libraries in 13 African countries, not one was found to have a viable serials collection; expense is simply prohibitive. The structural adjustments required in the late 1980s forced the previously fine scientific library at Addis Abba University to cancel 90 percent of its subscriptions. Authors from developing countries accounted for 0.3 percent of articles in *Science* and 0.7 percent in *Nature* in 1994. Medical literature was a bit better— 2.7 percent for *The Lancet*. Partly as a result of the information-poor basis for research, without a Western coauthor a third world scientist has a very poor chance of getting an article accepted for publication in a journal read by the international scientific community. Third world periodicals are rarely included in the chief databases; for example, in 1993 the Science Citation Index cataloged 3,300 journals, of which 50 were published in the less developed nations. Thus, scientists from developed countries are systematically ignorant of actual research and perspectives from the less developed world, including in vital areas like ecology, forestry, and agriculture. This note is a synopsis of Gibbs 1995.

9 Focusing on U.S. agricultural science and biodiversity politics, Glen Bugos (1992; 1994) explores in exquisite detail and analytical rigor the historical periodization and the dynamic division of labor that characterize the interplay among changing industrial structure, intellectual property conventions, and the methods and results of technoscience research in the movement from natural genetic diversity to finished commodity in the food and pharmaceutical domains of capital accumulation. Narrating how germplasm becomes database, where the question of who owns biodiversity gets worked out in material detail, Bugos's story puts biotechnology, especially genetic engineering, into rich perspective.

10 Thanks to Deborah Heath, who is engaged in the ethnography of molecular biological laboratories. See also Beardsley 1994:94.

11 Jeremy Rifkin (1984a; 1984b) and his Foundation for Economic Trends and Michael Fox (1983; 1992) have been especially outspoken about purity of type and natural integrity. See also Krimsky 1991:50–57 and OTA 1989:98–102, 127–38. Rifkin leads the opposition to Calgene's Flavr Savr tomato and Monsanto's genetically engineered bovine growth hormone under the banner of the Pure Food Campaign. Pure food is a curious concept to invoke for the tomato, a member of the deadly nightshade family. An American fruit by origin, the tomato was imported into Europe in the sixteenth century but was regarded there as toxic and grown as an ornamental item until the eighteenth century. Well before genetically engineered fruits joined the fray, the tomato has been at the center of struggles over immigra-

tion, science, food, and labor in California's agribusiness fields, state research institutions, grocery stores, and kitchens (Hightower 1973). On biotechnology and world agriculture, see Hobbelink 1991, Shiva 1993, and Juma 1989.

12 Press release, June 6, 1995, "Broad Coalition Challenges Patents on Life," contact person, Philip Bereano, University of Washington. The press release covered meetings in the Adirondack Mountains to plan oppositional strategies. The group issued a position statement called the "Blue Mountain Declaration." Working with indigenous organizations to eliminate funding for the Human Genome Diversity Project emerged at the meeting as a major priority. The coalition's statement did not evoke arguments about purity of natural kinds, but the sanctity of life and opposition to manipulation of the natural world remained important ideological resources. I recognize, and often share, the power and importance of those commitments and languages, but I wish my fellow travelers seemed more nervous and less self-certain in their presence. The historical pedigree, for both "indigenous" and "Western" speakers, of those languages, ideologies, and associated actions hardly gives cause for unruffled calm. I think progressive politics have to be rooted in more fraught, unsettled, dirty, hybrid languages and expressions of belief, hope, and action.

13 I owe the particular inflection on "life itself," the splicing of an ever ungraspable fire, "life," with the essence of the object world, "itself," to Sarah Franklin's (1993b) distillation of Foucault's notion of biopower.

14 Pickering 1992. How various scholars and activists describe practice and culture is another matter, which generates important arguments about agency, accountability, representational practice, ethics, politics, the furniture of the world, and much else.

15 For views of the many sites of action in technoscience, see Rouse 1993, Hess and Layne 1992, Martin 1994, Escobar 1994, and Clarke and Montini 1993.

16 Thanks to John Law for pointing out the absence of computers in this advertisement.

17 The most dyspeptic recent complaint, by a marine scientist and a mathematician, about the disorderly crowd of meddlers in scientific authority—including feminists, environmentalisms, multiculturalists, science studies scholars, postmodernists, and other "leftists"—is Gross and Levitt 1994. Would that the "left" were really so unified! *Higher Superstition's* publication by a major university press and the book's outrage at the modest institutional base of authority and prestige obtained by what the authors call "the left" locate this publication in the middle of contestations over the material foundations of science, culture, knowledge, and democracy. For a cogent critical review, see Berger 1994.

18 Pickering and Stephanides (1992) examine conceptual practice in mathematics, specifically Hamilton's nineteenth-century work in complex-number algebra and geometry.

19 Brian Smith (1994), in discussion following his paper.

20 Morrow et al. 1974. See Wright 1986 for an excellent history of recombinant DNA technology in commercial, political, academic, news media, and scientific contexts.

21 Latour (1993) claims that *We Have Never Been Modern,* a point with which I largely concur.

22 Pioneering a key institutional form linking basic research and commercial development that grew up with recombinant DNA technology, Cetus was founded by two MBAs, one a biochemist-molecular biologist and one a physician, "to tap the practical potential of molecular biology" (Wright 1986:308).

23 As a dimension of feminist method and science studies, the important question of the membership of objects in communities of practice that web together historically situated humans, nonhumans (natural and artifactual), and actions is richly taken up by Star (1994). See also Downey et al. 1994; Latour 1987; Callon 1986; Haraway 1985; 1992a. A materialist, antireductionist, nonfunctionalist, nonanthropomorphic, and semiotically complex sense of the dynamism of nonhumans in knowledge-making and world-building encounters animates critical theory in biology (Margulis and Sagan 1995), information and computer sciences, cultural studies, and much else. Collins and Yearley (1992) object to Callon's and Latour's treating all actants in science-making in the same manner. In her social-network approach, Oudshoorn (1994) develops cogent feminist science studies resistance to an overly exuberant sense of the agency of things. David Hess (discussion notes, School of American Research, conference on Cyborg Anthropology, October 1993) cautions that "granting membership" to things can be a fancy phrase for the reification and fetishization of commodities. Things have always been luminous sources of fascination in capitalism. Hess points out that legally corporations have the status of persons, and such "membership" is crucial to the reproduction of capitalist relations, in which extracting liveliness from people and embedding it in things and abstractions are fundamental processes. It is precisely these troubles I wish to evoke, but not resolve, in the disturbing signifiers and narrative figures the FemaleMan© and OncoMouse™. Appealing to the Subject is surely the least helpful way to deal with the disturbing half-lies of undead Objects. Located in Society and outside Nature, the bounded individual with property in the self is perhaps the chief fetishized object—that is, thing mistaken for a living being, while the actual living beings and processes that produce and sustain life are effaced—in Western political and economic writing after about 1700. Responsible for some astounding narrative and theoretical contortions in evolutionary biology to save a good-enough, bounded unit of one that can at least copy itself (Dawkins 1982), this same bounded individual has caused serious trouble in theoretical population biology (Keller 1992a). One can hardly invoke that individual and his stripped-down, body-phobic societies to object to the liveliness of mice, microbes, narrative figures, lab machines, and various chimerical collectives of humans and nonhumans. How to "figure" actions and entities nonanthropomorphically and nonreductively is a fundamental theoretical, moral, and political problem. Practices of figuration and narration are much more than literary decoration. Kinds of membership and kinds of liveliness—kinship, in short—are the issues for all of us.

24 U.S. Constitution, article I, section 8, clause 8, as quoted in Chon 1993:98.

25 Star (1991; 1994) and Suchman (1994) develop central arguments, which are friendly to Chon's, for a feminist, democratic politics at every level of the onion of technoscientific practice.

26 I am indebted to Michael Flower (n.d.; 1994), who teaches biology and science studies at Portland State University, for the idea of liberty in technoscience.

27 Christie wrote this in reference to cyberspace and the networked informatics of domination, figured within the aesthetic of the technological sublime, but his characterization could equally well apply to DNA become database in a New World Order, Inc., where, like other kinds of toys, Genes R Us. It would be hard to find a better illustration of the subject become the tool and vice versa, and all in a kind of second-order space of nonclassical materiality.

28 Shelley (1818). Russ's *Female Man* is to Shelley's *Frankenstein* as OncoMouse™ is to Michael Crichton's *Jurassic Park* (1990). *Frankenstein* is about the tragedy of man as his own alienated product; *Jurassic Park* is about the comedy of the escaped commodity. Shelley's fiction participates in the dramas of Enlightenment humanism; Crichton's tale of escaped cloned dinosaurs in a theme park is firmly located in the dilemmas of the New World Order, Inc., where commercial biologicals give body to the idea of nature enterprised up.

29 I am once again indebted to Hayden White's transformative writing on theories of the text in *The Content of the Form* 1987.

30 For histories and theories of feminist SF, see Lefanu 1989, especially chapter 14, "The Reader as Subject: Joanna Russ"; and Barr 1992.

31 Lest the reader decide Russ's and my feminist meditations on unnatural acts are the preserve of white, anglo-saxon, U.S. women with origin stories that begin somewhere around 1968, consider this typological, essentializing, edifying list of recent, arguably feminist SF written by North Americans: *OutLook* magazine's African American Latina poetry editor Jewelle Gomez's (1991) lesbian vampire chronicle; Jewish American Marge Piercy's (1991) parallel story of the golem in sixteenth-century Prague and the cyborg protector of the near-future Jewish freetown, who is the heterosexual lover of the town's defense-system programmer, a grandmother, and of her interface-software-designer granddaughter; African American textual theorist and SF writer Samuel R. Delany's (1988) outpouring of innovative investigations of language technologies that craft what gets to count as nature, freedom, and sex; Québeçoise writer Elisabeth Vonarburg's (1988) interrogation of a city's self-perpetuating technology and the genetic manipulations by a woman who sought to rebuild human life on the outside; anglophone European Canadian writer Candas Jane Dorsey's (1988) work; European American SF writer John Varley's (1986) explorations of cyborg embodiments of the circuits of suffering and agency for a quadriplegic intergalactic popular culture star and a Vietnamese American woman computer hacker; and African American SF writer Octavia Butler's (1987; 1988; 1989) troubling explorations of kinship, apocalypse, bondage, colonization, and reproductive freedom in her Xenogenesis trilogy.

32 Advertising text, "Stalking Cancer," *Science*, April 27, 1990. Image published by

permission of Du Pont NEN Products. On May 19, 1995, Du Pont announced its intention to divest its medical products businesses. The former Du Pont NEN Products will become NEN Life Science Products.

33 The particular creature bearing the trademark name OncoMouse™ that was advertised in *Science* in 1990 carried a mutated form of the *ras* gene, which codes for a protein that is part of a powerful intracellular signaling system for transducing messages from the cell surface to the nucleus (Gilbert 1994:683, 685). Building on extensive research, recent work on organisms including yeast, fruit flies, nematode worms, and mammals has established a universal function for the ras protein in controlling a cell's decision to grow or differentiate. First studied in the early 1980s, mutations in the *ras* gene (oncogenes) are responsible for a large fraction of human tumors in many tissues, including the mammary gland. See Hall 1994:1413. The original form of the oncomouse carried a different bit of transplanted DNA, "the mouse '*myc*' (myelocytomatosis) gene under control of a promoter or regulatory gene sequence derived from the mouse mammary tumor virus (MMTV LTR). Gene fusions of the *myc* and MMTV LTR genes were created and inserted into fertilized one-cell mouse eggs via micro-injection" (TA 1989:99). The treated eggs were then implanted in hormonally prepared female mice and the offspring tested for inclusion and expression of the desired genes.

34 For the initial part of the story of OncoMouse™ and evolving patent rights in relation to genetic technologies, see Krimsky 1991:43–57. For a fundamental early analysis, see Yoxen 1984; for further references, see Woodman, Shelly, and Reichel 1989. For oncogene research as "do-able science," see Fujimura 1992:168–211; 1996. One is at least as least as likely to find the latest news on transgenic animals on the business pages of the newspaper as in the science and medicine section. Bioengineered, transgenic farm animals captured much of the early attention, but the present stress is on biomedical products that are likely to be crucial for biotechnology companies to raise capital in the 1990s (Andrews 1993:1A).

35 Du Pont was interested in transgenic mice, or, more broadly, in lines of animals genetically predisposed to cancer, in three main ways: as research projects in their own right, as test systems for toxicology, and as vehicles for crafting cancer therapies. Du Pont issued research licenses to use its patented process to produce transgenic animals without fee to academic and other nonprofit investigators, in exchange for those researchers keeping Du Pont informed of scientific developments.

36 I am indebted to officers of Du Pont, who preferred not to be named, for generous and time-consuming discussions of these and related matters in 1994 and 1995. Du Pont people saved me from many errors of fact, but I remain responsible for the interpretations.

37 Teitelman (1994:50, 184) points out that the splicing of biology and medicine—and academic research and the drug industry—at both a verbal level (*biomedicine*) and an organizational level began in the 1970s, the same decade that saw *E. coli* genes working in frog cells. "The factors driving this process were quite involved,

reflecting the social complexity of the modern scientific enterprise: from government (the war on cancer), academia (the development of genetic engineering and the rise of the immunotherapies), and the economy (the inflation of the 1970s, the deregulation of Wall Street, various tax reforms)" (184).

38 See Moskowitz, Katz, and Levering 1980:606-10 for a history of Du Pont the company and du Pont the family before the acquisition of Conoco in 1981. That acquisition complexified Du Pont culture significantly, and by the 1990s du Ponts, whose power in the company was already diluted over three generations, do not hold even a significant minority interest.

39 An early "indication that the practical potential of molecular biology was beginning to be taken seriously in the private sector was the establishment in 1967 of a lavishly supported molecular biology research institute in New Jersey by the giant Swiss pharmaceutical, Hoffman-La Roche" (Wright 1986:308).

40 See Harvey 1989:147–97 for a full discussion of flexible accumulation. Martin (1992) develops the idea for contemporary biological bodies.

41 See Hoover, Campbell, and Spain 1991:221, 378 and Moskowitz, Katz, and Levering 1980:229-32.

42 My sources for the following allegory are Noble 1977; Hounshell and Smith 1988; Teitelman 1994; and Du Pont's own current brochure, *The World of Du Pont: Better Things for Better Living.*

43 *The Gene Exchange* 2(4) (December 1991):6.

44 *Science* 253 (July 5, 1991):33.

45 Seed banks, like all other technoscientific institutions, are also undergoing structural readjustments in the New World Order. The donors of the 18 international agricultural research centers (IARCs) spread around the globe in the past 25 years constitute a consortium called the Consultative Group on International Agricultural Research (CGIAR). In 1994, the IARCs faced a long-term structural funding gap, threatening their scientific staff and many functions. The World Bank stepped in with plans for a bailout in return for the research centers' reassessment of priorities and organization. But controversy over the alignment with the World Bank arose over the fate of the IARCs' collection of 500,000 samples of plant germ plasm, which account for about 40 percent of the world's accessions. IARC germ plasm banks have held their genes in trust, with free material available to all users. In practice, this system has meant that genes from the developing world have been used, without reimbursement to the research centers or countries of origin, for high-value corporate genetic crop development. The Biodiversity Convention, negotiated at the Earth Summit in Rio de Janeiro in 1992, requires that genetic resources be brought under the control of the governments of countries of origin. In 1993 the CGIAR developed plans to make its collections part of a broad international network, the Intergovernmental Commission on Plant Genetic Resources, overseen by the United Nations Food and Agriculture Organization (FAO), where the United Nations' one country-one vote principle would apply. The intergovernmental commission would work out how gene users would reimburse research centers and

countries of origin. But in the context of the new funding arrangement with the World Bank, the CGIAR wanted to review the legal ramifications of an agreement with the FAO. Controversy ensued. Critics felt that the World Bank, although it is an intergovernmental body and eligible under the Biodiversity Convention to control genetic resources, would advance primarily Western interests. World Bank members vote according to their donations, so the bank is dominated by rich countries. See MacKenzie 1994 and Stone 1994.

46 For this important story see OTA 1989; Krimsky 1991; and Wright 1986.

47 Venture capital was greatly encouraged from the mid-1970s on by cuts in capital gains taxes from 48 percent to 28 percent (Wright 1986:332).

48 In her definitive book on the history of molecular politics and especially British and American regulatory policies from 1972-1982, Susan Wright (1994) argues that the large multinational corporations, which had closely monitored events in molecular biology and genetic engineering, began to invest substantially in the field after 1977 after bacteria were first coaxed to produce human proteins in academic laboratories. At the same time, the multinationals moved powerfully and decisively to control the field politically as well as commercially. The Pharmaceutical Manufacturers Association (PMA) made the unsubtle threat that it would move overseas, with its billions in revenues, if Congress passed strict regulatory legislation. The focus in Congress shifted magically from worries about safety to worries about U.S. competitiveness in this critical new field. Social consequences of genetic technology had not ever seriously entered the agenda for discussion at all, but safety had until serious money spoke in 1978. Wright meticulously documents direct pressure in a series of private meetings of representatives of the PMA with officials in the Department of Commerce; Department of Health, Education and Welfare; and the National Institutes of Health. The pharmaceutical representatives pressed for as little disclosure of sensitive technical data as possible and full protection, with criminal penalties, of any information that did have to be disclosed. NIH did not publicize this backstage arm-twisting that deeply influenced its own actions. In the late 1970s and early 1980s, in response to environmental and consumer safety movements, the multinationals pressed a complete—and successful—agenda critical to rapid commercialization of molecular science and technology. The agenda included tax relief, budget allocation, patents, and deregulatory policies. The net result is a large science-based industry essentially unregulated in areas of environment, health, and occupational safety, not to mention social effects. Wright argues that an effective democratic response must be as transnational as the scope of the industry. Just for perspective, remember that in 1994 the top 100 multinationals held $3.4 trillion in global assets. Oil, chemical, and pharmaceutical companies are not minor members of that club. Multinationals directly or indirectly employ 150 million people (that is, 20 percent of the world's nonagricultural work force) and control one-third of world economic output and one-third of world trade. Rohde 1994.

49 Nobel Prize winner Joshua Lederberg, himself a founder of the first biotechnology company, Cetus, in 1971, was hired by Whitehead to find a director for the institute. Lederberg got Nobel Prize winner David Baltimore, then a professor at MIT, to agree to take the post. Landscape architect Martha Schwartz designed a rooftop "splice garden" for the building of the Whitehead Institute. The innovative, completely synthetic garden splices together design elements of Japanese and French gardens (see Johnson 1988). Thanks to landscape architect Anne Spirn for the tip. In the 1990s, the federally funded Whitehead Institute/MIT Center for Genomic Research is the largest genome research center in the United States. Its current director, Eric Lander, and the director of France's genome effort, Daniel Cohen, were founding scientific advisors to the new biotech firm Millennium Pharmaceuticals (Fisher 1994:9A).

50 Universities do all they can to help their scientist faculty thrive in the world of research enterprised up. For example, in spring 1995, I received an announcement titled "Science That Means Business" from my university Contracts and Grants Office inviting me to sign up for a March 23 national video conference produced by the University of Maryland at Baltimore's Office of Technology Development, Mentor Media, Inc., and the Association of University Technology Managers. PBS Adult Learning Satellite Services presented the program, which featured presenters from academia, government, industry, and finance. Conspicuously absent from this cooperative undertaking were producers or presenters representing academic or public interest points of view outside a market perspective. The presentation was for "today's university scientists who look toward technology transfer as a solution to the decrease in traditional sources of research funding." Topics included "how to effectively move [sic] promising research from the lab to the marketplace, . . . company formation, . . . how universities can best promote collaborations with industry." Research faculty, graduate students, administrators, patent attorneys, startup executives, and industry licensing and acquisition managers were among those urged to attend.

51 Fisher 1994:9A. By the mid-1990s some of the shine was off investment confidence in biotechnology, one of the most volatile sectors of the stock market. But still, total capitalization was at $41 billion in 1994 ($7 billion less than 1992)— "impressive for an industry less than 20 years old" (Beardsley 1994:90). Economists and investors were worrying in the mid-1990s about the lack of profitability and the undercapitalization of many biotech firms and about the weakness of the sector generally. Too many companies were chasing too little capital and had shown too little by way of results to continue to succeed by promise alone. The period of firm failures and buyouts is characteristic of the restructuring expected in a more mature industry (see Hamilton 1994). In July 1995, led by Amgen, Inc., which announced an experimental antiobesity hormone that caused weight reduction in mice, biotechnology was again a hot item on Wall Street (Petruno 1995). Volatility is the name of the game in stocks, if not in the weights of U.S. hominid dieters.

52 See Haraway 1988 and Harding 1992 for full discussion of situated knowledges

and strong objectivity developed in feminist science theory.

53 This report was distributed through an Internet electronic posting. See also Sclove 1995.

54 The mice, among other animate lab tools and autopoietic biomedia, might not agree, despite better climate control in their cleaner cages. I have not entered in this chapter into the important moral questions about the use of animals as our surrogates in research. My own ambivalence is fundamentally unresolved. For insight into how biologists involved in animal experiments defend their practices and view those who do not share their commitments, see Michael and Birke 1994. At the very least, naming out loud and in print that "our" kind of scientific knowledge is dependent on the systematic suffering of animal surrogates should be part of discussions of materials and methods in scientific publishing. Kinship requires at least that acknowledgement.

55 See especially Yoxen 1981; Kay 1993; Haraway 1991; Wright 1986; Martin 1994; Keller 1992; and Spanier 1991.

56 These are not the only discourses of life that animate biological practice today, but they are powerful and serviceable. For a view of life as autopoiesis, see Margulis and Sagan 1995. See Gilbert 1994 for a consistently nonreductionist view of molecular biology and development. Rarely, but significantly, when she writes about the dynamism of "planetary capitalism," even Margulis's innovative and fruitful workings of the idea of autopoiesis threaten to congeal into the same turgid brew as notions of flexible accumulation. The view of the living tissues of the planet in the Gaia hypothesis, which is Margulis's fundamental focus, is not an organic, nontechnological, alternative biology. Quite the opposite, the view of terran life from a satellite or a spaceship is semiotically, but also technically, intrinsic to the Gaia hypothesis. That is one reason why Gaian thinking was built into the programming for the SimEarth computer game by the Maxis Corporation. It should not be surprising that the Gaia hypothesis, the artificial life thinking at the Santa Fe Institute, and Dawkins's formulations of the selfish gene and extended phenotype are all inspirational for and technically useful to the Maxis game designers of SimEarth, SimLife, and SimCity.

57 For an examination of mice as part of the material culture of science, see Reder (in progress). Mice are *The Right Tools for the Job* (Clarke and Fujimura 1992). For a survey of how transgenic animal technology has been applied to a wide range of biological problems, see Grosveld and Kollias 1992.

58 Being in business for a profit is not the same thing as making one. Between 1991 and 1993, GenPharm invested about $4 million in transgenic mice and filled about 140 orders at $400-$600 for an average of five mice per order (Cone 1993:A17). Future promise is often the driving force in technoscience. Clean and abundant nuclear energy comes first to mind. "Too cheap to meter" was the slogan. To me, that sounds a lot like "where better things for better living come to life." GenPharm markets the best selling knockout mouse, TSG-p53 (a mouse with the p53 gene deleted).

59 The patent relating to OncoMouse™ is broad—applying to any "transgenic non-

human mammal all of whose germ cells and somatic cells contain a recombi-
nant activated oncogene sequence introduced into said mammal, or an ances-
tor of said animal, at an embryonic stage" (1988, U.S. Patent No. 4,736,866).
By the time it obtained the license for OncoMouse™, Du Pont had made
$15 million in unrestricted grants to Harvard, plus incurring subsequent mar-
keting and administration costs. In 1994, a Du Pont licensing officer, who did
not wish to be credited by name, told me that the company, with its long-
term interest in cancer therapies, through Charles River Laboratories estab-
lished a conservative pricing policy to encourage use and never intended to
recoup the costs of research and development through the price of the
rodent. Requiring only that it be kept informed of developments, Du Pont
readily granted research licenses for use of organisms covered by the patent to
scientists in universities and nonprofit institutes. On the other hand, in a
model of what many scientists dislike, the company originally wrote a reach-
through royalty clause that applied to any product or drug developed with the
aid of organisms covered by this patent. The company subsequently dropped
the clause and lowered the use price, but use of OncoMouse™ itself
remained low (Arthur 1993).

60 Braverman (1974) noted that capitalism developed labor systems in connection
with the transfer of physical skill from bumptious worker to paper.
Recordkeeping and filing made the modern corporation and its labor
arrangements possible. In postmodernity's practices of flexible accumulation,
the database is to the filing systems of monopoly capital as the computer is to
the typewriter and cyberspace is to mundane space.

61 See Cuticchia et al. 1993 and Hilgartner 1994 for discussions of informatics devel-
opment in the genome project.

62 The chart is a genetic map with loci defined by markers assayed by polymerase
chain reaction (PCR) and by cloned gene probes that detect restriction frag-
ment length polymorphism (RFLP). Thus, the map juxtaposes sequence
length polymorphisms with gene-based loci.

63 I am drawing heavily from Christie's (1993) reading of cyberspace, flexible accu-
mulation strategies, and temporality.

64 Monsanto won the race with Eli Lilly, Upjohn, and American Cyanamid to genet-
ically engineer bacteria to produce bovine somatotropin (BST), which stim-
ulates milk production. BST came on the market amidst major controversy
about its impact on dairy farmers, supply of milk (a commodity for which
surpluses are a major economic problem), consumers, and cows themselves.
No one expects lower milk prices, and smaller farmers are likely to be driven
out of business. Spending about $1 billion to develop BST, Monsanto
financed its drive to become the biotech frontrunner with its large portfolio
of industrial and consumer products, including Roundup herbicide, which
brought in about $1.4 billion in annual revenues in the early 1990s. With a
total annual gross receipt of over $8 billion in 1993, the diversified company
also makes polyesters, plastics, Nutrasweet, and, through Searle, many drugs.
The company is considered a "light heavyweight" behind giants such as Dow

and Du Pont (see Feder 1993). In June 1995, Monsanto, with its strength in pesticides, announced its intention to acquire a 49.9 percent share of Calgene, a significant agricultural biotechnology company with an acute need for fresh cash. Part of the deal was to give Calgene the means to improve the marketing system for its transgenic tomato, Flavr Savr. See *The Gene Exchange*, July 1995, p. 13.

65 I am, though, still worried about Rob.

66 Centers for Disease Control statistics, reported on National Public Radio, April 22, 1994.

67 My discussion of Flower is taken from an undated manuscript (n.d., but written in 1991) and a paper delivered at the meetings of the Society for Social Studies of Sciences (1994). Without further specific citation, descriptions and quotations in the following paragraphs come from one or the other of these documents.

68 I like the identity of the acronym with that of Stanford's Linear Accelerator (SLAC), where elementary particle physics gets done.

69 Barad (1995b), who teaches quantum physics at Pomona College, argues that her reworkings of Bohr's philosophy-physics in light of contemporary debates in feminist science studies has significant implications for teaching physics.

70 Feminist emphasis on "difference" and "multiculturalism" is not relativist but historical and constructivist, in the sense that the possibility, not inevitability, of connection, communication, and articulation is always open. That applies to different domains inside the "same" culture as well as "cross" culturally. Well documented in science studies, ordinary interdisciplinary practice in science and technology abundantly illustrates the point. "Universality," in knowledge projects as well as in politics, depends upon a stabilized material-semiotic web. Human rights and molecular biology are both good examples of this kind of universality. This approach to "difference" and "multiculturalism" matters in considering historically specific approaches to quantification and mathematics broadly. Everything is not "equal," but all practices are "local" in the sense of being contextually specific and embodied in both material and semiotic aspects. See Watson-Verran and Turnbull 1995 for analysis of the meeting of Western math teaching conventions and Australian aboriginal abstract ordering systems in working out math textbooks in contemporary Australia. The translations are where the interesting epistemological and political action lies. See Eglash 1995 and in progress for analysis of intentional production of fractal patterns in particular African cultural practices and the implications for math teaching. Eglash argues that his approach avoids "both the orientalist interpretation, which would see fractals as proof of a transcendental, mystical intuition of the non-west, and the primitivist interpretation, which posits a concrete unconscious expression of oneness-with-nature. Here we will view African fractals as intentional products of mental and physical labor, arising from a wide variety of motivations and utilizing certain universal mathematical properties" (1995:2).

Part III Pragmatics: Technoscience in Hypertext

1 *Foundation* (Morris 1938) is the second publication in the important Chicago series, the International Encyclopedia of Unified Science, that later published Kuhn (1962).

2 My discussion of Mosaic is based on Coates (1994).

3 Joseph Dumit, personal communication, December 4, 1992. Dumit's dissertation (1995) on the development of positron emission tomography (PET) brain imaging focuses on the professional, technical, popular, legal, and industrial interactions that forge new disciplines and discourses. His project examines closely the interdisciplinary development of computer sciences and the interfacing of such specialties with neurosciences in brain-scanning research.

4 The Human Genome Project haunts many chapters in *Modest_Witness@Second_Millennium.* On genome databases at the beginning of the 1990s, see "Genome Issue: Maps and Database," *Science* 254 (October 11, 1991):201–07. For the Human Brain Mapping Project, see Roberts (1991) and AAAS 1993. The 1990s is the "Decade of the Brain," a designation for transnational technoscience something like the United Nations' Decade of the Woman or Year of the Child. Such labels signal conferences, declarations, and high-status locations. Data from molecular neurobiology, systems neuroscience, developmental neurobiology, and genetics, as well as new graphics and data storage capacities of computers, have revolutionized brain-mapping practices, necessitating major changes in the nature of atlases and research interactions. Nonorganic "brains" also continued in the 1990s as objects of rapt technoscientific attention in artificial intelligence and robotics research. For example, see Travis 1994. In the last decade of the millennium, the action lies in the "marriage of computational models and experimentation" (Barinaga 1990:524–26).

Chapter 4. Gene: Maps and Portraits of Life Itself

1 Advertisement in *Science News* 142, no. 20 (November 14, 1992):322. See Karakotsios (1992).

2 In 1927, the heyday of popular eugenics, in *Buck v. Bell* Supreme Court Justice Holmes approved the sterilization of a teenage mother on the grounds that "three generations of imbeciles are enough." Life's experimental practice had made its class and gender naturalizing point. On the credits page of the *SimLife* manual, the makers of the game give "inspirational thanks" to sociobiologist Richard Dawkins (1976) and artificial life researcher Christopher Langton (1992). See also the program and papers for the Artificial Life Conference on Emergence and Evolution of Life-Like Forms in Human-Made Environments, February 5-9, 1990, Santa Fe Institute, New Mexico. Several of the most energetic participants in the independent institute worked at the Center for Non-linear Studies at Los Alamos National Laboratory. For an ethnography of the artificial life (ALIFE) community, see

Helmreich 1995. Easy interdisciplinarity and the sense of being at the leading edge are the scientific birthright of these men, just as they were for the scientists just after World War II who gathered at the Macy Foundation conferences on circular causal feedback systems (cybernetics) in an atmosphere of intellectual innovation and excitement. The powerful informatics and computing resources of the U.S. weapons laboratories were critical to organizing the Human Genome Project, with its oceans of data. GenBank© started at the Los Alamos Labs.

3 My confidence in such travel and spectacular scenery is due to "Miracle of Life," the 1983 Time-Life video with Lennart Nilsson's photomicrography.

4 Although various Jewish and Christian readings of shared scriptural texts can be similar, I use *Christian* rather than *Christian and Jewish* or *Judeo-Christian* to emphasize that despite the significant numbers of Jewish scientists in the fields this book examines, the sacred-secular narratives are overwhelmingly inflected by both Catholic and Protestant Christian accounts in which Jewish materials are brought into "salvation history," with its figurations and appropriations. Most often the significant religious elements of technoscience discourse are disavowed and denied, tempting an almost psychoanalytic interpretation of U.S. Christian-secular scientific culture. The Christian Coalition has nothing over the search for the Holy Grail in genome discourse. See Lewontin (1992). When I use the term *Judeo-Christian*, I am referring to Christian readings of Jewish sources, historically in the context of the many-layered oppression of Jewish populations. See Piercy (1991) for Jewish accounts of the golem and cyborg that inflect technoscience stories quite differently from the "Judeo-Christian" figurations (e.g., genome and cyborg) in sacred-secular salvation history.

5 For related arguments about the gene as a sacralized object in contemporary U.S. culture, see Nelkin and Lindee 1995:38–57.

6 See also Franklin, Lurie, and Stacey forthcoming and Franklin 1995:63–77. I draw also from Paul Rabinow's (1992b:236) notion of "biosociality" (nature modeled on culture and understood as practice). On the ethnospecific—if widely disseminated—hybridizations of nature and culture that are characteristic of the inventiveness of technoscience in its globalized proprietary networks, see also Strathern 1994. In the light of quite different kinds of Melanesian heterogeneous hybrids, Strathern dissects the technoscientific hybrids sighted by Latour (1993). By insisting on the specific proprietary webs that infiltrate Western meanings of "inventiveness," Strathern teases out the asymmetrical meanings of "networks" in the proliferation and exchange of hybrids and their constitutive practices transnationally. My analysis is deeply in her debt.

7 See Mohanty 1991 for rich "cartographies of struggle" in local/global women's movements.

8 My arguments about spatialization are indebted to Harvey (1989). In his theory of geographical historical materialism, Harvey insists that spatialization is social practice; spatiotemporalities are contingent materialities, not containers for action and actors. He concentrates on the spatialities constituted by capitalist

relations. Harvey's *The Condition of Postmodernity* tends to represent other material social practices, such as those of racialization and gendered sexualization—which in my view also constitute bodies-in-the-making and contingent spatiotemporalities—as derivative or as limited to "place" and "fixed" identity. That is, gender and race, but not class, seem to be about identities and places but not about world-building practices and processes. But I think the basic logic of Harvey's 1989 book and the explicit arguments of his current work-in-progress result in a more intersectional, interleaved analysis of spatialization processes and bodies-in-the-making.

9 A radical redefinition of property is implicit in the Australian High Court ruling. In legal theory in the United States, which has a similar history as a white settler colony whose immigrant inhabitants had to dispossess established indigenous populations from every square foot of territory, legitimate property rights were derived from "first possession." Possession implied certain kinds of relation to the land, such as enclosure, fixed residence, agriculture, monetary valuation, and the like. That is, the indigenous populations' occupation of the land could not count legally as possession. The conquered land had to be epistemologically reconstructed as vacant to allow processes of enclosure, alienation, and development. The institution of property depended on an epistemological commitment that necessitated that indigenous populations' activities did not count as enclosure, or as mixing labor with nature to produce property. As a corollary, their ideas about the ties of land and people did not count as rational knowledge but only as primitive custom. At least one obvious legacy embedded in this tragic history is the racialization of notions of rational knowledge and of legitimate property at the foundation of the colonial democracies. Deracialization is about refounding in the most basic sense. See Harris 1993.

10 See Eglash (in progress) for analysis of African fractal geometry in material culture that also troubles the assumptions of both science studies and ethnomathematics and has implications for thinking about mathematics as material-semiotic practice. I draw on Barker's (1995) discussion of the recently produced subject, the Global Native.

11 See Flower and Heath 1993 for delineation of the heterogeneous semiotic-material negotiations that go into solidifying gene maps, in general, and the "consensus DNA sequence" that is meant to instantiate "the" human genome, in particular. Using Latour's notion of centers of calculation and Foucault's ideas about anatomopolitics and biopower to study the production of the consensus genome in the Human Genome Project, Flower and Heath discuss how the historical processes get obscured as the products assume a privileged status as matters of fact, "foster[ing] the notion that there is a direct, unmediated relationship between inscriptions and the object of study—here, human DNA" (1993:32). See Dumit 1995 for the many instrumental-semiotic processes that go into getting a consensus object called a PET brain scan.

12 Even the word *fetish* is rooted in a mistake and disavowal of the colonialist and racist kind, one shared by both Marx and Freud, in which "Westerners" averred that

"Primitives" mistook objects to be the real embodiment or habitation of magical spirits and power. Fetishism, these rational observers claimed, was a kind of misplaced concreteness that depended on "Primitives'" lower powers of abstract reasoning and inferior forms of religious faith, not to speak of deficient scientific reason. "Primitive" fetishes were about "magical thinking," that is, about the potency of wishes, where the desire was mistaken for the presence of its referent. Anthropologists have long discarded this doctrine of fetishism, but the racialized meaning, connoting the underdeveloped, irrational, and pathological, persists in many domains. Indeed, I ultimately depend on those tainted resonances for my own argument in this chapter, even though I direct the diagnosis to the secular-sacred point where the culture of no culture and the nature of no nature implode. The irony of the doctrine of "primitive" fetishes is that, if one follows Whitehead's (1948:41-56) explanation of the "fallacy of misplaced concreteness" that comes from the belief in simple location, relation- and observer-free preexisting objects, and a metaphysics of substantives with primary and secondary qualities, then the children of the Scientific Revolution are the world's first and maybe only serious fetishists, whose most extraordinary abstractions are taken to be reality itself. If "life itself" is about the technoscientifically instrumentalized desire for mastery over life, and perhaps nonliteral complexity in general, by a hold on monological information carriers called genes, then fetishism in the classical colonialist sense has come home to roost, right along with the rest of empire's apparatuses.

13 Objectifications are dense nodes in webs of material-semiotic interaction. "Solid" objects with "simple location" are useful ways to designate stabilized interactions in a given frame of reference, but the provisional quality of the boundaries and stabilizations should not be "forgotten."

14 Examining the links between "master-molecule" and "possessive-individualism" discourses, Keller (1992a) dissects the odd avoidance of questions—for example, about the consequences of sexual reproduction (twoness) in the equations of population genetics—in genetic, evolutionary, and ecological biology. Also tracking the curious balancing act between belief and knowledge evident in the history of modern biology, which I am calling fetishism, Keller examines where the appearance of the greatest neutrality and objectivity, such as in mathematical ecology and molecular genetics, makes it hard to see invested avoidances in what counts widely as the best science. Most interesting for *Modest_Witness@Second_Millennium*, Keller asks why the avoidances are there. In molecular biology, she locates the answer in the instrumentalized desire to translate life into a problem that can be "solved." A culturally specific kind of control is at issue, a certain way of engaging with the material-semiotic world (1992a:108). Keller pursues her interest in how the discourse of molecular biology is structured into *Refiguring Life* (1995).

15 By *wholeness* and *potency* I mean the opposite of autotelic and self-sufficient. *Whole* does not mean "bounded off," as imagined within the story frame of possessive individualism so common in gene discourse. In my story, *whole* means inside

articulations, never reducing to a thing-in-itself, in sacred or secular terms.

16 By *subject* I mean the multilayered person discursively constituted through the material-semiotic practices of molecular genetics, or technoscience more broadly. Subject formation is a lifelong matter. I don't mean an amorphous collective subject, but the question still remains whether the psychoanalytic account can be invoked for processes that bear precious little if any relation to the traumas of subject formation in early psychosexual/linguistic development that Freud thought he was talking about.

17 In my story, confusing the penis with the phallus is like confusing the gene with the articulated processes that constitute the dynamic unit of structure and function in biology.

18 Alert to the Christian narrative so readily taken up by members of "a scientific community with a high concentration of Eastern European Jews and atheists," Lewontin (1992:31) does a devastating job on the Arthurian quest in fetishized molecular genetics.

19 In film theory, fetishism has to do with the balance of knowledge and belief in the status of the image (Doane 1987); the analogy to the status of the inscription and the image in technoscience is promising. Julian Bleecker (forthcoming) is developing an interweave of film theoretic and science studies approaches to "special effects," especially in technoscientific visual culture.

20 It is a pity that Linus Pauling was not right about DNA being a triple-stranded helix. Maybe he would be assuaged by the triple-stranded helix of gene fetishism, but there is surely no Nobel Prize for this structure!

21 Whitehead has been important to my understandings of biology at least since reading him with the ecologist G. Evelyn Hutchinson in the 1960s in graduate school at Yale. See Haraway 1976. In addition to following the latest word on the translation of maternal messenger RNA in the oocytes of sea urchins, and similar such doings, the graduate students in Hutchinson's lab read and discussed, over English tea, Whitehead, Gödel, Piaget, Karen Stevenson, Simone Weil, Alan Turing, and much else. Hutchinson's lab was not given to overly simple location! No wonder Hutchinson developed a theory of n-dimensional niche space. It's where he stashed his graduate students. I also read Whitehead as a an undergraduate, and I believe this philosopher-mathematician lurks in the tissues of many a resister to gene fetishism in feminist science studies and elsewhere. Bruno Latour recently turned to Whitehead as an ally for his approach to science-in-the-making. Also distinguishing "misplaced concretism and concrete situations," sociologist of science Susan Leigh Star draws from "feminism, race critical theory, multiculturalism, and information science" to examine multiple memberships, borderlands, boundary objects, and method. She defines membership "as the experience of encountering objects, and increasingly being in naturalized relationship with them" (1994:23). "Boundary objects arise over time from durable cooperation between communities of practice, as working arrangements which resolve anomalies of naturalization without imposing a naturalization from one community or from the outside" (27). Articulation work and invisible work

that manage anomalies and cope with standardized inscriptions creatively are at the center of her attention (31–33).

22 The word *genome* results from the splicing, with deletions, of *gene* + *chromosome*; *chromosome* is a compound of *chromo* (color) and *soma* (Greek, body). *Dorland's Illustrated Medical Dictionary*, 27th edition (Philadelphia: W. B. Saunders, 1988).

23 *Science*, February 1, 1991, back cover.

24 In this chapter, I am mainly concerned with maps. For a discussion of a related category of technoscientific representational artefacts, see Lynch 1991. Lynch treats diagrams as constituents of a work in process, where "reality" cannot be independent of representational labor. What a picture is *doing* is not what it *resembles*. If this concept is no surprise, it nonetheless bears repeating in a U.S. scientistic culture that continues to forget that referential meanings of pictures, maps, and diagrams are always context dependent and sustained by the labor of communities. The visual is no more self-evident than any other mode of relating in the world.

25 Microsoft's spokeswoman said that Gates intends to share the manuscript with the public by lending it to museums, beginning with one in Italy.

26 Sequenase™ is a DNA polymerase used in sequence analysis. The marketed enzyme comes in versions, for example, Sequenase Version 1.0 or 2.0, just like software, such as Microsoft Word 5.0—one more signifier of the close bond between informatics and genomics. The instruments and products have a resonating conceptual framework down to the details of iconography. Gene Codes Corporation sells a software program for analyzing DNA sequencing data on Mac machines called Squencher. Another software choice could be Gene Runner 3.0 for Windows from Hastings Software, Inc. Biologists are notoriously Mac friendly, one reason they have found Unix-based systems for electronic collaboration unappealing. S. Leigh Star, personal communication.

27 The ad has run many times, including *Science* 18, no. 1 (1995):77. A nonradioactive DNA-detection tool from Boehringer Mannheim is called Genius™ System, with the slogan "leaving the limits behind." Appearing in *Biotechniques* 17, no. 3 (1994): 511, one ad links the Genius™ System protocols with the delicate toepads of a tree frog, "allowing it to perform the most sensitive maneuvers . . . in pursuit of insect prey." The company offers natural design, delicacy, transcendence, and genius. Who could want more?

28 Warhol repeatedly, and very profitably, appropriated iconic commodity images for his challenges to the ideologies of originality and art. Sculptor Suzanne Anker, who writes about the intersection of art and biology, draws on Warhol's replication of the *Mona Lisa* in her text for the exhibit Gene Culture: Molecular Metaphor in Visual Art, which she curated for the Plaza Gallery of Fordham College at Lincoln Center. Anker wrote, "The practice of art over the last several decades has relied heavily on techniques of recontextualization. . . . The current artistic practice of appropriation, or the copying of one artist's style by another . . . tests the notion of copyright while at the same time challenging the accepted value of originality" (1994:1, 2). As Anker would agree, the least that can be said is that molecular genetics also

proceeds by means of recontextualization. *Zoosemiotics*, Anker's own installa-
tion in 1993 at the Hanes Art Center at the University of North Carolina at
Chapel Hill, used patterned and reflected three-dimensional sculptural simu-
lations of various animals' metaphase chromosomes.

29 Later, I decided from theme and line that the cartoon had to be Sidney Harris, who
indeed owned up and kindly gave me permission to reprint.

30 Spun off from dog medical genetics and diagnostics, a small private company
already exists. Inevitably, it is called Vetgen. I first learned of the dog genome
work in a conference paper by one of the researchers, Ostrander (1992).

31 Mouse or fruitfly geneticists would be unmoved. Their genealogies make pure-
bred dogs (not to mention Mormons) look like mongrels.

32 For a paper proposing a comprehensive system of nomenclature for the dog
genome, see Ostrander, Sprague, and Rine 1993.

33 Remarks made by Daniel Koshland Jr., editor of *Science*, at the First Human
Genome Conference in 1989, quoted in Keller 1992b:282. Noting that many
homeless people are judged to be mentally ill, Koshland holds that much
mental illness is genetically caused. On the association of IQ (with high heri-
tability), social class, and ethnicity, see Herrnstein and Murray 1994.

34 Compare this quotation with the UNESCO statements on race and human nature
in 1950 and 1951, discussed in Part III, Chapter 6, "Race: Universal Donors
in a Vampire Culture."

35 *Science* 250 (October 12, 1990)

36 *Science* 250 (October 12, 1990):185.

37 The multiple authorship alone signifies the different kind of authority and mode
of knowledge production in play.

38 I owe my sense of how the comic works in technoscience to Helsel's (1993) analy-
sis of Herman Kahn's *On Thermonuclear War*.

39 "A Few Words about Reproduction from a Leader in the Field," *Science*, May 1,
1983, Logic General Corporation advertisement.

Chapter 5. Fetus: The Virtual Speculum in the New World Order

1 The controversy over Paul Simon's relation to African musicians in his 1986 album
Graceland, from which this song is taken, is part of the many layers of irony in
my appropriating and recontextualizing the lyrics of "The Boy in the
Bubble" in this chapter.

2 Anthropologists and science studies scholar Sarah Franklin (1993b) describes and
theorizes the emergence of "Life Itself." Duden (1993) discusses the appear-
ance of life as a system to be managed and women as an environment for
"life." See also Laqueur 1990 and Terry 1989. Foucault's concept of biopower
is braided into feminist histories of the body (Foucault 1978).

3 Technoscientific liberty is Michael Flower's (n.d.; 1994) concept. A rallying cry for
the civil rights movement, *Keep Your Eyes on the Prize!* is the title of Henry
Hampton's (1986–1987) famous television series, produced by Blackside,

Inc., and the Corporation for Public Broadcasting, on the African American freedom struggles of the 1950s and 1960s.

4 Kelly's cartoon illustrated an article in a special issue on reproductive technology of a Norwegian feminist journal (Stabel [1992:44]).

5 Teresa de Lauretis gave me a copy of an early-thirteenth-century "virtual speculum," called *The Creation of Eve*, from the Creation Dome in the entrance hall in the Basilica di S. Marco in Venice. In this flat, iconic, narrative painting, God is bending over the sleeping Adam in the Garden of Eden and extracting from his side the rib that will be formed into the First Man's wife and companion. This is not the creation scene that has inspired the iconographers of technoscientific advertising, conference brochures, and magazine-cover design. For these twentieth-century graphic artists, on the other hand, the touch between God and Adam depicted by Michelangelo has incited orgies of visual quotation. See magazine covers for *Omni*, April 1983, *Time*, November 8, 1993, and *Discover*, August 1992. For fans of Escher in the artificial life community, studied ethnographically by Stefan Helmreich (1995), the poster image for the second ALife conference (Farmer et al. 1990) features a visual quotation from *The Creation of Adam* in the cyberspace mode. This creation scene takes place at night, with a quarter-moon shining through a window that is also a screen onto the starry universe. Describing the image, Helmreich writes, "The notion that Man replaces God and renders Woman irrelevant in the new creations of Artificial Life is vividly illustrated . . . in a poster for the second workshop on Artificial Life, in which a white male programmer touches his finger to a keyboard to meet the waiting fingers of a skeletal circuit-based artificial creature (itself somewhat masculine)" (personal communication, May 18, 1995). The programmer himself is a kind of merman figure; the head and torso is of a human male, but the bottom half is a video display terminal whose nether end hooks into the eye of the circuit-skeletal figure. The Escheresque circular composition, full of arrows and fractal recursive shapes connoting self-organization, is a kind of uroborus, eating its own electronic tail in an orgy of self-creation. The men who got the conference together called themselves the "self-organizing committee." The conference was sponsored by the Center for Non-Linear Studies at the Los Alamos National Laboratory.

6 For comments on sonographic family bonding—and on the pleasures of screen viewing and the terrors of needle assays in amniocentesis—see Rapp (forthcoming). See also Hartouni 1994:79.

7 For discussion of U.S. fetal protection statues and of 1981 Senate hearings on a Human Life Statute, see Hartouni 1991. For analysis of events in the United Kingdom, see Franklin 1993a. The sonogram is only one in a battery of visual artifacts that establish the fact of fetal life within political, personal, and biomedical discourse.

8 For analysis of this sequence of images in historical and political context, see Stabile 1992. The landmark feminist analysis of fetal visual culture was Petchesky 1987.

9 This project is reviewed by Gasperini, who assures the potential buyer,

"Interactivity remains an option, never an interruption or a chore" (1994:198).

10 Susan Harding (1990) explores how God's creation and the first and second births of man work in the Christian right's innovative narrative technology that addresses abortion.

11 A visual gynecological examination be a male physician did not become common until the early nineteenth century in European societies; and manual touching of pregnant and birthing women was overwhelmingly a female practice at least through the seventeenth century—later in most places. Vision without touch could be mediated by the metal speculum, which also functioned as an instrument for opening the cervix to remove an obstructing fetus during childbirth. The gynecological speculum existed for many hundreds of years before debates emerging in the late-seventeenth and early-eighteenth centuries in Europe foregrounded the complex gender struggles between male and female birth attendants and between gendered epistemological practices. The symbolic status of the metal speculum as a tool of male domination of women's bodies (and minds) emerged unevenly in the last couple hundred years in European-derived cultures. See Tatlock 1992:757–58. Thanks to Londa Schiebinger for calling my attention to this article. The complex history of gender conflict over the tools, practices, and people facilitating birth was crucial to the emergence of the plastic speculum as a symbol of women's liberation in self-help groups in the United States in the early 1970s. See Gerson forthcoming.

12 Gross and Levitt (1994) outrageously caricature the feminist science studies insistence on the contingency of "reality" and the constructedness of science. It is important that my account of reality as an effect of an observing interaction, as opposed to a treasure awaiting discovery, not be misunderstood. "Reality" is certainly not "made up" in scientific practice, but it is collectively, materially, and semiotically constructed—that is, put together, made to cohere, worked up for and by us in some ways and not others. This is not a relativist position, if by relativism one means that the facts and models, including mathematical models, of natural scientific accounts of the world are merely matters of desire, opinion, speculation, fantasy, or any other such "mental" faculty. Science is a practice, an interaction inside and with worlds. Science is not a doctrine or a set of observer-independent but still empirically grounded (how?) statements about some ontologically separate nature-not-culture. At a minimum, an observing interaction requires historically located human beings; particular apparatuses, which might include devices like the hominid visual-brain system and the instruments of perspective drawing; and a heterogeneous world in which people and instruments are immersed and that is always prestructured within material-semiotic fields. "Observers" are not just people, much less disembodied minds; observers are also nonhuman entities, sometimes called inscription devices, to which people have materially delegated observation, often precisely to make it "impersonal." (As we will see below, statistics can be one of those instruments for making reality imper-

sonal.) "Impersonal" does not mean "observer-independent." Reality is not a "subjective" construction but a congealing of ways of interacting that makes the opposition of subjective and objective grossly misleading. These ways of interacting require the dense array of bodies, artifacts, minds, collectives, etc., that make up any rich world. The opposition of "knowing minds," on one hand, and "material reality" awaiting description, on the other hand, is a silly setup. Reality is eminently material and solid, but the effects sedimented out of technologies of observation/representation are radically contingent in the sense that other semiotic-material-technical processes of observation would (and do) produce quite different lived worlds, including cognitively lived worlds, not just different statements about worlds as observer-independent arrays of objects. I think that is a richer, more adequate, less ideological account than Gross and Levitt's insistence that science is reality driven (1994:234). Obviously, neither I nor any other science studies person, feminist or otherwise, whom I have ever met or read, means the "laws of physics" get suspended if one enters a "different" culture. That is a laughable notion of both physical laws and cultural, historical difference. It is the position that Gross and Levitt, in deliberate bad faith or else astonishingly deficient reading, ascribe to me and other feminist science studies writers. My argument tries to avoid the silly oppositions of relativism and realism. Rather, I am interested in how an observation situation produces quite "objective" worlds, worlds not subject to "subjective" preference or mere opinion but worlds that must be lived in consequence in some ways and not others. Mutating Hacking's title (1983), I am interested in "representing as intervening." For a theory of "agential realism," to which my arguments about "situated knowledges" is closely related, see Barad 1995a.

13 The *Sharper Image Catalogue* is a lavishly illustrated advertising brochure for high-technology personal-fitness technology and related paraphernalia. With *Sharper Image* products, the shopper can recraft the body into a properly enhanced platform for supporting the upper-echelon citizens of techno-science.

14 Dürer's, Titian's, Velázquez's, Rubens's, and Manet's nudes all figure prominently in accounts of the emergence of modern ways of seeing. See Clark 1985. The relation between Manet's African serving woman and the reclining European nude also figures in the fraught racialized visual history of modern Woman. See Nead 1992:34–36; Harvey 1989:54–56.

15 An obstetrical nurse told me Kelly's First Woman might be replaying the sequential images of her pregnancy, which she was given on compact disc (CD) from the several sonograms recorded over the months of gestation. These CDs are narrative visual imagery that are solidly inside the conventions of Christian realism and its practices of figuration.

16 For a wonderful treatment of masculine self-birthing, see Sofia 1992.

17 Stefan Helmreich (personal communication) correctly insists that the "differently embodied" or materialized entities called information structures, which ALife researchers make and play with, must not be equated with "embodi-

ment" as a point of reference for "locating situated and accountable lived experience." See Hayles 1992. Note also that AI and ALife are not the same thing. Langton argues that ALife uses "the technology of computation to explore the dynamics of interacting information structures. It has not adopted the computational paradigm as its underlying methodology of behavior generation, nor does it attempt to 'explain' life as a kind of computer program" (as AI has) (1988:38).

18 Monica Casper 1995b suggested the notion of the fetus as a work object, from which Kelly led me to extrapolate to the fetal work station. Casper was a graduate student in medical sociology at the University of California at San Francisco.

19 Ginsberg and Rapp (1991) provide a cogent, reflexive narrative and an invaluable 378-item bibliography for considering the historical, cultural, biological, technological, and political complexity that must inform any consideration of human reproduction.

20 The authors identify reproductive and other scientists' groups; pharmaceutical companies; antiabortion groups; feminist prochoice groups; women's health movement groups; politicians, Congress, and the Food and Drug Administration; and women users and consumers of RU486. For a discussion of the transition from a "modernist" focus on control of pregnancy and birth to programs of "postmodern" redesign, see Clarke 1995.

21 From her dissertation through her current book, *Making Life Make Sense*, Hartouni (forthcoming) has shaped my thinking about feminist theories of reproductive freedom.

22 For these kinds of meanings of ethnographic practice in science studies, see the papers in Downey, Dumit, and Traweek forthcoming and Escobar 1994. I adapt my discussion of being at risk as intrinsic to doing ethnography from conversations with Susan Harding, Anthropology Board, UCSC.

23 Quoted in Braidotti (1994:2). In her discussion of figuration as a "politically informed account of an alternative subjectivity," Braidotti (1994:1–8) recalled my attention to bell hooks's discussion of "postmodern blackness" in terms of that kind of consciousness called "yearning." Braidotti's nomadic subjects and hooks's yearning are akin to Chéla Sandoval's notions of oppositional and differential consciousness (Sandoval forthcoming).

24 An examination of the perverse desires of the mutated, antiracist, feminist modest witness in technoscience can be advanced by adopting the reading practices of Teresa de Lauretis (1994).

25 This heading is in honor of Clarke and Fujimura 1992.

26 Remember Audre Lorde's famous warning rom the 1970s: "The Master's Tools Will Never Dismantle the Master's House" (Lorde 1984).

27 Boston Women's Health Book Collective (1976; 1979). The Boston Women's Health Book Collective began putting out *Our Bodies, Ourselves* in newsprint form in the 1970s as an integral part of activist health struggles. See Gerson (forthcoming). For a bibliography of the early women's health movement and feminist science and medicine studies from the 1970s, see Hubbard, Henifin, and Fried 1982. Despite its extensive concern with instruments and tools,

practices in and out of the laboratory, and science-in-the-making, the kind of activist-based material in Hubbard, Henefin, and Fried's bibliography is systematically excluded from professional, academic histories of science and technology studies. See, for example, Knorr-Cetina and Mulkay 1992.

28 Moulton was William Moulton Marston, psychologist, attorney, inventor of the lie-detector test, prison reformer, and businessman. Marston's conventional feminism ascribed force bound by love to women and opposed that to men's attraction to force alone. Despite her origins in the Amazon, Wonder Woman's ethnicity was unmistakably white. Her expletives ("Merciful Minerva!" and "Great Hera!") and her other cultural accouterments locate her firmly in the modern myth of Western origins in ancient Greece, here relocated to the New World. She could have easily joined a U.S. white sorority in the 1940s and 1950s, with their Greek-revivalist themes and rituals. The guiding goddesses of Wonder Woman's Amazonian matriarchal paradise were Aphrodite and Athena. See Edgar 1972. Thanks to David Walls and Lucia Gattone for the Ms. Wonder Woman issue and to Katie King for Wonder Woman lore.

29 SimCity2000™ is one of a series of highly successful simulation games put out by the Maxis Corporation. See Bleecker 1995.

30 Thanks to Adele Clarke for pointing out the Sister cartoon and Ehrenreich and English's use of it.

32 See, for example, Committee for Abortion Rights and Against Sterilization Abuse 1979; Coalition for the Reproductive Rights of Workers 1980; Black Women's Community Development Foundation 1975; Davis 1981; Smith 1982; White 1990. This literature reflects the dominance of the black-white racial polarity of U.S. society and understates the presence and priorities of other racial-ethnic women in women's health and reproductive politics of that period. See Moraga and Anzaldúa 1981.

32 I am in permanent debt to Nancy Harsock's (1983) pioneering formulation of nonessentialist feminist standpoint theory. Standpoint theories are not private reservations for different species of human beings, innate knowledge available only to victims, or special pleading. Within feminist theory in Hartsock's lineage, standpoints are cognitive-emotional-political achievements, crafted out of located social-historical-bodily experience—itself always constituted through fraught, noninnocent, discursive, material, collective practices—that could make less deluded knowledge for all of us more likely. My arguments in this chapter also draw from Harding 1992 on strong objectivity as a mode of extended critical examination of knowledge-producing apparatuses and agents; Collins 1991 on the internally heterogeneous and insider/outsider locations that have nurtured Black feminist thought; Star 1991 on viewing standards from the point of view of those who do not fit them but must live within them.; Butler 1992 on contingent foundations as achievements and agency as practice rather than attribute; Haraway 1988 on situated knowledges in scientific epistemology and the refusal of the ideological choice between realism and relativism; hooks 1990 on yearning—rooted in the his-

torical experience of oppression and inequality but unimpressed by stances of victimhood—that can bind knowledge and action across difference; Sandoval forthcoming on the potential of learning and teaching oppositional consciousness across multiple and intersecting differentiations of race, gender, nationality, sexuality, and class; Bhavnani 1993 on feminist objectivity within a polyglot world; and Tsing 1993a and b on multiple centers and margins and on the stunning complexity and specificity of local-global cross-talk and circulations of power and knowledge. That Hartsock, Harding, Collins, Star, Bhavnani, Tsing, Haraway, Sandoval, hooks, and Butler are not supposed to agree about postmodernism, standpoints, science studies, or feminist theory is neither my problem nor theirs. The problem is the needless yet common cost of taxonomizing everyone's positions without regard to the contexts of their development, or of refusing rereading and overlayering in order to make new patterns from previous disputes. I am recontextualizing all of this writing to make a case for how thinking about reproductive freedom should make its practitioners reconfigure how to do technoscience studies in general. Theory and practice develop precisely through such recontextualization. For learning to read the always topographically complex history of feminist theory (and theory projects broadly), see King 1994.

33 Adele Clarke (personal communication, May 16, 1995) reminded me of the history of recent feminist efforts to build reproductive policy from the standpoints of the most vulnerable, for example, the explicit program of the Reproductive Rights National Network in the 1970s and '80s. Clarke recounted the example of the passage of sterilization regulations in California, which applied to all sterilizations, not just those funded by Medicaid. Developed by Coalition for Abortion Rights and Against Sterilization Abuse (CARASA), national sterilization regulations applied only to Medicaid recipients. Shepherded by the Committee to Defend Reproductive Rights (CDRR), the California regulations—the only ones to pass on a state level—were the fruit of difficult coalition-building between middle-class, mostly white women from the National Organization for Women, who were more affected by inaccessible sterilization, and working-class and non-white women's groups, who were more impacted by abusive sterilization. In the 1990s, the ordinary situation of multiple and heterogeneous vulnerabilities and capabilities, which imply conflicting policy needs, demands urgent feminist attention in local and global dimensions. The International Reproductive Rights Research Action Group (IRRRAG) is a collaborative, multicountry research project on the meanings of reproductive rights to women in diverse cultural settings See Petchesky and Weiner 1990. Petchesky is the coordinator of IRRRAG. Written by an international group of feminist activists and scholars, the papers in Ginsberg and Rapp 1995 put reproduction at the center of social theory in general and, through detailed and culturally alert analyses, show how pregnancy, parenting, birth control, population policies, demography, and the new reproductive technologies shape and are shaped by differently situated women. Nonreductive feminist

reproductive discourse and policy can flourish in this context. For example, Barroso and Corrêa (1995:292–306) show how the difficult interactions of feminists and researchers around the introduction of Norplant into Brazil resulted ultimately in raised public consciousness, attention to informed consent in Norms of Research on Health approved by the Ministry of Health, and effective local ethics committees. Nonfeminist approaches to reproductive technologies still abound everywhere. At the 1994 American Fertility Society's 50th Anniversary Meetings in San Antonio, Texas, a Norplant ad poster prominently features the words "Compliance-free contraceptive." Thanks to Charis Cussins for photographic evidence.

34 For the story of public health statistics intrinsic to freedom projects in the twentieth-century United States, see Fee and Krieger 1994. For a view of a feminist economics think tank, see the publications (e.g., Spalter-Rother et al. 1995) of the Washington, D.C., Institute for Women's Policy Research, cofounded by Heidi Hartman, winner of a 1994 MacArthur Fellowship for her work.

35 Following Rutherford, my point here is about toxics and reproductive freedom. In a related argument that has shaped my own, Giovanna DiChiro (1995a and b) shows how antitoxics movements, very often led by working-class and urban women of color, contest for what counts as nature and environment, what constitutes scientific knowledge, and who counts as producers of such knowledge.

36 My uses of the family of words around the signifier modern is in conversation with Bruno Latour, *We Have Never Been Modern* (1993). I continue to use the flawed, deceptive terms *modern* and *postmodern* partly to highlight the narratives about time in which we all still generally work and partly to insist on the dispersed, powerful, practical networks of technoscience that have changed life and death on this planet, but not in the ways most accounts of either progress or declension would have it. *Modern* and its variants should never be taken at face value. I try to force the words—like all meaning-making tools—to stumble, make a lot of racket, and generally resist naturalization. It's a losing battle.

37 Scheper-Hughes was tracking births and deaths that still escape the net of official national or international statistics late in the twentieth century. She points out that the statistic for infant mortality was first devised in Britain in 1875. The British Registration Act of 1834 required that all deaths be recorded and given a medical cause, thus replacing the "natural deaths" of children and the aged, at least in the intentions of the reformers. Pediatrics emerged as a medical specialty in Western medicine in the first decades of the twentieth century. Relative to other discourses critical to the regimes of biopower, child survival, much less fetal and infant survival, has a late pedigree everywhere as a problem requiring statistical documentation and action. Childhood malnutrition was first designated a pediatric disease in 1933 in the context of colonial medicine. "Protein-calorie malnutrition in children (of which there was an epidemic in nineteenth-century England) . . . only entered medical nosology when British doctors working in the colonies discovered it as a 'tropical' disease" (Scheper-Hughes 1992:274–75). For the pioneering history of mor-

tality statistics in France and their connection to class formations, production, residence, and contending political ideologies, see Coleman 1982.

38 Actually, for the middle- and upper-class Brazilian women in this town, modern scientific birth meant delivery by cesarean section rather than the "new reproductive technologies" favored by their Northern sisters. Scheper-Hughes recounts watching young girls play at giving birth by enacting the imagined surgical scenario. After the successful play-birth, the new "infant was immediately put on intravenous feedings!" Regional newspapers report that cesarean-section delivery rates among private maternity patients in northeastern Brazil approach 70 percent (Scheper-Hughes 1992:329).

39 See also MacArthur 1962. The mathematical equation need not carry the ideological interpretation that seems to proliferate so readily in the texts of some sociobiologists, but the interpretation is, so to speak, a natural. Stefan Helmreich summarized for me a particularly egregious racial-sexual rendering of r- and K-selection arguments, with people of African descent having more extramarital affairs, Black men having longer penises, Black women having shorter menstrual cycles, and a host of other racist-sexist pseudo-facts leading to the conclusion of different evolutionary strategies among (leaving aside the problem of the biological reality of the categories) white, Black, and Oriental populations. See Rushton and Bogaert 1987, and for an internalist response to their work as bad science, see Fairchild 1991. Without question, "good" and "bad" science are categories worth fighting for within the perspectives of strong objectivity, agential realism, and situated knowledge. It's just that the categories only do a bit of the needed critical work. How is it that sexual behavior, human and otherwise, as nonideologically represented by the best science, is solidly an instance of investment strategies, ontologically indistinguishable from other kinds of portfolio management, where the point is to stay in the game? How and why, materially-semiotically, did we make the world-for-us this way? Who are we? Are there still alternatives? The matter is hardly observer-independent, no matter what mathematical tools are in play! The matter is also not conceivably solved by individual choice of a different representational apparatus. Chic resistance talk will get one nowhere; material-cultural analysis might have a chance of providing consequential insight.

40 The blunt racist imagery of the warm, sordid, genital, fecund, and colored tropics contrasted to the cold, hygienic, cerebral, reproductively conservative, and white North is officially disavowed and discredited, but I believe it still haunts U.S. popular and technical discourse on many levels and on many occasions, including elections and periods of white middle-class frenzy about "welfare mothers."

41 "In the U.S., 30 million people suffer chronic under-consumption of adequate nutrients. Almost half of the hungry are children . . . 76% of the hungry are people of color" (Allen 1994:2). In October 1994, in race-undifferentiated figures, the U.S. Census Bureau reported that 15 percent of the population, that is, 39.3 million people, officially lived in poverty in 1993. That year, the federal government defined poverty as a family of four with a total annual income of $14,800 or less. The U.S. child-poverty rate is about double that of

any other industrialized nation.

42 Scheper-Hughes estimated that the shantytown women she worked with, or for whom she could get records, had about six more pregnancies than their wealthier townswomen living nearby but ended up with only *one* more living child. In her ethnographic account, poorer women, especially in younger cohorts, expressed a preference for fewer children than did more affluent women, not more. These preferences were not realizable in the semiotic and material conditions that the women experienced.

43 Scheper-Hughes's descriptions and interpretations of parental reactions to child morbidity and mortality in the impoverished Brazilian Nordeste are controversial (see Nations and Rebhun 1988), but the descriptions of malnutrition and infant mortality are not disputed. Brazil has the eighth-largest economy in the world, but about 75 percent of its citizens in the Nordeste are malnourished.

44 Immunization was not the only way that contemporary allopathic medicine marked the bodies of the extremely poor. In contrast to the infants and children of the rich, the poorest babies also ate a steady diet of strong antibiotics and many other types of medicine. In this context, the marginalized poor might say, "We have never *not* been modern."

45 "In Brazil the decline in breast-feeding has been precipitous; between 1940 and 1975 the percentage of babies breast-fed *for any length of time* fell from 96% to less than 40%. . . . Since that time it has decreased even further" (Scheper-Hughes 1992:317). Breastfeeding has also declined in the United States. In 1993, only 50 percent of all new mothers initiated breastfeeding while in the hospital, and only 19 percent persisted after six months. In the United States, breastfeeding is also deeply differentiated by class and race, with the most privileged groups "choosing" breastfeeding the most often, and their less-well-off sisters "choosing" artificial formula. For example, 70 percent of college-educated mothers breastfed their infants at birth, compared to 43 percent of those with a high school education and 32 percent of those with an elementary school education; 23 percent of Black mothers breastfed their babies at birth, compared to 59 percent of white mothers (Blum 1993:299). Through its Women, Infants, and Children Program (WIC), the U.S. government purchases about $1.7 billion of formula per year for use by poor mothers, covering about 40 percent of all U.S. babies (Baker 1995:25). Advertising by formula companies remains a big issue, and it works in conjunction with the absence of child-care and maternal support policies that would make breastfeeding feasible for economically disadvantaged people.

46 Lest we lose sight of biotechnology in this chapter, genetic engineering is on the way to duplicating human breast milk. The product could be sold to affluent mothers (or bought by taxpayers for the less affluent) whose own milk might not be quite the thing or whose children might not thrive on current artificial milk. Dutch research with cows involves bovine transgenics with milk-specific human genes so that the animal's secretion mimics the human fluid. See Crouch 1995b. I am not opposed to this research as a violation of inti-

mate female experience and cultural categories of nature, but, like Crouch, I am highly skeptical that this research would do as much to improve babies' and mothers' health as similar amounts of R&D money spent on maternal support policies that increased ordinary breastfeeding or on environmental policies that reduced the toxin burden in women's bodies all over the world.

Chapter 6. Race: Universal Donors in a Vampire Culture: It's All in the Family. Biological Kinship Categories in the Twentieth-Century United States

1 Race, nature, gender, sex, and kinship must be thought together. Starting points for grasping U.S. kinship discourse include Schneider 1968, 1984; Stack 1974; Spillers 1987; Collier and Yanagisako 1987; Yanagisako and Delaney 1995; Griswold del Castillo 1984; and Zinn 1978. The nexus of race is tightly webbed together with property, both in terms of transmission of bodily substance and transmission of worldly goods and privileges. For an exhaustive historical and legal argument about white racial status as a persistent form of property still recognized in U.S. law, see Harris 1993.

2 The first vampire novel in English was published in 1847. For the identification of the vampire with Jews, foreigners, capital, mobility, cosmopolitanism, and much else, see Gelder 1994. Starting his story in 1879, Geller (1992) discussed the ties of political anti-Semitism, syphilis and its medical study (and dermatology), doctrines of heredity, beliefs about diseased reproduction, gender and sexuality, acculturation/assimilation and ethnic separation, prostitution and poverty among displaced populations in Central Europe, fear and fascination related to the mimetic arts and masquerade, practices of passing, contested rituals of circumcision, money trafficking and accusations of idolatry, blood pollution ascribed to Jews, and bloodcurdling readings of Hitler's *Mein Kampf* and Dinter's (1917) *volkish* classic, *Die Sünde wider das Blut*, as well as of Marx's anticapitalist and anti-Semitic vampire tropes. Geller argues that "the representations of both syphilis and the Jew are informed by particular constructions of gender and sexuality. Indeed, no single marker of identity—such as disease, race, gender, sexuality—can be determined without recognizing how it interconnects with the others" (1992:23). For tracking the vampire through queer discourse and the problem of lesbian representation, see Case 1991.

3 *Nosferatu* was loosely based on Bram Stoker's 1897 novel, *Dracula*, the dominant source of the twentieth-century image of the vampire in popular culture. The anti-Semitic, sexualized swamp of images in which vampire stories flourished silently soaked the tissues of *Nosferatu*, from the rat-toothed Count Orlock, who controlled the rodents that brought plague to Bremen, to the word *Nosferatu*, derived from an old Slavonic word tied to the concept of carrying the plague, to the illicit sale of German property, signifying the "foreign" threat to an "innocent" German town, a danger mediated by money trafficking, to the mobilization of the *Volk* to chase the monster, to the virgin of pure heart who must save the people by her sacrifice (Gelder 1994:94–98;

Melton 1994:436–39).

4 Thanks to Karen Barad, Physics Department, Pomona College, for suggesting this mathematical trope to subvert the literal effects of historical periodization and above all for emphasizing that it is the resurgence of racism in hereditarian and biologicized dogmas and in anti-immigration hysterias in the 1990s, with eerie similarities to the pre-World War II period, that prompts her unhappiness with the flat table. Metaphors grow out of bodily historical trauma; blood pollution and ethnic cleansing show at least that much. Also, returns and repetitions are never identities.

5 Eugenics is race-hygiene or race-improvement discourse. For the history of eugenics, the classics include Haller 1963; Kevles 1985; Chorover 1979; and Cravens 1978. The development of Mendelian genetics after 1900, in the context of the dominant interpretation of the writing of the late-nineteenth-century German biologist August Weismann, which separated the passage of acquired characteristics from the genetic continuity of the germinal plasm, gradually eroded much of the racial and eugenic discourse I am discussing here. But many U.S. life scientists did not consistently rely on that distinction in their approach to evolution and race until near midcentury, and they certainly did not use Mendelian genetics to develop an antiracist scientific position. If they did insist on the separation of nature and culture, the effect was likely to harden into a genetic, trait-based eugenic doctrine even less open to "liberal," environmentalist contestation. For meanings of "race," see Stocking 1968; Stepan 1982; Barkan 1992; Harding 1993; Gould 1981; and Goldberg 1990.

6 For African American women's configurations of racial discourse, including scientific doctrines, in the late nineteenth and early twentieth centuries, see Carby 1987.

7 Charlotte Perkins Gilman's *Herland* (1979), serialized in *The Forerunner* in 1915, is full of the unself-critical white racialism that wounded so much of American feminism. Grant's writing (1916), is replete with unadulterated Nordic superiority and condemnation of race-crossing. A corporation lawyer, Madison Grant was a leader in eugenics, immigration restriction, and nature conservation politics—all preservationist, nativist, white-supremist activities. See Haraway 1989:57.

8 The full story of the Akeley African Hall is told in Haraway 1989:26–58, 385–88.

9 The discipline of population genetics—as opposed to the more ecologically minded population biology—has tended to exclude the development of organisms from their explanatory hypotheses and to rely almost exclusively on mutation and other ways to alter the frequency and products of individual genes to account for evolutionary change at all levels. Working against this severely limited focus, Scott Gilbert argues that for evolution above the sub-species or population level, changes in developmental pattern are key. Drawing on the molecular analysis of genes critical to homologous developmental pathways in a wide range of organisms—analytical procedures only possible since the late 1980s—Gilbert, Optiz, and Raff (1996) discuss the idea of homologies of process, as well as of older homologies of structure, in the context of a new

310

evolutionary synthesis that emphasizes, unlike population genetics, embryology, macroevolution, and homology. In this new synthesis, the developmental or morphogenetic field is "proposed to mediate between genotype and phenotype. Just as the cell (and not its genome) functions as the unit of organic structure and function, so the morphogenetic field (and not the genes or the cells) is seen as a major unit of ontogeny, whose changes bring about changes in evolution" (Gilbert, Optiz, and Raff 1996:357). I think this kind of evolutionary synthesis, in the context of the much more common "gene individualist" arguments in 1990s genomic and biotechnological discourse, is both refreshing and scientifically exciting. In the kind of work Gilbert signals and contributes to, neither the dominant gene/population nor genome/database formulations take one to the center of evolutionary questions. Gilbert, Optiz, and Raff's proposals should remind the reader that my chart seriously oversimplifies the debates going on today in molecular biology, development, and evolution.

10 For an overview of these complex developments, see Mayr and Provine 1980; Kaye 1986; Simpson 1967; Dobzhansky 1962; and Keller 1992a.

11 The African American physical anthropologist Ashley Montagu Cobb at Howard University, one of the very few doctoral Black experts in the field, was not asked to sign the document. In the context of constitutively self-invisible, international, white scientific hegemony, his signature seemed to imply racial favoritism, not universalist, culture-free, scientific authority. In a spirit of peace, I won't even mention the gendering of the new plastic universal man—until he starts hunting in a species-making adaptation that will defeat my present restraint.

12 This account is an illustrative caricature of much more contradictory processes and practices within which the UNESCO documents lived. For a fuller but still inadequate account, see Haraway 1989:197-203. The cartoon version of the sharing way of life in the following section of this essay is argued in sober detail in Haraway 1989:186-230, 405-08.

13 The infamous gem of Man-the-Hunter theorizing was Washburn and Lancaster 1968. Woman the Gatherer made her debut in Linton 1971. She was fleshed out in Tanner and Zihlman 1976.

14 If one is weary of narrative drama and its unmarked psychoanalytic, political, and scientific universalist plots, feminist theory is the place to turn. See de Lauretis 1984:103–57; LeGuin 1988:1–12; Kim and Alarcon 1994; Sandoval 1991; V. Smith 1994.

15 Mr. Matternes refused permission to publish his painting in this chapter. *Fossil Footprint Makers of Laetoli* can be seen in *National Geographic Magazine*, April 1979, pp. 448–49.

16 Ongoing debate over the origin of modern *Homo sapiens* is another effort to track humanity's travels, with Africa again at the center of controversy. Since the late 1980s, the main alternative hypotheses are the multiregional origin account, founded on comparative anatomical studies, and the out-of-Africa theory, grounded in mitochondrial-DNA (mtDNA) analyses that are interpreted to mean that the most recent common ancestor of all living humans is

a female who lived in Africa perhaps as recently as 112,000 years ago (Gibbons 1996:1271). The sperm contribute no mitochondria (a kind of cell organelle) to the fertilized egg cell, so mtDNA is inherited only through the female line. Providing a kind of clock, genetic changes accumulate over time. The mtDNA from the sampled populations living in Africa, itself an immense continent, shows the most variation compared to all other studied mtDNA taken from modern people living in different major geographical areas. This fact ought to give giant pause in the face of any generalizing genetic arguments about people of African descent, including the idea that modern races have much, if any, genetic meaning—if any such reminder is needed to maintain a skeptical attitude about claims that genetic bases justify contemporary racial classifications. This issue should be kept firmly in mind in addressing resurgent claims about heritability of IQ and association of IQ differences with ethnic/racial groups. The flap surrounding publication of *The Bell Curve* is the most important recent controversy. See Herrnstein and Murray 1994; Jacoby and Glauberman 1995. The fact that the greatest reservoir of human variation exists in Africa ought also to make organizers of genetic databases of human nuclear DNA think harder about how to develop reference composite standards for the species. Showing how deeply embedded the idea of race still is in physical anthropology, Brendan Brisker (1995), a graduate student in the Anthropology Board at the University of California at Santa Cruz, analyzed the inadvertent use of racial typologies in the geographical sampling procedures and central arguments in the first mtDNA paleoanthropological studies. A special issue of *Discover* in November 1994 sketches the renewed debate in the 1990s about the scientific reality of race, and Lawrence Wright (1994) describes the controversy in the United States about racial typologies built into the U.S. census, which do not reflect the current multiplying racial/geographical categories and mixes claimed by people.

17 The special pull-out section of this *Science* magazine annual issue on the genome was dedicated to databases. See also Nowak 1993:1967.

18 Making life into a force of production and reorganizing biology for corporate convenience can be followed in Yoxen 1981; Wright 1986; and Shiva 1993.

19 The incisive critique of human sociobiology is Kitcher 1987. On unit-of-selection debates, see Brandon and Burian 1984. Defying classification as technical or popular, Dawkins 1976 and 1982 are the best expositions of the logic of the fierce competitive struggle to stay in the game of life, relying on strategies of flexible accumulation that strangely seem so basic to postmodern capitalism as well. For the theory of flexible accumulation in political economy, see Harvey 1989. For multilevel feminist working of the theme of flexibility in the American biomedical body, see Martin 1994.

20 The idea of nature and culture "enterprised up" is borrowed from Marilyn Strathern 1992, a treatment of assisted conception and English kinship in the period of British Thatcherism.

21 In eugenics thinking, the good of the "race" is the central ideological value. The

collective aspect is hard to overstress. In 1990s genetic biomedical discourse, the "race"—either humanity as a whole or a particular racial category such as "white people"—plays little or no role, but individual reproductive investment decisions and individual genetic health are central.

22 A good place to start reading on the subject is Kevles and Hood 1992. Flower and Heath (1993) show how the semiotic-material definition of the human species in the world's genetic databases works through the multiple and heterogeneous processes that construct a reference sequence, or "consensus DNA sequence," as "the" human genome.

23 On "agency" in Internet habitats, see Waldrop 1994.

24 The supplement to the *Oxford English Dictionary* puts the first uses of the term *genom* (sic) in the 1930s, but the word did not then mean a database structure. That sense emerged from the consolidation of genetics as an information science, and especially since the 1970s.

25 I am indebted to an unpublished manuscript by the UCSC anthropology graduate student Cori Hayden (1994a). See Cavalli-Sforza et al. 1991; RAFI 1993:13; Spiwak 1993; and RAFI 1994.

26 I have been instructed by Giovanna DiChiro (1995a and 1995b) on what and who will count as science and as scientists. I draw also on Tsing 1993a and Cussins 1994. All three analysts trouble inherited categories of body and technology, nature and culture, wilderness and city, center and margin—all of which are part of producing the ideological distinction between modern and traditional that makes it seem odd for indigenous peoples to be savvy users and producers of genome discourse. For excellent analysis of problematic discourses of racial difference in ecofeminism, partly rooted in continuing separation of nature and culture and turning to "native" women as resources against the violations of industrial culture, see Sturgeon forthcoming.

27 See Star and Griesemer 1989 for development of the concept of boundary objects.

28 The scramble for the control of "biodiversity," itself quite a recent discursive object, is complex, global, and fraught with consequences for ways of life. Hayden 1994b discusses the 1991 "biodiversity prospecting" agreement between INBio, a Costa Rican nonprofit environmental institute, and Merck, Sharpe and Dohme, the world's biggest pharmaceutical firm. The agreement is a controversial effort to control biopiracy and turn biodiversity resources in "gene-rich" developing countries to their advantage. Biodiversity prospecting arrangements, the Human Genome Diversity Project, debt-for-nature swaps, the Biodiversity Convention, and GATT are just a few examples of the emerging institutional structure shaping human relations to nature in a world where the relations of technoscience to wealth and well-being have never been tighter. See World Resources Institute et al. 1993; Juma 1989; Shiva 1993.

29 See Tsing 1993b for a subtle ethnographic treatment of the complexities of what counts as marginal/central and local/global in an area of Indonesia that is also at the heart of environmental controversies.

30 Reprinted with permission of Du Pont NEN Products. On May 19, 1995, Du Pont announced its intent to divest its Medical Products businesses. The former

Du Pont NEN Products business will become NEN Life Science Products.

31 According to the *Oxford English Dictionary*, the term *miscegenation* was coined in the United States in 1864.

32 A \$3-million National Pregnancy and Health Survey of 2,613 women who gave birth at 52 hospitals around the nation in 1992 suggests how many and which U.S. pregnant women actually use substances that could harm the fetus (and the bottom line for an HMO). Conducted for the National Institute on Drug Abuse and released in September 1994, the study concludes that more than 5 percent of the four million U.S. women who gave birth in 1992 used illegal drugs, while about 20 percent used cigarettes and/or alcohol. Smokers and drinkers were more likely to use illegal drugs than were ethanol and nicotine abstainers. White women were more likely to drink or smoke during pregnancy than women of color (23 percent of white women drank, compared to 16 percent African American and 9 percent Hispanic; 24 percent of white women smoked, compared to 20 percent Black and 6 percent Hispanic). The racial categories here are crude and partial, but they still have limited utility. Poor, less-educated, unemployed, and unmarried women were more likely to use illegal drugs than more privileged women. About 11 percent of pregnant African American women used such drugs, compared to 5 percent of white and 4 percent of Hispanic mothers-to-be. That still means that more than half of the 221,000 pregnant women who used illegal drugs were white, 75,000 were Black, and 28,000 Hispanic. Alcohol and tobacco can harm a developing fetus as much or more than illegal drugs but with less social and financial stigma. Overall, about 820,000 babies were born to smokers and 757,000 to imbibers. The same baby can show up in all the user categories. The study showed that most women tried to avoid illegal drugs, alcohol, and smoking during pregnancy, but few who used these powerful substances succeeded entirely. See Connell 1994:A7. The need for supportive, nonpunitive treatment for women trying to have a healthy pregnancy could hardly be clearer. Along with readily available, prowoman, substance-treatment programs for those with any of these addictions, raising the incomes and improving the educations of women would likely be the most successful public health measures. Such measures would far outstrip the benefit to child and maternal health from intensive neonatal care units in high-tech hospitals, not to mention the dubious health results from criminalizing users. There is an unholy alliance between medicine as a system and millions of pregnant women in the United States, and it is reflected in the incomes of physicians compared to the incomes of at-risk mothers-to-be. The direction of flow of precious bodily fluids is the reverse of that suggested by the gleaming tooth and gold wedding band of the PreMed ad.

33 Selling in early 1994 for \$239 for Macintoshes and \$169 for Windows–using machines, Morph was widely used by scientists, teachers, special-effects designers for Hollywood movies, businesspeople making presentations, and law enforcement personnel, for example, for aging missing children. A competitor in the market, PhotoMorph, came with graphics for practicing— "women turning into men, a girl turning into an English sheepdog, a frog

"women turning into men, a girl turning into an English sheepdog, a frog turning into a chicken" (Finley 1994:F1-2). Finley illustrated his article with a series of morphed transformations between the competing personal computer giants, Apple Computer confounder Steve Jobs and Microsoft founder Bill Gates. Mergers in the New World Order can be effected by many means. Needless to say, anyone still believing in the documentary status of photographs had better not get a copy of Morph, go to the movies, or look at the missing children on milk cartons.

34 Morphed photograph by Nancy Burson in Jones, Martin, and Pilbeam 1992. Thanks to Ramona Fernandez of the University of California at Santa Cruz for sending me this example.

35 Thanks to Giovanna DiChiro, University of California at Santa Cruz, for the tip on this image and for Hiro's comments from the *Today Show* of August 17, 1994.

36 The computer chip "impresses" its form on the morphed woman; the chip "informs" its electronic progeny in enduring Aristotelian doctrines of masculine self-reproduction that have "impressed" thinkers in the West for many centuries. The perfecting of the copy of the father in the child could be marred by the lack of transparency in the medium of the mother. Mutations on this theme proliferate in cyberspace, as in many other technoscientific wombs at the end of the Second Christian Millennium. For a discussion, which informs my chapter, of doctrines of impression, reproduction, and sanctity in medieval women saints, see Park 1995.

37 Scott Gilbert, personal e-mail communication, September 26, 1995, in response to a previous version of "Universal Donors." Thanks to Gilbert for insisting that I include "Black and White."

38 Fernandez (1995b) emphasizes the trickster theme in her essay on traveling through Disney's many worlds, reading with the mixed cultural literacies required in the turn-of-the-century United States.

39 Thanks to Rosi Braidotti and Anneke Smelik, new parents of two lovely morphed offspring, for this description of what they found possible in America in 1995. These sober European feminist theorists testified that they bonded instantly with their cyberchildren when they saw the compelling photographs of offspring so like and unlike themselves. The emotions were quite potent, even if the children were a little ethereal. I think there is potential here for population-reducing ways of having one's own children after all, in as great a number as one's willingness to put $5 in the machine will allow.

40 Castañeda's and my interpretations of the figures in this issue of *Time* evolved together in conversation, her hearing of my talk for a History of Consciousness colloquium Feb. 9, 1994, and my reading of her paper. I also draw on undergraduate students' readings of these images in a final exam in my fall 1993 course Science and Politics.

41 Meanwhile, fitting the analysis found in Emily Martin's *Flexible Bodies*, U.S. corporations attempt to capitalize on a particular version of multiculturalism. For an unembarrassed argument, see J. P. Fernandez 1993. See also Kaufman 1993.

REFERENCES

AAAS (American Association for the Advancement of Science). 1993. *Mapping the Human Brain*, AAAS Special Symposium, February 14–15 at Boston.

Allen, Patricia. 1994. "The Human Face of Sustainable Agriculture: Adding People to the Environmental Agenda." Center for Agroecology and Sustainable Food Systems, University of California at Santa Cruz. *Sustainability in the Balance Series* (Issue Paper No. 4).

Alpers, Joseph. 1994. "Putting Genes on a Chip." *Science* 264:1400.

Althusser, Louis. 1971. "Ideology and Ideological State Apparatuses." *Lenin and Philosophy and Other Essays*. New York: Monthly Review Press, 121–73.

Anderson, Christopher. 1993. "Researchers Win Decision on Knockout Mouse Pricing." *Science* April 2, 260:23–24.

Andrews, Edmund L. 1993. "U.S. Resumes Granting Patents on Genetically Altered Animals." *New York Times*, February 3, A1, C5.

Anker, Suzanne. 1994. *Gene Culture: Molecular Metaphor in Visual Art.* New York City: Plaza Gallery.

Appiah, Kwame Anthony. 1985. "The Uncompleted Argument: Du Bois and the Illusion of Race." *Critical Inquiry* 12:21–35.

_____. 1990. "Racisms." In *Anatomy of Racism*, edited by D. T. Goldberg. Minneapolis: University of Minnesota Press, 3–17.

Aratani, Lori. 1993. "Students Learn 'Lofty" Science Is Within Their Reach." *San Jose Mercury News*, April 25, 2B.

Arthur, Charles. 1993. "The Onco-Mouse That Didn't Roar." *New Scientist* 138 (1879):4.

Auerbach, Erich. 1953. *Mimesis: The Representation of Reality in Western Literature.* Princeton: Princeton University Press.

Baker, Linda. 1995. "Message in a Bottle." *In These Times* 19 (20):24–26.

Bakhtin, Mikhail. 1981. *The Dialogical Imagination.* Edited by M. Holquist. Austin: University of Texas Press.

Barad, Karen. 1995a. "Meeting the Universe Halfway: Ambiguities, Discontinuities, Quantum Subjects, and Multiple Positionings in Feminism and Physics." In *Feminism, Science, and the Philosophy of Science: A Dialog,* edited by L. H. Nelson and J. Nelson. Norwell, MA: Kluwer Press.

_____. 1995b. "A Feminist Approach to Teaching Quantum Physics." In *Teaching the Majority: Breaking the Gender Barrier in Science, Mathematics, and Engineering*, edited by S. V. Rosser. New York: Teachers College Press.

Barinaga, Marcia. 1990. "Neuroscience Models the Brain." *Science* 247 (February 2):524–26.

———. 1994. "Knockout Mice: Round Two." *Science* 265 (July 1):26–28.

Barkan, Elazar. 1992. *The Retreat from Scientific Racism: Changing Concepts of Race in Britain and the United States Between the World Wars.* New York: Cambridge University Press.

Barker, Benjamin. 1984. *Strong Democracy.* Los Angeles and Berkeley: University of California Press.

Barker, Joanne. 1995. "Indian Made." Qualifying essay, History of Consciousness Board, University of California at Santa Cruz.

Barr, Marleen S. 1992. *Feminist Fabulation: Space/Postmodern Fiction.* Iowa City: University of Iowa Press.

Barroso, Carmen, and Sônia Corrêa. 1995. "Public Servants, Professionals, and Feminists: The Politics of Contraceptive Research in Brazil." In *Conceiving the New World Order: The Global Politics of Reproduction,* edited by F. D. Ginsberg and R. Rapp. Los Angeles: University of California Press, 292–306.

Beardsley, Tim. 1994. "Big-Time Biology." *Scientific American* 271 (5):90–97.

Becker, William, and Michael Flower. 1993. "Science in the Liberal Arts Curriculum." National Science Foundation Grant Proposal.

Bereano, Philip. 1995. "Broad Coalition Challenges Patents on Life." Press release, June 6.

Berger, Bennett M. 1994. "Taking Arms." Review of *Higher Superstition,* P. Gross and N. Levitt. *Science* 264:985–89.

Bernal, Martin. 1987. *Black Athena: The Afro-Asian Roots of Classical Civilization.* Vol. 1. London: Free Association Books.

Bhavnani, Kum-Kum. 1993. "Tracing the Contours: Feminist Research and Feminist Objectivity." *Women's Studies International Forum* 16 (2):95–104.

Bishop, Jerry E., and Michael Waldholz. 1990. *Genome: The Story of the Most Astonishing Scientific Adventure of Our Time—The Attempt to Map All the Genes in the Human Body.* New York: Simon and Schuster.

Black Women's Community Development Foundation (BWCDF). 1975. *Mental and Physical Health Problems of Black Women.* Washington, DC: BWCDF.

Bleecker, Julian. 1995. "Urban Crisis: Past, Present, and Virtual." *Socialist Review* #94/1+2:189–221.

———. forthcoming. "'Helping Build a Better Dinosaur': The Special Effects of Technoscience." *Cultural Studies.*

Blum, Linda M. 1993. "Mothers, Babies, and Breastfeeding in Late Capitalist America: The Shifting Contexts of Feminist Theory." *Feminist Studies* 19 (2):291–311.

Boose, Lynda E. 1994. "'The Getting of a Lawful Race': Racial Discourse in Early Modern England and the Unrepresentable Black Woman." In *Women, "Race," and Writing in the Early Modern Period,* edited by M. Hendricks and P. Parker. New York: Routledge, 35–54.

Boston Women's Health Book Collective. 1976. *Our Bodies, Ourselves: A Book by and for Women.* 2nd ed. New York: Simon and Schuster.

Boston Women's Health Book Collective. 1979. *Nuestros Cuerpos, Nuestras Vidas.* Somerville, MA: BWH Book Collective, Inc.

Bouchard, Thomas J., Jr., D. T. Lykken, M. McGue, N. L. Segal, and A. Tellegen. 1990. "Sources of Human Psychological Differences: The Minnesota Studies of Twins Reared Apart." *Science* 250 (October 12):223–28.

Bowker, Geoffrey. 1993. "How to Be Universal: Some Cybernetic Strategies." *Social Studies of Science* 23:107–27.

Braidotti, Rosi. 1994. *Nomadic Subjects: Embodiment and Subjectivity in Contemporary Feminist Theory*. New York: Columbia University Press.

Brandon, Robert N., and Richard M. Burian, eds. 1984. *Genes, Organisms, Populations: Controversies over the Units of Selection*. Cambridge: MIT Press.

Braverman, Harry. 1974. *Labor and Monopoly Capital*. New York: Monthly Review Press.

Bremer, Michael. 1992. *SimLife User Manual*. Orinda, CA: Maxis.

Brisker, Brendan R. 1994. "Rooting the Tree of Race: mtDNA and the Origin of *Homo sapiens*." Unpublished manuscript, Anthropology Board, University of California at Santa Cruz.

Bugos, Glenn. 1992. "Intellectual Property Protection in the American Chicken-Breeding Industry." *Business History Review* 66:127–68.

———. 1994. "Making Biodiversity Public and Private: Three Eras of American Biodiversity Institutions." Unpublished manuscript in progress for Arnold Thackray, ed., *Private Science*.

Bugos, Glen E., and Daniel J. Kevles. 1992. "Plants as Intellectual Property: American Practice, Law, and Policy in World Context." *Osiris* (7):75–104, 2nd series.

Butler, Judith. 1992. "Contingent Foundations: Feminism and the Question of Postmodernism." In *Feminists Theorize the Political*, edited by J. Butler and J. Scott. New York: Routledge, 3–21.

Butler, Octavia. 1987. *Dawn*. New York: Warner Books.

———. 1988. *Adulthood Rites*. New York: Warner Books.

———. 1989. *Imago*. New York: Warner Books.

Callon, Michel. 1986. "Some Elements of a Sociology of Translation: Domestication of the Scallops and the Fishermen of St. Brieuc Bay." In *Power, Action and Belief: A New Sociology of Knowledge?* edited by J. Law. London: Routledge, 196–223.

Campbell, Nancy. 1995. "Cold War Compulsions: U.S. Drug Science, Policy, and Culture." Ph.D. diss., History of Consciousness Board, University of California at Santa Cruz.

Campbell, Neil A. 1993. *Biology*. 3rd ed. Redwood City, CA: Benjamin Cummings.

Canguilhem, Georges. 1989. *La conaissance de la vie*. Revised and augmented 2nd ed. Paris: J. Vrin.

Carby, Hazel V. 1987. *Reconstructing Womanhood: The Emergence of the Afro-American Woman Novelist*. New York: Oxford University Press.

Case, Sue-Ellen. 1991. "Tracking the Vampire." *differences* 3 (2):1–20.

Casper, Monica. 1995a. "Fetal Cyborgs and Technomoms on the Reproductive Frontier: Which Way to the Carnival?" In *The Cyborg Handbook*, edited by C. H. Gray, H. Figueroa-Sarriera, and S. Mentor. New York: Routledge, 183–202.

Casper, Monica. 1995b. "The Making of the Unborn Patient: Medical Work and the Politics of Reproduction in Experimental Fetal Surgery, 1963–1993." Ph.D. diss., Graduate Program in Sociology, University of California at San Francisco.

Castañeda, Claudia. 1994. "Transnational Adoption as U.S. Racist Complicity?" Paper read at American Ethnological Society Meeting, April.

Castañeda, Claudia. In progress. "Worlds in the Making: Childhood, Culture, and Globalization." Ph.D. diss., History of Consciousness Board, University of California at Santa Cruz.

Cavalli-Sforza, L. L., A. C. Wilson, C. R. Cantor, R. M. Cook-Deegan, and M. C. King. 1991. "Call for a Worldwide Survey of Human Genetic Diversity: A Vanishing Opportunity for the Human Genome Project." *Genomics* 11:490–91.

Chon, Margaret. 1993. "Postmodern Progress': Reconsidering the Copyright and Patent Power." *DePaul Law Review* 43 (1):97–146.

Chorover, Stephan L. 1979. *From Genesis to Genocide: The Meaning of Human Nature and the Power of Behavior Control.* Cambridge: MIT Press.

Christie, John R. R. 1993. "A Tragedy for Cyborgs." *Configurations* 1:171–96.

Clark, Timothy J. 1985, 1984. *The Painting of Modern Life: Paris in the Art of Manet and His Followers.* New York: Knopf.

Clarke, Adele. 1995. "Modernity, Postmodernity and Reproductive Processes, c1890–1990." In *The Cyborg Handbook,* edited by C. H. Gray, H. Figueroa-Sarriera, and S. Mentor. New York: Routledge, 139–55.

Clarke, Adele, and Joan Fujimura, eds., 1992. *The Right Tools for the Job: At Work in Twentieth-Century Life Sciences.* Princeton: Princeton University Press.

Clarke, Adele, and Teresa Montini. 1993. "The Many Faces of RU486: Tales of Situated Knowledges and Technological Constestations." *Science, Technology, and Human Values* 18 (1):42–78.

Clynes, Manfred E., and Nathan S. Kline. 1960. "Cyborgs and Space." *Astronautics* (September 26–27):75–76.

Coalition for the Reproductive Rights of Workers (CRROW). 1980. *Reproductive Hazards in the Workplace: A Resources Guide.* Washington, DC: CCROW.

Coates, James. 1994. "Navigating the Web." *Santa Rosa Press Democrat,* December 26, D1, 5.

Coleman, William. 1982. *Death Is a Social Disease: Public Health and Political Economy in Early Industrial France.* Madison: University of Wisconsin Press.

Collier, Jane F., and Sylvia Junko Yanagisako, eds. 1987. *Gender and Kinship: Essays Toward a Unified Analysis.* Stanford: Stanford University Press.

Collins, H. M., and Steven Yearley. 1992. "Epistemological Chicken." In *Science as Practice and Culture,* edited by A. Pickering. Chicago: University of Chicago Press, 302–26.

Collins, Patricia Hill. 1991. *Black Feminist Thought: Knowledge, Consciousness, and the Politics of Empowerment.* New York: Routledge.

Committee for Abortion Rights and Against Sterilization Abuse (CARASA). 1979. *Women Under Attack: Abortion, Sterilization Abuse, and Reproductive Freedom.* New York: CARASA.

Cone, Marla. 1993. "The Mouse Wars Turn Furious." *Los Angeles Times,* May 9, A1, A16–17.

Connell, Christopher. 1994. "Pregnancy Study Shows Bad Habits." *The Santa Rosa Press Democrat,* September 13, A7.

Courteau, Jacqueline. 1991. "Genome Databases: Special Pull-out Secton." *Science* (Genome Issue, Maps and Databases) 254:201–07.

Cravens, Hamilton. 1978. *The Triumph of Evolution: American Scientists and the Heredity-Environment Controversy, 1900–1941*. Philadelphia: University of Pennsylvania Press.

Crichton, Michael. 1990. *Jurassic Park*. New York: Random House.

CRICT (Center for Research into Innovation, Culture and Technology). 1995. Workshop on the Subject(s) of Technology: Feminism, Constructivism, and Identity.

Crouch, Martha L. 1990. "Debating the Responsibilities of Plant Scientists in the Decade of the Environment." *The Plant Cell* 2:275–77.

———. 1995a. "Thinking Globally, Acting Locally." *The Women's Review of Books* 12 (5):32–33.

———. 1995b. "Like Mother Used to Make?" *The Women's Review of Books* 12 (5):31–32.

Cruse, Julius M., and Robert E. Lewis, Jr. 1993. "Transgenes Today." *Transgene* 1 (1):1–2.

Culliton, Barbara. 1990. "Mapping Terra Incognita (*humani corporis*)." *Science* 250 (October 12):210–12.

Cussins, Charis. 1994. "Ontological Choreography: Agency for Women Patients in an Infertility Clinic." Unpublished manuscript. Science Studies Program, University of California at San Diego. Under review for *Social Studies of Science*.

Cuticchia, A. Jamie, Michael A. Chipperfield, Christopher J. Porter, William Kearns, and Peter L. Pearson. 1993. "Managing All Those Bytes: The Human Genome Project." *Science* 262 (October. 1):47–49.

Daly, Martin, and Margo Wilson. 1978. *Sex, Evolution, and Behavior: Adaptations for Reproduction*. North Scituate, MA: Duxbury Press.

Darnell, James, Harvey Lodish, and David Baltimore. 1986. *Molecular Cell Biology*. New York: Scientific American Books.

Davis, Angela. 1981. *Women, Race and Class*. New York: Random House.

Dawkins, Richard 1976, 1989. *The Selfish Gene*. New York: Oxford University Press.

———. 1982. *The Extended Phenotype: The Gene as a Unit of Selection*. London: Oxford University Press.

Delany, Samuel R. 1977. *The Jewel-Hinged Jaw: Essays on Science Fiction*. New York: Berkeley Books.

Delany, Samuel R. 1988. *Tales of Nevèrÿon*. London: Grafton.

de Lauretis, Teresa. 1984. *Alice Doesn't: Feminism, Semiotics, Cinema*. Bloomington: Indiana University Press.

———. 1994. *The Practice of Love: Lesbian Sexuality and Perverse Desire*. Bloomington: Indiana University Press.

Derrida, Jacques. 1976. *Of Grammatology*. Translated by Gayatri Chakravorty Spivak. Baltimore: Johns Hopkins University Press.

DiChiro, Giovanna. 1995a. "Local Actions, Global Visions: Women Transforming Science, Environment and Health in the U.S. and India." Ph.D. diss., History of Consciousness Board, University of California at Santa Cruz.

———. 1995b. "Nature as Community: The Convergence of Environment and Social Justice." In *Uncommon Ground: Towards Reinventing Nature*, edited by W. Cronon. New York: Norton, 298–320.

Dinter, Artur. 1917. *Die Sünde Wider das Blut*. Leipzig: Mathes and Thost.

Disease Pariah News, vol. 5.

Doane, Mary Ann. 1987. *The Desire to Desire*. Bloomington: Indiana University Press.

Dobzhansky, Theodosius. 1962. *Mankind Evolving: The Evolution of the Human Species*. New Haven: Yale University Press.

Dorsey, Candas Jane. 1988. *Machine Sex . . . and Other Stories*. A Tesseract Book. Victoria: Porcépic books.

Downey, Gary, Joseph Dumit, and Sharon Traweek, eds. Forthcoming. *Cyborgs and Citadels: Anthropological Interventions on the Borderlands of Technoscience*. Seattle: University of Washington Press.

Downey, Gary Lee, Joseph Dumit, and Sarah Williams. 1995. "Granting Membership to the Cyborg Image." In *The Cyborg Handbook*, edited by C. H. Gray, H. Figueroa-Sarriera, and S. Mentor. New York: Routledge, 341–46.

Drexler, Edward, Maud A. W. Hinchee, Douglas T. Lundberg, Laurence B. McCullough, Joseph D. McInerney, Jeffrey Murray, and Richard Storey. 1989. *Advances in Genetic Technology*. Lexington: D. C. Heath & Co.

Du Bois, W. E. B. 1971. "The Conservation of Races." In *A W. E. B. Du Bois Reader*, edited by A. G. Pashcal. New York: Macmillan, 19–31.

———. 1989, 1903. *The Souls of Black Folks*. New York: Bantam Books.

Duden, Barbara. 1993. *Disembodying Women: Perspectives on Pregnancy and the Unborn*. Cambridge: Harvard University Press.

Dumit, Joseph. 1995. "Mindful Images: PET Scans and Personhood in Biomedical America." Ph.D. diss., History of Consciousness Board, University of California at Santa Cruz.

Easlea, Brian. 1980. *Witch-Hunting, Magic, and the New Philosophy*. Brighton: Harvester Press.

Edgar, Joanne. 1972. "Wonder Woman Revisited." *Ms.* 1 (1):52–55.

Edwards, Paul. 1994. "Hypertext and Hypertension: Post-structuralist Critical Theory, Social Studies of Science, and Software." *Social Studies of Science* 24:229–78.

———. 1996. *The Closed World: Computers and the Politics of Discourse in Cold War America*. Cambridge: MIT Press.

Eglash, Ronald. 1992. "A Cybernetics of Chaos." Ph.D. diss., History of Consciousness Board, University of California at Santa Cruz.

———. 1995. "Afractals: Math Education Software from African Ethnomathematics." Ford Foundation Grant Proposal.

———. In progress. *African Fractals: Culture and Construction in Non-linear Perspective*.

Ehrenreich, Barbara, and Dierdre English. 1973. *Complaints and Disorders: The Sexual Politics of Sickness*. Old Westbury, NY: The Feminist Press.

Engels, Eric. 1991. "Biology Education in the Public High Schools of the United States from the Progressive Era to the Second World War: A Discursive History." Ph.D. diss., Sociology Department, University of California at Santa Cruz.

Erickson, Deborah. 1992. "Hacking the Genome." *Scientific American* (April):128–37.

Escobar, Arturo. 1994. "Welcome to Cyberia: Notes on the Anthropology of Cyberculture." *Current Anthropology* 35 (3):211–31.

Etzkowitz, Henry, and Andrew Webster. 1995. "Science as Intellectual Property." In

Handbook of Science and Technology Studies, edited by S. Jasanoff, G. E. Markle, J. C. Petersen, and T. Pinch. Thousand Oaks: Sage, 480–505.

Fairchild, Halford. 1991. "Scientific Racism: The Cloak of Objectivity." *Journal of Social Issues* 47 (3):101–16.

Farmer, D., C. Langton, S. Rasmussen, and C. Taylor (self-organizing committee). 1990. "Artificial Life." Paper read at Artificial Life: Conference on Emergence and Evolution of Life-like Forms in Human-made Environments, February 5–9, at Santa Fe, New Mexico.

Feder, Barnaby J. 1993. "In Battling for Biotech, Monsanto Is the Leader." *New York Times,* December 24, C1, C4.

Fee, Elizabeth, and Nancy Krieger. 1994. "What's Class Got to Do with Health? A Critique of Biomedical Individualism." Paper read at Meeting of the Society for the Social Studies of Science, October 12–16, at New Orleans.

Fernandez, John P. 1993. *The Diversity Advantage: How American Business Can Out-perform Japanese and European Companies in the Global Marketplace.* New York: Lexington Books, Macmillan.

Fernandez, Ramona. 1991. "Reading Trickster Writing." Qualifying Essay, University of California at Santa Cruz.

_____. 1995a. "Imagining Literacy." Ph.D. diss., History of Consciousness Board, University of California at Santa Cruz.

_____. 1995b. "Pachuco Mickey." In *From Mouse to Mermaid: The Politics of Film, Gender, and Culture,* edited by E. Bell, L. Haas, and L. Sells. Bloomington: Indiana University Press, 236–53.

Finley, Michael. 1994. "The Electronic Alchemist." *San Jose Mercury News,* March 6, F1–2.

Fisher, Lawrence M. 1994. "Gene Project Is Already Big Business." *San Jose Mercury News,* January 30, 9A.

Flower, Michael. 1994. "A Native Speaks for Himself: Reflections on Technoscientific Literacy." Paper read at American Anthropological Association Meeting, November 30–December 3, at Washington, DC.

_____. n.d. "Technoscientific Liberty." Unpublished paper, University Honors Program, Portland State University.

Flower, Michael, and Deborah Heath. 1993. "Anatomo-politics: Mapping the Human Genome Project." *Culture, Medicine and Psychiatry* 17:27–41.

Foucault, Michel. 1970. *The Order of Things: An Archaeology of the Human Sciences.* New York: Pantheon.

_____. 1978. *The History of Sexuality. Vol. 1: An Introduction.* Translated by Robert Hurley. New York: Pantheon.

Fox, Michael. 1983. "Genetic Engineering: Human and Environmental Concerns." Unpublished briefing paper.

_____. 1992. *Superpigs and Wondercorn: The Brave New World of Biotechnology and Where It All May Lead.* New York: Lyons and Burford.

Franklin, Sarah. 1993a. "Making Representations: The Parliamentary Debate on the Human Fertilisation and Embryology Act." In *Technologies of Procreation: Kinship in the Age of Assisted Conception,* edited by J. Edwards, S. Franklin, E.

Hirsch, F. Price, and M. Strathern. Manchester: Manchester University Press, 96–131.

———. 1993b. "Life Itself," paper delivered at the Center for Cultural Values, Lancaster University, June 9.

———. 1993c. "Essentialism, Which Essentialism? Some Implications of Reproductive and Genetic Technoscience." In *Issues in Biological Essentialism Versus Social Constructionism in Gay and Lesbian Identities*, edited by J. Dececco and J. Elia. London: Harrington Park Press, 27–39.

———. 1994. "Comments on Paper by Celia Lury." Center for Cultural Studies, University of California at Santa Cruz.

———. 1995. "Romancing the Helix: Nature and Scientific Discovery." In *Romance Revisited*, edited by L. Pearce and J. Stacey. London: Falmer Press, 63–77.

———. Forthcoming. "Life." *Encyclopedia of Bioethics*. New York: Macmillan.

Franklin, Sarah, Celia Lury, and Jackie Stacey, eds. Forthcoming. *Second Nature: Body Techniques in Global Culture.*

Freud, Sigmund. 1963, 1927. "Fetishism." In *Sexuality and the Psychology of Love*, edited by P. Rieff. New York: Collier, 204–09.

Fujimura, Joan. 1992. "Crafting Science: Standardized Packages, Boundary Objects, and Translation." In *Science as Practice and Culture*, edited by A. Pickering. Chicago: University of Chicago Press, 168–211.

———. Forthcoming. *Crafting Science and Transforming Biology: The Case of Oncogene Research.* Cambridge: Harvard University Press.

Gabilondo, Joseba. 1991. "Cinematic Hyperspace, New Hollywood Cinema and Science Fiction Film: Image Commodification in Late Capitalism." Ph.D. diss., Literature Department, University of California at San Diego.

Galison, Peter. 1989. "The Trading Zone: Coordination Between Theory and Experiment in the Modern Laboratory." Paper read at History of Science Colloquium, October 20, at Princeton University.

Gasperini, Jim. 1994. "The Miracle of Good Multimedia." *Wired* (February):198.

Gerson, Deborah. Forthcoming. "Speculum and Small Groups: New Visions of Female Bodies. Unpublished manuscript from dissertation-in-progress: "Practice from Pain." University of California at Berkeley.

Gelder, Ken. 1994. *Reading the Vampire.* New York: Routledge.

Geller, Jay. 1992. "Blood Sin: Syphilis and the Construction of Jewish Identity." *Faultline* 1:21–48.

Gibbons, Ann. 1995. "Out of Africa—at Last?" *Science* 267 (March 3):1272–73.

Gibbs, W. Wayt. 1995. "Information Have-nots." *Scientific American* 272 (5):12B–14.

Gilbert, Scott. 1994. *Developmental Biology.* 4th ed. Sunderland, MA: Sinauer.

———. Forthcoming. "Bodies of Knowledge: Biology and the Intercultural University." In *Changing Life in the New World Dis/order*, edited by P. Taylor, S. Halfon, and P. Edwards. Minneapolis: University of Minnesota Press.

Gilbert, Scott F., John M. Optiz, and Rudy Raff. 1996. "Resynthesizing Evolutionary and Developmental Biology. *Developmental Biology* 173:357–12.

Gilman, Charlotte Perkins. 1979, 1915. *Herland.* Serialized in the *Forerunner*, 1915. London: The Women's Press.

Ginsberg, Faye, and Rayna Rapp. 1991. "The Politics of Reproduction." *Annual Reviews in Anthropology* 20:311–43.

Ginsberg, Faye D., and Rayna Rapp, eds. 1995. *Conceiving the New World Order: The Global Politics of Reproduction.* Los Angeles: University of California Press.

Goldberg, David Theo, ed. 1990. *Anatomy of Racism.* Minneapolis: University of Minnesota Press.

Gomez, Jewelle. 1991. *The Gilda Stories.* Ithaca: Firebrand Books.

Gould, Stephen J. 1981. *The Mismeasure of Man.* New York: W. W. Norton.

Grant, Madison. 1916. *The Passing of the Great Race, or the Racial Basis of European History.* New York: C. Scribner.

Gray, Chris Hables. 1991. "Computers as Weapons and Metaphors: The U.S. Military 1940–90 and Postmodern War." Ph.D. diss., History of Consciousness Board, University of California at Santa Cruz.

Griswold del Castillo, Richard, ed. 1984. *La Familia: Chicano Families in the Urban Southwest, 1848 to the Present.* Notre Dame: University of Notre Dame Press.

Gros, François. 1988. "The Changing Face of the Life Sciences." *UNESCO Courier*:7.

Gross, Paul R., and Norman Levitt. 1994. *Higher Superstition: The Academic Left and its Quarrels with Science.* Baltimore: Johns Hopkins University Press.

Grosveld, F., and G. Kollias, eds. 1992. *Transgenic Animals.* San Diego: Academic Press.

Hacking, Ian. 1983. *Representing and Intervening: Introductory Topics in the Philosophy of Natural Science.* Cambridge: Cambridge University Press.

Hall, Alan. 1994. "A Biochemical Function for Ras—at Last." *Science* 264 (June 3):1413–14.

Haller, Mark. 1963. *Eugenics, Hereditarian Attitudes in American Thought.* New Brunswick, NJ: Rutgers University Press.

Hamilton, Joan O'C. 1994. "Biotech: An Industry Crowded with Players Faces an Ugly Reckoning." *Business Week* (September 26):84–90.

Hampton, Henry. 1986–87. *Eyes on the Prize: America's Civil Rights Years, 1954–65.* Alexandria, VA/Boston: Blackside, Inc., and CPB for WGBH Boston. Television series.

Haraway, Donna J. 1976. *Crystals, Fabrics, and Fields: Metaphors of Organicism in Twentieth-Century Developmental Biology.* New Haven: Yale University Press.

_____. 1985. "Manifesto for Cyborgs: Science, Technology, and Socialist Feminism in the 1980s." *Socialist Review* (80):65–108.

_____. 1988. "Situated Knowledges: The Science Question in Feminism as a Site of Discourse on the Privilege of Partial Perspective." *Feminist Studies* 14 (3):575–99.

_____. 1989. *Primate Visions: Gender, Race and Nature in the World of Modern Science.* New York: Routledge.

_____. 1991. *Simians, Cyborgs and Women: The Reinvention of Nature.* New York: Routledge.

_____. 1992a. "The Promises of Monsters: A Regenerative Politics for Inappropriate/d Others." In *Cultural Studies*, edited by L. Grossberg, C. Nelson, and P. Treichler. New York: Routledge 295–337.

_____. 1992b. "When Man™ Is on the Menu." In *Incorporations*, edited by J. Crary and

Sanford Kwinter. New York: Zone Books, 38–43.

———. 1994a. "A Game of Cat's Cradle: Science Studies, Feminist Theory, Cultural Studies." *Configurations: A Journal of Literature and Science* 1:59–71.

———. 1994b. "Never Modern, Never Been, Never Ever: Some Thoughts About Never-Never Land in Science Studies." Paper read at Meeting of the Society for Social Studies of Science, October 12–16, at New Orleans.

———. Forthcoming. "Modest Witness: Feminist Diffractions in Science Studies." In *The Disunity of Sciences: Boundaries, Contexts, and Power*, edited by P. Galison and D. Stump. Stanford: Stanford University Press.

Harding, Sandra. 1992. *Whose Science? Whose Knowledge? Thinking from Women's Lives.* Ithaca: Cornell University Press.

———. 1993. *The "Racial" Economy of Science: Toward a Democratic Future.* Bloomington: Indiana University Press.

Harding, Susan. 1990. "If I Die Before I Wake." In *Uncertain Terms: Negotiating Gender in American Culture*, edited by F. Ginsburg and A. L. Tsing. Boston: Beacon Press, 76–97.

Harris, Cheryl I. 1993. "Whiteness as Property." *Harvard Law Review* 106 (8):1707–91.

Harrison, Ross. 1937. "Embryology and Its Relations." *Science* 85 (2207) April 16:369–74.

Hartouni, Valerie. 1991. "Containing Women: Reproductive Discourse in the 1980s." In *Technoculture*, edited by C. Penley and A. Ross. Minneapolis: University of Minnesota Press, 27–56.

———. 1992. "Fetal Exposures: Abortion Politics and the Optics of Allusion." *Camera Obscura: A Journal of Feminism and Film Theory* 29:130–49.

———. 1994. "Breached Birth: Reflections on Race, Gender, and Reproductive Discourse in the 1980s." *Configurations* 2 (1):73–88.

———. Forthcoming. *Making Life Make Sense: New Technologies and the Discourses of Reproduction.* Minneapolis: University of Minnesota Press.

Hartsock, Nancy. 1983. "The Feminist Standpoint: Developing the Ground for a Specifically Feminist Historical Materialism." In *Discovering Reality: Feminist Perspectives on Epistemology, Methodology, and Philosophy of Science*, edited by S. Harding and M. Hintikka. Dordrecht/Boston: Reidel, 283–310.

Harvey, David. 1989. *The Condition of Postmodernity: An Enquiry into the Origins of Cultural Change.* Oxford: Basil Blackwell.

Hayden, Cori. 1994a. "The Genome Goes Multicultural." Unpublished manuscript, Anthropology Board, University of California at Santa Cruz.

———. 1994b. "Purity, Property and Preservation." Paper read at American Anthropological Association Meetings, November 27–December 4, at Atlanta, GA.

Hayles, N. Katherine. 1992. "The Materiality of Informatics." *Configurations* 1:147–70.

Heath, Deborah. Forthcoming. "Bodies, Antibodies, and Modest Interventions." In *Cyborgs and Citadels: Anthropological Interventions in the Borderlands of Technoscience*, edited by G. Downey, J. Dumit and S. Traweek. Seattle: University of Washington Press.

Heidegger, Martin. 1977. *The Question Concerning Technology and Other Essays.* Translated by William Lovitt. New York: Garland.

Helmreich, Stefan. 1995. "Anthropology Inside and Outside the Looking-Glass Worlds of Artificial Life." Ph.D. diss., Department of Anthropology, Stanford University.

Helsel, Sharon. 1993. "The Comic Reason of Herman Kahn: Conceiving the Limits to Uncertainty in 1960." Ph.D. diss., History of Consciousness Board, University of California at Santa Cruz.

Hendricks, Margo. 1992. "Managing the Barbarians: The Tragedy of Dido, Queen of Carthage." *Renaissance Drama*, New Series 23:165–88.

———. 1994. "Civility, Barbarism, and Aphra Behn's *The Widow Ranter*." In *Women, "Race," and Writing in the Early Modern Period*, edited by M. Hendricks and P. Parker. New York: Routledge, 225–39.

———. 1996. "Obscured by Dreams: Race, Empire and Shakespeare's *A Midsummer Night's Dream*." *Shakespeare Quarterly* 47, no. 1:37–60.

Herrnstein, Richard J., and Charles Murray. 1994. *The Bell Curve: Intelligence and Class Structure in American Life*. New York: The Free Press.

Hess, David J., and Linda L. Layne, eds. 1992. *Knowledge and Society: The Anthropology of Science and Technology*. Vol. 9. Greenwich, CT: JAI Press.

Hightower, Jim. 1973. *Hard Tomatoes, Hard Times: A Report of the Agribusiness Accountability Project on the Failure of America's Land Grant College Complex*. Cambridge: Schenkman.

Hilgartner, Stephen. 1994. "Genome Informatics: New Communication Regimes for Biology." Paper read at Society for Social Studies of Science, October 12–16, at New Orleans.

Hitler, Adolph. 1941. 1925–1927. *Mein Kampf.* Munich: Zentralverlag der NSDAP.

Hobbelink, Henk. 1991. *Biotechnology and the Future of World Agriculture*. London: Zed Books.

hooks, bell. 1990. *Yearning*. Boston: Southend Press.

Hoover, Cary, Alta Campbell, and Patrick J. Spain, eds. 1991. *Hoover's Handbook of American Business, 1992*. Austin: The Reference Press.

Hounshell, David, and John Kenly Smith Jr. 1988. *Science and Corporate Strategy: Du Pont R&D, 1902–1980*. New York: Cambridge University Press.

Hubbard, Ruth, Mary Sue Henifin, and Barbara Fried, eds. 1982. *Biological Woman—The Convenient Myth: A Collection of Feminist Essays and a Comprehensive Bibliography*. Cambridge: Schenkman.

Information Infrastructure, Task Force. 1993. "The National Information Infrastructure: Agenda for Action." U.S. Department of Commerce, National Technical Information Service.

Irigaray, Luce. 1985. *Speculum of the Other Woman*. Translated by Gillian C. Gill. Ithaca: Cornell University Press.

Jacoby, Russell, and Naomi Glauberman, eds. 1995. *The Bell Curve Debate: History, Documents, Opinions*. New York: Times Books/Random House.

Jansen, H. W., and Dora Jane Jansen. 1963. *History of Art*. Englewood Cliffs/New York: Prentice-Hall and Harry N. Abrams.

Jensen, Arthur. 1969. "How Much Can We Boost IQ and Scholastic Achievement?" *Harvard Educational Review* 39 (Winter):1–123.

Johnson, Jory. 1988. "Martha Schwartz's 'Splice Garden': A Warning to a Brave New World." *Landscape Architecture* (July/August).

Jones, Steve, Robert Martin, and David Pilbeam, eds. 1992. *The Cambridge Encyclopedia of Human Evolution*. New York: Cambridge University Press.

Jordanova, Ludmilla. 1989. *Sexual Visions: Images of Gender in Science and Medicine Between the Eighteenth and Twentieth Centuries*. Madison: University of Wisconsin Press.

Juma, Calestous. 1989. *The Gene Hunters: Biotechnology and the Scramble for Seeds*. Princeton: Princeton University Press.

Kahn, Patricia. 1994. "Genetic Diversity Project Tries Again." *Science* 266 (November 4):720–22.

Karakotsios, Ken. 1992. *SimLife*. Orinda, CA: Maxis. Game.

Kauffman, L. A. 1993. "The Diversity Game: Corporate America Toys with Identity Politics." *Village Voice* (August 31):29–33.

Kay, Lily E. 1993. *The Molecular Vision of Life: Caltech, the Rockefeller Foundation, and the Rise of the New Biology*. New York: Oxford.

Kaye, Howard L. 1986. *The Social Meaning of Biology: From Darwinism to Sociobiology*. New Haven: Yale University Press.

Keller, Evelyn Fox. 1985. *Reflections on Gender and Science*. New Haven: Yale University Press.

_____. 1990. "Gender and Science: 1990." *The Great Ideas Today*. Chicago: Encyclopedia Britannica, Inc.

_____. 1992a. *Secrets of Life, Secrets of Death: Essays on Language, Gender and Science*. New York: Routledge.

_____. 1992b. "Nature, Nurture, and the Human Genome Project." In *The Code of Codes: Scientific and Social Issues in the Human Genome Project*, edited by D. J. Kevles and L. Hood. Cambridge: Harvard University Press, 281–99.

_____. 1995. *Refiguring Life: Metaphors of Twentieth-Century Biology*. New York: Columbia University Press.

Kevles, Daniel J. 1977. *The Physicists: The History of a Scientific Community in Modern America*. New York: Knopf.

_____. 1985. *In the Name of Eugenics: Genetics and the Uses of Human Heredity*. New York: Knopf.

Kevles, Daniel J., and Leroy Hood, eds. 1992. *The Code of Codes: Scientific and Social Issues in the Human Genome Project*. Cambridge: Harvard University Press.

Kim, Elaine H., and Norma Alarcón, eds. 1994. *Writing Self, Writing Nation: Essays on Theresa Hak Kyung Cha's Dictée*. Berkeley: Third Woman Press.

King, Katie. 1991. "Bibliography and a Feminist Apparatus of Literary Production." *Text* 5:91–103.

_____. 1993. "Feminism and Writing Technologies." Paper read at conference on Located Knowledges, April 8–10, at UCLA.

_____. 1994. *Theory in Its Feminist Travels: Conversations in U.S. Women's Movements*. Bloomington: Indiana University Press.

Kitcher, Philip. 1987. *Vaulting Ambition: Sociobiology and the Quest for Human Nature*. Cambridge: MIT Press.

Knorr-Cetina, Karin, and Michael Mulkay, eds. 1983. *Science Observed: Perspectives on the Social Study of Science*. Beverly Hills: Sage Publications.

Koshland, Daniel, Jr. 1990. "The Rational Approach to the Irrational." *Science* 250 (October 12):189.

Krimsky, Sheldon. 1991. *Biotechnics and Society: The Rise of Industrial Genetics.* New York: Praeger.

Krol, Ed. 1992. *The Whole Internet. Users Guide and Catalogue.* Sebastapol, CA: O'Reilly and Associates, Inc.

Kuhn, Thomas. 1962. *The Structure of Scientific Revolutions.* Chicago: University of Chicago Press.

Kuletz, Valerie. 1996. "Geographies of Sacrifice: Nuclear Landscapes and Their Social Consequences in the U.S. Inter-desert Region, 1940–96." Ph.D. diss., Sociology Board, University of California at Santa Cruz.

Langton, Christopher G. 1988. "Artificial Life." In *Artificial Life: SFI Studies in the Sciences of Complexity*, edited by C. G. Langton. Boston: Addison-Wesley, 1–47.

Langton, Christopher G., ed. 1992. *Artificial Life II: Proceedings of the Workshop on Artificial Life Held February in Santa Fe*, NM. Vol. X. The Santa Fe Institute Studies in the Sciences of Complexity. Redwood City, CA: Addison-Wesley.

Laqueur, Thomas. 1990. *Making Sex: Body and Gender From the Greeks to Freud.* Cambridge: Harvard University Press.

Latour, Bruno. 1983. "Give Me a Laboratory and I Will Raise the World." In *Science Observed: Perspectives on the Social Study of Science*, edited by K. Knorr-Cetina and M. Mulkay. London: Sage, 141–70.

———. 1987. *Science in Action: How to Follow Scientists and Engineers Through Society.* Cambridge: Harvard University Press.

———. 1993. *We Have Never Been Modern.* Translated by Catherine Porter. Cambridge: Harvard University Press.

———. 1996. *Petit réflexion sur le culte moderne des dieux faitiches.* Le Plessis-Robinson: Synthélabo.

Latour, Bruno, and Steve Woolgar. 1979. *Laboratory Life: The Social Construction of Scientific Facts.* Beverly Hills: Sage Publications.

Lawler, Andrew. 1995. "NSF Hands Over the Internet . . ." *Science* 267 (March 17):1584–85.

Lefanu, Sarah. 1989. *Feminism and Science Fiction.* Bloomington: Indiana University Press.

LeGuin, Ursula. 1988. "The Carrier-Bag Theory of Fiction." In *Women of Vision,* edited by D. D. Pont. New York: St. Martin's Press, 1–12.

Lewontin, Richard C. 1992. "The Dream of the Human Genome." *New York Review of Books* (May 28):31–40.

Linton, Sally. 1971. "Woman the Gatherer. Male Bias in Anthropology." In *Women in Perspective: A Guide for Cross-Cultural Studies*, edited by S.-E. Jacobs. Urbana: University of Illinois Press, 9–21.

Locke, John. 1690. *Two Treatises of Government.* London: Cambridge University Press.

Longino, Helen. 1990. *Science as Social Knowledge.* Princeton: Princeton University Press.

Lorde, Audre. 1984. "The Master's Tools Will Never Dismantle the Master's House." In *Sister Outsider: Essays and Speeches*, edited by A. Lorde. Trumansburg, NY: Crossing Press.

Lukács, Georg. 1971. *History and Class Consciousness.* Translated by Rodney Livingstone. Cambridge: MIT Press.

Lury, Celia. 1994. "United Colors of Diversity: Benetton's Advertising Campaign and the New Universalisms of Global Culture, a Feminist Analysis." Paper delivered at the Center for Cultural Studies, University of California at Santa Cruz.

Lynch, Michael. 1991. "Science in the Age of Mechanical Reproduction." *Biology and Philosophy* 6 (2):205–26.

MacArthur, R. H. 1962. "Some Generalized Theorems of Natural Selection." *Proceedings of the National Academy of Sciences* 48:1893–97.

MacKenzie, Debora. 1993. "Activists Join Forces Against the Onco-Mouse." *New Scientist* (January 16):7.

_____. 1994. "Battle for the World's Seed Banks." *New Scientist* (July 2):4.

Margulis, Lynn, and Dorion Sagan. 1995. *What Is Life?* New York: Simon and Schuster.

Martin, Emily. 1992. "The End of the Body?" *American Ethnologist* 19 (1):121–40.

_____. 1994. *Flexible Bodies: Tracking Immunity in American Culture from the Days of Polio to the Age of AIDS.* Boston: Beacon Press.

Marx, Karl. 1976. *Capital.* Translated by Ben Fowkes. Vol. 1. New York: Random House.

Mayr, Ernst, and William B. Provine. 1980. *The Evolutionary Synthesis: Perspectives on the Unification of Biology.* Cambridge: Harvard University Press.

Melton, J. Gordon. 1994. *The Vampire Book: The Encyclopedia of the Undead.* Detroit: Visible Ink Press.

Merchant, Carolyn. 1980. *The Death of Nature: Women, Ecology, and the Scientific Revolution.* San Francisco: Harper and Row.

Mestel, Rosie. 1994. "Ascent of the Dog." *Discover* 15 (10):91–98.

Michael, Mike, and Lynda Birke. 1994. "Accounting for Animal Experiments: Identity and Disreputable Others." *Science, Technology, and Human Values* 19 (2):189–204.

Mohanty, Chandra Talpade. 1991. "Cartographies of Struggle: Third World Women and the Politics of Feminism." In *Third World Women and the Politics of Feminism,* edited by C. Mohanty, A. Russo, and L. Torres. Bloomington: Indiana University Press, 1–47.

Moraga, Cherríe, and Gloria Anzaldúa, eds. 1981. *This Bridge Called My Back: Writings by Radical Women of Color.* Watertown, MA: Persephone Press.

Morris, Charles. 1938. *Foundation of the Theory of Signs.* Chicago: University of Chicago Press.

Morrison, Toni. 1992. *Jazz.* New York: Knopf.

Morrow, John F., Stanley N. Cohen, Annie C. Y. Chang, Herbet Boyer, Howard M. Goodman, and Robert Helling. 1974. "Replication and Transcription of Eucaryotic DNA in *Escherirchia coli.*" *Proceedings of the National Academy of Sciences,* USA 71:1743–47.

Moskowitz, Milton, Michael Katz, and Robert Levering. 1980. *Everyone's Business, an Almanac: The Irreverent Guide to Corporate America.* New York: Harper & Row.

Mulvey, Laura. 1993. "Some Thoughts on Theories of Fetishism in the Context of Contemporary Culture." *October* 65 (Summer):3–20.

Murnau, Friedrich Wilhelm. 1922. *Nosferatu, eine Symphonie des Garuens.* Berlin: Prana-Films. Film.

Nations, Marilyn K., and L. A. Rebhun. 1988. "Angels with Wet Wings Won't Fly: Maternal Sentiment in Brazil and the Image of Neglect." *Culture, Medicine and Psychiatry* 12:141–200.

Nead, Lynda. 1992. *The Female Nude: Art, Obscenity and Sexuality*. New York: Routledge.

Nelkin, Dorothy, and M. Susan Lindee. 1995. *The DNA Mystique: The Gene as a Cultural Icon*. New York: W. H. Freeman.

Nilsson, Lennart. 1977. *A Child Is Born*. New York: Dell.

———. 1987. *The Body Victorious: The Illustrated Story of Our Immune System and Other Defenses of the Human Body*. New York: Delacourt.

Nilsson, Lennart, and Lars Hamberger. 1994. *A Child Is Born*. Philips. CD-I (compact disk).

Noble, David F. 1977. *America by Design: Science, Technology, and the Rise of Corporate Capitalism*. New York: Oxford University Press.

———. 1992. *A World Without Women: The Christian Clerical Culture of Western Science*. New York: Oxford University Press.

Nowak, Rachel. 1993. "Draft Genome Map Debuts on Internet." *Science* 262 (December 24):1967.

NSB (National Science Board, National Science Foundation). 1993. "Science and Engineering Indicators." Washington, DC: U.S. Government Printing Office.

Ostrander, Elaine. 1992. "The Dog Genome Project." Paper read at Science Innovation 1992, New Techniques and Instruments in Biomedical Research, July 23, at San Francisco.

Ostrander, E. A., G. F. Sprague Jr., and J. Rine. 1993. "Identification and Characterization of Dinucleotide Repeat (CA)n Markers for Genetic Mapping in Dogs." *Genomics* 16 (1):207–13.

OTA (Office of Technology Assessment). 1989. "New Developments in Biotechnology: Patenting Life." Washington, DC: U.S. Government Printing Office.

Oudshoorn, Nellie. 1994. *Beyond the Natural Body*. London: Routledge.

Oyama, Susan. 1985. *The Ontogeny of Information*. Cambridge: Cambridge University Press.

Park, Katherine. 1995. "Impressed Images: Reproducing Wonders." Paper read at Histories of Science/Histories of Art, November 3–5, at Harvard and Boston Universities.

Pauly, Philip. 1991. "The Development of High School Biology: New York City, 1900–1925." *Isis* 82:662–88.

Petchesky, Rosalind Pollock. 1987. "Fetal Images: The Power of Visual Culture in the Politics of Reproduction." *Feminist Studies* 13 (2):263–92.

Petchesky, Rosalind Pollack, and Jennifer Weiner. 1990. *Global Feminist Perspectives on Reproductive Rights and Reproductive Health*. New York: Hunter College/Reproductive Rights Education Project.

Petruno, Tom. 1995. "Biotech Hot Again on Wall Street." *Santa Rosa Press Democrat*, July 29, E1, 4.

Pickering, Andrew, ed. 1992. *Science as Practice and Culture*. Chicago: University of Chicago Press.

Pickering, Andrew, and Adam Stephanides. 1992. "Constructing Quaternions: On the Analysis of Conceptual Practice. In *Science as Practice and Culture*, edited by A. Pickering. Chicago: University of Chicago Press, 139–67.

Piercy, Marge. 1976. *Woman on the Edge of Time*. New York: Fawcett Crest.

———. 1991. *He, She, and It*. New York: Knopf.

Porter, Theodore M. 1994. "Objectivity as Standardization: The Rhetoric of Impersonality in Measurement, Statistics, and Cost-Benefit Analysis." In *Rethinking Objectivity*, edited by A. McGill. Durham: Duke University Press, 19–59.

_____. 1995. *Trust in Numbers: The Pursuit of Objectivity in Science and Public Life.* Princeton: Princeton University Press.

Potter, Elizabeth. Forthcoming. "Making Gender/Making Science: Gender Ideology and Boyle's Experimental Philosophy." In *Making a Difference*, edited by B. Spanier. Bloomington: Indiana University Press.

Rabinow, Paul. 1992a. "Metamodern Milieux." Paper read at American Anthropological Association Meetings, December 4, at San Francisco.

_____. 1992b. "Artificiality and Enlightenment: From Sociobiology to Biosociality." In *Incorporations*, edited by J. Crary and S. Kwinter. New York: Zone Books, 234–52.

RAFI (Rural Advancement Foundation International). 1993. "Patenting Indigenous Peoples." *Earth Island Journal* (Fall):13.

_____. 1994. "Following Protest, Claim Withdrawn on Guaymi Indian Cell Line." *GeneWatch: A Bulletin of the Council for Responsible Genetics* 9 (3–4):6–7.

Randolph, Lynn. 1993. "The Ilusas (deluded women): Representations of Women Who Are Out of Bounds." Paper delivered at the Bunting Institute, Cambridge, MA, November 30.

Rapp, Rayna. 1994. "Refusing Prenatal Diagnostic Technology: The Uneven Meanings of Bioscience in a Multicultural World." Paper read at the Society for Social Studies of Science, October 12–16, at New Orleans.

_____. Forthcoming. "Real Time Fetus: The Role of the Sonogram in the Age of Monitored Reproduction." In *Cyborgs and Citadels: Anthropological Interventions on the Borderlands of Technoscience*, edited by G. Downey, J. Dumit, and S. Traweek. Seattle: University of Washington Press.

Reder, Karen. In progress. "Making Mice: Clarence Little, the Jackson Laboratory, and the Standardization of *Mus faeroensis* for Research." Ph.D. diss., Department of the History and Philosophy of Science, Indiana University.

Rifkin, Jeremy. 1984a. *Algeny: A New Word, a New World*. New York: Penguin Books.

_____. 1984b. "Letter to William Gartland." *Federal Register* 49 (184) (September 30):37016.

Roberts, Leslie. 1991. "A Call to Action on a Human Brain Project." *Science* 252 (June 28):1794.

Rohde, David. 1994. "Developing Nations Win More Investment." *The Christian Science Monitor*, August 31, 4.

Rose, Hilary. 1994. *Love, Power, and Knowledge: Towards a Feminist Transformation of the Sciences.* Bloomington: Indiana University Press.

Rose, Mark. 1993. *Authors and Owners: The Invention of Copyright*. Cambridge: Harvard University Press.

Rosenberg, Charles. 1995. "Catechisms of Health: The Body in the Prebellum Classroom." *Bulletin of the History of Medicine* 69:175–97.

Rouse, Joseph. 1993. "What Are Cultural Studies of Scientific Knowledge?" *Configurations* 1:1–22.

Rubenstein, Nicolai, et al. 1967. *The Age of the Renaissance.* New York: McGraw-Hill.

Rubin, Gayle. 1975. "The Traffic in Women: Notes on the Political Economy of Sex." In *Toward an Anthropology of Women,* edited by R. R. Reiter. New York: Monthly Review Press, 157–210.

Rushton, J. Philippe, and Anthony F. Bogaert. 1987. "Race Differences in Sexual Behavior: Testing an Evolutionary Hypothesis." *Journal of Research in Personality* 21:529–51.

Russ, Joanna. 1975. *The Female Man.* New York: Bantam Books.

Rutherford, Charlotte. 1992. "Reproductive Freedoms and African American Women." *Yale Journal of Law and Feminism* 4 (2):255–90.

Sandoval, Chéla. 1991. "U.S. Third World Feminism: The Theory and Method of Oppositional Consciousness in the Postmodern World." *Genders* 10:1–24.

_____. Forthcoming. *Oppositional Consciousness in the Postmodern World.* Minneapolis: University of Minnesota Press.

Scheper-Hughes, Nancy. 1992. *Death Without Weeping: The Violence of Everyday Life in Brazil.* Berkeley/Los Angeles: University of California Press.

Schiebinger, Londa. 1989. *The Mind Has No Sex? Women in the Origins of Modern Science.* Cambridge: Harvard University Press.

Schneider, David M. 1968. *American Kinship: A Cultural Account.* Englewood Cliffs: Prentice-Hall.

_____. 1984. *A Critique of the Study of Kinship.* Ann Arbor: University of Michigan Press.

Schrage, Michael. 1992. "Increasing Medical Dilemmas Mean Job Security for Budding Bioethicists." *San Jose Mercury News,* October 19, 3D.

_____. 1993. "Biomedical Researchers Scurry to Make Genetically Altered Mice." *San Jose Mercury News,* February 8, 3D8.

_____. 1994. "NIH Boss Seeks to Squeeze More Science out of Stagnant Budget." *San Jose Mercury News,* May 16, 3D.

ScienceScope. 1994a. "Egypt to Build Science City in Desert." *Science* 263 (March 18):1551.

_____. 1994b. "A Maryland Motif for Biotech Ventures." *Science* 264 (May 20):1071.

Sclove, Richard E. 1994. "Citizen-Based Technology Assessment? An Update on Consensus Conferences in Europe." Loka Institute electronic posting.

_____. 1995. *Democracy and Technology.* New York: Guilford Publications.

Shapin, Steven. 1988. "Following Scientists Around." *Social Studies of Science* 18 (3):533–50.

_____. 1994. *A Social History of Truth: Civility and Science in Seventeenth-Century England.* Chicago: University of Chicago Press.

Shapin, Steven, and Simon Schaffer. 1985. *Leviathan and the Air-Pump: Hobbes, Boyle, and the Experimental Life.* Princeton: Princeton University Press.

Shelley, Mary. 1818, 1987. *Frankenstein, or the Modern Prometheus.* Harmondsworth: Penguin.

Shiva, Vandana. 1993. *Monocultures of the Mind: Perspectives on Biodivesity and Biotechnology.* London: Zed Books.

Simpson, G. G. 1967, revised (1st ed. 1949). *The Meaning of Evolution.* New Haven: Yale University Press.

Smith, Beverly. 1982. "Black Women's Health: Notes for a Course." In *Biological Woman—The Convenient Myth: A Collection of Feminist Essays and a Comprehensive Bibliography*, edited by R. Hubbard, M. S. Henifin, and B. Fried. Cambridge: Schenkman, 227–40.

Smith, Brian Cantwell. 1994. "Coming Apart at the Seams: The Role of Computation in a Successor Metaphysics." Paper read at Intersection of the Real and the Virtual, June 2–4, at Stanford University.

Smith, Victoria. 1994. "Loss and Narration in Modern Women's Fiction." Ph.D. diss., History of Consciousness Board, University of California at Santa Cruz.

Sofia, Zoë. 1992. "Virtual Corporeality: A Feminist View." *Australian Feminist Studies* 15 (Autumn):11–24.

Spalter-Roth, Roberta, Beverly Burr, Heidi Hartman, and Lois Shaw. 1995. *Welfare That Works: The Working Life of AFDC Recipients.* Washington, DC: Institute for Women's Policy Research.

Spanier, Bonnie. 1991. "Gender and Ideology in Science: A Study of Molecular Biology." *NWSA Journal* 3 (2):167–98.

Spillers, Hortense. 1987. "Mama's Baby, Papa's Maybe: An American Grammar Book." *Diacritics* 17 (2):65–81.

Spiwak, Daniela. 1993. "Gene, Genie, and Science's Thirst for Information with Indigenous Blood." *Abya Yala News* 7 (3–4):12–14.

Stabel, Ingse. 1992. "Den Norske Politiske Debatten om Bioteknologi." *Nytt om Kvinneforskning* 3:43–48.

Stabile, Carol A. 1992. "Shooting the Mother: Fetal Photography and the Politics of Disappearance." *Camera Obscura: A Journal of Feminism and Film Theory* 28:178–205.

Stack, Carol. 1974. *All Our Kin: Strategies for Surviving in a Black Community.* New York: Harper & Row.

Star, Susan Leigh. 1991. "Power, Technology and the Phenomenology of Conventions: On Being Allergic to Onions." In *A Sociology of Monsters: Power, Technology and the Modern World*, edited by J. Law. Oxford: Basil Blackwell, 26–56.

———. 1994. "Misplaced Concretism and Concrete Situations: Feminism, Method and Information Technology," Gender-Nature-Culture Working Paper, Odense University, Denmark.

Star, Susan Leigh, and James R. Griesemer. 1989. "Institutional Ecology, 'Translations,' and Boundary Objects: Amateurs and Professionals in Berkeley's Museum of Vertebrate Zoology, 1907–39. *Social Studies of Science* 19:387–420.

Steichen, Edward. 1955. *The Family of Man.* New York: Maco Magazine Corporation for the Museum of Modern Art.

Stepan, Nancy Leys. 1982. *The Idea of Race in Science: Great Britain, 1800–1960.* Hampden, CT: Archon Books.

———. 1986. "Race and Gender: The Role of Analogy in Science." *Isis* 77:261–277.

Stepan, Nancy Leys, and Sander L. Gilman. 1993. "Appropriating the Idioms of Science: The Rejection of Scientific Racism." In *"Racial" Economy of Science,* edited by S. Harding. Bloomington: Indiana University Press, 170–93.

Stephens, J. C., M. L. Cavanaugh, M. I. Gradie, M. L. Mador, and K. K. Kidd. 1990.

"Mapping the Human Genome: Current Status." *Science* 250 (October 12):237–44.

Stocking, George, Jr. 1968. *Race, Culture and Evolution: Essays in the History of Anthropology*. New York: The Free Press.

———. 1993. "The Turn-of-the-Century Concept of Race." *Modernism/Modernity* 1:4–16.

Stoker, Bram. 1897. *Dracula*. Westminster, London: A. Constable & Co.

Stone, Richard. 1994. "World Bank Bailout Seeks Changes in Global Network." *Science* 265 (July 8):181.

Strathern, Marilyn. 1992. *Reproducing the Future: Anthropology, Kinship and the New Reproductive Technologies*. New York: Routledge.

———. 1994. "Knowing Oceania: Constituting Knowledge and Identities." Paper read at Conference of the European Society for Oceanists, December, at Basel.

Sturgeon, Noël. Forthcoming. "The Nature of Race: Discourses of Racial Difference in Ecofeminism." In *Ecofeminism: Multidisciplinary Perspectives*, edited by K. Warren. Indianapolis: University of Indiana Press.

Suchman, Lucy. 1994. "Located Accountability: Embodying Visions of Technology Production and Use." Paper read at the Intersection of the Real and the Virtual, June 2–4, at Stanford University.

Tanner, Nancy, and Adrienne Zihlman. 1976. "Women in Evolution, Part I: Innovation and Selection in Human Origins." *Signs* 1:585–608.

Tatlock, Lynne. 1992. "*Speculum Feminarum*: Gendered Perspectives on Obstetrics and Gynecology in Early Modern Germany." *Signs* 17(4):725–60.

Taylor, Peter, and Frederick Buttel. 1992. "How Do We Know We Have Global Environmental Problems? Science and the Globalization of Environmental Discourse." *Geoforum* 23:405–16.

Teitelman, Robert. 1994. *Profits of Science: The American Marriage of Business and Technology*. New York: Basic Books.

Terry, Jennifer. 1989. "The Body Invaded: Medical Surveillance of Women as Reproducers." *Socialist Review* no. 19(July–Sept.): 13–31.

Timpane, John. 1992. "Careers in Pharmaceuticals and Biotechnology." *Science* 256 (May 8):advertising supplement (not paginated).

———. 1994a. "Careers in Pharmaceuticals and Biotechnology: West Coast." *Science* 263 (February 11):advertising supplement (not paginated).

———. 1994b. "Futures in Academic and Industrial Science for BS and MS Scientists." *Science* 265 (August 26):advertising supplement (not paginated).

———. 1995. "Euroscience at Work: Career Opportunities in European Pharmaceuticals and Biotechnology." *Science* 267 (February 24):advertising supplement (not paginated).

Travis, John. 1994. "Building a Baby Brain in a Robot." *Science* 264 (May 20):1080–82.

Traweek, Sharon. 1988. *Beamtimes and Lifetimes*. Cambridge: Harvard University Press.

———. 1992. "Border Crossings: Narrative Strategies in Science Studies and Among Physicists in Tsukuba Science City, Japan." In *Science as Practice and Culture*, edited by A. Pickering. Chicago: University of Chicago Press, 429–65.

Treichler, Paula, and Lisa Cartwright. 1992. *Imaging Technologies, Inscribing Science*. Special

Issue, *Camera Obscura: A Journal of Feminism and Film Theory* nos. 28 and 29.

Tsing, Anna Lowenhaupt. 1993a. "Forest Collisions: The Construction of Nature in Indonesian Rainforest Politics." Unpublished manuscript.

———. 1993b. *In the Realm of the Diamond Queen: Marginality in an Out-of-the-Way Place.* Princeton: Princeton University Press.

Turnbull, David. 1993. *Maps Are Territories: Science is an Atlas.* Chicago: University of Chicago Press.

UNESCO. 1952. *The Race Concept: Results of an Inquiry.* Paris: UNESCO.

Varley, John. 1986. "Press Enter." *Blue Champagne.* New York: Berkeley Books, 230–90.

Virilio, Paul, and Sylvere Lotringer. 1983. *Pure War.* New York: Semiotext(e).

Vogel, Carol. 1994. "Leonardo Notebook Sells for $30.8 Million." *New York Times,* November 12, A1, A11.

Vonarburg, Elisabeth. 1988. *The Silent City.* Translated by Jane Brierley. A Tesseract Book. Victoria, British Columbia: Porcépic Books.

Waldrop, M. Mitchell. 1994. "Software Agents Prepare to Sift the Riches of Cyberspace." *Science* 265 (Aug 12):882–83.

Washburn, S. L., and C. S. Lancaster. 1968. "The Evolution of Hunting." in *Man the Hunter,* edited by R. Lee and I. DeVore. Chicago: Aldine, 293–303.

Watson-Verran, Helen. 1994. "Re-negotiating What's Natural." Paper read at Meetings of the Society for Social Studies of Science, October 12–15, at New Orleans.

Watson-Verran, Helen, and David Turnbull. 1995. "Science and Other Indigenous Knowledge Systems." In *Handbook of Science and Technology Studies,* edited by S. Jasanoff, G. Markle, J. Petersen, and T. Pinch. Thousand Oaks, CA: Sage, 115–39.

Weldon, Fay. 1994. "Gender War in Judges." In *Out of the Garden: Women Writers on the Bible,* edited by C. Buchmann and C. Spiegel. New York: Fawcett/Columbine.

Westerveld, Bab. 1979. *Cat's Cradle and Other String Figures.* Translated by Plym Peters and Tony Langham. New York: Penguin.

Wheeler, Bonnie. 1992. "The Masculinity of King Arthur: From Gildas to the Nuclear Age." *Quondam et Futurus: A Journal of Arthurian Interpretations* 2 (4):1–26.

White, Evelyn, ed. 1990. *The Black Women's Health Book.* Seattle: Seal Press.

White, Hayden. 1987. *The Content of the Form: Narrative Discourse and Historical Representation.* Baltimore: Johns Hopkins University Press.

Whitehead, Alfred North. 1948, 1925. *Science and the Modern World.* New York: Mentor Books.

———. 1969, 1929. *Process and Reality.* New York: Free Press.

Wilson, Johnny L. 1991. *The SimEarth Bible.* Berkeley: McGraw Hill.

Winner, Langdon. 1986. "Do Artifacts Have Politics?" In *The Whale and the Reactor: A Search for Limits in an Age of High Technology.* Chicago: University of Chicago Press, 19–39.

Wolf, Ron. 1994. "Biotech Boom." *San Jose Mercury News,* March 14, 1D, 9D.

Woodbridge, Linda. 1984. *Women and the English Renaissance: Literature and the Nature of Womankind, 1540–1620.* Urbana: University of Illinois Press.

Woodman, William F., Mack C. Shelly II, and Brin J. Reichel. 1989. *Biotechnology and the Research Enterprise: A Guide to the Literature.* Ames: Iowa State University Press.

Woolgar, Steve. 1988. *Science, the Very Idea!* London: Tavistock.

Woolgar, Steve, ed. 1995. *Feminist and Constructivist Perspectives on New Technology.* Special Issue, *Science, Technology, and Human Values* 20 (Summer: 3).

World Resources Institute, INBio (Costa Rica), Rainforest Alliance (U.S.), and the African Centre for Technology Studies (Kenya), eds. 1993. *Biodiversity Prospecting: Using Genetic Resources for Sustainable Development.* A contribution to the WRI/IUCN/UNEP, *Global Biodiversity Strategy,* WRI/IUCN/UNEP, May 1993.

Wright, Lawrence. 1994. "One Drop of Blood." *The New Yorker* (July 25): 46–55.

Wright, Susan. 1986. "Recombinant DNA Technology and Its Social Transformation." *Osiris* 2 (second series):303–60.

_____. 1994. *Molecular Politics: Developing American and British Regulatory Policies for Genetic Engineering, 1972–1982.* Chicago: University of Chicago press.

Yanagisako, Sylvia, and Carol Delaney, eds. 1995. *Naturalizing Power: Essays in Feminist Cultural Analysis.* New York: Routledge.

Yeganogolou, Meyda. 1993. "Veiled Fantasies: Towards a Feminist Reading of Orientalism." Ph.D. diss., Sociology Board, University of California at Santa Cruz.

Yoxen, Edward. 1981. "Life as a Productive Force: Capitalizing the Science and Technology of Molecular Biology." In *Science, Technology and the Labour Process,* edited by L. Levidow and B. Young. London: CSE Books, 66–122.

_____. 1984. *The Gene Business.* New York: Harper & Row.

Zinn, Maxine Baca. 1978. "Marital Roles, Marital Power and Ethnicity: A Study of Changing Chicano Families." Ph.D. diss., Sociology Department, University of California at Berkeley.

INDEX

internet, Internet 4–6, 126, 246
interpellation, interpellated 49–52, 58, 97,
 115, 170–71
 and the joke 169
intertextuality 128
invention
 organisms as 79, 80
inventors and patents 73
IQ 160, 162, 299n33, 312n16
Irigaray, Luce 83

J

Jackson Laboratories 99
Jackson, Michael 261–62
Janus 34
Jefferson, Thomas 73, 85, 113
Jensen, Arthur 162
Jews 1–2, 11, 21, 233, 278n10
 and vampire stories 80, 215–17,
 309n2–3
joke(s) 152, 157, 167, 192, 258–59
 as sign of successful interpellation 169
 as way of working 154
 mathematical 523
joking practice 148
Jurassic Park 249, 285n28

K

Kant, Immanuel 43
Kin Wah Lam 263
Keller, Evelyn Fox 53, 278n15, 284n23,
 296n14
Kelley, Ann 175–88
kin 8, 14, 119–21, 254
 cybergenetic 262–67
 FemaleMan© and OncoMouse™ as 99
King, Katie 3, 37, 77, 121, 304n28
kinship 2, 49, 52–53, 56, 62, 67, 82, 217, 230,
 236, 255, 265, 290n54
 and flows of information v. blood 134
 and race 213–65
 discourse 309n1
 formalized recursive representations of
 140–41
Kleiner Perkins Caulfield & Byers 156, 183
Kline, Nathan 51, 280n2
knowledge(s) 24–25, 28–29, 35, 42, 51, 66, 73,
 104, 192, 199

articulation of disparate 139
 rational, as tropic 138–39
knowledge-making practice(s) 73
knowledge projects as freedom projects
 191–92, 271
Koshland, Daniel, Jr. 162, 299n33
Krimsky, Sheldon 93
Kubrick, Stanley 242
Kuletz, Valerie 281n7

L

labor 26, 42–42, 67, 94
 and commodity fetishism 141
 mixed with nature 72, 82, 90
 power 26
 system(s) 291n60
Laboratory, The, or The Passion of OncoMouse 16,
 46–47
laboratories 271
 biotechnological 15
 federal and private industry cooperative
 research 92
 high school science labs funded by
 biotechnology corporations 105–106
 national 53, 74, 95
laboratory 25, 52, 60, 66, 79
 and epistemological and material power
 257
 as theater of persuasion 270
 as world-building space 83
 molecular biological 66, 153
LANDSAT 245
Langton, Christopher 293n2
Larson, Gary 9
Latour, Bruno 3, 33–35, 43, 163–64, 191,
 276n9, 279n1, 279n18, 283n21, 297n21,
 306n36
Law, John 283n16
Leakey, Mary 241
Leder, Philip 80
Lederberg, Joshua 289n49
"Leonardo da Vinci's Dog" 159
lesbian 78, 233
 and the vampire 285n31
Leviathan and the Air-pump 23–27, 167
Levitt, Norman 301–302n12
Lewontin, Richard 145, 297n18
liberty 73, 105, 189
 technoscientific 114–16, 175, 197, 201,

Z